CW01035351

175

The Perfect Place to Grow: 175 Years of the Royal College of Art
© 2012 Royal College of Art
ISBN 978-1-907342-51-6

British Library Cataloguing-in-Publication Data.

Royal College of Art

Published by:
Royal College of Art
Kensington Gore
London SW7 2EU
+44 (0)20 7590 4444
www.rca.ac.uk

Editor: Octavia Reeve
In-house writer: Gina Lovett
Publishing assistants: Magda Nakassis, Esme Chapman
Proofreader: Davina Thackara
In-house photography: Nick Frayling, Dominic Tschudin

Creative direction, design and layout by Research Studios London:
Slip cover design concept and RS Champions typeface: Neville Brody
Publication designer: Tom Balchin
Publication design assistant: Eleonora Papini
Project manager: Phil Rodgers

The Royal College of Art has an environmental print policy, to minimise its impact on the natural environment.

Printed by Pureprint Group using their Pureprint™ environmental print technology. Vegetable inks were used throughout and 99% of all waste associated with the production of these catalogues was recycled.

Text and cover paper: Chorus Lux Silk, which is manufactured at a mill that is accredited to ISO 14001 standards and is supported by the Forest Stewardship Council

Inks: 100% vegetable oil-based

Typeface: Typeset in Benton and RS Champion © Neville Brody 2012, all rights reserved

The Perfect Place to Grow:
175 Years of the Royal College of Art

CONTENTS

Royal College of Art

Postgraduate Art and Design

PREFACE
His Royal Highness The Duke of Edinburgh

I am delighted to have this opportunity to congratulate the Royal College of Art on its 175th anniversary. I have been able to visit several of the annual exhibitions of work by students, and it is quite evident that the College has been doing extremely well since its 150th anniversary. This was not a foregone conclusion. The last 25 years have seen remarkable developments in materials, in electronics, digital design and in methods of manufacture. In some ways this may have made things easier for students, but in other ways, the challenge to get the answers right has become even more daunting.

What has not changed in the last 25 years, or indeed during the whole 175-year life of the College, is the need for students to learn the 'grammar' of the fine arts, and for students of design to learn to combine the arts with manufacturing so that the products are not simply efficient and fit for purpose but are also aesthetically pleasing.

The College cannot create talent, but it has proved over the years that it can successfully discover talent and give it every opportunity to develop and to flourish.

1

Tracey Emin
The Perfect Place to Grow
2001
Wooden birdhouse with metal roof,
watering can, plants and super-8 film

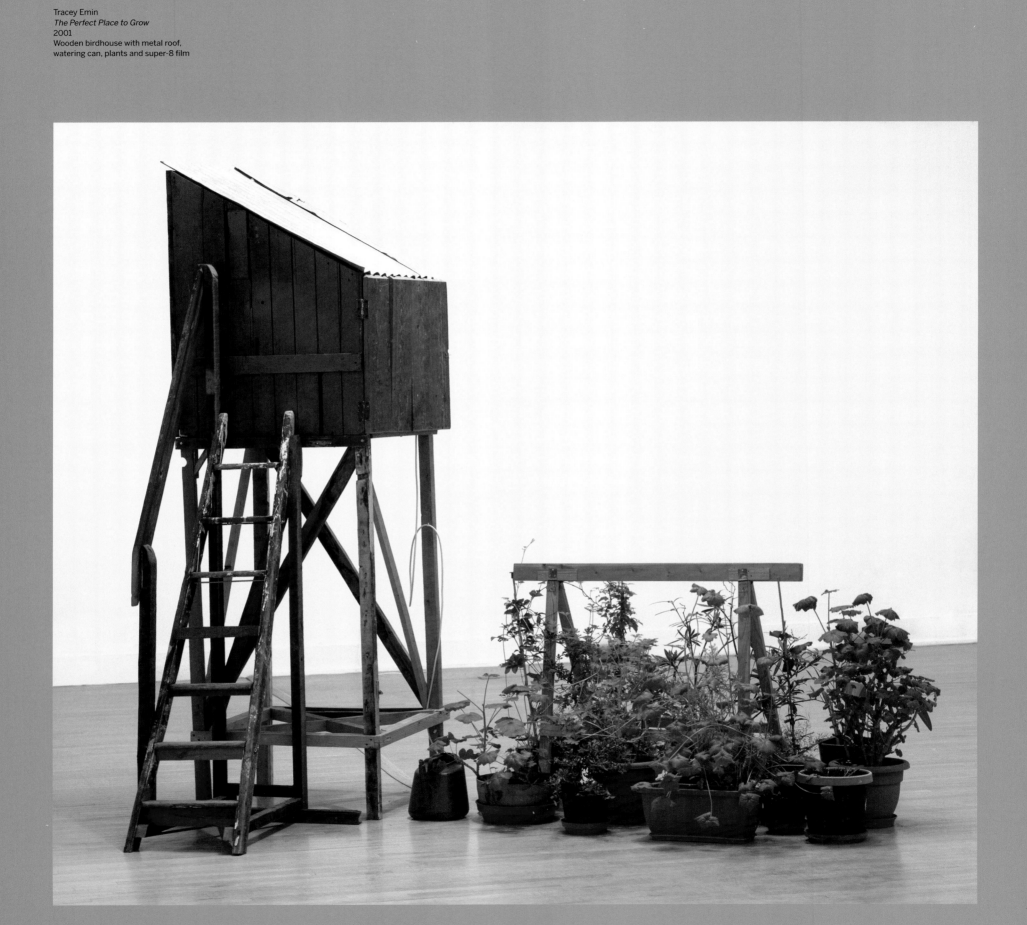

FOREWORD
Dr Paul Thompson, Rector, Royal College of Art

The reason for publishing this book is straightforwardly one of celebration and elucidation. The 175th anniversary of the RCA is a just cause for celebration; and it is a time to reflect upon the history of the College told to date, most recently in *Art & Design: 100 Years at the RCA*, written in 1996 by rector Professor Christopher Frayling. Of course much has changed in the world of art and design since then, and much no doubt will change in the years between 2012 and 2037, when the RCA will celebrate the 200th anniversary of the founding of the Government School of Design. Maybe that history will be disseminated by a technology destined to replace the e-book, of which we are now unaware!

This publication adds another stratum of years to the continuum of RCA history. Its central core has been written by Fiona MacCarthy, an eminent historian and biographer who is close, but not too close, to the RCA; by current Humanities faculty Professor Jane Pavitt, Joe Kerr and Dr Sarah Teasley; by Dr Glenn Adamson, director of Research at the Victoria and Albert Museum who, through our two institutions' joint research projects and Master's course in the History of Design, is both a scholar of British applied arts and, consequently, of many of our alumni, and also someone whose day-to-day professional dealings with the institution give him an added sense of our inner workings; and by visiting Professors Colin McDowell (Fashion) and Rick Poynor (Critical Writing in Art & Design), who have a very close sense of what's really happening with the students, beyond the Trollopian intrigues of the Senior Common Room.

Art historians Robert Upstone and Andrew Wilson cast their eyes over British art from the nineteenth century right up to 2012. Both are curators at the Tate (and in Robert's case, now a director of the august Fine Art Society), as well

as experts in the milieu of London's art world: its schools, artists, galleries, collectors and public museum collections. In their combined three essays, they chart the ebb and flow of British art on an international stage, and appraise the very recent history of the yBas as they approach their fiftieth birthdays. A recent appointment to the faculty of the School of Humanities, Dr Sarah Teasley, has been entrusted with the crystal ball, to address what she sees will be the defining values and purpose of art and design schools in the coming years. Sarah's is surely the most difficult essay of all to write, and certainly the one which will be most judged by history! My thanks to all of the contributors. Together, I hope we have created the most complete and multi-faceted appraisal to date of this wonderful institution.

Particular thanks are due to those alumni who were interviewed for this publication: Christopher Bailey, Margaret Calvert, James Dyson, Tracey Emin, David Hockney and Ridley Scott. Their contributions portray an era before tuition fees and the internet; each gives a sense of what it must have been like, receiving that offer letter from the RCA, and the mystique in which the institution was shrouded in the eyes of a teenager from either the 1960s, '70s or '80s. Thanks also to Neville Shulman CBE, manager to Ridley Scott, Julie Payne at Scot Free Films, Eimar O'Raw at Tracey Emin's studio, Jenna Littler at Burberry, Julie Green at David Hockney Inc, and the many staff, students and alumni who have allowed us to use their images in this publication.

The RCA is very grateful for The Henry Moore Foundation's kind support of the accompanying *175 Years of the Royal College of Art* exhibition, taking place from 16 November 2012 to 3 January 2013 in the Royal College of Art galleries, Kensington. All works of art in the exhibition are kindly insured under Her Majesty's Government Indemnity Scheme, a programme administered by the DCMS.

Especial thanks to alumna Tracey Emin, for graciously allowing us to borrow the title of her installation work *The Perfect Place to Grow* (2001). Tracey's work refers to her father's amazing ability with plants, but lousy carpentry skills. I have appropriated the title to refer to the RCA, with deliberate irony: of course for Tracey the College was not always such a welcoming milieu; for others, it was positively barren; but for the overriding majority of talented students who have passed through this institution, it has clearly been an amazingly fertile place embraced by a sound structure. As Christopher Bailey says, 'The RCA is a truly inspiring place to study. The wonderful thing about being a student there is that your experience is touched and influenced by the most incredible range of designers from diverse backgrounds and in so many different mediums. On any one day, you could be collaborating with fine artists, textile designers, silversmiths, architects, photographers or filmmakers. It's a creative immersion that opens up your design mind.'

Finally, huge thanks to Octavia Reeve, senior publishing manager at the RCA, who has edited this publication so beautifully and under such tremendous time constraints; to alumna Nancy Casserley for compiling the College's history and in assisting so many of us with our research; to Magda Nakassis, publishing assistant, for her assiduous picture research; to Gina Lovett for drawing out the experiences of our alumni interviewees so sensitively; to Neil Parkinson, manager of the RCA's archive, for his patience and diligence over many months, assisting each of us with our research; and to alumna Wilhelmina Bunn, whose work on the accompanying exhibition necessarily spilled over into working on this book. Thanks are due, too, to Professor Neville Brody and his team at Research Studios, for creating such a strikingly beautiful design for this publication. All in all, it has truly been a 'College effort'!

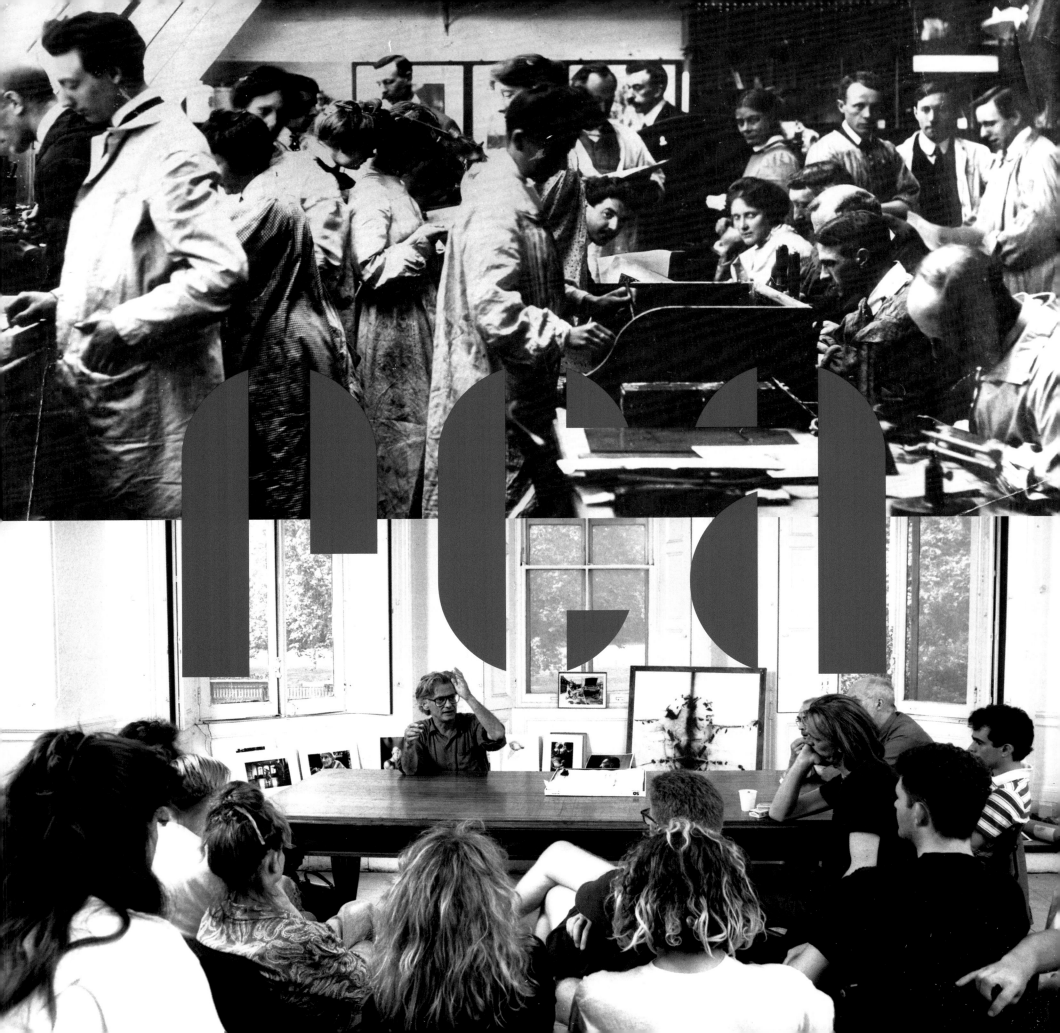

'A magnet for talent':
An Intimate Portrait of the Royal College of Art
Fiona MacCarthy

Students in the RCAfé
2003

WHAT HAS GIVEN THE ROYAL COLLEGE OF ART ITS SPECIAL CHARACTER? WHAT HAS CAUSED THIS RELATIVELY SMALL, SPECIALIST POSTGRADUATE INSTITUTION TO OCCUPY A UNIQUE PLACE IN OUR NATIONAL CULTURE?

'A magnet for talent':
An Intimate Portrait of the Royal College of Art
Fiona MacCarthy

To outsiders the Royal College of Art has often seemed intriguingly mysterious: a college founded back in the nineteenth century, whose atmosphere and ethos is breathtakingly modern; a college where visual and intellectual studies interconnect and inspire one another. No portrait of the RCA can be definitive. All I can claim is to have known it all my life, first as a child being brought up in Queen's Gate in the early post-war years and attending a local school – Miss Ironside's – where many of the pupils were the children of the RCA professors. The man who taught me art, Christopher Ironside, nephew of the headmistress, was also a tutor in life drawing at the College, while his wife Janey Ironside was a legendary head of the RCA Fashion School in its 1960s heyday.

Later I was, so to speak, to marry into the RCA myself as the wife of the designer David Mellor, an RCA student of the early Darwin era and an honorary doctor of the College. As a writer on design I became an honorary fellow and then a senior fellow of the RCA myself. Like so many people who have been connected with it, I have come to love this highly professional and often wonderfully wayward institution.

The College has been through many different permutations since it was founded in 1837 as the Government School of Design, based at Somerset House under the aegis of the Board of Trade. In 1864 it was transformed into the National Art Training School, having moved to South Kensington as part of 'Albertopolis', Prince Albert's visionary cultural and scientific metropolitan development. In 1896 it finally became the Royal College of Art, an early model for the specialist art and design college as it developed through the coming century.

In 1967 the College was granted a Royal Charter, turning it into an independent institution of university status, able to grant its own degrees and directly funded through the Department of Education and Science. The story of the politics behind these many changes is a fascinating one. But just as interesting are the personal experiences of the multitude of students from many different backgrounds who arrived at the College over this long period. Their particular talents, their tenacious ambitions and, so often, their creative clashes with authority have made it the exhilarating place it is.

Early Years 1837–52

Christopher Dresser, who was to become the most versatile and brilliant nineteenth-century industrial designer, arrived at the Government School of Design in 1847 as a boy of 13. What kind of institution did he find? It was a school that had been founded with a specific purpose, the result of a parliamentary Select Committee on Arts and Manufactures set up to investigate the evident shortcomings of design in British manufacturing. In textiles and ceramics especially, the British were not holding their own against the French. The export trade was suffering. The Government School of Design had been set up to remedy this situation by giving a training in 'ornamental drawing', a training that had been nothing to do with self-expression but that would teach apprentices from industry to master the techniques of applied design.

To start with there were only 17 students, mostly very young apprentices released by their employers, but by the middle 1840s numbers had increased to around 280 male students, mostly aged between 15 and 20, crowded into the upper storeys of Somerset House, the grandiose public building on the Strand. A separate section for women students was opened in 1842 on the lower floor. The young Christopher Dresser would have followed a rigorous regime of set hours during which the students remained seated and silent, copying and copying examples of architecture, plant forms and geometric design. An educational library had been set up at the school, predecessor of our present-day National Art Library, as well as the first beginnings of the collection

that grew into the Victoria and Albert Museum – mainly classical casts as well as examples of stained glass, Sèvres vases, terracotta, metalwork and textiles. Somerset House became still more overcrowded as these casts piled up alongside full-size copies of Pompeian mural paintings. It was by all accounts a well-meaning but a somewhat chaotic and confusing place.

The main problem was the lack of clear consensus on how design for manufacturing should actually be taught. The Government School's first two superintendents, William Dyce and Charles Heath Wilson, each stayed for only a few years before retiring baffled and exhausted. Teachers disagreed and came and went. One of the potentially ablest of instructors, Charles James Richardson, an architect and former assistant to Sir John Soane, left the school after complaining bitterly that one of his students had had to spend three months on shading in a detailed drawing of a ball. In 1845 the students had themselves rebelled and written to the Board of Trade to complain of ineffective teaching and bad morale. Thirty-five of the students were suspended. The following year there was a staff uprising too. Richard Burchett, a leader of the dissidents who was himself later to be appointed headmaster of the school, gave evidence to the subsequent official committee of enquiry, that the school was 'an utter and complete failure'.[1] It was hardly an auspicious start.

The Cole and Redgrave Years 1852–75

In 1852 a complete and much-needed regime change began with the advent of Henry Cole, a hugely ambitious and efficient civil servant now appointed overall superintendent of the new Department of Practical Art. Henry Cole was a systems man incarnate who had not only reformed the Public Records Office but also had been instrumental in the introduction of the Penny Post. He had also commissioned the first ever Christmas card from J C Horsley in 1843 and had founded his own company, Summerly's Art Manufactures, an early version of design consultancy, through which he commissioned designs for new industrial products from his

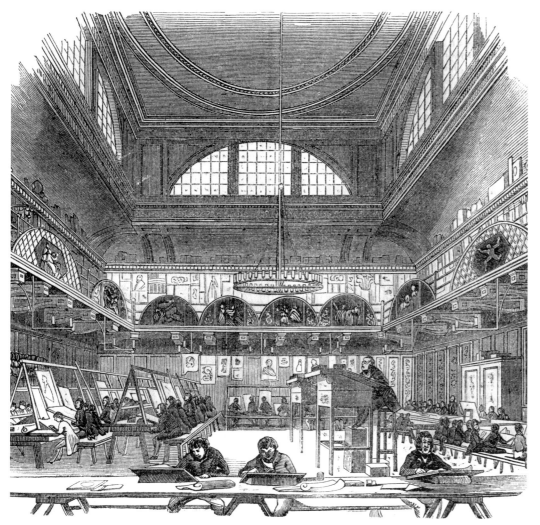

SCHOOL OF DESIGN.

The Government School of Design
at Somerset House, London
May 1843

'A magnet for talent':
An Intimate Portrait of the Royal College of Art
Fiona MacCarthy

artist friends. Himself a designer *manqué*, Henry Cole rose to the challenge of reforming the Government School of Design, which he now envisaged as the apex of a far-reaching national network of provincial art and design training institutions. His Summerly's colleague, the artist Richard Redgrave, was appointed the school's first superintendent of Art.

Cole had built up good relations with Prince Albert, based on their shared reforming zeal. The Prince Consort was then involved in purchasing land in South Kensington with proceeds from the 1851 Exhibition. It was envisaged that the newly reinvigorated school would eventually be part of a whole cultural complex, alongside the South Kensington Museum, the Science and Natural History Museums, the Imperial Institute, the Royal College of Music and the Royal Albert Hall. But prospects for this permanent move were still far off and meanwhile Queen Victoria, perhaps influenced by the sentimental memory that Honiton lace for her wedding dress had been designed by a female student of the School of Design, offered temporary accommodation for the school in 40-or-so rooms in Marlborough House.

Complaints of inadequate accommodation is one of the recurring motifs of this story. Student numbers were rising, with reportedly 422 enrolments for the first seven months of 1853. It was now a mixed population of full-time National Scholars en route to be designers, part-time students already in employment who came for evening classes, art teachers in training and an increasing number of fee-paying students, many of them women. Classes overflowed out from the main building into makeshift wooden huts in the gardens of Marlborough House.

Further pressures on space were caused by the museum, now removed from Somerset House and given pride of place in its new setting. It was open to the public. Central to Cole's mission in completely overhauling national art was to simultaneously educate the public into demanding higher standards of design. He set out to demonstrate the good, enlarging the original Somerset House collection into a Museum of Manufactures and displaying his approved examples of design. Alongside was the soon-notorious 'Chamber of Horrors', assembled as a warning to the students and the public, of artefacts designed on what Cole saw as false principles. This was the endeavour satirised so devastatingly

in Charles Dickens's magazine *Household Words*, in which Mr Crumpet, the clerk from the suburbs, returns home 'haunted by the most horrid shapes'.

Kate Greenaway, one of the most delicate and charming Victorian illustrators, the protégé of Ruskin, enrolled as a full-time student in 1865. She was then 19 and had already been studying at her local London art school from the age of 12. By the time that she arrived the school had moved once more from temporary accommodation in South Kensington, the early eighteenth-century Brompton Park House, to its own purpose-built premises on the 12-acre site adjoining Brompton Oratory, assigned to Henry Cole by Prince Albert and the Royal Commission for the Exhibition of 1851 for the development of the museum and the school. The school, now renamed the National Art Training School had been transferred from the control of the Board of Trade to that of the Privy Council Committee of Education. It had more or less reverted to being a school for teacher training, although lip service was still being paid to its original purpose, the training of designers to raise standards in British industry.

Richard Redgrave continued as Cole's right-hand man and principal, alongside Richard Burchett the headmaster. The school, often now referred to simply as 'South Kensington',

Richard Redgrave
Self-portrait
Oil on canvas

Anthony Carey Stannus
Experiments with the Model of the
Memorial of the Exhibition of 1851
(Foreground: Henry Cole)

'A magnet for talent':
An Intimate Portrait of the Royal College of Art
Fiona MacCarthy

was becoming more middle class in tenor and more female, though ladies were still not allowed to go to life classes for reasons of public decency. In the early 1860s the upper-middle-class Gertrude Jekyll was a student, attending Owen Jones's lectures and absorbing his theories of ornament and colour, a training that affected her notable career as the designer of some of the most beautiful, evocative gardens of the period. The South Kensington intake extended far up-market when, in 1868, Princess Louise was enrolled as a student of modelling and sculpture, prompting her mother Queen Victoria to issue that now famous warning: 'Beware of artists – they mix with all classes of society and are therefore most dangerous.'[2]

Some students at the school found the training system anything but stimulating. The German-born painter and illustrator Hubert von Herkomer, who had previously studied at the Munich Academy, spent two summers at South Kensington in 1866 and 1867, describing the teaching as 'aimless and undirected'.[3] The painter George Clausen, a National Scholar from 1873, remembered some years later, 'there was but little active direction in the School when I was there. The Headmaster, Mr Burchett, was a good deal of an invalid, and, unfortunately, we saw but little of him.' Other masters are described as 'good easy men, more than a little tired as teachers are apt to be with long continuance'. The masters left the students to their own devices and they simply 'muddled through'.[4] The combination of rigidity and apathy reported by students of the period goes some way to reinforcing Ruskin's furious attack on the corrosive influence of Cole, which, he said, had 'corrupted the system of art teaching all over England into a state of abortion and falsehood from which it will take twenty years to recover'.[5] The Cole and Redgrave system of 22 strict stages of instruction left no space for developing the artist's individual creative soul.

There were, however, compensations. First of all, the close proximity of the museum. The students had their own way in, along a hidden corridor and down a flight of steps. According to Clausen, 'The Museum was our best teacher; the Italian Court with the fine sculptures and terracottas we got to know very well.'[6] This reminds us of the impact made by the South Kensington Museum at this period on the work of William Morris and Edward Burne-Jones. The students of the school

were drawn in to assist with the actual construction of the museum, for example the galvanised iron buildings that were known as the 'Brompton boilers'. A class of women students painted tiles for the public refreshment rooms. Students took part in decorations in *sgraffito* on the Science College building (now the Science Museum) in Exhibition Road. With the construction of the great round Albert Hall in progress, the whole South Kensington area was then a giant building site.

The school then had little formal social life. There was no student common room. Clausen informs us that 'the only festivity was an annual pothouse supper to the men who were leaving; but it was amusing enough'.[7] However, this was the time we first become aware of the emergence of student solidarity, the creative interactions between students that remain such an important factor in modern College life. Von Herkomer and Luke Fildes, Henry Woods, George Clausen and his brother William formed a group together in the life class. Edward Poynter, Millais, Leighton, Alma-Tadema, Watts and Fred Walker were the painters they most talked of and admired. They knew little of the Pre-Raphaelite artists, apart from Holman Hunt who came in to complete his painting *The Shadow of the Cross* in Burchett's studio. With the one obvious exception of Alfred Stevens, once a disaffected master at the School of Design, now a leading light of 'Albertopolis' masterminding decoration for almost all its buildings, contemporary sculpture seemed of little interest. But this would quite soon change.

The Poynter and Armstrong Years 1875–98

The appointment of Edward Poynter as principal in 1875 brought a new mood to the school. Cole and Redgrave had retired almost simultaneously. The ailing headmaster Richard Burchett was now dead. The politically astute and ambitious Edward Poynter was now in a powerful position as both director of Art and principal of the National Art Training School. Poynter, himself a practising artist with a Paris *beaux arts*

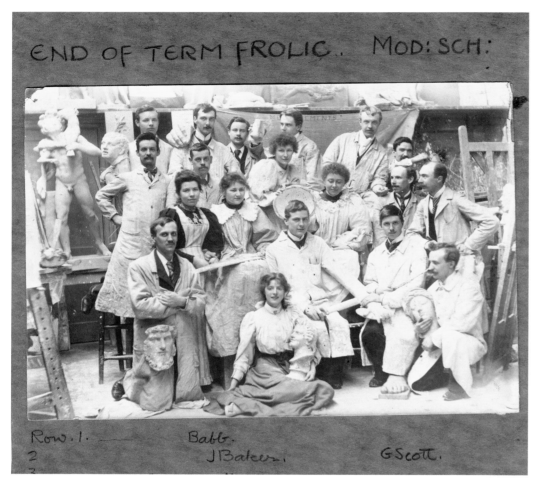

END OF TERM FROLIC. MOD: SCH:

Row. 1. — Babb.
2 J Bateu.
3 G Scott.

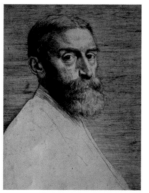

End of Term Frolic
c. 1894
Alphonse Legros
Sir E J Poynter
c. 1863
Black ink on paper (etching)

background, a belief in the study of the living model and a predeliction for very large-scale paintings showing dramatic scenes from ancient Greece and Rome, shifted the school's main thrust from education in design for manufacture towards an academic training in fine arts.

Edward Poynter was a rather dour and problematic character. His brother-in-law Edward Burne-Jones would complain that even to be in the same room with him was torture. But he had a great ability to get things done, dispensing with members of the tired old staff and bringing in exponents of the French *atelier* system. Poynter's close associate Alphonse Legros was brought in to head the etching class. Still more influential was Aimé-Jules Dalou, a sculptor who had worked with Rodin before coming to London as a refugee from the Paris Commune of 1871. Poynter now appointed him to run the class in modelling.

Dalou's direct teaching methods, which included precise demonstrations of technique, came as a revelation to the students. According to his pupil and disciple Edward Lantéri, he 'knew how to inspire them with the *desire* to work as well as the *love* of work, and succeeded in awakening an extraordinary enthusiasm where all before him seemed dormant'.[8] After two years he retired and Lantéri took over. The first seeds of the indigenous British 'New Sculpture' movement of the final decades of the nineteenth century were now emerging, whose leading lights included ex-modelling class students Albert Toft, Alfred Drury, Francis Derwent Wood and Esther Moore. Poynter's regime saw the beginnings of the school's new reputation as a serious academy of art.

In 1881 Edward Poynter departed on the next stage of an upwardly mobile career that culminated in his becoming concurrently director of the National Gallery and president of the Royal Academy. He was made a baronet in 1902. He was succeeded as director of the school by Thomas Armstrong, whose friendship with Poynter dated back to their student days in Paris. Both appear as clearly recognisable characters in George du Maurier's best-selling Paris novel *Trilby* (1894). So much of the story of the RCA is founded on such networks of the past.

To a student arriving in the middle 1880s, the school could seem a very mystifying place. The painter Harold Speed was just a boy of 14 when he enrolled there: 'what a new

and strange world it was to be sure,' he later recollected, 'made up chiefly of plaster casts, young gentlemen from the provinces and retired military officers'.[9] There were students from all parts of the country, a cacophony of accents. He identified the two distinct species of students, 'those who were going to be artists and those who were going to be art masters'. The latter had little interest in art 'but were intent on certificates'.[10]

Student conditions at that period were appalling. The original L-shaped building adjoining the museum was now badly over-crowded, not only with students but with abandoned, decaying plaster casts. Female students were especially badly housed in rooms over the lodgings of the South Kensington buildings' engineers, disturbed by crying children and the smells of cooking. There was also the clatter from the busy public road. Complaints were made to the Department but nothing much was done. Unsatisfactory conditions may have been one reason for a decline in student numbers, from almost 900 – the majority fee-paying – in the early 1880s, to just over 600 in 1885. But one still gets a sense of warmth and camaraderie amongst those students with serious ambitions, grasping what opportunities this new environment could offer to make themselves a future life in art. Certainly Harold Speed, writing in the RCA student magazine for 1912, looked back with some nostalgia: 'I wonder if you still sit on a coil of hot-water pipes in the antique room and eat sandwiches at lunchtime.'[11] Almost certainly they did.

The Crane Years 1898–1900

A fresh influence began to infiltrate the school as the aesthetic movement burgeoned and William Morris's ideas on the supremacy of craftwork came into wider public circulation. Morris may have allowed his daughter May to enrol at the school to study embroidery in 1881. He may have agreed to act as an official examiner to the Department, an onerous duty that continued until the year he died. The school's proximity to his beloved South Kensington Museum almost certainly softened William Morris's heart.

Frederick Hollyer
Walter Crane
1886
Platinum print

W R Lethaby's Manuscript Regarding
His Appointment and Proposed
Syllabus
1901

School of Design and Crafts

Mr Bowden
Please reproduce
me six copies
if possible at.
We have them
by 9 am. tomorrow
for Royal College
fast.
Aug Spencer

7. 3. 01.

Stencils prepared
6 Copies Reprint
1/3/01

A.L

Prof. Lethaby

Please See
R.S. 7. 3. 01.

In the School of Design
and Crafts practical work-
manship in different classes
is taken concurrently with
the general drawing work
of the studio, and every advanced
student of Design is expected
will be expected to make
himself proficient in the
technique of one craft.
Practical workshop classes are
already established in Stained
glass; wood carving & gesso work;
stone and marble cutting,
pottery painting; and Etching.
Others including Text writing
and Illumination; Tapestry
weaving and Embroidery;
Bookbinding; Silver work,
jewellery, and Enamelling &c
will be opened immediately.
the course of study in the
studio and the museums is given
below but it must be taken as
suggesting the scope of study rather
First year: Second term:
An introductory course of design
based on the general syllabus
which follows
a plan to be followed in exact
sequence
Every student of design will be
required to make a series of careful
studies in the Museums, these should
as far as possible be uniform in
size for ready reference

'A magnet for talent':
An Intimate Portrait of the Royal College of Art
Fiona MacCarthy

But in theory he was just as ferociously opposed as Ruskin had been to the Henry Cole regime based on grammar of ornament and linear geometry – the 'Mr Gradgrind' system of art education lampooned by Charles Dickens in *Hard Times* (1854), which could have no part in his grand Socialist vision. For Morris, a truly democratic art could only develop through personal involvement in the processes of making, a fundamental understanding of techniques and creative practicalities. His beliefs in the superior moral value of handmaking, as opposed to the heartless drudgery of factory production, were taken up by a younger group of architects and designer–makers, most of whom were members of the Art Workers' Guild that had been founded in 1883.

Thomas Armstrong had been active in the introduction of Arts and Crafts values to the school. He brought in Walter Crane, artist–illustrator, socialist and a leading member of the Art Workers' Guild, to lecture to the students and organise demonstrations of such crafts as gesso and decorative plasterwork, stencilling, embroidery and *repoussé* metalwork. Armstrong also invited Louis Dalpayrat, renowned expert on Limoges enamel painting, to come across from Paris and give a series of lecture-demonstrations to the students. One of these students was a National Scholar, Alexander Fisher, who had already used enamels on pottery but so far had no knowledge of enamelling on metal. These lectures were the start of Fisher's long career as the leading artist craftsman in enamel in Britain in the late nineteenth century.

There were other examples. One of these was Gertrude Jekyll's great collaborator Edwin Lutyens, a student from 1885, whose boyhood enthusiasm for the Arts and Crafts and vernacular architecture was further encouraged by his two years at South Kensington. Another was Nelson Dawson, at the school from 1891, who became a skilled and innovative art metal-worker, much featured in *The Studio* magazine. Gordon Forsyth, Dawson's near-contemporary, became a well-known decorative arts potter who specialised in lustreware. Forsyth designed the wondrous Royal Lancastrian vases, bowls and ginger jars, without which no tasteful Edwardian interior could feel itself complete.

In 1898 Walter Crane was appointed principal of what was now redesignated the Royal College of Art. Maybe Queen Victoria had come around to artists. In some ways Walter

Crane must have seemed the perfect choice to take over the newly reconstituted College, now given the authority to grant its own diplomas. Crane was a decorative artist and designer with an international reputation, a respected figure in Art Workers' Guild circles. But the appointment did not work out, partly because he was in the end unwilling to allot the necessary time and energy to reform an institution which, to his depression, 'had been chiefly run as a sort of mill in which to prepare art teachers and masters'.[12] Besides, it appears Crane was totally lacking in communication skills. A past student described how 'Crane was unable to express himself in words'. Giving public lectures, he stuttered and gabbled. 'If one could coax a pencil into his hand that was the way to get help from him'.[13] He found the RCA altogether daunting. After only 18 months Crane retired.

He left a lasting legacy, however, in drawing up a scheme for a fundamental reorganisation of art and design training at the College. It was now that an architecture school was first established, directed by Art Workers' Guild architect Beresford Pite. This was in line with Arts and Crafts theories of architecture as 'the mother of all the arts'. And still more far-reaching in the story of the College was the appointment of W R Lethaby as Britain's first ever professor of Ornament and Design.

The reticent self-effacing Lethaby, adorer of Morris, was an easy man to underestimate. Someone once said he looked like a white rabbit. In fact Lethaby was a man of considerable powers – creative, intellectual and administrative. As a theorist Lethaby was now the prime exponent of the 'doing is designing' Arts and Crafts philosophy. He had already set up a notably effective regime of craft training as head of the Central School of Arts and Crafts. He saw the acquisition of craft skills as the necessary route to imaginative freedom in design. He viewed a workshop training, giving students a deep knowledge of processes and materials, as the key for improving design in industry. For Lethaby's broad interests included manufacturing. In the RCA archive is Lethaby's original handwritten plan for the RCA Design School, scrawled out and scribbled over. It is both a touching and a historic document. Lethaby's ideas were to dominate RCA design teaching far into the twentieth century.

The Spencer Years 1900–20

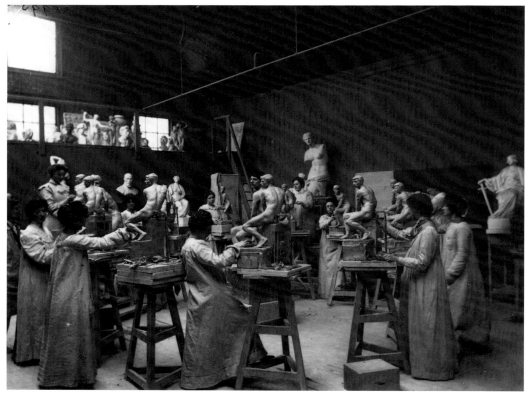

Women's Life Modelling Class
c. 1905

William Rothenstein
Portrait of Augustus Spencer
1920
Red and white chalk on toned paper

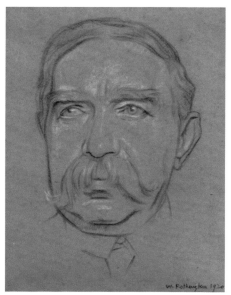

We should not get carried away into imagining an immediate improvement in conditions at the College. Crane's successor as principal, Augustus Spencer, former head of Leicester Municipal School of Art, was accused by one disaffected student, Sylvia Pankhurst the artist–suffragette who came to the College in 1904, of running a hopelessly incompetent and politically incorrect regime. 'Miss E S Pankhurst' had been among a delegation of students giving evidence in 1909 to the Departmental Committee of the Board of Education then compiling an official report on the Royal College of Art, to be published two years later. Pankhurst's complaints, as one might expect, were focused on poor treatment of the female students, the imbalance at the College between male and female staff and the fact that the best teaching posts in the world outside inevitably went to men.

Sylvia Pankhurst, a considerable dramatiser, stressed the miseries of the lives of students scattered around London in insalubrious lodgings. Some were practically starving. 'At the Royal College of Art, I know that a great many students do not eat enough. It is not very easy to live on the little money that they get, and they do not look after themselves properly in many instances.'[14] She told the enquiry that she personally knew of five cases of insanity in students who were at the College or had recently left. The worst cases of depression were in the Painting School. However, the *Royal College of Art Students' Magazine*, started in 1911, tells a rather different story, with ebullient accounts of Common Room Christmas socials and the costumed Arts Balls that were becoming a popular feature of artistic London at that period.

In 1912 eight RCA students worked on the Peace Palace building at The Hague, supplying the stained glass, gesso and tile work, and painted decoration. In another two years hopes of peace would be subsumed into the beginnings of the First World War. In what the student magazine refers to as 'the stress of unavoidable circumstances',[15] the autumn 1914 issue has no editorial foreword since the editor had recently been called up. It was reported proudly, in those early

'A magnet for talent':
An Intimate Portrait of the Royal College of Art
Fiona MacCarthy

months of patriotic fervour, that 21 current students and 18 past students had already joined the colours. One of these ex-students listed is the sculptor Charles Sargeant Jagger, prize pupil of Lantéri, who had foregone a Rome scholarship to join the Artists' Rifles. Jagger's Royal Artillery Memorial at Hyde Park Corner was to be a significant reminder of the terrors of that war.

The whole College was fragmented as the war effort took over, Sketching Club exhibition rooms being commandeered at very short notice by the military, sewing parties being organised by the women students to supply garments for the troops. The commotion and financial privations of the war put paid to the improvements recommended in the Department of Education's highly critical 1911 Report. In particular, officially approved plans for a new building on an independent site, separate from what was now the Victoria and Albert Museum, were now abandoned. The desperately needed purpose-planned new building would not materialise for another 50 years.

The Rothenstein Years 1920–35

It was only in the 1920s that the RCA resurfaced. When William Rothenstein took over as principal in 1920 he was faced with the daunting task of reinventing a college still affected by the trauma of a war in which 23 RCA students had been killed. According to his son John Rothenstein, 'the place had the look – and even the smell – not of an art school but of an inferior elementary school: the members of staff I happened to see resembled clerks; the retiring Principal [the hapless Spencer] wore a morning coat, and the students seemed to have sunk into apathy'.[16]

Rothenstein's success in transforming a college of poor morale and relative obscurity, with no fixed position in the London art world, was partly the result of an unprecedented level of talent amongst incoming students. This was the generation that included Barbara Hepworth, Henry Moore, John Tunnard, Ceri Richards, Edward Burra, Edward Bawden and Eric Ravilious. But the main catalyst for change in the

spirit and ambitions of the College was the 'benevolent, electric presence'[17] of the principal himself.

William Rothenstein was himself a well-known painter and draughtsman specialising in portraits of the then cultural and political celebrities. He was well connected and gregarious, at the centre of a circle of Bohemian artist friends. He may have been physically unimpressive. Prospective student Ruskin Spear, arriving for his interview, expressed surprise that the little figure looking like a wizened monkey was actually the principal. But this was far outweighed by his energy and charm, his candour and impulsiveness, as well as by the fact that there in their midst the students had a working artist, carrying on his own practice in his College studio.

In 1922 and again in 1930 Rothenstein put himself in charge of the Painting School and though the students often found his interventionist approach annoying, groaning when 'Rothy', as they called him, seized the pencil from their hand and corrected their own drawing, they sensed that his heart was very much in the right place. This was the artist who wanted to make *artists*. He continued the work that Poynter had begun in moving the College on from its remit to train teachers, insisting that 'only where the art school is training for a *specific purpose* can it be useful'.[18]

The Slade School at the time had a far superior reputation for the training of artists. Rothenstein set out to challenge this supremacy by teaching art within a broader context of studies at the College, now to be structured into the four principal Schools of Sculpture, Painting, Design and Architecture. The Engraving School later became a major one under the long-serving Sir Frank Short. Some of the old Morris aficionados lingered: the wood carver George Jack, for example; the calligrapher Edward Johnston, who was still holding lettering classes at the College attended by his fans who 'were mostly girls, some of whom brought cameras to the Lecture Theatre to photograph the Master's drawings on the blackboard as soon as he laid down his chalk'.[19] But now the teaching staff was greatly reinforced as Rothenstein imported his own artist friends of a different generation, the beginning of an important new tradition of distinguished practitioners teaching part-time at the RCA.

He did not succeed in appointing Eric Gill, who refused on the somewhat unlikely grounds that there were far too many

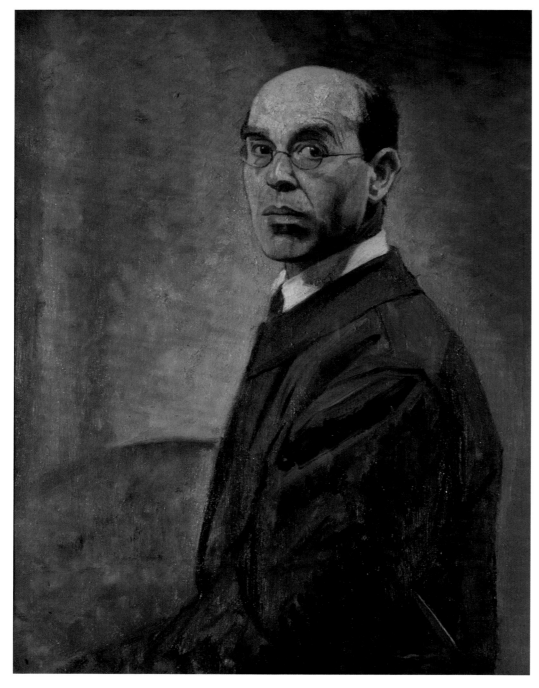

William Rothenstein
Self-portrait
1930
Oil on canvas

women at the College. But Rothenstein's policy of outside appointments enriched students' experience by giving them an insight into the lives of working artists, with their tensions, doubts and triumphs. One of his most influential of recruits was Paul Nash, who taught at the School of Design from 1924. His approach to teaching was less as an authority than as an equal, relating to his students 'in the manner of artists exchanging their personal experiences'.[20]

The students of that time were exposed to Rothenstein's generous concept of the College as 'a true University of the Arts'.[21] They felt the benefits of his many contacts with leading contemporary writers, poets and philosophers. T E Lawrence, Rabindranath Tagore, G K Chesterton and Walter de la Mare came to speak in the Student Common Room. Rothenstein had an enlightened feeling for the multicultural. Even a Tibetan lama was brought in. He invited students to his house in Airlie Gardens, Campden Hill, for what became routine Sunday evening gatherings to meet such well-known writers as Joseph Conrad, Arnold Bennett and Max Beerbohm. The mix of guests could be completely unpredictable. John Rothenstein describes these Sunday evenings as 'unique in several respects but in none more conspicuously than for their extraordinary intermingling of the brilliant with the tedious'.[22]

For many of the students, especially those from working-class backgrounds, the experience of being at the College in the 1920s enlarged their expectations. One of these was Henry Moore, a scholarship student brought up in a Yorkshire mining village arriving in London in 1921. 'For the first year,' Moore remembered, 'I was in a dream of excitement. When I rode on the open top of a bus I felt I was travelling in Heaven almost, and that the bus was floating in the air.'[23] London gave him a sense of endless possibility: here he felt he could learn about all the sculptures that had ever been in the world.

The College was then quite small, at around 200 students. There was the sense of belonging to an intensely creative small community. Moore was one of a small contingent of students, also including Barbara Hepworth, who had arrived at the College via Leeds School of Art. They all tended to band together in the Common Room, sitting at what became known as the Leeds table. So much so that the student magazine began complaining about the preponderance of

'A magnet for talent':
An Intimate Portrait of the Royal College of Art
Fiona MacCarthy

Leeds students: 'This is beyond a joke. Would it not be advisable for the whole college to remove to Leeds and save travelling expenses on Scholarships?'[24] The small scale and the intimate feeling of the College encouraged the students to work closely, side by side, watching one another, influencing one another. Moore and Hepworth both started to develop as stone carvers while they were in the Sculpture School. William Rothenstein's son John had been aware of Hepworth, 'ambitious, cool and hard-working' with one eye 'ever attentive to what Moore was doing'.[25]

A particularly fascinating aspect of the College has been the fluctuation in reputation of different departments through the generations. In Rothenstein's regime it was certainly the Painting School that was the favoured child, a fact of life that caused some dismay in the Design School where applied arts student Edward Bawden felt relegated to the shameful situation of 'being an orphan, the offspring of a gentleman and a whore'.[26]

But in point of fact the work of the Design School in the inter-war period was just as distinguished as that of the so-called Paradise of Painters. Indeed John Piper, a student in the Painting School, admitted himself jealous of what was being achieved by the designers, paying particular attention to the work of two already close friends, Edward Bawden and Eric Ravilious. This productive friendship between the awkward, cagey, introspective Bawden and the lighter hearted, wittier Ravilious, a leading member of the College football team, continued until Ravilious, by this time a war artist, was reported missing in Iceland in 1942. The particular English mode of art they had evolved, rooted in the graphic, precise and referential, affectionate but never anodyne, became almost the RCA's adopted style.

By the early 1930s many of Rothenstein's hopes had been achieved: artistically speaking the standing of the RCA was relatively high. But the problem he was far from solving, had not even tried to tackle with serious intent, was the main aim behind the founding of the College as the Government School of Design back in 1837: the raising of national standards of industrial design.

Rothenstein had by no means risen to the challenge of twentieth-century Modernism. Serge Chermeyeff might visit the Architecture School, but the by-now ageing and ailing

Rothenstein's chief sympathies were not with the machine age. He seemed a remote 1890s figure, the man who had actually known Degas and Verlaine. The professor of Design, Professor E W Tristram, was a distinguished medievalist, expert in the restoration of cathedral wall paintings. Tristram was said to dislike 'the very *thought* of Industrial Design. He was happier restoring the Tomb of the Black Prince at Canterbury'.[27] When Robin Day, a design student from a High Wycombe furniture trade background, ventured to consult him on his designs for interiors, the professor said, 'Well my boy, you obviously know more about this than I do'.[28] Industry and commerce had found no natural place in the University of the Arts envisaged by Rothenstein as itself 'a refuge from the market place'.[29]

Yet another report highly critical of the RCA was published in 1936. The Hambledon committee considering 'Advanced Art Education in London' at the instigation of the Board of Education concluded unequivocally, 'it is impossible to feel that all is well with the Royal College'.[30] Why had the RCA so signally failed 'to influence manufacturers or to interest them in its products'?[31] Many possible reasons were discussed: the endlessly recurring problem of inadequate College buildings and equipment; the lack of opportunities for specialist designers within an apathetic British industry. The overriding view of things was that throughout its history the serious reformative intentions of the College had 'tended to be deflected by the superior attractions of Fine Art'.[32]

Far-reaching reforms were proposed. In compiling its report the Hambledon committee had even sought advice from Walter Gropius, founder of the Bauhaus, now living temporarily in London. The Nazis had by this time closed the Bauhaus down. It appears that Walter Gropius had been fleetingly considered to take over as director of Design at the RCA on Rothenstein's retirement in 1935, an appointment that might well have altered British design history. But in the event Percy Jowett was appointed as Rothenstein's successor. The mild-mannered Jowett was an ex-RCA student, New English Art Club painter and former principal of the Central School. Hardly an epoch-making choice.

Very little had changed by the time the decade ended. Nor would it until a good deal later on. The painter Richard Seddon, then a student, described the atmosphere at the

'A magnet for talent':
An Intimate Portrait of the Royal College of Art
Fiona MacCarthy

Eric Ravilious in the Football Team
(Third left, back row)
1920s

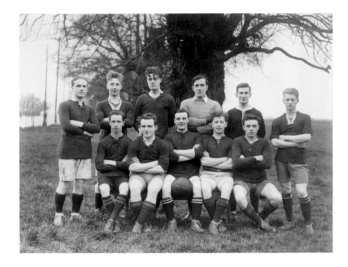

tions with the Romantic movement in poetry and painting. The town had become a centre for tourism in the pre-war years. The exodus to Ambleside proved, for some staff and students, an excitement and a stimulus, in which their work developed in some unexpected and interesting new directions. The principal, Percy Jowett, initially reluctant, came to love the Lake District. For others the four-and-a-half years in Ambleside was to be a long ordeal of dislocation.

The complement of students, standing at around 400 in the middle 1930s, was now much reduced. Only 120 students registered for the first term in Ambleside. The male/female ratio altered considerably as men were absorbed into the armed forces. Among remaining male students some were waiting for call up, some had been pronounced unfit, while others were conscientious objectors, which made for a volatile community. Some of the best College staff – Paul and John Nash, Ravilious and Bawden, Barnett Freedman – had been recruited as war artists, Jowett himself being on the War Artists' Advisory Committee. Teaching staff at Ambleside was dominated by the old-time College traditionalists, having an average age of 58.

The College made the move with its four main schools intact: Painting, Sculpture, Design and Engraving. Ambleside's two chief hotels were taken over. The Painting School had studios on the first and second floors of the Queen's Hotel on the main street, while the Engraving School was based at the Salutation Hotel up the hill a short distance away. The Design School premises were scattered through the town. The upstairs room of the Market Hall was scheduled for Mural Decoration. Professor Tristram had overseen the transfer of as much of the College's equipment as proved practical. But there was no kiln for firing pottery. The pottery students had to share facilities 30 miles away at Lancaster College of Art.

The immediate problem of autumn 1940 was finding accommodation for this influx of strangers to the town. Jowett and his wife were installed in the Salutation, more well-connected members of staff arranged to stay with friends in the locality. But student accommodation was more make-shift, a series of shared lodgings in small cramped rooms and haylofts. An Ambleside painting student, Donald Pavey, recollected 'One student's studio spanned the narrow River Rothay, in a tiny house that was so damp that all his drawing paper curled up.

RCA during the uneasy summer of 1939: 'whether I worked in the shadowy peace of the V&A museum, or in the tweedy long-haired industry of the college studios alongside the great museum, we went on making our drawings and our paintings'.[33] Meanwhile in Kensington Gardens to the north the spoil heaps, air-raid trenches and barrage balloons began appearing. The RCA tutor John Nash made the comment that you only had to knock the trees about a bit for Kensington Gardens to look just like the landscapes First World War artists had painted on the Western Front.

The Jowett Years 1935–48

Students arriving at the RCA in September 1940 to start the autumn term found the buildings closed with a note on the main door saying that the College would re-open 'sometime in the future and somewhere in the country'.[34] It was not the first time that closure had been threatened. Students had been sent away after the long vacation in 1938, the summer of the Munich crisis. With the Munich agreement, the College had reopened. But this time, two years later, as the Blitz began in London, the closure was for real.

The place chosen for the RCA in exile was Ambleside, a small town in the Lake District, an area historic in its associa-

ROYAL COLLEGE OF ART
at Ambleside, Westmorland

May 1943

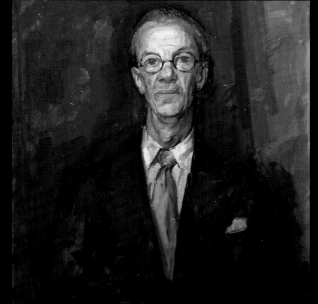

Dear Sir or Madam,

1. I am glad to be able to inform you that you have been
successful in the recent examination for admission to the
Royal College of Art. ~~and have moreover been awarded a~~

2. Whether successful candidates in the recent examination
should be admitted to the Royal College of Art next September
or whether their admission should be deferred until they are
free from liabilities under the National Service Acts and the
Registration for Employment Order depends on whether there is
a satisfactory prospect of their being able to complete not
less than two terms' attendance at the College before being
called up. This depends on which of the undermentioned cate-
gories they belong to.

3. Men Students
Admission next September will be limited to (1) those who
were born after 29th February 1926 and are physically fit
and (2) those who are not likely to be called up for National
Service owing to their being physically unfit.

4. Women Students intending to become Full-Time Art
Teachers who will be under 19 on 30th September, 1943.
All these students will be admitted, since under the regu-
lations of the Ministry of Labour and National Service
relating to calling up, they will be allowed to take the
Diploma course and become teachers. Moreover, if they wish,
after taking the Diploma, provided that they are qualified as
regards preliminary general education, they may take a year of
professional training for the Board of Education's Art Teachers'
Diploma, but this will not be obligatory. Those of them who
will be under 18 on the 30th September, 1943, will take the full
3-year course for the Diploma. Those who will be 18 and under
19 on that date will take a shortened (2-year) course for the
Diploma, since the regulations of the Ministry of Labour and
National Service do not permit of longer.

5. Other Women Students
Admission next September will be limited to those who have
a satisfactory prospect of being able to complete not less
than two terms' attendance before being called up.

6. Students who commence their course at the Royal
College of Art next September but are unable to complete it
owing to calling up should write and let me know as soon as
they are free to return to the College when the question of
their re-admission and the resumption of any award will be
considered sympathetically.

7. On receipt of this letter it is requested that you
will, as soon as possible, inform me how you stand under
paragraphs 3-5, and complete and return to me the accompanying
form.

Yours faithfully,

G.F. Sandilands

REGISTRAR

Miss Erica J. Porter

P.S. The Board of Education are taking steps to secure
an early recommendation from the Burnham Committee on
the question whether a Diploma gained after two years'
study can be accepted as entitling a teacher to be
placed on the graduate scale. Any candidate affected
by and desiring to be notified of the decision is
requested to let me know.

19th May 1943 G. S. S.

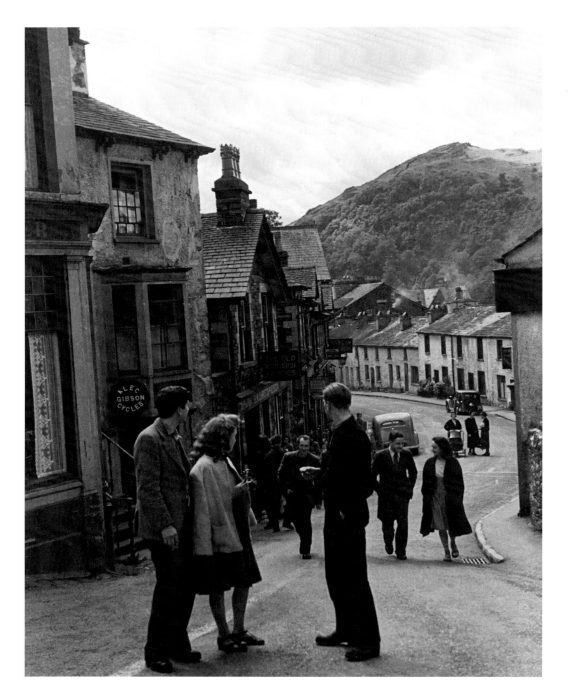

RCA Students Out for a Stroll in Ambleside, Cumbria 1943

Donald Pavey was thrilled by local oddities of landscape, the way in which 'the rivers and waterways carved out Henry-Moore-like shapes, tunnels and slides'.[37] As Design School student Sheila Donaldside expresses it in her sometimes ecstatic memoir of Ambleside written out by hand and now in the College archive, the Lake District 'had NATURE'. They walked and climbed in spring and bathed in summer and skated on Rydal Water in the winter. Student romances burgeoned and some of the women settled into close connected female groups known as the Attic Virgins. For many of the students Ambleside began providing 'a companionable romantic way of life'.[38]

But as the war continued tensions began to surface. The problems that had once been a challenge and excitement had become an increasingly wearying routine: the shivering coldness of the winters through which students in the studios worked in their scarves and gloves; the dismal light for painting as the misty Lakeland evenings drew in. The College Report for 1943–4 describes that session as 'the most trying we have experienced since the College was evacuated'. There was widespread illness, malnutrition and depression amongst the staff and students. The shock of a first-year female student's sudden death from a heart attack while working in the College gardens had been followed by the suicide of Richard Seadon, an 18-year-old found shot in his shared room at the Queen's Hotel.

The effects of war itself could not be avoided as many former students returned wounded or psychologically damaged from the fields of battle to the RCA community at Ambleside. Staff and students were involved in the local war effort, joining the Home Guard and donating blood. In 1944 more war refugees arrived in Ambleside, evacuees from the flying bombs now assailing London. As the College's exile was extended far beyond what had ever been imagined at the outset, the work made by students in Ambleside became notably more anguished and politicised, an obvious example being Pavey's large-scale triptych, at the centre of which is the young figure of Christ in 1940s battledress haranguing the cathedral hierarchies. For Pavey, the fatherless boy Jesus was a potent symbol of the time.

The final RCA Report from Ambleside covering the years 1944–5 does its best to be positive about the experience

Another had a studio in a hut built up a tree. Our very existence there seemed surreal.'[35]

To start with one senses the euphoria of discovering a strange new land of such overwhelming beauty. 'The RCA has chosen a superb spot. The country is grand and fine landscapes and magnificent vistas abound on all sides,'[36] the painting tutor Percy Horton told his brother. There was the extra frisson of the Lake District connections with Wordsworth, Farrington and Girtin, and indeed John Ruskin. Interestingly, Kurt Schwitters also found himself in exile in Ambleside for a few months during the Second World War.

'A magnet for talent':
An Intimate Portrait of the Royal College of Art
Fiona MacCarthy

of evacuation to 'a small town remote from the metropolis'.
Good connections with the North-west had been established.
Besides, the College's 'close contact with nature in a very
beautiful district was an influence for good that cannot be
lightly dismissed'. But the return of the RCA to London in
summer 1945, following the VE Day lunch at the Salutation
and the final presentation of diplomas in the Queen's Hotel
pavilion, was surely the occasion of considerable relief.

The Darwin Years
1948–71

The RCA made its tentative return to London for the autumn
term of 1945. The College buildings had been damaged in
the war and repairs were being carried out around them
as the staff and students moved back in. There was still a
sense of suspended activity, compared by one student to the
bizarre atmosphere they had experienced in the phoney war.
Student numbers were now up from around 90 in Ambleside
to 177 for the new term just beginning. The College was
bracing itself for the realities of finding a new role for itself in
a Britain only just recovering from war.

Young silversmith David Mellor was one of the early post-war
intake. He was typical in coming from a working-class back-
ground in the industrial north. He and his contemporary, the
painter Derrick Greaves, had sat their entrance exam in Shef-
field, the set task being the complicated drawing of a lobster.
David had been accepted in 1948 but his entry was deferred
for him to do his National Service in the 8th Tank Regiment
at Catterick camp in Yorkshire, finally arriving to take up his
place at the RCA in autumn 1950. What was the mood of the
College at this time?

Crucially, a new principal had been appointed. Robin Darwin
had taken over from the amiable, non-confrontational and
not entirely effective Percy Jowett on his retirement in 1948.
Darwin, a great-grandson of Charles Darwin and part of
that whole Cambridge intellectual elite, was a man of great
complexity, irascible and charming. 'A curious personal-
ity. Minotaur or Ass's Head? A bit of both,'[39] suggested Iris
Murdoch, for a while a part-time lecturer at the RCA. Darwin,

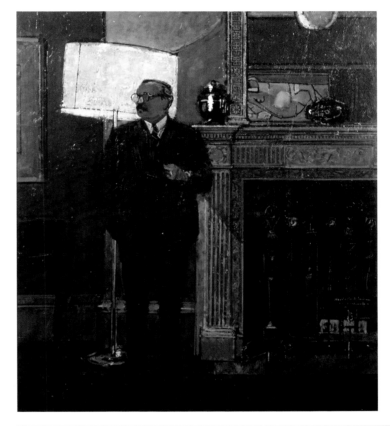

Ruskin Spear
Portrait of Sir Robin Darwin
1961
Oil on board

Edward Ardizzone
Senior Common Room
Cromwell Road
1951
Pen and watercolour on paper

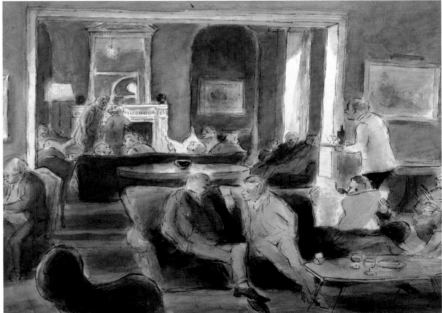

himself a painter who had studied at the Slade, was a man of tremendous ambitions for the College. It was he who brought into reality the government's intention 'to make the Royal College of Art the leading institution of its kind in Europe'.[40] And it was Darwin who returned the College to the original intentions of its founders in placing the main emphasis on design for industry.

Robin Darwin had been ruthless in dispensing with old staff. All past appointments were automatically terminated. The professor of Painting Gilbert Spencer, brother of Stanley, left a poignant description of how he was got rid of, summoned to a meeting of the College governors chaired by Sir Josiah Wedgwood, Darwin's cousin. 'Away to the west sat Darwin casting his shadow like the setting sun over my future.'[41] There was a commotion over the sacking of Mrs Gibson, head of the Department of Dress since 1926, and her replacement at twice the salary by Madge Garland, a former editor of *Vogue*. Mrs Gibson's case was taken up by her MP but Darwin was adamant, threatening more essential staff changes to come.

At an early stage Darwin had lamented the lack of 'effervescence' at the College. This was a lack he worked fast to remedy by bringing in his cronies, many of whom had served with him in wartime in specialist units the corps of camouflagers set up to disguise potential military targets from the enemy. Darwin had himself been secretary to the Directorate of Camouflage. Ex-camouflager Richard Guyatt was brought in to head the newly constituted School of Graphic Design; Robert Goodden was appointed professor of Silversmithing and Jewellery; Dick Russell, professor of Wood Metal and Plastic. Dick Russell's brother Gordon was concurrently director of the Council of Industrial Design, the government-supported body recently founded to raise national design standards. These interconnections were powerful. Darwin's RCA operated as a kind of mafia. In 1951 Hugh Casson, another ex-camouflager, became professor of the new School of Interior Design.

The effervescence of tone instigated by Darwin transferred itself quickly to the student population. This was a new breed of student, older, more worldly-wise than the majority of the pre-war generation. Some had fought in the war or had only recently finished National Service. Quite a number of students were already married. Some came from foreign backgrounds, like Frank Auerbach who had arrived in Britain in 1939 as a boy refugee from Nazi Germany and was never to be reunited with his parents. Their many experiences of dislocation brought these students a new maturity and an intense determination to catch up with their careers.

There was an optimism and engagement in the way that RCA students got involved in public projects at a time when Britain itself was 'going modern', experiencing a short-lived post-war bonanza of contemporary architecture and design. Hugh Casson was the architect in charge of the Festival of Britain South Bank exhibition. Professors Robert Goodden and Dick Russell were designers of the Lion and Unicorn Pavilion. Part of Darwin's philosophy in restructuring the College was to appoint staff who continued to operate their own professional practices. Around 40 RCA students were given the real-life experience of working on the Lion and Unicorn Pavilion in their professors' open-plan office on the College premises.

Darwin was a progressive. He was also, with his Cambridge background, a romantic, attuned to the traditions of the ancient universities. Under his aegis the Cambridgeisation of the RCA continued apace. From 1949 an end-of-year convocation had been held in the Concert Hall of the nearby Royal College of Music, a Darwin invention involving formal gowns and academic hoods, flourishes of trumpets and a ceremonial silver mace – the 'College yardstick' – borne in by a beadle and featuring a dodo at one end and a triumphant phoenix at the other, symbolising Darwin's resurrection of the RCA.

In 1949 a long lease had been taken on two substantial houses near the College, 21 and 23 Cromwell Road, allowing Darwin to realise another of his dearest ambitions in the founding of a Cambridge-style Senior Common Room where staff at last could mingle over a convivially bibulous lunch and entertain potentially influential guests. Darwin himself presided over the exclusive Painters' Table, equivalent of a university high table, where anyone ignorant enough to sit in Darwin's chair (as my future husband once attempted) bore the scars for life.

The ethos of the place can be gauged from the SCR Suggestions Book, which opens with a plea from Painting tutor John Minton, 'Could we possibly have some Brandy glasses?'

'A magnet for talent':
An Intimate Portrait of the Royal College of Art
Fiona MacCarthy

progressing to requests for Madeira and Marsala and more frequent treacle pudding. The Junior Common Room, which had been housed since 1910 in a ramshackle tin hut reputedly built on Florence Nightingale's instructions for receiving casualties from the Crimean War, was now relocated to Cromwell Road. David Gentleman, a student from 1950, first in Graphic Design and then in Illustration, recalls student life in Cromwell Road as close-knit and enjoyable with film shows taking place in a room upstairs.

Darwin's immense respect for 'the spirit which hallows all universities'[42] inspired the setting up of the College's own press, the Lion and Unicorn, emulating the best English private press traditions and publishing from the 1950s onwards a sequence of erudite and beautiful volumes. I still treasure my copy of Stanley Morison's *Splendour of Ornament*, specimens selected from Tagliente's sixteenth-century Venetian *Essempio di recammi*, the first Italian manual of decoration, published in a marvellous gold cloth binding by the Lion and Unicorn in 1968.

Another Cambridge ideal, that of a broad culture and tolerant outlook, the concept of an 'amused and well-tempered mind',[43] led to the development of the General Studies department, of which the first head, later the professor, was Christopher Cornford, a Darwin distant cousin and a libertarian of wonderful elegance and style. According to Darwin's successor, Lionel Esher, Darwin had been shocked by the literacy level of some of his recruits from the provincial art schools. This he sought to remedy by the appointment of visiting lecturers able to give courses on Contemporary Britain, the History of Science, African, Polynesian and Chinese Art and so on. Michael Jaffé called the General Studies course 'a home for failed geniuses',[44] as Isaiah Berlin came to lecture on Marx and George Steiner on de Sade.

The 1950s and early '60s were glory days for Darwin. His original concept of the RCA becoming 'a magnet for talent'[45] was beginning to be realised. In Metalwork & Jewellery David Mellor's generation also included Robert Welch and Gerald Benney, all of whom extended their craft silversmithing training into designing for industry as well. In Wood Metal and Plastic (or Furniture Design as it soon became) Ron Carter and Robert Heritage made much of the new opportunities for working with furniture manufacturers who were now

espousing the 'contemporary' style. Ceramics students Neal French and David White designed what was named 'the Royal College Shape' for W T Copeland in Stoke-on-Trent. In 1952 the RCA was boasting that 44 of its first 59 graduating Des RCA students had gone straight into posts in industry.

Memories of those times have often been ecstatic. Peter Blake talks of how they all *loved* the RCA. Blake was one of an extraordinary influx of young painters in the early 1950s: John Bratby, Joe Tilson, Robyn Denny and Bridget Riley, who describes how Blake 'had a corner in one of the studios, but it was something more than a corner. One always had the feeling of an event.'[46] Blake himself remembered having to avoid standing next to fellow students Frank Auerbach or Leon Kossoff: 'we'd get smothered with charcoal, from an area of three feet around where they were working.'[47] Much of the excitement came from the stimulus of working alongside highly motivated, competitively talented young contemporaries.

There were valuable interactions between departments. The painters were aware of developments in Graphic Design, where students in the 1950s included Raymond Hawkey, Len Deighton and Alan Fletcher. Ridley Scott came to the College in 1958 after four years at Hartlepool College of Art. 'The competition to get into the RCA then was like getting a place on a moon landing,' he says. He loved the flexibility the RCA allowed him. By his second year Scott was 'beginning to leak into the Photography Department'.[48] The Film and Television School was then just starting and he was one of the first students to submit a film for his diploma. This was *Boy on a Bicycle*. Anton Furst, another RCA student of that vintage, went on to design Tim Burton's *Batman* film (1989).

'The RCA suddenly was the big arena, there was lots of competition, a lot of motherfuckers kicking around, who all knew exactly what they were doing.'[49] Scott defined the extreme confidence of the RCA as the shabby, grotty postwar landscape of South Kensington and Chelsea transformed itself into smart and shiny Swinging Sixties London. The College was at the heart of this transformation scene, in particular the students of the Fashion School in its own little empire in Ennismore Gardens ruled over by the dramatic and unstable Professor Janey Ironside. One favourite male student, Antony Price, respected Janey for her over-the-top

'A magnet for talent':
An Intimate Portrait of the Royal College of Art
Fiona MacCarthy

qualities, the Disneyesque characteristics that made her a cross between Cruella De Vil and the wicked stepmother in *Snow White*. Female students, such as Marian Foale and Sally Tuffin, dressed as Janey's clones in black-and-white clothes off-set by brilliant crimson lips. She was an intrepid spotter and bringer on of talent: Ossie Clark from Salford, African–American airman Hylan Booker. The RCA was right at the centre of the *zeitgeist*, the youth cult, the beginnings of 1960s social and sexual mobility.

At this period British art schools were important as the nurturers of brilliantly iconoclastic skills. Often RCA students moved on to become famous in other areas of creativity. Alan Rickman studied graphic design and ran his own design studio Graphiti before training as an actor. Ian Dury graduated from the Painting School in the mid-1960s. Later maintaining he got good enough at art to realise he wasn't going to be in the top flight as an artist, Dury became a leading performer in the punk and New Wave era of rock music. He formed Ian Dury and the Blockheads, becoming a star of anarchy.

Richard Wentworth, recent professor of Sculpture at the College, was himself a student in what now seems an era of amazing possibilities. He remembers how one morning in 1967 his tutor took him with his fellow students James Dyson, Corinne Julius, Charles Dillon and Miriam Anschel to visit the IT consulting firm Reliance Systems. He now adds wryly: 'observe long-term effects'.

James Dyson had entered the Royal College of Art in 1966. He had previously been at public school at Gresham's, then spent a year studying drawing at the Byam Shaw. He enrolled in the Furniture School and then moved on to Interiors where he discovered Buckminster Fuller's geodesic structures. Engineering innovation became his burning interest. This was a time when engineering design was beginning to be taken seriously at the College. Dyson was at the RCA for four formative years. He wrote later, 'It taught me the importance of making things well, of making prototypes to prove ideas in action, and above all it gave me the confidence to dream.'[50] In this evocation of the RCA as the place of self-discovery, a factory of dreams, Dyson echoes many other past students of the College. Not all of them, of course, were destined to return to the RCA as provost, as Dyson was to do in 2011.

Dyson had been a student at an important period of the College's development. The new large purpose-designed space, mooted for so long, had at last been achieved in 1962 with the opening of the Darwin Building, a glass-and-concrete structure designed by H T Cadbury-Brown with RCA professors Robert Goodden and Hugh Casson, which occupied an inspiriting position opposite the Albert Memorial. The Design and Applied Arts courses, previously scattered in sites around South Kensington, including the Western Galleries of the Imperial Institute, were now centralised here with their staff offices and workshops. Only the Painting School was left somewhat marooned in its old Exhibition Road premises behind the V&A. When in 1967 the College was granted a Royal Charter giving it university status, the degree ceremonies that Darwin had invented could be held conveniently just alongside the new building in the Victorian splendour of the Royal Albert Hall.

The principal was raised in status to a rectorship. It might seem that by now Robin Darwin had achieved everything he originally set out to do. But dissident student voices had made themselves heard early and they grew in volume through what one can only describe as Darwin's reign. *Ark*, the College magazine founded in 1950, soon became the voice of bolshie students. In a sense Robin Darwin had only himself to blame with his policy of breadth of education at the College. His fostering of General Studies was certainly effective in increasing students' verbal expressiveness and encouraging debate. But one might also say that this forcible increase in cultural awareness sowed the seeds of the coming student discontents.

The most vigorous of protests were always from the painters, who felt themselves marginalised in a regime that was putting so much stress on industrial design. A student generation fascinated with popular culture and American-style consumerdom set themselves against the traditionalist values of the post-war RCA Painting School. Derek Boshier says of Pop, 'One of the things I remember about the whole thing getting off the ground in terms of the excitement of it was a fight against the staff.'[51] There were confrontations. Allen Jones, one of the most obviously talented students of that generation, was expelled at the end of his first year. It was clear to fellow students that he had been victimised.

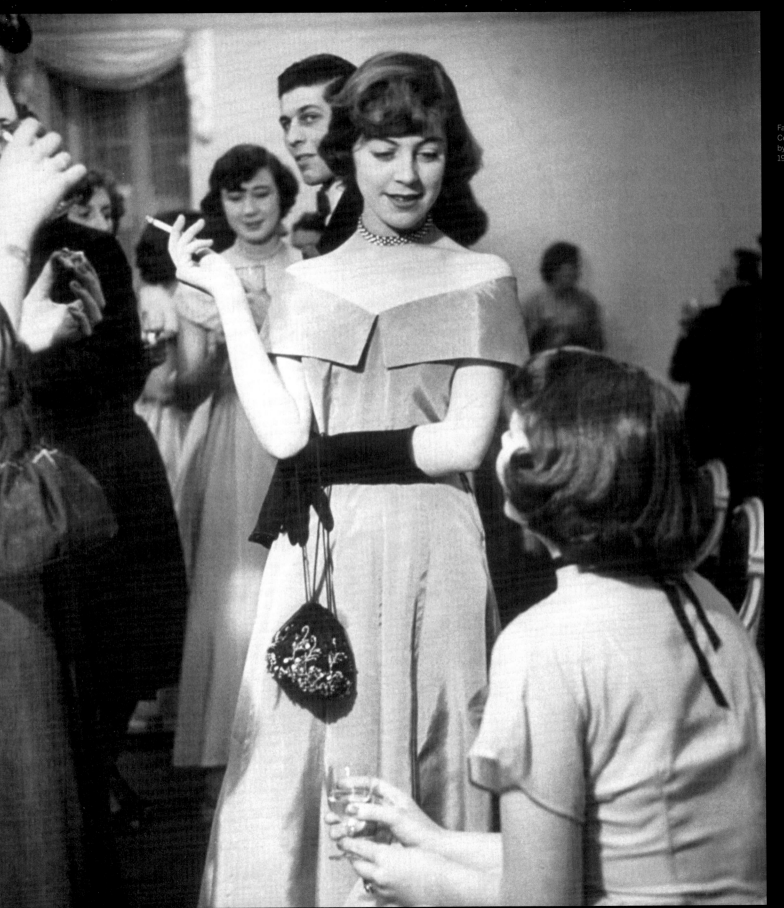

Fashion Students at the Royal
College of Art at a Party Given
by Bianca Mosca
1949

David Hockney
Diploma Print
1961

Darwin Building
1963

Leonard Rosoman
*Portrait of Lord Esher in a Studio
at the RCA*
1978
Acrylic on canvas

'A magnet for talent':
An Intimate Portrait of the Royal College of Art
Fiona MacCarthy

Jones's contemporary David Hockney had been initially failed on grounds of low marks for his General Studies thesis. The authorities relented and instead awarded Hockney a gold medal. He went to the Albert Hall to receive it dressed in a gold lamé jacket in a famous fuck-you gesture of the period.

Darwin felt the tide gradually turn against him. In his 1959 Annual Report he had courageously tried to tackle the issue of student disaffection in a section entitled 'The "Beat" Generation'. As he saw it, 'the more imaginative among them have come to reject all material preoccupations, easements and satisfactions as diminishing their stifled ideals; they reject attachment of any kind, and every connection is so tainted that even love is suspect.' Interestingly, he found industrial design students proof against the worst of this nihilism; 'but as far as those in the fine arts are concerned, most are basically out of trim'.[52]

Through the next decade the very successes that Darwin had achieved at the RCA began to be piled up to his detriment: There were sneers about the gentrification of the College with its 'beautiful upper-class ladies' on the governing body and the dark green Senior Common Room high on the upper floor of the new building, which struck visitors as 'a mixture of High Table and grand country house'. There was snide analysis of the 'particular element of old-fashioned smartness within the College corporate style which hovers half-way between Heal's and the old Faber & Faber house styles (when Barnett Freedman designed charming dust-jackets for Walter de la Mare anthologies)'.[53] The widespread student protests throughout 1968 were especially vigorous in the British art schools. In 1970, by then in shaky health and with a sure strategic instinct 'that student politics were about to pass beyond his patience and his skills',[54] Darwin decided to retire.

The Esher Years 1971–8

Alison Britton was a student in ceramics from 1970 to 1973. Looking back on her time there she said, 'It changed me in a way I was really pleased with.' Coming from a more conventionally structured training at the Central School, she found the freer atmosphere of ceramics at the RCA liberating, terrifying. 'So there I was, pitched into a complete playpen where you could do anything.'[55] As for many College students, these freedoms constituted an essential phase in her artistic growing up.

In the early 1970s the RCA Ceramics School was in a very interesting state of flux. The professor, David Queensberry, was himself a successful commercial ceramicist in partnership with his ex-RCA student Martin Hunt. They were later to be joined by Robin Levien, another Queensberry ex-student in what became Britain's leading tableware design consultancy. In the Darwin era the emphasis had been on recognisably functional design for industry.

But with Queensberry's imaginative appointment of sculptural ceramicist Hans Coper as a departmental tutor this emphasis had changed. Coper was a potent influence, not just on Britton but on other ceramics students Jacqueline Poncelet, Glenys Barton and Carol McNicoll who overlapped with her. McNicoll's work in particular challenged the old RCA aesthetic of the sensible and practical with a new wild and witty self-expressiveness. If this was the age of the subversive stitch, it was also the beginning of the subversive teapot, mocking old standards of correct behaviour. It was no accident these students were all female. The new mood in ceramics was part of dawning feminism. Britton and her fellow students were all reading Germaine Greer's *The Female Eunuch* (1970), 'which was putting words around things we had felt but never articulated'.[56]

The subversive spirit spread to other RCA departments. In the 1970s the College was in the vanguard of the movement one might label the New Crafts. In furniture an obvious example is Fred Baier, with his bold poetic versions of time-honoured household objects. This was the reversal of all Lethaby had stood for in terms of right-making, the sententious moral values of the Arts and Crafts. It was not a rural movement but a youthful urban stance, shrill and highly critical of society. Within this rebellious context some upliftingly beautiful works of art were made. Many students of the College were included in the first exhibition highlighting this new movement, *The Craftsman's Art* of 1973 at the V&A. As it happened Wyndham Goodden, the exhibition curator, was the brother of Robert, professor of Silversmithing at the RCA.

There was a kind of fierceness at the RCA in this stage. Britton recollected the student bar quite often being smashed to pieces, especially by the sculptors and the printmakers. 'Some of those lads got really plastered, and violent.'[57] It has to be remembered that, in years at least, these were mature postgraduate students. Many of them had already been radicalised by the student uprisings of the late 1960s at their previous colleges of art.

Discontents spread through virtually all RCA departments, particularly the School of Industrial Design, where many doubting voices, anti-design voices, called in question the industrial designer's very *raison d'être*. Frank Height in his inaugural lecture as professor of the School in 1975 expressed all too well the unnerving coincidence of crises: 'there is the world crisis of resources, food, minerals and energy. There is a crisis in our faith that our organisations are capable of dealing with the obvious defects of modern society... and there is the domestic United Kingdom crisis of the economy. Design is inevitably involved in all this.'[58]

The protestors found much of their intellectual ballast in the Painting School where the new professor Peter de Francia, appointed in 1972, was a formidable theorist, a Marxist hardliner at odds with the ideology of much of British culture and antagonistic towards the self-serving and parochial attitudes he discovered at the RCA. There was an increasingly confrontational Marxist element within the School of Film and Television too, a department now severing itself from the film industry and becoming more concerned with politics, semiotics and experimental work.

For many students this was an exhilarating period. There is a stimulus in confrontation. Bliss was it in that dawn to be alive, etc. But for the incoming rector, Lord Esher, the 1970s were to be a wearying ordeal. Esher, who succeeded his father as fourth Viscount in 1963, had been in a way an in-house appointment as Darwin's successor. He had known Darwin since Eton. He had been on the governing body of the College in the 1960s and 'had caught the general euphoria the place then exuded'.[59] In many respects his credentials were impeccable.

Lionel Esher was an architect who, while still a child, had been inspired by sitting at the feet of Edwin Lutyens as the great architect sat working with his sketchbooks on his knee. In his own gently idealistic practice Esher (then still Lionel Brett)

had been involved in Britain's post-war reconstruction. He was architect–planner for Hatfield New Town and had also worked on Stevenage and Basildon. His ideas for the College were in theory the right ones. He was in real sympathy with the crisis of conscience then overtaking the art and design world, seeing the urgent need for designers to tackle the increasing ecological and visual degradation of the planet, arguing valiantly for the centrality of spiritual values, the concept of 'relevance to our inner selves'.[60] It is rather poignant to read Esher's public statements, harking back to Ruskin and Ruskin's conviction that 'the only wealth is life'. Ruskin, he felt, had more relevance than Olivetti to the 1970s student generation.

But if Esher's theoretical approach was admirable, he himself was in the wrong place at the wrong time. At a time of incipient student revolution his aristocratic antecedents, his patrician appearance and his courteously conciliatory personality acted as the red rag to the bull. According to Reg Gadney, then a General Studies tutor, 'Bad feeling seemed to have been generated among students because the college had accepted a commission to design a novel policeman's helmet, with flashing blue lights. There were dark rumours that the CIA was sponsoring top-secret cartography on the premises.'[61] The mood grew more hysterical. The rector could not win.

In February 1977 militant RCA students took direct action. Ostensibly the cause of the protest was the recent Government announcement of an increase in foreign students' fees. The leaders were from the revolutionary Film School. The RCA administrative premises were occupied and ransacked. Esher was banned from entering his office, where the organisers of the uprising sat in triumph with their feet resting on Darwin's old black leather-covered desk. The sit-in lasted for a month. The following summer Lord Esher left the RCA 'with joy',[62] never to return.

He later made the wry comment on the College, 'The object of the report of 1835 from which it originated – to boost exports and improve the quality of life (in that order) – have the familiarity of the Irish problem. Not for want of trying, we seemed to have a blind-spot for both.'[63]

'A magnet for talent':
An Intimate Portrait of the Royal College of Art
Fiona MacCarthy

The Stevens Years 1984–92

Sarah Hopkins (now better known as Sarah Younger) came to the RCA in 1986, one of a fresh intake of ambitious female students. All of the four students then enrolling for the first year of the College's new Design Management course were women. Students arriving at the College in the middle 1980s found a new and highly energetic new regime beginning. After Lionel Esher's departure there had been what amounted to an interregnum: first the temporary rectorship of Richard Guyatt, benign and by now elderly professor of Graphic Design, one of Darwin's original camouflage brigade; then the short-lived incumbency of Lionel March, a former professor of Systems Design whose obsession with computer-aided technology clashed badly with the broadly civilised values of the College. (Not another *Lionel*, people were heard to say.) After his departure the professor of Photography, John Hedgecoe, stood in as pro-rector through 1983.

The new rector, Jocelyn Stevens, came from a very different background of magazines and newspapers. Through the 1960s he had been a famously irascible editor of *Queen*. Like Robin Darwin, Stevens, another Old Etonian, had huge ambitions for the College, which he set at the centre of the fashionable world.

This was to be another time of ruthless College overhaul. The Rector's Report for 1985 boasts that 'there is not one single activity within the College that has not been examined and improved'. Of the total 19 RCA departments, four – Animation and Audio Visual Arts, Film, Architecture and Design Studies and Transport Design – were either new or completely re-organised. Meanwhile Design Research, Design Education and Environmental Media would be closing. One can sense the personal upheavals behind Stevens' bland announcement that eight new professors and heads of departments had taken or were about to take up their new posts.

There was certainly a buzz about the RCA in those days. Stevens was very adept at publicity, at home in the new 1980s climate of glamorous London galleries and patronage. He thought nothing of inviting 79 industrialists to breakfast

Jocelyn Stevens
1989

in the Senior Common Room to convince them of the talents of his students and the commercial value of design. Stevens had an unexpected ally in the then prime minister, Margaret Thatcher, seen on a mid-1980s television programme, in which the RCA was prominently featured, extolling the virtues of the Durabeam torch designed by ex-College student Nick Butler. This she described as being 'very very good design'. Making the most of his connections with high-profile politics, the Rector's reports become increasingly excitable, heady with the rhetoric of heading for the open seas.

In 1985 the College had begun its autumn term with 626 students, the first intake to register for the two-year MA course that now became the standard. How was it for these students as the new rectorship progressed? On the whole the rector kept his distance from the students. He was not as hands-on or as gregarious a principal as William Rothenstein. This was an elitist and, from time to time, a bullying regime. But many speak with admiration, indeed gratitude, for the confidence he radiated through the College, the conviction that even at a time of serious retrenchment in British manufacturing there was still indeed a future for design given

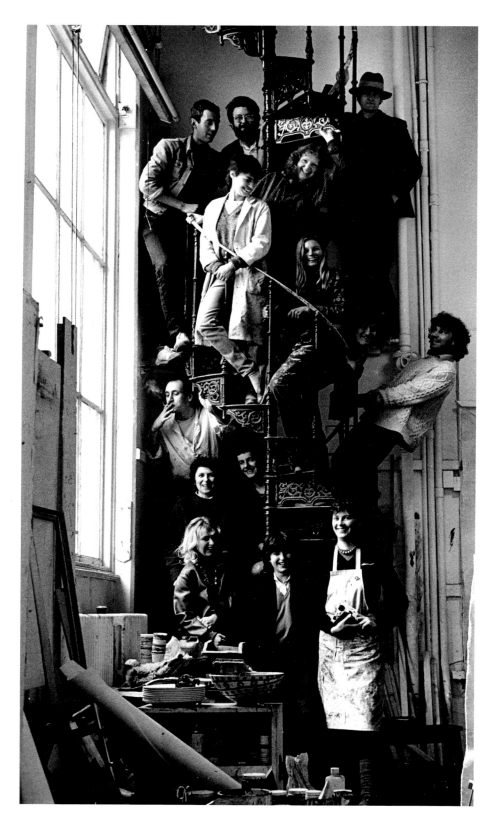

Painting Students on Spiral Staircase
c. 1986

a much broader and more imaginative interpretation. The mood was optimistic. Sarah Younger remembers, 'You felt you could go on and do anything you wanted.'[64]

In this new high-profile incarnation of the College, the Fashion School was now the favoured child. Philip Treacy, enrolling in 1988 for the start of Alan Couldridge's new course in hat design, was enthralled by the College's extreme sophistication, its 'incredibly grown-up environment'. Coming from a strict Roman Catholic upbringing in Ireland he found RCA Fashion 'like a breath of fresh air'.[65] And working in this place of infectious possibility, Treacy evolved new concepts of headcoverings and hats.

Obviously not all students were so smilingly contented. Some painters became particularly paranoid, not feeling themselves part of Stevens' worldly and materialistic visions of the future of the College. Especially unhappy, it appears, was Tracey Emin, whose two years in the Painting School from 1987 rate as a further episode in her preposterously miserable early history. She was seen destroying some of her early paintings in the courtyard of the College in despair. But for many of the students just being at the RCA, in that close community of talented young people, outweighed any reservations they might have about the current ideology. As Philip Treacy puts it, 'Just by being there we were learning, everyone was intelligent enough to understand that.'[66]

College cross-connections were incredibly important. Philip Treacy describes the intimate feel of it as 'like a private club'. Some of the most productive interactions came in the Department of Furniture, where Jasper Morrison and James Irvine coincided as students. The Furniture School had once been the home of the beautiful dovetail joint. No more. Together with a slightly later student, the German-born designer Konstantin Grcic, Morrison and Irvine evolved a new aesthetic in furniture design based on a small batch production using ready-made industrial components. According to Morrison a furniture designer had to build 'his own factory, not with bricks but from the sprawling backstreets teeming with services and processes'.[67] This expresses well the confident mood of self-sufficiency developing in the 1980s among the students of the RCA.

'A magnet for talent':
An Intimate Portrait of the Royal College of Art
Fiona MacCarthy

The Frayling Years 1996–2009

The student voices accumulate through the 1990s. For the architect David Adjaye, who studied at the RCA from 1991, and then became a tutor from 1998, the place was 'a diverse melting pot of creativity… the most exciting design labora-tory in the world'.[68] Adjaye typified the coming generation in his internationality. He was born in Dar es Salaam, Tanzania, the son of a Ghanaian diplomat. He was brought up in Egypt, Yemen and Lebanon before coming to Britain at the age of nine. From its early beginnings as a trade training school for young English apprentices, the College was now altering beyond all recognition. In the early 1900s the one or two students coming from 'the Empire' merited a comment. By 2009 the 948 postgraduate students at the RCA were of 53 different nationalities. A diverse melting pot indeed.

There was also great diversity in the opportunities the College was now offering. The peculiarly inventive architect–designer Thomas Heatherwick started at the RCA in 1992. He recently described the stimulating mix of disciplines he found: 'studying at the Royal College of Art gave me space to think about the way in which I might practise as a designer when I left the education system. Instead of rigidly dividing artistic thinking with separate crafts and professions such as sculpture, architecture, fashion, embroidery, metalwork and landscape, product and furniture design, I wanted to consider all design in three dimensions, not as multi-disciplinary design, but as a single discipline: three-dimensional design.'[69]

A model for Heatherwick's experimental birch plywood gazebo had been spotted on a visit to the Furniture School by Terence Conran, already a friend and supporter of the College who was to become the provost in 2003. Aware that the gazebo was too large to be built within the College, Conran invited Heatherwick to come and live in his house in Berkshire and construct the gazebo in his own furniture workshops. This is a good example of the quasi-familial support system that still operates within the RCA.

This whole concept of the RCA as family, linked through an almost mystic connection point in art, was dear to the heart of Christopher Frayling, who became rector in 1996. He succeeded Anthony Jones whose term of office had been cut short by family problems. Frayling already had his long connections with the College. He had been professor of General Studies, which he quickly renamed Cultural History ('more broadly European'),[70] since 1979 and he had a deep feeling for the ethos of the place, its particular historic position in the culture of this country. In terms of the general official criteria laid down by the Higher Education Funding Council for England, the Royal College of Art was an anomaly: 'too small, too face-to-face, too concentrated, too focused, too inadequate and too expensive.'[71] But Frayling was prepared to defend it with his life.

The justification for the RCA was that it was 'vital to a thriving and tangible creative economy'.[72] These were of course the years of so-called 'Cool Britannia', a second wave of youth culture, as – in a landscape of ever-waning factory produc-tion – the Blair government latched onto the importance of the creative industries. Successive Annual Reports trumpet the successes of the students. In the years from 1990 to 1995 an average of 92.5 per cent of graduates had 'gone on to work at the right levels in areas for which the College helped to equip and educate them'.[73] In Computer Related Design that figure was 100 per cent, in Vehicle Design 98 per cent, in Fashion 98 per cent. Even Painting and Sculpture (a rather less tangible figure to arrive at) achieved a success level of 92 per cent.

The mood within the College can at this point be gauged by a six-part documentary, 'The Royal College of Art', made by the BBC in 1998 and watched by two million or so viewers. The documentary was effectively fronted by the rector, himself a tried and tested television performer, presenter of *The Face of Tutankhamen* and a series on Gothic horror, *Nightmare*. The rector comes over as accessible, unpompous, the picture of intellectual affability.

The programmes also focus in on the professors. Frayling had continued Robin Darwin's policy of appointing part-time professors to the College who were already stars within their own professional spheres. One of these was Nigel Coates, professor of Architecture and Interior Design, an ironist and an upheaver, an alternative voice in the British architectural elite. Another controversial new appointment was Ron Arad,

'A magnet for talent':
An Intimate Portrait of the Royal College of Art
Fiona MacCarthy

maverick and genius who became professor of a new joint Department of Furniture and Industrial Design. In the course of the television documentary Arad's students confront his rather intermittent record of attendance, the downside of employing celebrity professors. Here are echoes of past students complaining about staff absenteeism through the ages. *Plus ça change.*

In some respects student life seemed to have altered very little over the past century. There were still the laments over lack of money and poor living conditions, students washing clothes in buckets, though now with central London property values rising astronomically students were more likely to be sharing lodgings in Brixton than in South Kensington or Fulham. There were still updated versions of that early student camaraderie, student fancy dress balls centred on theatrical funk and Brazilian soul music, featuring such guest bands as Super Thriller and Savannah Soul. As the television documentary reveals there was still appalling panic in the run up to degree shows. There were still the old self-doubts and *crises de conscience* when it came to active selling. Should they really be making works of art for filthy rich consumers? The old William Morris dilemma rides again.

But the Frayling years in fact brought quite considerable changes. There were physical changes that altered the orientation of the College. As student numbers rose and rose, making more demands on space, the long-running and endlessly frustrating plans for expanding the South Kensington site were finally abandoned. It was Frayling's initiative that all new development should now take place in Battersea, forming a large second campus alongside the School of Sculpture, which had moved south of the river in 1991. Frayling the historian liked the connection across the river to the north with the old artistic Chelsea of Whistler and the Arts and Crafts designer C R Ashbee. Viewed the other way, looking south across the Thames, the RCA buildings could be seen as a new bastion of art and design as symbolic and inspiring as the historic Bauhaus building in Dessau.

The other great legacy of the Frayling years has been of course the intellectual one. We should not forget that Henry Cole and 'Albertopolis' were at the forefront of mid-nineteenth-century scientific and educational innovation. It was Cole who had appointed the great Gottfried Semper, leading German design

theorist, to lecture at the Department of Practical Art. In one sense the College was returning to its roots in the emphasis placed from the 1990s onwards on design in relation to technological research. As digital design increased vastly in importance, the RCA promoted itself as the professional testbed for the use of computers in creative applications.

Ideals for design for public good, so central to William Morris and his followers' campaigns, saw a resurgence in the 1990s with the opening of the Helen Hamlyn Centre for Design, endowed by the Helen Hamlyn Trust. This specialist design research centre was originally founded to improve the quality of lives of an ageing population, but it has now expanded to apply design expertise and inventiveness across a whole range of social needs. The interesting thing is that Helen Hamlyn was herself a fashion student at the College in the 1950s before becoming head designer for Cresta and for Debenhams. I like to see her in the great tradition of enlightened Victorian female philanthropists, a latter-day Baroness Burdett-Coutts.

Frayling in his time also initiated the return of close relations between the RCA and the immense intellectual resources of the V&A, initiating joint programmes of research. The secret passageway between the two historic institutions, so familiar and enthralling to the RCA students of the nineteenth century, was opened up again.

As an institution the Royal College of Art has found a unique way of negotiating between the past and present, of combining the realms of the intuitive and practical. It was always Frayling's view that the particular balance of art and design within the College gave it an educational value that one could not find elsewhere. He defended Fine Art not as an optional luxury, not merely as a back-drop to the serious business of training industrial designers, as the painters and the sculptors had tended to be viewed in the early post-war period, but as central and essential to RCA activities. As Terence Conran once put it, with his masterly talent for the statement of the obvious, 'That is why we are called the Royal College of Art.'[74]

Peter Blake
Portrait of Professor Sir Christopher Frayling
2009
Oil on canvas

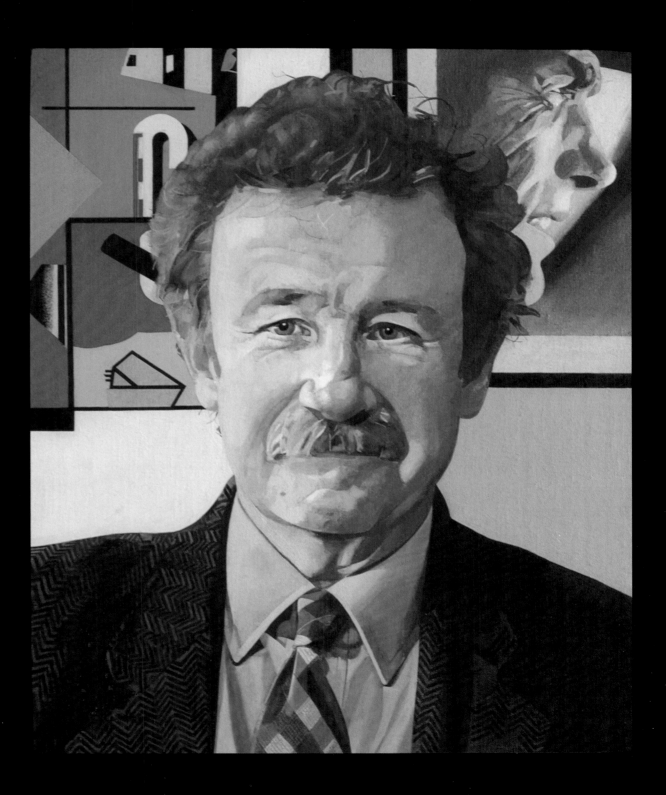

The Thompson Years 2009 – the Future

In early summer 2012 I spent two days ensconced in the Senior Common Room at the RCA, a room replete with its past history and crowded with its ghosts. Robin Darwin proud, avuncular in Ruskin Spear's grand portrait, gilded mirror in the background. John Minton painted by Lucian Freud, wild-eyed and vulnerable, already a potential suicide.

But by this time I was nearing the end of research for this essay, and I was less concerned with the College's past than with its present and its future. My original intention, as will by now be clear, had been to focus in on student experience over 175 years of College history. I wanted to gauge how greatly or indeed how little it has altered within the College now. I was lucky enough to have the opportunity of half-hour individual conversations with 14 current students drawn from across the whole spectrum of the RCA's total of six academic disciplines, the MA Schools of Architecture, Communication, Design, Fine Art, Humanities and Materials.

As they told me their stories, the first thing that impressed me was the high degree of motivation in these students. Many had taken long physical journeys to arrive finally in London. Ng'endo Mukii, the Animation student, who had started in Nairobi and studied in Rhode Island before travelling on to the RCA. She will be returning to Nairobi after her degree. Inderjeet Sandhu, the Jewellery student specialising in surreal adornments for the body, born into an Indian family in Wolverhampton who subsequently moved to Amsterdam. Lily Cain, voluble printmaker, expert on femininity and 'our criticality in approaching women's bodies', who had 'felt stuck' in California and has found the RCA a 'usefully challenging environment'. Students now come from all over. According to Kate Warner, a painter born in County Wicklow, this eclectic mix of nationalities gives 'a kind of validity to where you come from too'.

I also heard the tales of their journeys of the mind. The excitement with which Ruth Mason, MA student in History of Design, had been pursuing her special interest in nineteenth-century non-conformist religious artefacts. Her second year dissertation had been on the design of locations of Wesleyan Methodism. Naomi Pearce, a student on the new programme of Critical Writing in Art & Design, has been finding the course a challenging mix of 'different voices, different ideas'. Tobias Revell in Design Interactions, described as the most conceptual wing of the School of Design, has been focusing broadly on scenario planning and 'examining large, sprawling social, cultural and economic criteria that might, in tandem with certain technologies or particular movements, lead to unpredictable events and phenomena'. Revell talks with a transfixing lucidity on possible future global models of power and transnationalism.

For almost all the students that I talked to the RCA has provided a space for self-discovery, the thing that Andrew Lacon, a student in Photography coming from the Midlands, calls 'growing as an individual'. Being at the College gave Amos Field Reid, the maturest of the students, born in 1970, the chance to reassess his earlier career as a furniture designer

'A magnet for talent':
An Intimate Portrait of the Royal College of Art
Fiona MacCarthy

Sackler Building
Battersea Campus
2010

Dr Paul Thompson

in favour of projects that 'directly address sustainability', most notably his new design invention, Velopresso, a morally marvellous, pedal-powered coffee-making machine delivering the highest quality espresso as it parades the streets.

Describing her experiences Deshna Mehta, Visual Communication student from Mumbai, reached for the familiar, indeed time-honoured, RCA student cliché: 'It was like living a dream.' But the College would not be the College without a voice of dissidence. The self-confident student from the Sculpture programme, the German-born Chris Succo, provided this on cue with complaints of the lack of good visiting lecturers and the waste of College money on expensive publications instead of student courses. All in all he found the RCA 'too like a school'.

This was the College seen through student eyes in summer 2012. What of the future? It was time to ask the rector, Paul Thompson. I've known Paul for many years, dating back

to when he was the dynamic young director of the Design Museum. I remember asking him when he left London to run the Cooper-Hewitt, National Design Museum in New York whether he would be returning as director of the V&A. He replied that he'd probably prefer the Tate. In the event it was the RCA that claimed him. He took over from Christopher Frayling in 2009.

Paul has a distinct new vision for the College. He counts himself fortunate in having inherited Christopher Frayling's 'brilliant solution' to the age-old space problem that had bedevilled the College since its original Somerset House days. By 2015 the student population will have risen to a total of around 1,500. By more or less that time 37 per cent of all RCA students, including a new influx of applied arts students from Ceramics & Glass and Goldsmithing, Silversmithing, Metalwork & Jewellery, will be based at the new campus in Battersea. This ongoing expansion of RCA facilities has given him the scope to rethink the academic masterplan and

reconsider just what kind of advanced education in art and design the College should ideally be offering through the early twenty-first century.

As Thompson now sees it:

> *The RCA's main academic offering is undoubtedly its Master's courses. All 21 of them. But my sense is that Research – both at faculty level but also our MPhil and PhD provision – has over the years played 'second fiddle' to the taught Master's. Gradually, this will be rebalanced. Nowadays, university academics are required to be not only inspiring teachers, but also five-star research generals, consummate grant writers and brilliant scholars.*

> *The world of the RCA, in which part-time practising artists and designers teach Master's students, won't disappear, but it will now be buttressed by an increasingly powerful cohort of 'new academics' for whom scholarship and faculty research is second nature. The applied research programmes of the Helen Hamlyn Centre for Design are testament to the powerful role which the RCA plays in research programmes with NHS Trusts, third-sector and corporate partnerships. With the appointment of new School research leaders*

> *I hope that this model of applied and practice-based research can be accelerated and deepened within the six academic schools.*[75]

This is a serious, even a solemn, statement of priorities. The danger is of course that the creative spontaneity, the 'effervescence' (to use the Darwin word for it) so characteristic of the College, could be lost. We must leave it to the students, with their rhythms of work, their creative interactions, their love affairs and friendships, their innate irreverence, to ensure that the RCA's inimitable atmosphere of student exuberance survives. Remember what George Clausen wrote 140 years ago: 'however good the teaching in a school may be, it is the communion of the students which keeps their work alive.'[76]

Amos Field Reid and Lasse Oiva
Velopresso
2012

'A magnet for talent':
An Intimate Portrait of the Royal College of Art
Fiona MacCarthy

Acknowledgements

In preparing this essay I was fortunate enough to have two lengthy conversations with Sir Christopher Frayling, whose admirable histories of the RCA I have drawn on at all points. I have also enjoyed hearing from the present rector Paul Thompson about his vision for the future of the College.

Special thanks to David Gentleman for his graphic descriptions of life at the College in the early 1950s and fascinating reminiscences from Frank Height, Allen Jones and Richard Wentworth, not forgetting the daughters of the Camouflage corps professors, Dinah Casson, Virginia Ironside and Henrietta Goodden. Sarah Younger talked to me about life as an RCA student in the 1980s.

Neil Parkinson, RCA archives & collections manager, has been wonderfully patient in answering my queries, as has Octavia Reeve, senior publishing manager. Octavia also spared the time to give me the full tour around the fast developing new College campus at Battersea. Finally, I want to thank the 14 current students who gave me such a valuable insight into their experiences and future hopes: Lily Cain, Emma Elston, Amos Field Reid, Andrew Lacon, Alexander Lamb, Ruth Mason, Deshna Mehta, Ng'endo Mukii, Naomi Pearce, Tobias Revell, Inderjeet Sandhu, Ruby Steel, Chris Succo and Kate Warner.

[1] Richard Burchett to the Government School of Design Council's Committee of Enquiry, 19 March 1847

[2] Frayling, C. (1996) *Design of the Times: One Hundred Years of the Royal College of Art*, Somerset: Richard Dennis, 9

[3] Herkomer, H. von (1910) *The Herkomers*, vol. 1, London: Macmillan, 57

[4] Clausen, G. (1912) 'Recollections of the Old School', *The Royal College of Art Students' Magazine*, first series, vol. 1 (7) June, 155

[5] Frayling, C. (1987) *The Royal College of Art, One Hundred and Fifty Years of Art & Design*, London: Barrie & Jenkins, 41

[6] Clausen, G., op. cit., 157

[7] Ibid., 161

[8] Lantéri, E. (1911) *The Royal College of Art Students' Magazine*, first series, vol. 1 (1) December, 10

[9] Speed, H. (1912) *The Royal College of Art Students' Magazine*, first series, vol. 2 (8) November, 34–5

[10] Ibid., 36

[11] Ibid.

[12] Crane, W. (1907) *An Artist's Reminiscences*, New York: Macmillan, 457

[13] Robertson, J. (1900) 'Recollections of R.C.A. Sept. 1897 – July 1900', ms, RCA Archive, 6

[14] *The Departmental Committee on the Royal College of Art: 1911*, Proceedings of the Thirteenth Day, 19

[15] *The Royal College of Art Students' Magazine* (1914), first series, vol. 3 (24) Autumn, 1

[16] Rothenstein, J. (1965) *Summer's Lease, Autobiography 1901–1938*, Hamish Hamilton, 99

[17] Ibid.

[18] William Rothenstein to the Board of Education (1987) in: Christopher Frayling, op. cit., 89

[19] Bliss, D. P. (1979) *Edward Bawden*, Godalming: Pendomer Press, 19

[20] Bawden, E. (1988) in: *Exhibition Road, Painters at the Royal College of Art*, London: RCA, 24

[21] Rothenstein, W. (1921) *The Royal College of Art Students' Magazine*, second series, vol. 1 (1) February, 3

[22] Rothenstein, J., op. cit., 113

[23] Russell, J. (1968) *Henry Moore*, London: Penguin, 22

[24] *The Royal College of Art Students' Magazine* (1923), second series, vol. 1 (6) June, 102

[25] Rothenstein, J., op. cit., 100

'A magnet for talent':
An Intimate Portrait of the Royal College of Art
Fiona MacCarthy

26 Bawden, E. (1988) in: *Exhibition Road, Painters at the Royal College of Art*, London: RCA, 20

27 Bliss, D. P., op. cit., 55

28 Jackson, L. (2001) *Robin and Lucienne Day, Pioneers of Contemporary Design*, London: Mitchell Beazley, 10

29 Rothenstein, W. (1921) *The Royal College of Art Students' Magazine*, second series, vol. 1 (1) February, 3

30 Hambledon Committee Report (1936), 11

31 Ibid., 7

32 Ibid., 8

33 Seddon, R. (1963) *A Hand Uplifted: A Fragment of Autobiography*, Muller, 18

34 Duxbury, L. (2008) *Bohemians in Exile, The Royal College of Art in Ambleside, 1940–1945*, Leslie Duxbury, 4

35 Osborne, R. (2009) *Don Pavey, His Life and Work on Aesthetics and Colour*, self-published memoir, 22

36 Percy Horton to Ronald Horton, 16 November 1940, in: Robert Woof (ed.) (1987) *The Artist as Evacuee, The Royal College of Art in the Lake District 1940–1945*, Wordsworth Trust, 40

37 Osborne, R., op. cit., 14

38 Donaldson, S. (1996), memoir, ms, RCA Archive, 17–19

39 Conradi, P. J. (2001) *Iris Murdoch: A Life*, London: W. W. Norton & Co, 470

40 Robin Darwin to Ministry of Education, 4 June 1948, quoted in: Hilary Cunliffe-Charlesworth (1991) 'The Royal College of Art, Its Influence on Education, Art and Design 1900–1950', DPhil thesis, Sheffield City Polytechnic, 266

41 Spencer, G. (1974) *Gilbert Spencer, R. A., Memoir of a Painter*, London: Chatto & Windus, 143

42 Darwin, R. (1954) 'The Dodo and the Phoenix', lecture to the Royal Society of Arts, 20 January

43 Ibid.

44 Conradi, P. J., op. cit., 473

45 Darwin, R., op. cit.

46 Riley, B. (1988) 'RCA memories', in: *Exhibition Road, Painters at the Royal College of Art*, London: RCA, 84

47 Blake, P., ibid., 86

48 Scott, R. (1999) 'RCA memories', in: Christopher Frayling, *Art and Design, 100 Years at The Royal College of Art*, London: Collins & Brown, 256

49 Ibid., 259

50 Dyson, J. (1999) 'RCA memories', in: Christopher Frayling, op. cit., 111

51 Boshier, D. (1988) in: *Exhibition Road, Painters at the Royal College of Art*, London: RCA, 41

52 Darwin, R. (1959) *Royal College of Art Annual Report*, 25

53 Robertson, B. (1988) in: *Exhibition Road, Painters at the Royal College of Art*, London: RCA, 68

54 Esher, L. (1985) *Ourselves Unknown*, London: Gollancz, 169

55 Britton, A., (1999) 'RCA memories', in: Christopher Frayling, op. cit., 164

56 Ibid., 166

57 Ibid.

58 Height, F. (1975) 'And Cheap Tin Trays', inaugural lecture as professor of Industrial Design

59 Esher, L., op. cit., 166

60 Esher, L. (1973) 'Easy Does It', RCA inaugural address

61 Gadney, R. (2004) obituary of Viscount Esher, *The Guardian*, 13 July

62 Esher, L. (1985) op. cit., 186

63 Ibid., 166

64 Sarah Younger in conversation with the author, April 2012

65 Treacy, P. (1999) 'RCA memories', in: Christopher Frayling, op. cit., 214

66 Ibid., 217

67 Morrison, J., ibid., 136

68 Adjaye, D. (2010) in: RCA new building prospectus

69 Heatherwick, T. (2012) *Making*, London: Thames & Hudson, 11

70 Christopher Frayling in conversation with the author, 22 March 2012

71 *Rector's Review 1996/7*

72 *Rector's Review 1999/2000*

73 *Rector's Review 1996/7*

74 Conran, T. (1997) in: Battersea appeal brochure

75 Thompson, P., email to the author, 9 June 2012

76 Clausen, G. (1912), op. cit., 155

'The New Sculpture':
A Revolution in South Kensington
Robert Upstone

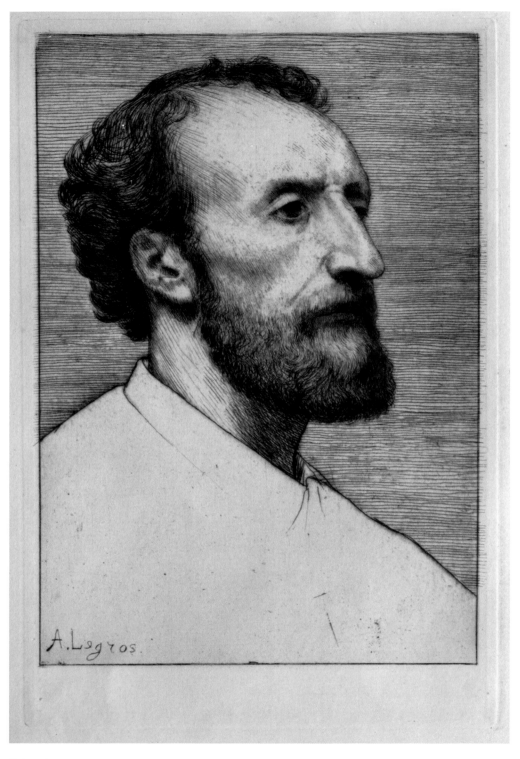

THE CHANGE IN
THE TEACHING OF
SCULPTURE AT THE
SOUTH KENSINGTON
SCHOOL CAME
ABOUT PARTLY BY
THE ACCIDENT OF
INTERNATIONAL
EVENTS AND PARTLY
THROUGH DEFT
NETWORKING AND
WELL-INTENTIONED
INFLUENCE

South Kensington was the hub of a dramatic revival of British sculpture that took place in the closing decades of the nineteenth century. Dubbed 'The New Sculpture',[1] tired Neo-Classical prototypes were abandoned in favour of a new naturalism and a dynamic, sensuous approach to modelling and surface, and innovative subjects were chosen that were subtle and allusive, often suggesting complex emotional states. The artists who pioneered this approach were recognised as leading a phenomenon that marked sculpture as the highest expression of British artistic achievement in the 1880s and '90s, giving it an unparallelled status both at home and abroad. Central to this revival was the abandonment from the 1870s of outmoded methods of teaching, and the utilisation of French practical instruction by the sculpture masters Jules Dalou and Edward Lantéri, who joined the teaching staff of the National Art Training School (commonly known as the South Kensington School) after settling in London. These were somewhat bold appointments at a time when French influences were viewed with jingoistic suspicion by conservative elements within the British artistic establishment. The story of the shift in the Sculpture School's focus, and the achievements of its best teachers and pupils, also focused attention on the continuing debate through the nineteenth century as to what the purpose of the South Kensington School was to be, and on the emergence of the creation of 'fine art' as an end in itself, divorced from the stricture that Art was to only serve Industry.

The change in the teaching of sculpture at the South Kensington School came about partly by the accident of international events and partly through deft networking and well-intentioned influence. Alphonse Legros (1837–1911) was a French painter and etcher who in 1863, at Whistler's encouragement, had come to live in London. Legros was an intimate of Rodin and an important link with recent developments in French art. He held a special interest in sculpture

– which he himself began to practise in the 1880s – and in particular the work of Alfred Stevens. With the fall of the Paris Commune in 1871, Legros was contacted by a fellow former student from the École Impériale Spéciale de Dessin et de Mathémathiques in Paris – Aimé-Jules Dalou (1838–1902). Dalou was a sculptor with socialist political convictions who had become a prominent member of Courbet's Féderation des Artistes in the Commune, and one of those who was given responsibility for the Louvre. With the Commune's collapse, he had to go into hiding under threat of reprisals before seeking refuge in London. Legros, who was a great fixer but also a shrewd promoter of genuine talent, set out to secure him a steady job after some years of uncertainty in which Dalou got by in England on small commissions. In 1876 Legros succeeded Edward Poynter as professor of the Slade School of Art, who himself had become principal at South Kensington the previous year. Legros reflected: 'If I, who have never learned English, can teach drawing at the "Sled-School", why couldn't Dalou, who can't be worse than I at English, teach sculpture in another great school… at South Kensington, for example?'[2]

Dalou gave his first demonstrations of sculpture modelling at the Slade, supposedly leading Poynter to remark that the teaching of sculpture in England would benefit enormously if such demonstrations could be given at the South Kensington Schools.[3] In May 1877 Dalou was appointed as 'a teacher of modelling' at the National Art Training School. His salary was set at £7.10s a week, which was a quite generous reward as he was expected only to give a single lesson each week.[4] He was classified as simply a 'supplementary teacher' without an official title because there was an existing modelling master already, Felix Martin Miller (1819–1908). Miller was master from about 1860 to 1878, and was highly regarded in some quarters, particularly as a skilled exponent of bas relief.[5] However, whether it was known to him, he was paid a significantly lower salary than Dalou, and for more work. In 1887/8 he was paid £75 a year to attend the school on five

45

days and two evenings per week.[6] George Clausen recalled the teaching staff before Dalou's arrival as 'good. easy men, more than a little tired as teachers are apt to be with long continuance', but that Miller was completely out of touch with modern sculpture developments:

> Contemporary sculpture was non-existent as far as our knowledge and interest went, except for the work of Stevens, whose tradition was being carried on in the decoration of the [South Kensington] Museum. But I doubt whether our modelling master [Miller] ever looked on Stevens as a 'proper sculptor'. His ideal was [John Henry] Foley.[7]

Dalou faced a particular impediment in teaching in that reputedly he did not speak good English at all. However, his approach was not simply to teach the theory of sculpture or its practice – as had previously been the case at South Kensington – but to demonstrate it himself in practical lessons. In particular, Dalou believed in a lively, highly physical approach to modelling clay and to working it quickly to achieve a sense of spontaneity. Students had previously been taught that the clay should be worked endlessly with a variety of tools and smoothed with damp cloths. Dalou used his fingers instead to create a dynamic, vigorous surface and demonstrated the underlying structure of sculptural planes. His lessons were reputedly characterised by his practical demonstrations being punctuated by the phrase 'You do so!', which became an affectionate catchphrase among his students.[8]

Dalou's subjects in the early 1870s were variations on the theme of a mother suckling her baby. This was naturalistic both in its treatment and also for its selection of a working woman as its subject. In this Dalou was following principles already familiar in France but which were new and different in Britain. Naturalist subjects were in themselves implicitly French, expressed in the rural naturalist paintings of unromanticised peasants and country life painted from the 1870s onwards by Jules Bastien-Lepage (1848–84) and Jules Breton (1827–1906), which were emulated in Britain by advanced artists such as George Clausen (1852–1944) and Henry La Thangue (1859–1929) in the 1880s and after. Dalou's work found critical favour in Britain, where he exhibited frequently at the Royal Academy, and his terracottas were bought by major collectors such as Sir Lionel Coutts

Lindsay, who acquired *Peasant Woman Nursing a Baby* for the significant sum of 300 guineas in 1873. It was also an influential subject among young sculptors, who realised the potential of a more naturalistic approach to the figure. Alfred Gilbert, the great presiding genius of the New Sculpture revival, made his own homage to Dalou with his large marble carving *Mother Teaching Child* (1881), his first major work. The success of Dalou's subject was finally compounded by his commission to carve a more developed large marble of it for a drinking fountain at the back of the Royal Exchange in the City in 1877.[9]

In 1878 Dalou was made modelling master at South Kensington, but after the amnesty offered the Communards in 1879 he returned to Paris the following year. His former pupil Edward Lantéri (1848–1917) wrote how Dalou 'gave an extraordinary impetus to sculpture' during his tenure:

> By his sound method, his marvellous technique, and his lucid demonstrations he completely carried his students away with him. He knew how to inspire them with the desire to work, and succeeded in awakening an extraordinary enthusiasm where all before seemed dormant. It is no wonder that he gained the admiration of his students.[10]

Lantéri was a former student of Dalou who had followed him to London in 1872, and there Dalou had secured him the position of chief assistant to Edgar Boehm. On Dalou's recommendation Lantéri now succeeded him at South Kensington in 1880. Lantéri continued Dalou's regime of practical demonstration, and in particular also his practice of using live models, which can be seen in the women's class. British institutions such as the Royal Academy Schools restricted access to live models for some years, instead requiring students to draw endlessly from Antique casts. French practice recognised this as a slow way to learn, and instead gave students the opportunity to draw from life as soon as possible. While South Kensington students continued to also make drawings from the Antique, they were required by Dalou and Lantéri to work speedily rather than spend months on one sheet, and to prevent this each week Lantéri would move the casts around. In 1896 Lantéri responded to a memorandum from Thomas Armstrong (1832–1911), who as director of the Art Division of the Department of Science and

Alfred Gilbert
Mother Teaching Child
1881
Marble

Jules Dalou
Peasant Woman Nursing a Baby
c. 1873
Terracotta

Edward Lantéri
Pax
1896
Plaster

Art at the South Kensington Museum was responsible for the organisation of art education throughout Britain. Armstrong wrote: 'It is very desirable to have casts of better quality from life size full length statues than any that are to be obtained at present from the well known and much used antique figures in the Vatican Museum.'[11] Lantéri executed *Pax*, modelled 'from the living model a standing female figure 5 ft high', with arms held away from its body so that it could be clothed with drapery, and 'one of the arms will have a joint, so that the lower part of it may be removed and replaced by another with a somewhat different movement'.[12] This life-like cast was intended by Lantéri to be available to regional government art schools to aid a more naturalistic approach to modelling and drawing from the cast. His original was purchased for the South Kensington School for £100.

Lantéri also made a significant impact on British sculpture teaching with the publication of his three-volume practical manual which appeared between 1902 and 1911, *Modelling: A Guide for Teachers and Students*. This publication, which remained in use for some decades, took a pragmatic and uncomplicated approach to modelling. Based on the notes Lantéri used for his classes at South Kensington, it also summarised the ideology he followed in his teaching. Lantéri argued for the primacy of teaching practical techniques but that:

> Art is essentially individual, in fact 'individuality' makes the artist. All teaching, to be true and rational, must aim at preserving, developing and perfecting the individual sentiment of the artist... In thoroughly teaching each pupil the craft, not to say the trade, of a sculptor, there is no fear of destroying his individuality; on the contrary, having conscientiously learnt the craft he will gain confidence and the necessary power to express truthfully his personal sentiment... The aim of Art-teaching should be to put within the pupil's grasp all that is necessary to help him express his thoughts by the simplest, surest and quickest means. It should in particular sharpen his observation, without too much influencing his own judgment.[13]

This pluralistic view of nurturing individual expression and identity set Lantéri against the principles of national art training that had held sway in the nineteenth century. Students in the national schools were intended to follow the same syllabus, dictated by London, and produce works identical to each other to a consistent measured standard. Underlying these principles was the question of what the South Kensington School and other government art schools should be for. South Kensington's founding purpose was to produce students capable of increasing the aesthetic quality of manufacture and design, ultimately placing art as a servant of industry, and secondarily to produce art teachers who would carry these principles to the provinces. As a report of 1896 noted: 'The special object of the school is the training of Art teachers of both sexes, of designers, and of Art workmen... The Royal College of Art is not intended to train painters of easel pictures. As the National Art Training School, it was originally intended to train designers for fabrics, to train craftsmen rather than artists.'[14] The notion of art training as an end in itself, as a route to self expression, or following a career as an exhibiting artist did not enter into this equation. Indeed in the nineteenth century the purpose of art was often narrowly proposed as providing moral improvement. Such notions of 'Art for Art's Sake' that emerged with the Aesthetic movement of the 1860s became part of a wider moral debate, one later centred on Whistler's paintings, which operated directly on the senses without any suggestion of narrative or moral purpose. It was a position treated with outrage during the libel case Whistler brought against Ruskin in 1878, at which Whistler instead found his own artistic principles on trial, bringing him financial ruin.

Lantéri was revered by his students, and writing in 1901 the influential critic M H Spielmann judged: 'As a teacher he has no superior, and many a successful sculptor of today owes much to his untiring energy, encouragement, and interest, such as he takes in all who have the good fortune to come under his care.'[15] Lantéri nurtured a generation of sculptors who were able to utilise his practical modelling techniques to produce figure compositions observed from life that were natural rather than Classical, and which possessed an emotive, sensuous, vital surface that had an abstract visual satisfaction in its own right. These qualities were frequently deployed to create ideal subjects devoted to themes around love, death or the eternal, what came to be known as 'The New Sculpture' and which were in essence a manifestation of Symbolist subject-matter. One of Lantéri's most successful

Women's Life Modelling Class
c. 1905

Alfred Drury
The Prophetess of Fate
1899–1900
Bronze

students in this vein was Albert Toft (1862–1949), who had first worked as a modeller for Wedgwood but won a scholarship to South Kensington in 1881 and became one of the leading exponents of the New Sculpture style. In *The Spirit of Contemplation* (1899) Toft's model is treated with unmannered naturalism, but her eyes stare off into the distance in a still reverie of deep inward reflection; any 'meaning' remains elusive or reserved, only heightened by the allegorical figures in niches on her chair. There is no movement or narrative, only profound stillness and an inescapable, modern melancholy.

Depicting mental states of introspective self absorption was a recurrent theme of the New Sculpture, and psychologically it both reflected and recreated the experience of abstract emotion on the senses. This was an approach also found in *The Prophetess of Fate* (1899–1900) made by Alfred Drury (1856–1944). Drury was another National Scholar to South Kensington, and was trained by both Dalou and Lantéri. He followed Dalou back to Paris and from 1881 until 1885 he worked there as his assistant. His early terracotta figures were highly influenced by Dalou, but in *The Prophetess of Fate* he took a bold step towards depicting a symbolist subject. Clutching a crystal sphere, and wearing at her breast a decorative heart emblematic of love, the prophetess is essentially a sibyl, divining our unknown fate. But again, her introspection suggests something of the potential mournfulness of knowledge, and hence perhaps also of human existence. Drury balances these allegorical, symbolist dimensions and the portrait of a psychological state with an extremely naturalistic treatment of the face and the hands, the soft, expressive modelling suggesting an almost disquieting lifelikeness.

Both Drury and Toft were commissioned to make a great number of civic memorials and architectural pieces. Drury made four monumental pairs of allegorical figures depicting *Victory and Fame, Sorrow and Joy, Horror and Dignity, and Truth and Justice* for the War Office in Whitehall (1905), the immense figures of *Education, Fine Art, Science and Local Government* that decorate Vauxhall Bridge (1909), and figures and decorations for the façade of the Victoria and Albert Museum (1905–7). One of Toft's major commissions was for the memorial in Nottingham to Queen Victoria (1905). While the large marble figure is quite conventional, the base incorporates three bronze plaques depicting *Maternity,*

Albert Toft
The Spirit of Contemplation
1899–1900
Bronze

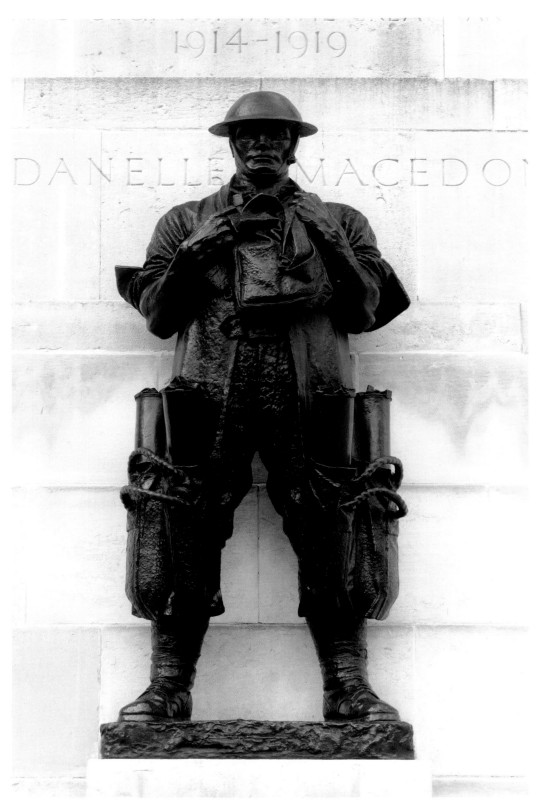

Feeding the Hungry and Clothing the Naked. These offered some commentary or foil to the glitter of imperial reign. In *Maternity* a hieratic robed female figure holds two infants, the group framed by an entwined bower of roses, the symbol of love. The two children hold a model train and steam ship respectively, symbols of all the driving ambition and technological advancement of the Victorian age. Yet, Toft seems to suggest, are these not merely toys in comparison to human love and charity? The meaning remains elusive, but Toft has introduced a symbolist dimension to a portrait memorial that takes it to a different level of interpretation, contrasting imperial majesty with the virtues of simple human sympathy.

Lantéri was made professor of Sculpture at the newly named Royal College of Art in 1900, and he continued teaching up until his death in 1917. One of the most original sculptors to emerge from the College in the early years of the new century was Charles Sargeant Jagger (1885–1934). Because of the subject-matter of his realist war memorials of the 1920s, Jagger is usually considered only as a 'modern' sculptor, but his continuation of the ideals of naturalism learned from Lantéri place him also as a final, late flowering of the New Sculpture movement. Jagger was awarded a scholarship to the Royal College in 1907 and achieved considerable success, winning a number of prizes. His sculpture from this period was firmly characterised by the type of natural life modelling that Lantéri taught. After completing his training in 1911 Jagger became Lantéri's studio assistant, and at his suggestion entered the first competition for the British School at Rome's scholarship, which he lost to a fellow Royal College graduate, Gilbert Ledward (1888–1960). The following year Jagger tried again, and this time was awarded the 1914 scholarship to study in Rome. But with the outbreak of war he instead enlisted in the Artists' Rifles.

The Great War was to be the defining experience of Jagger's life. He was twice wounded seriously, first at Gallipoli in 1915 and then in France in the final months of the conflict. Immediately after the war Jagger took up his scholarship but asked to serve it in London, where he worked on a large relief inspired by his experiences at Gallipoli, *No Man's Land* (1919–20). From this time onwards Jagger was asked to fulfil a number of major commissions to make war memorials, the first of which was at Hoylake in Lancashire (1919–22). All

of his memorials are characterised by the massive figures of ordinary soldiers – still, sombre, muscular, dignified, stalwart, possessing a striking emotional intensity and, most important of all, sincerity. They are not idealised but instead remain true to the naturalism Jagger had learned at the Royal College of Art, never straying into hyperbole. Jagger's masterpiece was sited just a short journey from where he had learned his craft, the Royal Artillery Memorial at Hyde Park Corner. The sentinel figures standing guard around their fallen comrade beneath a massive gun have enormous emotive power. They manage with superb control and judgment to give both a sense of the human suffering of war and of the necessary endurance of it, therefore with quiet dignity acknowledging both the horror and forbearance that the soldiers experienced. Jagger put his all into the memorial, and by its completion was drained. It must have been a bitter pill to read *The Times* art critic judge: 'It has neither the appeal to actuality, nor the more subtle or lasting appeal of monumental sculpture.' But the soldiers who had fought the War found in it an expression of their unspoken feelings. A former Artillery officer who had served wrote immediately to rebuke *The Times'* critic: 'The 'Gunners' memorial is nothing if not real, and conveys nothing if not actuality… It is terrible in its actuality, terribly real, terribly powerful – a lasting memorial of horrible, bloody war, of what human flesh did, and can endure; an enduring memorial that war means destruction. It is the Memorial our fallen comrades would have wanted. They knew actuality. They would not ask for anything else.'[16]

[1] Gosse, E. (1894) 'The New Sculpture, 1879–1894', *Art Journal*, 138–42

[2] Dreyfous, M. (1903) *Dalou, sa vie et son oeuvre*, Paris, 69–70

[3] Ibid., 69–70

[4] Beattie, S. (1983) *The New Sculpture*, New Haven & London: Yale University Press, 14

[5] *Art Journal*, October 1874, 306

[6] See 'List of Staff', in Report of the Departmental Committee on the Royal College of Art (1911) 60

[7] Lunn, R. (1912) 'Recollections of the Old School', *The Royal College of Art Students Magazine*, first series, vol. 1 (4) March, 61–3

[8] Dreyfous, M., op. cit., 69–70

[9] The weathered marble was replaced by an inferior bronze version in 1897

[10] Lantéri, E. (1902) 'Jules Dalou: Sculptor', *The Magazine of Art*, 377

[11] Cited in: Diane Bilbey with Marjorie Trusted (2002) *British Sculpture 1470 to 2000: A Concise Catalogue of the Collection at the Victoria and Albert Museum*, 315

[12] Ibid., 315

[13] Lantéri, E. (1922) *Modelling: A Guide for Teachers and Students*, I, London, 2–3. (By the time Lantéri published his manual he had become a naturalised British citizen and anglicised his name.)

[14] *Calendar of the Department of Science and Art*, 1896, quoted in: 'Royal College of Art (including National Art Training School)', *Mapping the Practice and Profession of Sculpture in Britain and Ireland 1851–1951*, University of Glasgow History of Art and HAT11, online database, 2011

[15] Spielmann, M. H. (1901) *British Sculpture and Sculptors of Today*, London, 128

[16] Letter from Major MacGregor Knox, late 15th Brigade (1925) *The Times*, 20 October, 15

The Skill Factory:
Workmanship at the RCA
Glenn Adamson

... AS ANY ARTIST OR DESIGNER KNOWS, MANY GOOD IDEAS ORIGINATE IN THE HANDS

Ron Lenthall

ributions
not his
n for
. He
ol should
r one-off
industry
Royal
se it is
for artists
each
ever to
ult for the

piece of
ch
l and
That was
e in.
I
f Prince
Frank
ed it.
found
ean

volved
ing and

13

T wo photos of men in their workshops, each accompanying an obituary. The first shows Ron Lenthall, a long-serving technician at the Royal College of Art. He stands in front of a wall festooned with the tools of the trade: saws, chisels, calipers, spokeshaves, planes piled in a cabinet. With his white lab coat, gaily chequered tie and thick-rimmed glasses, he seems every inch the approachable professional, ready to help – and able, too. The obituary accompanying this portrait, written by the great craft theorist David Pye, is quietly rhapsodic in describing Lenthall's skills. As an instructor in Furniture Design at the RCA, Pye had ample opportunity to see him at work. It was a 'treat to watch' this man, who gave little formal instruction to the students but served as an invaluable role model. From Lenthall, aspiring designers could learn the odd technique: how to cut a dovetail or plane a board. But above all they could see what it was to be a fine craftsman. As Pye

put it, 'I am inclined to think that the most valuable lesson a student could learn by watching such a man as Ron at work is that what laymen call skill is mostly a matter of taking very great trouble.'[1]

The second photo, and obituary, is of Pye himself. Though published ten years later it could be from the same photography session. Here are the profusion of tools, the glasses lending an air of authority, the work-ready attire. Yet to say that Pye identified with men like Lenthall wouldn't be quite accurate; better to say that he understood them well. In his landmark book *The Nature and Art of Workmanship* (1968), he had written famously of the 'workmanship of risk and the workmanship of certainty'. This was a fine distinction, based on long experience of technique, both as an observer and as a maker. Through a methodology of precise description, Pye sought to escape easy oppositions between craft and industry, and instead concentrate on the nuanced balance between control and 'variety' that inheres in any making

David Pye

rhament set
le Scottish

 two years
e disband-
 Scottish
's (SDA)
previously
 Scotland.
nakers, in
ing group
lied Arts
obbied for
rt as their
nd Wales,
ted by the

or of the
ord: 'The
al force in
ghted that
ecognised
 funds for
pen many
ly, nation-

provided by the Scottish Office through the Department of National Heritage.

OBITUARY: DAVID PYE

David Pye OBE – worker in wood, designer, theorist and teacher – has died at the age of seventy-eight. The frustration of having to submit to Parkinson's disease must have been enormous for one who derived so much satisfaction from fine workmanship; he once said in an interview: 'I like being master of the job.'

His was a life characterised by eccentricity, individualism and a deep questioning of both himself and others. Although he could claim direct descent to the Arts and Crafts Movement – his grandfather was the painter John Brett, a friend of Ruskin – he challenged

ual and original. Pye's passion for

Art of Workmanship (1968) – Pye

FI MCGHEE

David Pye, a key figure in the post-war professionalisation of the crafts

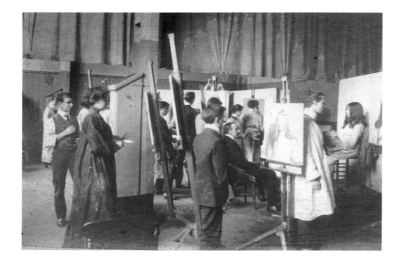

process. As for the term skill, which one would think incarnated by Lenthall and his type, Pye had little use for it: 'It does not assist useful thought because it means something different in each different kind of work… Like "function" you can make it mean what you please. It is a thought-preventer.'[2]

That was an interesting choice of words, because if the Royal College of Art has had one consistent goal throughout its 175-year history, it is to avoid the prevention of thought at all costs. Pye has a point about the notoriously slippery nature of the subject, but it is nonetheless clear that attitudes to skill have been crucial in shaping the history of the College. On the one hand, as any artist or designer knows, many good ideas originate in the hands. It is only by working directly with a material that new possibilities emerge. From this perspective, skill and thinking are so intimately intertwined that they could never be pulled apart. On the other hand, skill can indeed be a 'thought-preventer', though not quite in the way that Pye meant. It presents an insoluble dilemma: a lack of technical know-how can frustrate the creative process, but too much time spent learning skill leaves little room for anything else. These days, Master's students spend two years at the College – hardly long enough to learn the rudiments of any craft. Many students come with skills in place, having received training in a professional, vocational or educational context. Others have little such experience. But either way, even the most skilled student will sometimes run into the limits of their own competency, as they explore the cutting edge of their discipline, and cross into unfamiliar terrain.

This is where technicians, people like Lenthall, come in. They often produce a student's work, either in the form of a prototype or a finished object, but they take no share in the authorship. Lenthall was crystal clear on the point: his hands were at the service of the students. On one occasion, asked to evaluate a sampling of recent furniture designs by professionals, he expressed his frustration at the poor craftsmanship in evidence. 'Why the hell didn't this guy ask *me* to make it? Trouble is, they're none of them in the trade.'[3] When it came to the students, one senses that he took the same attitude. They should not be expected to master a craft, and he was there to fill the gap.

The affinity that Pye the theorist felt for Lenthall the technician is an unusually intimate version of a dynamic that one finds over and over in the history of the Royal College of Art: the attempt to marry great ideas with the skills necessary for their realisation. In the institution's early years, in its incarnation as the Government School of Design, this solution was found in drawing, a single skill that was thought to have a natural and directive relation to all others.[4] The architects of this new 'South Kensington system' of pedagogy presumed that designers would not make objects, but only render them, in the confidence that less highly educated artisans would complete the job. Drawing was a technical rather than a creative discipline. By the end of the century, however, that tacit priority of hand over head had completely reversed.[5] As the very name Royal College of Art (adopted in 1896) attests, painting and sculpture had become the template activity for the institution by the turn of the century. A Council of Advice for Art, formed at that time, bemoaned this development: 'much of the inventive design remains unpractical, and may be described as design in the abstract rather than design for some actual and clearly understood technical process.'[6]

Though the 18-month tenure of Walter Crane as rector would briefly trouble this tendency, leaving the imprint of the Arts and Crafts movement on the College, fine art remained the dominant practice at the RCA through the early decades of the twentieth century. There were certainly leading lights of the crafts at the RCA: W R Lethaby the architect; Edward Johnston the calligrapher; William Staite Murray the ceramicist; Enid Marx the pattern designer. But overall, the world of the College remained tilted on a fine art axis. The encour-

agement of personal expression rather than the inculcation of technical skill was the primary goal. Such, at least, was the conclusion of the Hambledon Committee, set up by the Board of Education in 1935 to assess the College. Its review bore the functionalist imprint of the Bauhaus in Germany (this was the same year that Walter Gropius was nearly hired as a faculty member). The committee's report echoed the terms of criticism from decades earlier: 'the absence of contact and co-operation between the College and industry has among other causes led to a certain lack of realism in the training provided for students of design... We therefore put as our first and most important recommendation that a new orientation should be given to the Royal College and that it should take the advanced study of all forms of applied art for its primary purpose.'[7] Nikolaus Pevsner, observing from the sidelines, summarised this recommendation as 'restoring to the Royal College its original purpose of serving industrial needs'. But in the same breath he added: 'How far these reforms will tend to increase cooperation between craft and design on one side, and the fine arts on the other side, can as yet not be seen.'[8]

The war-disrupted principalship of Percy Jowett – a transplant from the Central School of Art, who might have been expected to instill staunch craft values – did little to alter the situation. It was not until Robin Darwin took over in 1948 that attitudes to skill at the RCA would change again. One should remember that this was a fragile time for the College. It had to find a place in the reconstruction of war-torn Britain. The 1946 exhibition *Britain Can Make It*, held in the nearby Victoria and Albert Museum, was thronged with visitors who wondered when the designs on show (many by RCA graduates) would actually become commercially available. Darwin's strategy was akin to that outlined by the Hambledon Committee: to position the College as a driver for industry. Unlike his predecessors in the mid-nineteenth century, however, he did not want to produce an army of draftsmen. Rather, his ideal graduate was a designer who had a firm conceptual grasp of form, process and material. This did not necessarily entail learning hand skills of any kind. The painter William Johnstone described this policy as a 'professional elitist movement away from skilled craftsmanship toward "designing" or "directing",[9] and indeed it involved the establishment of a two-tiered staff structure that could

Alison Britton
Watershed
2012
Ceramic

be interpreted as reinforcing the traditional divide between the labouring and entrepreneurial classes, with technicians dutifully supporting the high-minded work of faculty and students. The age of vicarious skills had arrived. The professor of Furniture Design, Gordon Russell, commented that students in his department were 'constantly seeing actual work being carried out at the College by expert craftsmen, thus acquiring vivid experience of quality'.[10] Technique was now to be treated as a spectator sport, albeit a highly instructive one. One College publication described the pedagogical approach this way: 'The School does not attempt to train craftsmen or technicians, but it is constantly stressed in the designers' training that design must be related to, and intimately allied with, production technique.'[11]

One corollary of this policy was that 'Craft' activities narrowly conceived fared poorly at the College in the 1950s. The ancient art of calligraphy was presumably not fit for purpose in the post-war order, and it closed in 1953. Edward Johnston would not have an equally illustrious successor. Stained glass, another discipline that might well have seemed anachronistic, was still practised. In fact the College's Stained Glass Department had its finest hour in 1952, when the nave windows of new Coventry Cathedral were fabricated by Lawrence Lee, the head of department, and College students Keith New and Geoffrey Clarke. Lee, memorably described by Rosemary Hill as having had two great influences in his life – 'God and William Morris – in that order' – was one of the few remaining adherents of a purist Arts and Crafts tradition active at the RCA. He was himself a product of the teaching there, having studied at the College under his predecessor Martin Travers.[12]

But there is reason to think that the Stained Glass Department was very much the exception that proved the rule. It is worth remembering that in the 1950s and '60s, the RCA was still a deeply sexist institution, and the putatively minor field of stained glass was one place for female students to go. This was how the College dealt with Pauline Boty, one of the key figures in British Pop Art, who achieved brief and incandescent fame as one of the subjects of Ken Russell's film *Pop Goes the Easel*.[13]

Like furniture, metalwork and ceramics at this time held fast to Darwin's vision of an commercially oriented College. The

tutors put some emphasis on skills, but only as an adjunct to their role as form designers. 'Training in craftsmanship is secondary to training in design', in the Silversmithing Department, according to a 1963 College publication, 'but the student who completes his course will have sufficient practical ability to enable him to try out his designs in the material and make prototypes, and he should be worth his place as a designer in the industry'.[14] Robert W Baker, appointed as head of Ceramics in the post-war staffing rearrangement, was perhaps the most perfect exponent of Darwin's objectives amongst the applied arts faculty. Students in the department were taught 'chronologically' beginning with eighteenth-century techniques (imparted through the careful copying of historical objects) and continuing to the latest techniques employed in Stoke-on-Trent.[15] This curriculum tacitly conveyed a teleological mentality, in which hand-based processes were shown as gradually superseded by mechanisation. As in furniture, the support of technicians was crucial to Baker's approach. An infamous anecdote has him discovering that the department's equipment had been locked away 'in case the students should ask how to use it'.[16] He put the kit back in circulation, but it was the technicians who remained the trusted hands – once a student had absorbed the principles of throwing, moulding or transfer printing, they were not expected to master it.

In 1959 David Queensberry succeeded Baker, a transition that might have been expected to bring little in the way of change.[17] Queensberry's own training had included a spell at H & R Johnson in Stoke as a 'designer–maker, turning models, devising slips, and casting up shapes which were fired in the factory'.[18] There was demand for graduates to go to Stoke and serve the industry, so much so that he remembers explicit pressure from the British Pottery Manufacturers Federation 'to train designers that they considered appropriate to their needs'.[19] Yet it was his department that would experience the first and most pronounced rejection of the Darwin years. As Fiona MacCarthy relates in her contribution to this volume, a generation of young potters, many of them women, rebelled against the modernism of their training and embraced the improbable, the decorative, the non-functional. What is of greatest interest to our story, perhaps, is that this did not necessarily mean abandoning traditional technique. Quite the contrary: the historic collection of the

V&A, just around the corner, has remained a critical point of reference. But in Linda Sandino's words, their 'experimental, exploratory' approach required not deskilling, but rather 'a re-definition, a re-deployment of traditional skills'.[20] This was the postmodern moment, and just like appropriated imagery or quoted architectural motifs, skills were now points of conscious reference, not just practicalities of the studio. Sometimes this was explicit, as in Fred Baier's graduation piece in 1976, a chest of drawers that paid tribute to the skills of an industrial pattern maker.[21] At other times matters were more sublimated. To the untrained (and even the very observant) eye, RCA graduating shows in this era could seem like a free-for-all, in which individualistic expression had taken over and technique was wanting. The ever-waspish Peter York, reviewing the efforts of the class of 1984, quoted the exacting fashion designer Jean Muir – 'less Art, more craft' – and then wrote, 'One wants to be fair but one feels some of these young – and young-ish – people have been misled.'[22]

Such doubts certainly had a foundation in fact. The 1980s were a time when images and theories were more important than substance and skills, and the College was not immune to that broader trend. But 'the new crafts' as practised at the RCA struck a thoughtful balance between these two polarities, and sometimes found ways to contest the opposition itself. The work of Michael Rowe, for example, is broadly postmodern in tone, but for him theoretical engagement has always occurred through making itself. He had arrived as a student in the department in 1969, but at that time found design-oriented instructors David Mellor and Robert Welch unsympathetic to his avant-garde instincts: 'I had a huge respect for these designers and although they understood my proposal for a completely alternative trajectory for silver and metalwork they thought it was totally unworkable, which in their terms and at that time I suppose it was!'[23] Rowe would realise that trajectory upon his return as an instructor in his own right in 1979 (working alongside David Watkins from 1985). On a practical level, Rowe prizes the mastery of traditional techniques; but for him these skills are freighted with associations both philosophical and historical (the Utopian connotations of Constructivist logic). As he put it in a recent artist's statement, 'Interest in the foundational and the inner workings of form was a key element in Modernism and is present in certain strands of Postmodernist practice, but as an idea it

Fred Baier
Pattern Maker Chest
1976

61

Michael Rowe
Behind Glass I
2009
925 silver, acrylic, mdf

stands independent of any "ism", being ripe for re-appraisal and new expression in any age.'[24] The same union of artistic and technical exploration holds for potters like Alison Britton or Martin Smith, the long-serving anchors of the Ceramics & Glass Department. Aesthetically their approaches could not be more different – Britton is a historicist, a lover of decoration and gesture, while Smith is a formalist whose inspirations come from serial music and Minimalist sculpture. Britton makes 'in the moment', sometimes using high-risk techniques like free pouring of glaze and slip. Smith plans everything in advance, more like an engineer than a traditional potter. Yet for both, form is fundamentally process-driven. They do not conceive their skills as means of production, but as the very medium in which experiment occurs.

In Fashion and Textiles, too, the 1980s saw skill remaining a central concern while the palette of expressive possibilities broadened. Unlike peer institutions such as Central Saint Martins, which has become known for its sensational experimentalism, the fine art of tailoring has remained a hallmark of RCA fashion design, with graduates more likely to enter roles in established companies than to set up their own underground ateliers. Even in the midst of the dizzying whirl that was the 1980s London scene, a typical comment

was: 'We're not on the fashion merry-go-round, we're working more like couturiers.'[25] The rhetoric coming out of the College was similar when it came to Furniture Design, which 'should combine a sound specialist knowledge with skill acquired through intensive practical involvement'.[26] That sounds like the language of the Bauhaus. But it could apply equally to the wild-child creations of Ron Arad, the College's most prominent figure in furniture in recent years, which always evolve out of the investigation of particular materials and processes (some artisanal, some industrial).

Just as Darwin had been the perfect figure for his times, so too was Christopher Frayling the right man to lead the College into the twenty-first century. By the time he became rector in 1996, he had already been teaching for many years at the College and had developed (alongside his core interest in film history) a significant sideline as a theorist of skill. Together with his wife Helen Snowdon, he has written sensitively about Pye's ideas, helping to introduce him to a new generation of uncategorisable makers.[27] As rector, too, he took Pye's lessons to heart. By the time Frayling handed over the reins to Paul Thompson in 2009, skill at the College had been reinvented yet again. Technical expertise is as highly valued as it ever has been, but it is much less contained, less

predictably located. One sign of this is the much broader and more complex role played by technicians. Their relation to students is not simply supportive, but collaborative and pedagogical. Irene Gunston, the manager of the RCA foundry, points out that many technicians these days are themselves art school graduates, perhaps former students of the RCA itself. As a result, the vertically hierarchical arrangement in which faculty taught content and technicians 'were just keeping the store' has been overturned, in favour of a more vertically integrated approach.[28] Today faculty, technicians and students all contribute within a single experimental space, each contributing their own skills and ideas. Gunston describes her foundry as a 'crossroads where things pass', where there is no one right way to work. To be sure, students learn many lessons from her – she notes that 'even handling disappointment might be the thing we're trying to teach them'. But equally, Gunston relishes the challenge of reimagining her own craft when students press her to try things that would never be countenanced in a commercial environment. The artist Anya Gallaccio has described this same dynamic from the other side. She did not attend the College as a student but has worked with technicians in its glass workshop: 'I just go in there and ask these very stupid questions, or get them to do something in a way they may consider technically inappropriate. It's that area of slippage that interests me.'[29]

Unlike at other, comparable institutions, cross-disciplinary movement has not been particularly pronounced at the College. This is in large part due to the institution's continued investment in discipline-specific tooling, infrastructure and skills-based teaching. And you will find it everywhere, not just in the applied arts departments (gathered together in 2011 to form the new School of Material). From the model cars made in Vehicle Design to immaculately cut garments on a catwalk show to convincing prototypes made in Design Products to rapid-printed jewellery and, yes, the occasional hand-thrown pot, skill is everywhere in evidence at the Royal College of Art today. In his obituary for Ron Lenthall, Pye wrote, 'I do not think we ever took the idea very seriously that the school should not teach makers, but only designers.'[30] Today, 175 years after its founding, the RCA seems ready to follow the implications of that idea, wherever they may lead.

Martin Smith
Linear Diptych
2010
Red earthenware, platinum leaf, paint and glass

[1] Pye, D. (1982) 'Right "First Off"', *Crafts* 58, Sept/Oct, 13

[2] Pye, D. (1968) *The Nature and Art of Workmanship*, Cambridge: Cambridge University Press, 23–4

[3] Bayley, S. (1981) 'Are You Sitting Comfortably?', *Crafts* 50, May/June, 18

[4] See Kriegel, L. (2007) *Grand Designs: Labor, Empire, and the Museum in Victorian Culture*, Durham, NC: Duke University Press

[5] See Frayling, C. (1996) 'Design at the Royal College of Art: The Head, the Hand, and the Heart', in: Christopher Frayling and Claire Catterall (eds) *Design of the Times: One Hundred Years of the Royal College of Art*, Somerset: Richard Dennis Publications/Royal College of Art

[6] Ibid., 9

[7] Board of Education (1936) Report of the Committee on Advanced Art Education in London, London: HMSO, 12–14

[8] Pevsner, N. (1940) *Academies of Art Past and Present*, Cambridge: Cambridge University Press, 290–1

[9] Quoted in: Tanya Harrod (1999) *The Crafts in Britain in the 20th Century*, New Haven: Yale University Press, 236

[10] Russell, G. (1958) 'Foreword', in: *A Room of Our Own: An Exhibition of Furniture and Furnishings in the Surroundings Designed at the Royal College of Art*, London: John Roberts Press Ltd., np. (The exhibition was held 10–28 October 1958 at the Tea Centre, 22 Regent Street, London.)

[11] Royal College of Art Calendar 1963–4, 77

[12] Hill, R. (1989) 'Sources of Inspiration', *Crafts* 98, May/June, 42. See also Lawrence Lee (1977) *The Appreciation of Stained Glass*, London, New York and Toronto: Oxford University Press

[13] Watling, S. and Mellor, D. (1998) *Pauline Boty: The Only Blonde in the World*, London: Whitford Fine Art/Mayor Gallery

[14] Royal College of Art Calendar 1963–4, 83

[15] McClaren, G. (1996) 'Shaping the Future: The Ceramics Department and Industry after the Second World War', in: Frayling and Catterall (eds), op. cit., 29

[16] Ibid., 30

[17] Ibid., 31

[18] David Queensberry (1992) quoted in: Emmanuel Cooper, 'Queensberry Rules', *Crafts* 114, Jan/Feb, 46

[19] Queensberry, D. (2009) 'The Designer, the Craftsman and the Manufacturer: Introduction', *Journal of Modern Craft* 2/1, March, 81–90. (This reprinted text from 1975 is accompanied by a retrospective commentary by Queensberry.)

[20] Sandino-Taylor, L. (1996) 'Risks and Certainties: Ceramics, Metalwork and Furniture at the Royal College of Art, 1971–1987', in: Frayling and Caterall (eds), op. cit., 67

[21] See Harrod, T. (1999) op. cit., 373

[22] York, P. (1984) exhibition review of the Royal College of Art Degree Show, *Crafts* 70, Sept/Oct, 45

[23] Rowe, M., personal communication, 20 July 2012

[24] Rowe, M. (2003) 'Sources and Strategies: Notes on the *Conditions for Ornament* Series', in: Martina Margetts and Richard Hill, *Michael Rowe*, Farnham: Lund Humphries

[25] Carlyn Corben, quoted in: Geraldine Rudge (1991) 'Baubles, Bangles and Bustiers', *Crafts* 110, May/June

[26] RCA Prospectus 1988/9, 36

[27] Frayling, C. (2011) *On Craftsmanship: Toward a New Bauhaus*, London: Oberon Books; Frayling, C. and Snowdon, H. (1982) 'Skill – A Word To Start an Argument', *Crafts* 56, May/June, 19–21. (See also Helen Snowdon (1979) 'British Craftsmanship in the Machine Environment', unpublished thesis, Department of General Studies, Royal College of Art)

[28] All quotations from Irene Gunston are taken from an interview conducted on 29 June 2012. Gunston was trained as an artist in the late 1970s and early '80s, a period when 'object-making was disapproved of', and worked in the atelier of Barry Flanagan when he was reinstating metal casting at the heart of sculptural practice.

[29] 'Anya Gallaccio: On Wine and Macramé', *Crafts* 204, Jan/Feb 2007, 96

[30] Pye, D. (1982) op. cit., 13

Teaching Art for Modern Times
Robert Upstone

Peter de Francia
Execution of Beloyannis
1953
Oil on board

WHEN WILLIAM ROTHENSTEIN (1872–1945) ARRIVED AT THE ROYAL COLLEGE OF ART AS PRINCIPAL IN 1920, HE INHERITED AN INSTITUTION THAT IN MANY WAYS WAS STILL ROOTED IN THE PREOCCUPATIONS OF THE PREVIOUS CENTURY

T he advent of the modern world required a new kind of art teaching. How painting and sculpture was taught at the Royal College of Art, and the tension between needing to both impart practical skills suited to current times, and yet develop individual expression and independence were recurrent concerns from the 1920s onwards. At their heart lay unresolved questions around purpose – should students learn only to become art teachers in a particular mould, as they were at the beginning of the twentieth century, or should they be encouraged to break free from tradition and develop a singular, innovative voice? Yet in the post-war period the College was the cradle for important developments in modern British art. Frank Auerbach (RCA 1952–5), and Leon Kossoff (RCA 1953–6), evolved a new style of dark, expressive, thickly painterly realist works that took as their subject the shabby, bombed-out dereliction of the city and its reconstruction, or a raw, unromanticised approach to the figure. Retrospectively these painters came to be termed the School of London, and heralded a new kind of realism in British art. Related to them in his gritty urban subject-matter and also in thickness of paint was John Bratby (RCA 1951–4), at the hub of what in 1954 were termed by David Sylvester the Kitchen Sink painters, a grouping that included RCA-trained painters Jack Smith (1950–53), Derrick Greaves (1948–52) and Edward Middleditch (1949–52). These artists gave collective voice to the threadbare, anxious disaffection and frustrated energy of post-war London. And the war marked a watershed; afterwards successive generations of students no longer unquestioningly accepted the accumulated artistic learning of their elders. As deference and acceptance began to collapse more widely in 1950s and '60s Britain, art students sought to break free and evolve experimental, distinctive modes of expression. By the time of the avowedly Marxist Peter de Francia's appointment as professor of Painting in 1969, and through the years of economic crisis of the 1970s and social confrontation of

the 1980s, until his retirement in 1987, both teachers and students commonly viewed their shared relational experience, individual and collective identity, and the practice of art itself in explicitly political terms.

The journey to this point is an interesting and sometimes contradictory one, yet it echoes a wider social experience of changing relations. When William Rothenstein (1872–1945) arrived at the Royal College of Art as principal in 1920, he inherited an institution that in many ways was still rooted in the preoccupations of the previous century. As Henry Moore, who arrived on a scholarship in 1921, recalled:

> The college was pretty much in the doldrums. It had become a place to train teachers, to train teachers, to train teachers, and so on – something eating its own tail, having no real contacts with the outside world, or with the real world of painting and sculpture. Rothenstein, who believed that teaching art should not be a career in itself, shook up the college in many ways and gradually changed many of the old staff. He had lived in Paris for some years – he knew personally French Impressionist painters including Degas. He knew most of the writers of his time... He brought this air of a wider more international outlook into the college.[1]

Rothenstein's views on the limited ambition of the College had been expressed long before he became principal through his role as visitor and in his contributions to government reports concerning its teaching. Essentially, Rothenstein sought to produce professional and gifted artists who were true to their own artistic vision, and who were not training simply to become art teachers. This was a fundamental and quite radical shift. It was an end to the founding principle that fine art's purpose was to serve industry or design, and it recognised a more modern ethos that artistic expression had its own validity in itself. The French system of training that Rothenstein had gone through at the Académie Julian in Paris in the 1890s, dictated that teachers should not be

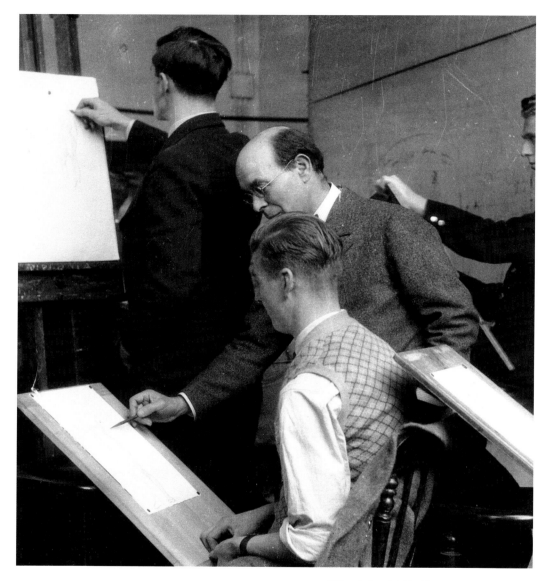

William Rothenstein Teaching
in the Life Class
1932

just good at teaching but should also be artists of merit and achievement. This was a principle he now followed in his appointments, and he insisted that staff generally teach only part-time, so their own work and creativity should flourish and further inspire their students. He himself signed a contract to work three days per week for the same reason, and occupied Edward Poynter's old studio where students were able to visit. Rothenstein had an extensive network of literary and artistic contacts, many of whom sat for their portraits there, and at his encouragement, they would give informal talks to the students in the Common Room. They included T E Lawrence, G K Chesterton, Rabindranath Tagore, Arnold Bennett, Walter de la Mare and Max Beerbohm. Rothenstein was instinctively generous in exposing students to such figures, and he wanted these connections to enhance the sense of the College's cultural life. Each Sunday he would invite a group of students to his home, where they again would meet creative and political luminaries and would be encouraged to participate equally with such figures. Henry Moore remembered the great confidence this experience gave him. Rothenstein:

> ...had an enormous and very distinguished circle of friends, and I remember meeting Walter de la Mare, for instance, and the then Prime Minister, Ramsay MacDonald.
>
> In fact, meeting MacDonald was another piece of education for someone like me. I remember being left alone with him and standing waiting for him to begin the conversation. He did say one or two words to me, and I remember feeling it was all perfectly ordinary and natural. I wasn't awed or anything, and so Rothenstein gave me the feeling that there was no barrier, no limit to what a young provincial student could get to be and do, and that's very important at that age.[2]

Rothenstein began replacing the teaching staff with artists of real ability, who had a recognised creative standing in their own right, and not simply as teachers. He appointed Allan Gwynne-Jones (1892–1982) as Professor of the School of Painting in 1923, and other painting teachers included Leon Underwood, Thomas Monnington, Charles Mahoney, William Simmonds, Randolph Schwabe, Barnett Freedman, Alan Sorrell, Percy Horton and Gilbert Spencer. To the School of

Design he appointed John and Paul Nash, and William Staite Murray to teach pottery. Rothenstein wrote:

> *I was gradually changing the College from being in large part a training school for teachers to an active school for practical designers and artists. The professional art-masters remained suspicious and sullenly hostile, and did all they could to counter this tendency by overt and secret attack. Fortunately, for most of the changes I proposed, I had the full support of the Board of Education, with the confidence of each succeeding President. A different class of student was now attracted to the Royal College. Whereas, under my predecessor, no one from the painting school had entered for the much sought after Rome scholarship for mural painting regularly gained by students from the Slade School, a fair proportion was now won by College County students, as well as scholarships for engraving and sculpture.*[3]

Rothenstein somewhat glossed over the resistance to his reforms. Art teachers' organisations threatened to mount a demonstration, the direction the College was taking was questioned in the House of Commons and, more candidly, Rothenstein admitted to his friend Max Beerbohm, 'The art masters are crying "Bolshevism".'[4]

When in 1924 the famously volatile Francis Derwent Wood resigned as Professor of Sculpture after what Rothenstein described as 'a difference' between them, Rothenstein recommended Jacob Epstein be his replacement. But this was a move vetoed by the Board of Education as it would be 'a very perilous experiment and might cause considerable embarrassment'.[5] Epstein was still considered avowedly avant garde and the still-recent memory of the bitter row over his supposedly 'obscene' decorations for the British Medical Association building in the Strand made him a difficult Government appointment. Evidently intent upon finding a figure who represented the new direction towards direct carving that advanced British sculpture was taking, Rothenstein approached Eric Gill. Gill however pronounced himself 'not of one mind with you and the aims you are furthering at the College,' and, furthermore felt that he would be 'unable to keep God out of it'.[6]

Like Lantéri before him, Rothenstein sought to make life drawing the heart of his students' learning, and also to provide the widest exposure to the arts as a whole. However, there were still brakes on practical progress. John Piper related how 'I was a bit shocked when I got to the college to find that life drawing – in which I believed profoundly, and wanted to do passionately – was made so boring.'[7] Henry Moore suffered the intense irritation of Derwent Wood's insistence that students learn only how to transfer clay and plaster models to stone by using a pointing machine. Moore desperately wanted to follow the example of ancient and Renaissance sculptors he had seen in the British Museum and the V&A by carving directly, forging a direct emotional, expressive relationship with the stone itself and harnessing the skills to carve confidently. When he was instructed by Wood to produce a copy of Domenico Rosselli's *Virgin and Child* in the Victoria and Albert Museum's collection by first making a relief modelled in plaster and then reproducing it by using a pointing machine, Moore rebelled and simply carved the sculpture direct. It is an extraordinary achievement, the carving possessing a softly sensuous quality. Perhaps to test or tease Wood, or perhaps to avoid a clash, Moore marked the final sculpture with pencil dots to emulate the use of the

pointing machine;[8] Wood appears never to have suspected. When Derwent Wood resigned in 1924, Rothenstein appointed Moore, the ablest sculpture student in the College, to take over temporarily for a term and a half.

Rothenstein's simple formula of improvement – that if the quality of teachers and teaching was upgraded the College would attract more capable students, however, proved correct. Moore was part of a quartet of gifted students from Leeds who quickly came to hold a strong identity within the College, sitting together in the refectory and open to Modernist ideals. The other three were Barbara Hepworth, who joined the Sculpture School in 1920, the painter Raymond Coxon and Edna Ginesi. Hepworth had her first exposure to the true Modernist art that was reproduced in the pages of *Cahiers d'Art* in the Common Room of the Royal College. It is easy to underestimate the effect such an injection of talent and personalities open to new ideas could have in the College, but it was quite a small place. Moore noted that when he was a student, 'There were no more than six or seven students in the sculpture school at that time. For a whole year I had a large studio and a model entirely to myself.'[9] Moore was also great friends with Eric Ravilious in the School of Design, himself part of another influential grouping with Edward Bawden and Helen Binyon, both also in Design, and Douglas Percy Bliss in Painting. They feigned disinterest in their fellow students by sitting in the Common Room with their backs to them, yet also rejuvenated the College's student magazine and made it a stimulating cradle for new creative talent. Bawden and Ravilious found some distinctive, common expression, far from the authentic Modernism of the continental avant garde and yet still inventively, quirkily, natively 'modern'. Ravilious's large tempera of Bawden in his studio (c. 1930) is a highly original treatment, whose arrangements of objects such as the rolls of drawings resembling organ pipes or the strange twists of the discarded guardsman's tunic have a distinct Surrealist tone like the objects in a de Chirico, and yet expressed with all the luminosity and obsessive detail of Pre-Raphaelitism. In 1928 Rothenstein got Bawden and Ravilious the commission to decorate the refectory of Morley College, working alongside Charles Mahoney, a student contemporary who in 1928 became one of the Painting tutors, who decorated the entrance hall. Opened by the prime minister Ramsay

Henry Moore
Head of the Virgin
1922–3
Marble

Macdonald in 1930, this was widely hailed as the most important British decorative scheme of the modern era. Rothenstein believed that rather than spend their final year receiving instruction in how to become teachers, and receiving a certificate to do so, students' time was better spent either preparing their work for a public exhibition or contributing to mural schemes or community-based art projects. To this end he pursued decorative schemes for a wide variety of public spaces, ranging from labour exchanges in the East End to the debating chamber of County Hall, India House and St Stephen's Hall in the Palace of Westminster.

Rothenstein's tenure ended in 1934 when he offered his resignation. The pressure to give Design the same significance and status as Fine Art within the College, and to more meaningfully integrate the two had become a topic of resentment and his leadership was criticised. Frank Pick as chairman of the Council of Art and Industry put open pressure on the Board of Education, demanding the kind of greater integration between the different branches of art, architecture and design that had characterised his brilliant development of London's Underground. Rothenstein's successor as principal was Percy Jowett, whose ability to pursue reforms and improvements was prevented by the need to evacuate the College to Ambleside during the Second World War and then bring it back to normal functioning in the economic aftermath of the conflict.

The greatest artistic convulsion the College was to experience came with the appointment of Robin Darwin as principal in 1948. Urbane, uncompromising and explosive, Darwin was a teacher, administrator and painter who sought to bring excellence to all departments and functions. His immediate action was to seek to dispense with most of the long-standing Fine Art staff; indeed, he later boasted that he had demanded the resignation of all the College's professors. In the key position of professor of Painting, Gilbert Spencer had held the post since 1932. Darwin unceremoniously brought him before the College Council who told him he was being let go. Spencer was shocked and subsequently complained to the Ministry about the circumstances, leading Darwin to deny he was prejudiced against him but simply justified his move as a necessary search for greater talent. Spencer's replacement in 1948 was Rodrigo Moynihan, who

commemorated the new guard in the Painting School in his conversation piece *Portrait Group* (1951). The picture shows from left to right: John Minton, Colin Hayes, Carel Weight, Rodney Burn, Robert Buhler, Charles Mahoney, Kenneth Rowntree, Ruskin Spear and Moynihan himself. Moynihan painted it for inclusion in the important Festival of Britain exhibition *60 Paintings for '51*, and it became an instantly famous image, believed to represent the new ambition and creativity of the College. Minton was an inspired recruit in 1949 to the Painting Department, whose gentle and generous manner endeared him to his students and whose emotionally charged modern reworkings of history painting fitted the questioning mood of 1950's youth. Yet Moynihan's painting offers a strange and uncomfortable characterisation of the painting school's relations. Minton sits apart, pensive and exiled from his colleagues like an outsider, perhaps because of his sexuality, while they bunch together. He looks up from his book like a sibyl that has read their fate, and this allegorical dimension is strengthened by the skull on the chest behind, emblem of art school anatomy lessons but also a *vanitas* symbol of temporality. And above Minton rests a vast blank canvas. Weight is the next most prominent figure, hesitating as if he has been charged with asking Minton an awkward question, while Ruskin Spear reclines on the chaise, incongruously set in the pose of Manet's *Olympia* (1863). Minton left the Royal College in 1956, and the following year committed suicide. Darwin wrote to *The Times* mourning his loss while admitting his death did not come 'altogether as a surprise'; Minton, Darwin wrote, 'had the shrewdest and most perceptive understanding of the problems confronting a painter today. He never deceived himself.'[10]

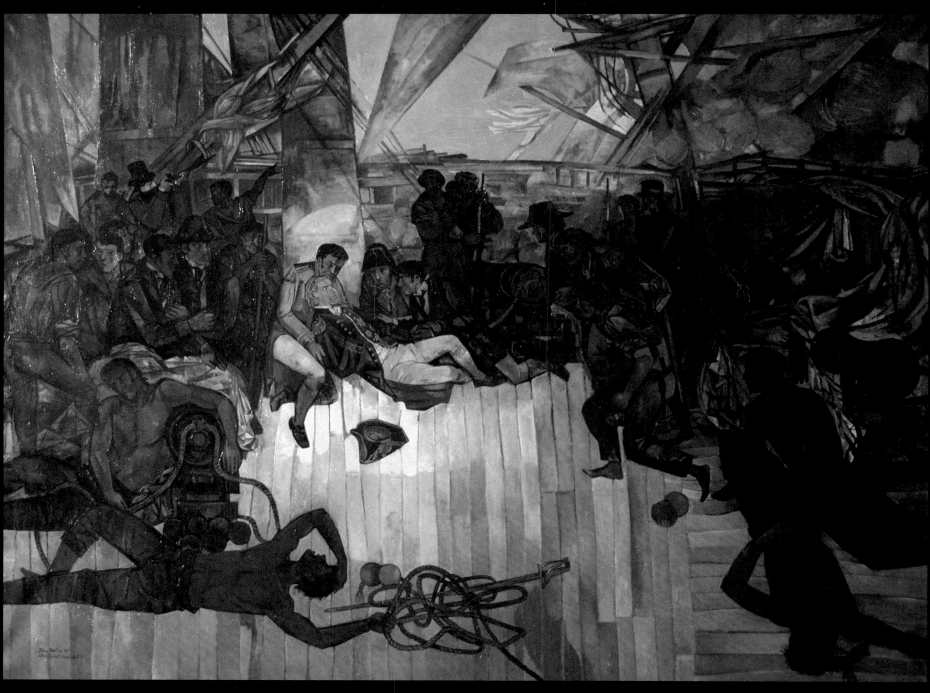

John Minton (after Daniel Maclise)
The Death of Nelson
1952
Oil on canvas

The generation of painters in Moynihan's conversation piece continued to immortalise themselves with a series of portraits of each other and the College's professors, binding their identity together as an act of self-purpose and the conscious shaping of art in Britain. Darwin painted portraits of Carel Weight and Hugh Casson; Ruskin Spear painted Darwin and Rodney Burn; and Weight painted Misha Black. Appalled by the lack of paintings or inherited objects in the College, and therefore the implied lack of pride in its past, Darwin started a collection of works of art made by staff and students to be displayed on its walls. He unashamedly admitted wanting to recreate the atmosphere of a Cambridge college, and to this end he established a Senior Common Room intended to further forge a firm identity among the teaching staff and elevate their status. Housed on the ground floor of 21 Cromwell Road the Senior Common Room was opulent and had the atmosphere of a gentlemen's club with great emphasis placed on the quality of food and wine. Darwin was a moderniser who formed new departments such as Industrial Design and administratively these held equal status with Painting. Yet socially this was not the case, and this social hierarchy was laid out in the rules and relations of the Senior Common Room. The painters had their own long table at which only they could sit; 'Painters were the aristocrats. Robin believed that the fine arts gave birth to the applied arts, so although Mary Fedden was allowed at the painters' table (the only woman), her husband... Julian Trevelyan, could only sit at the painters' table by invitation, since he taught at the Printing School', recalls Virginia Ironside, daughter of Janey Ironside the professor of Fashion Design. She gives a vivid picture of the boozy, predatorily masculine environment – 'the room reeked of cigars and wine' – and how when she dined there with her mother she would sit with her back to the painters' table 'because I didn't like them looking at me and leering'.[11]

A genuine achievement originating in this era was the suggestion in 1949 by Carel Weight that the Society of British Artists galleries in Suffolk Street be used to exhibit the work of young artists. The *Young Contemporaries* exhibitions showcased new work by students, with some of the most exciting cutting-edge exhibitors coming from the Royal College of Art. In 1961 Hockney exhibited to great acclaim a group of four paintings which had been made in his RCA studio. In that same year Peter Blake and R B Kitaj were also included, so heralding the emergence of a new type of British Pop Art.

What is certain is that Darwin instilled in the College both a new culture and a new departmental structure that fitted it for the demands of post-war reconstruction. The *Geometry of Fear* sculptor Geoffrey Clarke came to the College as a student in 1948. In 1967 when the College was granted university status he recalled the unified sense of dissatisfaction of his generation in an atmosphere of existential anxiety after the war. This was reflected in a change of attitude among students of his generation and after, partly reflected in the rapid changes that Darwin brought:

Peter Blake
Preparation for Entry into Jerusalem
1955–6
Oil on hardboard

> *The old gentle era under Jowett ceased and a new era exploded. Those who began in 1948, staff and students mostly ex-service, had mutual sympathies... All responding to discipline, and resenting it. Frustrated to bursting point, positive in mind after years to deliberate. In those early days the existing staff and students mostly wore bewildered expressions and fell in or fell out according to the resilience of their natures. We, the bristles of the new broom (not fully realizing our part at the time), had little reason to complain. Encouragement and backing were forceful and positive. The next decade saw the establishment among the students of the belief that denial of previous standards was the rule rather than the exception unless proved otherwise. The staff became correspondingly adept on the trapeze. Present students are now using effectively the attitudes which we, by comparison, tentatively adopted.*[12]

The questioning, sometimes rebellious approach of many post-war students that Clarke noted fostered the belief in the nurturing of individual self expression that had been at the heart of College reforms going back to the beginning of the century. Writing in 1967 in the same special *Times*

supplement that Clarke's piece appeared, Richard Guyatt, the professor of Graphic Design, approached head-on the tension between the need for students to innovate and the loss of learning from the traditions and achievements of past artists. 'Imitation,' Guyatt wrote, 'has always played a great part in learning, for it is through the emotions of attraction and admiration that young eyes can be opened and that knowledge can pass from one generation to another.' But:

> This traditional chain of influence in the arts collapses in a period such as ours when the very qualities which attract the younger generation are those which, in the older generation, have established the new freedoms. The young, searching in their turn to discover their own originality, feel impelled, in imitation of their elders, to find yet more barriers to break down. Fearful of being over-influenced, they turn their backs on those artists who have inspired them and the only tradition which is established is the necessity to break away. And such is the temper of today, the older artists add to the confusion by often feeling a necessity to keep pace with the younger ones.[13]

What many of the generation of students that went through the College in the 1950s and '60s frequently note is that in many cases they were given the freedom to find

their own creative voice, and that teachers such as Carel Weight, professor of Painting from 1957 to 1972, or Bernard Meadows, professor of Sculpture for 20 years from 1960, did not impose their own artistic or stylistic standards on their students. Meadows had strict views about technical quality but not form, and Weight's position was not because of resistance from his students but for liberal ideological motives that valued individuality. 'He was completely without bias,' Jack Smith recalled, 'he didn't try and make one paint in any particular way.'[14] The student, Weight wrote,

> must come to realise that he is no longer to be instructed or directed which way to turn. He must take his place in a community of fully fledged artists... Movements have happened in the past like Pop and Social Realists and will probably continue to happen and are very stimulating, but the backbone of a school depends just as much on the completely dedicated artists who seek to find themselves and the way they want to go.[15]

But this attitude could also bring enormous frustration. Bridget Riley, a painting student from 1952 to 1955 remembered this *laissez-faire* approach with great irritation:

> We were left to work it out for ourselves. We were abandoned, when what we needed (and hoped for) was help towards independence rather than having independence thrust down our throats... We were anxious to find out as much as we could but this was ignored – a certain fundamental bargain was not kept.[16]

But experiences varied. Peter Blake recalls that during his years as a student from 1953 to 1956 'the best thing was that you were actually taught'. In the life class:

> You would sit at the donkey and there would be two or three staff and they would say, 'May I sit down', and they'd draw either on your drawing or beside it and have no hesitation in rubbing out your drawing and adjusting it... Johnnie Minton would sit down and show you how to use the paint, which was very good.[17]

Blake judged this sort of intervention in the students' work wouldn't have been tolerated during his years as a tutor from 1964 to 1976 – 'you wouldn't have done it – the students would all have walked out'.[18] In the early 1960s tolerance was

also not a universal experience. Allen Jones was expelled at the end of his first year for what was termed 'excessive independence' along with eight others. Of the list of ten names put at risk, only Adrian Berg survived, who believed Jones was expelled because the teaching staff felt jealous.[19] Peter Phillips was told to stop painting large abstract canvases and confine himself to the set figure and still-life subjects or be expelled. His solution was to fulfil these but pursue his own subjects at home. There was considerable anger when this emerged and Phillips transferred to the Television School for his final year.[20] Hockney also faced problems when rebelliously he wanted to paint what he wanted and not the set nude subjects, and he stopped turning up to General Studies classes altogether, seeing anything that took him away from painting as irrelevant.

The tension between the need for students to learn the traditions of practical skills based on a syllabus while also encouraging their own drive for individual experiment and expression was probably inescapable, and it was a repeated issue faced from Rothenstein's time onwards. At the heart of it lies a necessary vigorous debate, shared by each generation of new artists and students to determine individually where the limits and potential of their art lies. While this can be a fruitful solitary pursuit, it can evidently also be enormously enhanced within the environment of the Painting or Sculpture School, between students and with tutors who are professional artists. The roster of alumni the Royal College has produced, and the step changes in the evolution of British art that they represent – from 1930s muralists and illustrators, to the Kitchen Sink realist painters, the School of London, Post-war Abstraction, Op Art, British Pop or the reinvention of sculpture by Richard Deacon, Tony Cragg, Richard Wentworth, David Mach and others, shifting the boundaries of traditional sculptural form and expression – all demonstrate that it probably works.

[1] 'Henry Moore', *The Times*, 2 November 1967, VI

[2] Russell, J., and Russell, V. (1961) 'Conversations with Henry Moore', *The Sunday Times*, 17 December, 17

[3] Rothenstein, W. (1940) *Since Fifty*, New York: Macmillan, 24–5

[4] Quoted in: Christopher Frayling (1987) *The Royal College of Art: One Hundred and Fifty Years of Art and Design*, London: Hutchinson, 89

[5] Rothenstein, W., op. cit., 37

[6] Quoted in: Christopher Frayling, op. cit., 91

[7] 'John Piper', *The Times*, 2 November 1967, VI

[8] Moore, H., and Hedgecoe, J. (1968) *Henry Moore*, London: Thomas Nelson, 33

[9] 'Henry Moore', *The Times*, 2 November 1967, VI

[10] Darwin, R. (1957) 'Mr John Minton', *The Times*, 23 January, 12

[11] Ironside, V. (2004) *Janey and Me: Growing Up With My Mother*, London: Harper Perennial, 139–41

[12] Geoffrey Clarke', *The Times*, 2 November 1967, VI

[13] Guyatt, R. (1967) 'Freedom for What?', *The Times*, 2 November, VIII

[14] Huxley, P. (ed.) (1988) *Exhibition Road: Painters at the Royal College of Art*, London: RCA, 82

[15] Carel Weight, quoted in: Andrew Brighton (1998) 'Since '62: The Last Twenty-five Years', in: Paul Huxley (ed.) *Exhibition Road: Painters at the Royal College of Art*, London: RCA, 57

[16] Huxley, P., op. cit. 84

[17] Ibid., 86

[18] Ibid., 86

[19] Ibid., 88

[20] Ibid., 44

'The Mother of All the Arts?':
The Making of Architecture
Joe Kerr

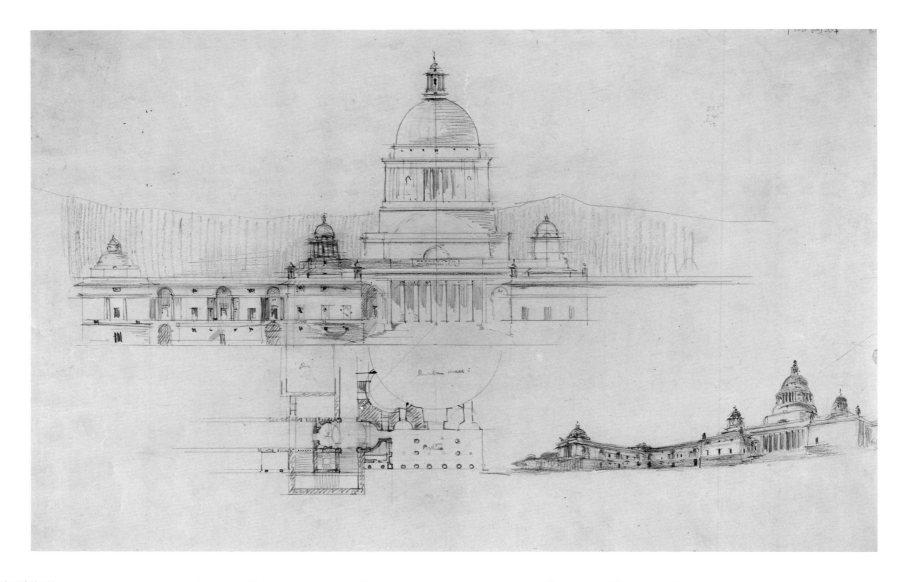

Sir Edwin Landseer Lutyens
Viceroy's House, New Delhi
c. 1912
Drawing

Previous Page:
Lion and Unicorn Pavilion
Festival of Britain
1951

ARCHITECTURE HAS NOT ONLY
EFFECTED A MAJOR CONTRIBUTION
TO THE DEVELOPING ETHOS
AND CULTURE OF THE COLLEGE,
BUT IT HAS ALSO ACHIEVED A
SIGNIFICANCE AND AN INTEREST
FAR BEYOND THE DISCRETE HISTORY
OF THE COLLEGE ITSELF

t was the critic John Ruskin who in the mid-nineteenth century had proclaimed architecture as the 'Mother of All the Arts', a simple but polemical proposition for an artistic hierarchy that placed architecture at the pinnacle of cultural production, and which underpinned the great reform movements in art education in Britain and in Germany that together laid the foundations for the modern art school. As the Bauhaus Manifesto was to proclaim in 1919: 'The ultimate aim of all creative activity is a building.'[1]

Given this, one might assume that the Government School of Design, which was established to sit at the summit of the national system of art training, would itself have situated architecture at the peak of its own structure and curriculum. But the surprising truth is that architecture did not exist as an independent discipline for most of the RCA's long history, and even when the subject was taught here, the architectural curriculum has rarely if ever claimed for itself, or even been permitted to suggest, any superiority to the myriad of other disciplines represented at the College.

This is not to say that architecture never enjoyed a prominent role at the College, and indeed the early history of the RCA embraces an impressive number of important and influential architectural practitioners and thinkers. Thus, for instance, in 1900 the celebrated architect and theorist William Lethaby was appointed professor of Design, and the wilfully original Beresford Pite was appointed professor of Architecture. However, these appointments failed to deliver any golden age of architectural education as we would conceive of it today, for their role was to teach architecture as a compulsory preliminary subject for all new students regardless of their intended discipline, and not with the primary intention of turning out trained architects.

It is the case that a number of students who later became successful architects did pass through the doors of the RCA in this era, notably Sir Edwin Lutyens (graduated 1887), the most highly regarded and successful British architect of the early twentieth century; Joseph Emberton (graduated 1913), whose Royal Britannia Yacht Club was the sole British representative in the fabled 1932 *International Style* exhibition at the Museum of Modern Art in New York; and Frederick Etchells (graduated 1911), Vorticist painter turned architect,

designer of one of London's first Modern office buildings and the first [mis]translator of Le Corbusier's *Vers Une Architecture*.[2]

Indeed, it would be possible to write a plausible essay on the architectural achievements of the RCA entirely centered on such renowned alumni, but that would be a gross distortion of the facts, firstly because the definitive list of architectural successes from this period would not contain any more names than theirs, but more importantly because it is debatable the extent to which the education they received at the RCA contributed to their later successes. In the case of Lutyens, his time at the College is alluded to by one biographer with the single terse sentence 'Little is known of his time in South Kensington',[3] and while this is not strictly true – there are surviving drawings executed by him while a student at the RCA,[4] and he also won the National Bronze Medal for architecture in 1888[5] – it is the case that having enrolled at the College at the tender age of 16, he left after only two years feeling that he had already learned all that was on offer. In the case of Emberton the evidence is even less helpful, for in his own words the two years he spent at the RCA 'were the dullest of his whole life. From his teachers he never received a single fundamental idea',[6] while his contemporary, the thoroughly modern Etchells, was equally damning: 'I was taught by Lethaby who was good but only interested in the early Italians, and the College was very corrupt, like the Church of England in the 1830s. The Principal was not the slightest bit interested in art.'[7]

A more celebratory overview of architecture at the RCA could be fashioned from the impressive roll call of architectural talents who have taught at the RCA. Such a survey would commence with its very foundation in 1837; its first director was J B Papworth, designer of many of Cheltenham's magnificent Regency estates, and architect to the King of Wirtemberg. Later in the century it would include the eminent German architectural theorist and revolutionary Gottfried Semper, designer of the Dresden Opera House and Synagogue; moving into the twentieth century it would embrace not only Lethaby and Pite but also Halsey Ricardo, architect of the fabulous Debenham House in Holland Park; and after the Second World War it would reach a crescendo with Sir Hugh Casson, director of architecture for the

Festival of Britain, Robert Goodden, co-designer of the Lion and Unicorn Pavilion at the same Festival, and Lionel Brett, Viscount Esher, architect–planner of Hatfield New Town.

However, such a survey would get no closer to a truthful narrative of architectural education at the RCA, for the one thing in common that unites these eminent practitioners was that they were not employed solely or primarily to educate architecture students. Thus, for instance, Semper was engaged as a professor in the School of Practical Art, Goodden was professor of Silver and Glass, and out of this entire list of distinguished faculty only Beresford Pite was actually titled a professor of Architecture. It has been an enduring feature of the RCA teaching method that architects have been employed in significant numbers in roles that only partially or tangentially related to their own discipline; remarkably, in 1953 the principal, Robin Darwin, noted that as many as 25 per cent of his full-time staff were architects[8] despite there being no proper architecture course!

Without wishing to labour the point, it is evident that there would be no useful purpose served by writing a general survey of architecture at the RCA over the last 175 years. However, I would argue that is merely because such a narrative would impose entirely the wrong kinds of critical and historical filters to the subject, and that if instead one sifts

the evidence rather more dispassionately, there is a fascinating history to be teased out. Indeed at certain key moments Architecture has not only effected a major contribution to the developing ethos and culture of the College, but it has also achieved a significance and an interest far beyond the discrete history of the College itself, and it is these moments that form the heart of the essay that follows.

Art is Unity

The story actually begins in earnest shortly after the Royal College of Art assumed its present name in 1896, for the following year the Arts and Crafts artist Walter Crane was appointed as principal, spearheading what was in effect a *coup d'état* by the Art Workers' Guild. This organisation was first formed in 1884 to promote engagement between the art professions on the basis of equality, rejecting on the one hand the artistic hierarchies traditionally imposed by the Royal Academy, and on the other the model of professionalism based on examination and regulation being promoted by such bodies as the Royal Institute of British Architects, which they saw as antipathetic to such key but unquantifiable aspirations as beauty and quality. Dominated from the outset by architects, it was rooted in a romantic adherence to the medieval guild system born of the Gothic Revival; it viewed architecture as the unifier of the arts, embracing design and craft in a common endeavour, much as they believed the craft guilds had come together to build the great cathedrals; as its motto proclaimed, 'Art is Unity'.

Given the Guild's hostility to the dreary learning by rote of the RIBA examination system, architectural education became an obvious battleground for their ideals, in what became known in the 1890s as the 'Profession or Art' controversy. Art schools such as the RCA were viewed with suspicion by the 'professional' camp, for fear they would turn out 'art architects' with no practical or technical knowledge, and their fears proved well founded, for it was at the RCA that the Guild grasped their opportunity to implement a radically different curriculum.

Crane was a leading member of the Guild, and so were all four members of the Council of Art, a body established in 1900 to advise on the 'College curriculum and the principles

that should govern its teaching'.[9] They in turn appointed prominent Guildsmen Lethaby and Pite, and Lethaby seized on this chance to pack his school with yet more members of the Art Workers' Guild; but this was not simply some kind of masonic preferment, for amongst his new design teachers were the very craftsmen and women with whom he collaborated professionally, including Christopher Whall and George Jack, who were to contribute stained glass and wood carvings for Lethaby's extraordinary church at Brockhampton-by-Ross, Herefordshire, built in his first two years at the RCA.[10]

The significance of this convergence is that Lethaby was making a serious and coherent connection between theory and practice, a simultaneous demonstration in his architectural and his didactic roles of the ideals of the Art Workers' Guild; just as his building embraced tapestry, metalwork, woodwork, stone-carving and stained glass in a unified artistic whole, or *Gesamtkunstwerk*, so also students of the various craft and design disciplines within his school were

learning alongside each other, mutually engaged in a system of workshop-centred education based on a practical knowledge and understanding of materials and techniques.

Beresford Pite's role as professor of Architecture was not purely or primarily to prepare architects for professional practice, partly because the RCA still retained its traditional role in training teachers rather than practitioners, but mainly because his one-year architecture course was delivered to all new RCA students irrespective of their discipline. Thus architecture did for the first time occupy centre stage at the College, if only as a preliminary subject prior to more specialist disciplinary training. His course created, as he observed, 'the only school in the kingdom where architectural design is systematically taught in conjunction with painting and sculpture'.[11] In the event, this rather idealistic curriculum did not prove wholly popular, and, famously, when Sylvia Pankhurst arrived as a painting student in 1904, having failed to realise she would have to attend the architecture course,

she immediately but unsuccessfully requested that she and her fellow art students do figure drawing instead.[12]

But regardless of these particular problems it would be hard to overstate the profound and sustained influences of these pedagogical reforms. In terms of the RCA, they cemented a relationship between architecture and all of the other disciplines at the College, which had tentatively emerged in various projects undertaken during the nineteenth century, but which was to remain the bedrock of the College's multi-disciplinary ethos for much of the next century; and indeed is not so markedly different in the RCA of the early twenty-first century, with its emphasis on workshop learning and on the possibility of collaboration across disciplinary boundaries. But looking beyond the College, although the reforms' radical influences on the curriculum are hard to measure definitively, they are potentially of profound significance and conse-quence. Alan Powers for one, believes that:

> The Arts and Crafts movement, represented by the network of the Art Workers' Guild, saw the fulfillment of a new relationship between architecture and the other arts, all involved in learning by doing, which was even-tually reproduced in teaching across the world, from the Bauhaus to Frank Lloyd Wright's Taliesin Fellow-ship. The teaching of architecture at the Royal College of Art after 1900 became part of this movement. By delivering a first-year architecture programme to all students, regardless of their discipline, the RCA created a forerunner of the Bauhaus Vorkürs and subsequent Foundation Courses and strengthened the idea of art being applied in real physical settings with an understanding of actual space and scale.[13]

If this purported connection with the Weimar revolution a generation later seems unlikely, it should be remembered that architecture did not feature as a discrete discipline on the Bauhaus' curriculum either, despite the first director being an architect, but instead as Feininger's iconic Manifesto image of a cathedral makes clear, architecture was conceived of in wholly Arts and Crafts fashion as the unifier of all of the arts. While the Modern Movement claimed for itself total rejection of the past and the image of radical originality, its debt to Ruskin and his disciples, and quite plausibly to the RCA specifically, should never be forgotten.

The Darwin Evolution

While the inter-war period was a golden age for many depart-ments of the RCA, this was not the case for architecture, which continued solidly in the same vein long after the principles that had inspired it had been supplanted by new ideas arriving from the continent. However it is intriguing to note that the future direction of architecture was briefly placed back on the agenda in the mid-1930s by the Board of Education's Hambledon Committee on Advanced Art Education in London. Its report of 1936 considered a range of suggestions from 'one of our most distinguished and authoritative witnesses',[14] Walter Gropius, the founder of the Bauhaus. While its recommendations were largely overtaken by world events, there was a brief discussion about whether Gropius might be offered a post at the RCA, perhaps even principal, although this was quickly quashed on the grounds of his ineligibility as a foreign national.[15]

In the aftermath of the Second World War, the Royal College underwent a dramatic reorganisation at the hands of its new principal Robin Darwin, who appointed many of his wartime comrades from the Camouflage Directorate to influential professorial positions, including the architects Robert Goodden and Hugh Casson and the designer R D (Dick) Russell, men whose military background had already instilled in them the necessity of working in unison. For the time being Architecture retained its traditional place in the curriculum, offering courses to students from all other disciplines (except fashion![16]), although the new professor of Architecture, Basil Ward – of pioneering Modern movement practice Connell, Ward & Lucas – did provide it with a determinedly Modernist slant. But in 1951, two hugely significant events occurred that together were to herald in a golden decade for architecture at the RCA, arguably the most successful and influential of its entire history to date. Once again, this was underpinned both by a profound and productive convergence of theory and practice, but also by a successful and sustained ethos of close collaboration between different disciplines at the College, united in the common goal of creating architecture.

That year is forever associated with the Festival of Britain, the most comprehensive exposition of contemporary design that this country had witnessed since the Great Exhibition a

Lion and Unicorn Pavilion
Festival of Britain
1951

century earlier. Its director of architecture was Hugh Casson, the principal among many RCA names who contributed to it, such as the architect H T Cadbury-Brown, whose name will crop up again. The closest link to the College came with the design of the Lion and Unicorn Pavilion, a commission awarded jointly to Goodden and to Russell in 1948, the year they arrived at the RCA. Darwin gave them his full support 'as long as the results would enhance the College's reputation. This agreement in fact proved beneficial to everyone, as a sizeable group of both staff and students eventually worked on the building, causing many (Darwin included) to believe that the commission had originally been given to the Royal College of Art and not to the two designers.'[17] Thus on the one hand, the RCA made a public commitment to the event that popularised modern design in this country, but on the other hand the staff and students worked together to create a unity of art, architecture and design in precisely the manner that Lethaby had advocated half a century earlier, and it comes as

no surprise to learn that a number of prominent figures associated with the post-war College were also active members of the now venerable Art Workers' Guild.

This negotiation between modernity and tradition is reflected in the other significant event of 1951, the establishment of a new Department of Interior Design under Hugh Casson. It was perhaps a surprising decision not to establish a full-blown architecture department, given that post-war reconstruction was in full swing; certainly there is an assumption that the College simply failed to gain the necessary RIBA validation and so opted for a genre of architectural design that didn't require professional regulation, but Sir Christopher Frayling is emphatic that Darwin definitely didn't want a conventional architecture school, and instead had the early Bauhaus model in mind, where architecture was the armature for all design disciplines, but was not taught in its own right.[18] What Darwin seemed to have in mind was the education of a small cohort of students within an elite department

that would operate as the 'meeting point of all the principal departments of Industrial Design',[19] that might specialise in a particular kind of bespoke commission, and which would result in a superior expertise to a conventional architect:

> I believe it is true that the College might, given the necessary students and appropriate facilities, make a significant contribution to the Architectural profession. Some members of that body are certainly known to be concerned about the present content of its normal education. I have heard it said for example that nowadays the Schools of Architecture appear to offer a course in which the anxious study of technics, ethics and politics produces an architect who can toss off pithead baths and municipal soup kitchens in his sleep, but who is paralysed when invited to design a setting for any kind of ceremony or for most kinds of pleasure. No doubt this is exaggerated, but the honest awkwardness of the exterior of the Royal Festival Hall reveals how even a mature and gifted architect can find himself at a disadvantage.[20]

In a sense, this was a clever gamble, because it presented the biggest disadvantages faced by the RCA in terms of architectural education – lack of experience and relatively modest scale – as if they were positive advantages. Somewhat paradoxically this ensured that architecture remained off the curriculum at the College for several more decades, while externally its tutors and students continued to collaborate on architectural commissions of exactly the kind referred to by Darwin above.

Space does not permit a detailed discussion of the various projects engaged in by the College, but a few stand out and are pertinent to this story. In terms of exhibition design, a number of those involved in the 1951 Festival, including Casson and professor of Industrial Design, Misha Black, and their students, regrouped to work on a garden display entitled 'Off-Duty Britain' at Expo 1958 in Brussels.[21] Of course, exhibition structures leave no permanent presence, but in this case an enormous linocut of the Lion and the Unicorn was bought back by the College, and for many years formed the backdrop for Convocation.

In between these two temporary structures came the single most important public commission ever to be awarded to

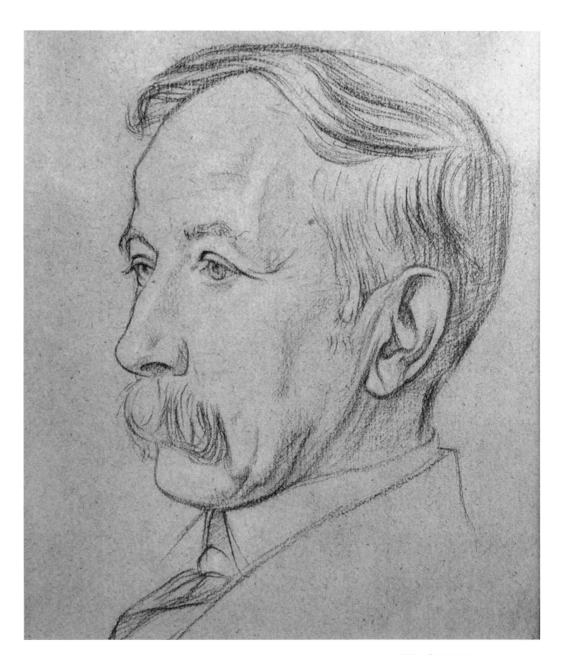

William Rothenstein
Portrait of Lethaby
Black chalk on paper

Sir Hugh Casson

THE FESTIVAL
OF BRITAIN

2pm Wednesday 4 February
Lecture Theatre, Royal College of Art

the Royal College of Art: as a headline in *Graphis* proclaimed: 'Coventry Cathedral Windows Entrusted to an Art College'![22] Basil Spence, the architect of the Cathedral had visited the Stained Glass Department at the RCA in 1951, and approached Darwin to see if the College would accept a commission, which was readily agreed. As Spence explained, in words that resonate right back to Lethaby at the start of the century: 'My problem was how to achieve unity, continuity, and consistency for so large a commission. Clearly, this was a team job. *A job for a guild.*' [23] [my emphasis] Thus the Coventry commission elegantly echoed the two great inspirations for architecture at the RCA, the Art Workers' Guild and the Weimar Bauhaus, in the sense of craftsmen working in tandem in the creation of a great cathedral.

However, the sensitive merging of traditional and modern motifs, materials and techniques that Coventry Cathedral represents would not necessarily have chimed with the tastes and ideals of RCA students in the same period. In 1958, they were responsible for launching 'Anti-Ugly Action', a protest movement against buildings that weren't sufficiently modern, that quickly spread to colleges across the country. They campaigned against 'the sponsors of Tudorbethan, English Renaissance and Bankers' Georgian or Edwardian' by marching with drums and banners ('Must Bad Buildings Speak for Britain?'; 'Don't Bank in Bankrupt Architecture') to 'attack' buildings they despised, and to cheer those they approved of. As Darwin observed, 'Perhaps for the first time in English history, buildings were cat-called, booed, and applauded as though they were a first night.'[24]

At any rate Anti-Ugly Action can hardly have objected to the great project then rising up around them at the College, for the greatest achievement of this period of public commissions was the new building for the RCA itself, designed and built between 1956 and 1961,[25] in a hard and ultra-contemporary Brutalist style. While the architectural press had called for a public competition, Darwin decided to keep the work 'in-house' and approached Casson. He in turn, in true RCA tradition, assembled a team of himself to liaise with the client, Robert Goodden who compiled the brief, and H T 'Jim' Cadbury-Brown, who actually designed it.[26] It should come as no surprise to learn that Cadbury-Brown, a former assistant and devoted admirer of Erno Goldfinger, who had

worked on the Festival of Britain, was actually employed by the RCA in the Sculpture School. The Darwin Building, as it is now known, still provides an uncompromising intervention in the decorative Victorian setting of Kensington Gore. It is unashamedly 'architects' architecture', despite the contemporary lack of an architecture department within, and it was listed in 2001 in recognition of its outstanding quality.

The End is So Near the Beginning[27]

Casson's School of Interior Design continued to provide the only spatial design discipline taught within the RCA for a further two decades, punctuated only by a change of name (to Environmental Design in 1972, to distance the discipline from the amateur practice of interior decoration) and a single change of leadership. Over the years it employed some noteworthy staff, including Terence Conran, and produced several eminent alumni, including Sir James Dyson. When John Miller took charge in 1975[28] it was with the express intention of seeking RIBA validation and establishing an Architecture Department, an ambition that was not universally supported within the RCA, although Darwin's successor, the architect Lord Esher, had proposed this several years earlier; his advocacy for architecture as 'the central discipline in the world of design'[29] seems plucked straight from the Bauhaus, or even earlier.

Gaining formal recognition, which proved a drawn-out process, was finally achieved in 1983, but shortly afterwards it only narrowly escaped being axed in a period of drastic cuts. The shorter history of a fully validated Architecture Department, headed successively after Miller by Derek Walker, Theo Crosby, James Gowan and Nigel Coates, while only covering a span of less than three decades, is nonetheless a complicated story, and deserving of its own detailed account elsewhere. While the aims and outputs of this department seem distant from all of those earlier manifestations of architectural education described here, it is worth concluding with the legacy of the previous century and more, whose imprint can still be traced in the RCA of today. For as architecture came

Nigel Coates
*Ecstacity, Exploring the Evolution
of Urban Space*
(part of 'Greetings from London'
project)
2003
Installation

so late to a College with an unparalleled tradition of teaching design and applied art, it has never achieved a hierarchically dominant position, nor has it sought to do so, thus remaining faithful to its Guild roots. Furthermore, in its newest manifestation it has continued to seek collaboration with other disciplines in a manner that Lethaby and Gropius would have felt at home with, except that those other disciplines now include Vehicle Design and Innovation Design Engineering rather than Stained Glass or Mural Painting.

Finally, it is instructive and appropriate to learn that the newly established School of Architecture makes reference to the past while imagining the future. Thus Interior Design is returning to the fold, while new head of Architecture Charles Walker has talked of the RCA in terms of a new Bauhaus, and acknowledges the importance of what has gone before:

> *The RCA has a great legacy that we hope to build on –
> expand, not replace… We want to retain the RCA's best
> characteristics while adding a new layer of the 'culture
> of construction': what you propose to build with and
> why, not just how. There will be an added emphasis on
> collaborative working, and a holistic approach to the
> process of making architecture.*[30]

While the language may have changed, the sentiment would have been applauded by Lethaby, to whom belongs the last word:

> *'Only that which is in the line of development can
> persist.'*[31]

Acknowledgements

I wish to thank Neil Parkinson, archives & collections manager at the RCA, and Claire Jamieson, PhD student in the Critical & Historical Studies programme, for their generous help in researching this essay.

[1] Gropius, W. (1919) *Manifesto of the Staatliches Bauhaus in Weimar* (The name of the Bauhaus itself is an explicit reference to the masons' guilds of mediaeval cathedrals.)

[2] Translated as *Towards a New Architecture* (1927). (He also translated Le Corbusier's *Urbanisme* as *The City of Tomorrow* (1929).)

[3] Gradidge, R. (1981) *Edwin Lutyens: Architect Laureate*, London: George Allen & Unwin, 4

[4] Frayling, C. (1987) *The Royal College of Art: One Hundred and Fifty Years of Art & Design*, London: Barrie & Jenkins, 5–56. (Naturally, this essay borrows extensively from Frayling's authoritative account of the College's history, and from various conversations I have had over the years with him.)

[5] Powers, A. (1982) *Architectural Education in Britain 1880–1914*, unpublished PhD thesis, University of Cambridge, 25. (I must credit the extraordinary generosity of Alan Powers, our foremost authority on the development of architectural education in this country, for the help he has provided me in writing this essay.)

[6] Reilly, C. H. (1983) 'Some Younger Architects of Today', *Building*, August 1931, quoted in: Rosemary Ind, *Emberton*, London: Scolar Press, 10

[7] Cork, R. (1983) *Vorticism and Abstract Art*, vol. 1, London: G. Fraser, 49, quoted in: Rosemary Ind, op. cit., 10

[8] *Royal College of Art Annual Report 1952/3*, 19

[9] Frayling, C. (1987) op. cit., 67

[10] Famously described by Pevsner as 'one of the most convincing and most impressive churches of its date in any country', in: Nikolaus Pevsner (1963) *The Buildings of England: Herefordshire*, London: Penguin, 91

[11] Quoted in Frayling, C. (1987), op. cit., 96

[12] Some years later, having left the RCA to devote herself to the suffragette cause, she gained her revenge by submitting evidence to the Board of Education, in which she said of Pite's course: 'We first went and did some measured woodwork, we then did some measured stonework; we designed the cloisters of a chapel and a house; we did not get any other styles…', quoted in Alan Powers (1993) 'Professor Pite' in Brian Hanson (ed.) *The Golden City: Essays on The Architecture and Imagination of Beresford Pite*, London: Prince of Wales's Institute of Architecture, 96

[13] From correspondence with the author, July 2012

[14] Board of Education (1936) *Report of the Committee on Advanced Art Education in London*, London: HMSO, 21

[15] Interestingly though, one recommendation in the Report, that a new School of Architecture should introduce classes in interior decoration, provides an intriguing hint as to the College's next great moment of architectural innovation.

[16] *Royal College of Art Annual Report 1949/50*, 15

[17] Goodden, H. (2011) *The Lion and The Unicorn*, London: Unicorn Press, 75

[18] In conversation with the author, July 2012

[19] *Royal College of Art Annual Report 1951/2*, 3

[20] *Royal College of Art Annual Report 1952/3*, 17–18

[21] In truth, it turned out a predictably confused and whimsical affair, and Casson wondered, 'Would it all be just a public puzzle, or, worse still, a private joke?' According to Darwin, working on the Expo caused 'one severe nervous breakdown and numerous cases of ill health'! Royal College of Art Annual Report 1958, 18

[22] *Graphis*, no. 80, 1958, 500

[23] Spence, B. (1956) 'Their Architectural Function', in: *Windows for Coventry*, London: RSA, 3 (The ten windows were executed by head of department Lawrence Lee, assisted by students Geoffrey Clarke and Keith New. Dick Russell designed the 2,000 oak stacking chairs.)

[24] Royal College of Art Annual Report 1958, 32. (One solid achievement of the campaign was to secure a public enquiry into the Monico Site in Piccadilly at which students gave evidence. Royal College of Art Annual Report 1959, appendix, 47–8.)

[25] Library and Common Room block finished 1964

[26] The full story of the project is told in James Dunnett (2006) 'The Royal College of Art: A Study in Modern Architecture and Urbanism', in: *Architectural Research Quarterly*, vol. 10, supplement 1

[27] William Lethaby (1932) quoted in: 'The Wit and Wisdom of Lethaby', *The Builder*, 15 January, 132

[28] With Kenneth Frampton as senior tutor. The staff also included Edward Jones, Su Rogers, Birkin Haward and Peter Rice. Visiting critics included James Gowan, Leon Krier and Demetrios Porphyrios. *Architectural Design*, 2 March 1978, 167

[29] Lord Esher, Fifth Meeting of the Court, 11 December 1972, 7. He proposed a merger with the Architectural Association. The same year saw the establishment of the RCA Projects Office, continuing the tradition of public works, which employed staff to run big projects, and provided practical experience and holiday jobs for students. Among its employees was RCA tutor David Chipperfield.

[30] Walker, C. (2012) 'I won't dismantle the RCA', *The Architects' Journal*, 1 January, 20

[31] *The Builder*, 15 January 1932, 132

Material Differences at the RCA
Colin McDowell

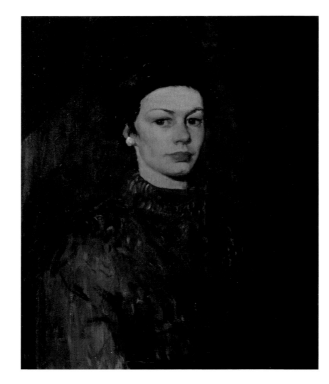

THE BEGINNINGS OF THE MODERN WORLD WERE FORGED BY A NEW CLASS OF ARTICULATE YOUNG STUDENTS, AND THE ROYAL COLLEGE OF ART SCHOOL OF FASHION WAS IN THE VANGUARD

The 1974 silver programme for the twenty-fifth anniversary of the Royal College of Art School of Fashion show might seem with hindsight rather hubristic but, if it was, there could be said to be a certain justification for it. The School had faced down a few problems – and there were more to come. It had taken a very long time for fashion education in general, including at the Royal College, to come out of the shadows to which it was confined in the nineteenth century, a time when new attitudes in education were taking shape across the country but did not, it must be said, encompass fashion design. In fact, fashion education was to arrive as a response to a demand that did not exist at all when the first steps toward what has become the Royal College of Art were being taken. There was no demand because there was no fashion industry. Until the end of the nineteenth century and into the early twentieth century, fashion was a grim industry largely run on an ad hoc basis in dreary factories and dank cellars.

Despite the fact that John Frederick Worth, who was born in Lincolnshire, developed an early form of couture in Paris from the fashion house he opened under his own name in the rue de la Paix in 1858, the vast majority of English women, even at the higher levels of society, had their clothes made anonymously by local dressmakers or family retainers, who consulted the man milliners (senior shop assistants in 'quality' retail establishments) who advised and procured the raw materials: the right fabric, the correct colour and the suitable trimmings required by the customer. There was rarely any evidence of a design hand, although the standards of workmanship were often remarkably high.

For the middle classes, clothes were also mainly made by professional and semi-skilled workers with very little training beyond the dressmaking skills – cutting, sewing and pattern cutting – which they learned in loose apprenticeships in the sweatshops found in every major British city at the time. But there were other workers in the clothes trade, paid as badly if not worse than the grafters from the working classes. These were the distressed middle- and occasionally even upper-class gentlewomen who, thanks to one or another sad twist of fate, found themselves living in poverty, often below the subsistence line, eking out an existence by using the lady-like skills of sewing and embroidery they had learned in happier times. There was little real ready-to-wear. That had to wait until the First World War, when the American Government, in response to the demand for uniforms, worked out the templates necessary for mass production and devised the machines for mass assembly.

So, it is not surprising that there was no suggestion that there should be a Fashion School as part of the Royal College. Socially, it would have been difficult to know how to fill it. Where would the students come from? Certainly, the middle classes, although not actually locking up their daughters, were very unhappy at the thought of them going into trade, let alone learning one at an art school, unchaperoned and surrounded by men considered, merely because of their artistic temperaments, to be untrustworthy and dangerous (remember how the aunts in John Galsworthy's *The Forsyte Saga* (1906–21) were so afraid and distrustful of Bossiney because he was an architect and his dress proclaimed him that most dangerous of creatures: a Bohemian and free thinker). And if well-brought-up girls could not study fashion in art schools, how could the working classes be permitted to enter such middle-class bastions? For them, there were trade schools set up in many of the great cities to serve the needs of the burgeoning garment business and the demands of the increasingly important department stores.

It took the decision-makers a very long time to acknowledge that fashion design could be considered a legitimate industrial training course like others at the RCA, although the value of training in textile design was understood very much earlier than 1948, the date the Fashion School was finally opened. Textiles, unlike dress design, was a craft subject offered to students in 1924; cotton printing by hand, weaving and embroidery were incorporated in 1928. Barbara Hepworth and Henry Moore both produced textiles as part of their student courses at the Royal College, and so did Paul Nash as a member of staff. The school was very much the School of Textiles and most of the design emphasis was on furnishing and wallpaper designs. The high point of this approach was, of course, the Festival of Britain in 1951, but even before that textiles for fashion houses were becoming increasingly important. With that importance came the realisation that there was a great opportunity for the Royal College to lead

the way in fashion design with the confidence it was showing with textile design.

The founding of a School of Fashion at the RCA in 1948 was, history can now reveal, a bodged job, with fashion admitted reluctantly and seen as a second-class discipline. As *Picture Post* rather cattily said, 'What once seemed a feminine priority is now dignified by university status' – except that that was not quite true.

Robin Darwin, a quixotic visionary, was appointed principal of the Royal College in 1948, a talismanic year for international fashion. In January of that year, Christian Dior had shown his New Look couture collection and it not only electrified fashion across the globe, it became a scandal and a talking point, with strong feelings for and against at all levels of society, making people aware of what had up to then been an arcane interest and pleasure for only the richest and most fashionable of women. But now the determination of women of all classes to have the new fashion kick-started the ready-to-wear industry, not only in France and America (where it was already well established) but also in Britain, a development that would have a great effect on the Royal College of Art. It was the beginning of the process of democratisation of the industrial arts in which the RCA and other top British colleges were to play an important role – as they continue to do today.

Janey Ironside, who would in time become professor of Fashion, recalls in *Janey*, her autobiography, that Darwin was given total freedom to do whatever he thought fit to establish the Royal College as the top body in Britain for education in the industrial arts, which, rather to his distaste, one imagines, included fashion. But Darwin was strong and knew what he wanted to achieve. As Ironside writes, he started as he meant to go on by sacking 'almost every member of the staff, senior or junior, unmoved by appeals and threats . It was the beginning of the salvation of the college.'

Faculties were split up into schools and new schools were set up. One of them, in response to the New Look, the increasing interest in design generally and the first stirrings of what journalists were shortly to dub 'the youth quake', was devoted to fashion. But its place below the other disciplines was made clear by the fact that for some years to come it would not be a physical part of the College. It was hived off in a rather

ramshackle house in Ennismore Gardens, then moved to Cromwell Road before finally being admitted alongside the other disciplines in the present College building.

To set up and establish the Fashion School, Darwin chose a *Vogue* editor, Madge Garland, as the first professor of Fashion. It was not an obvious choice for the changing times, but autocratic decisions can work well and this appointment did, despite superficial suggestions that it might not. Madge Garland was very much 'Old School'. Immaculately dressed in couture by Balmain, Balenciaga and even Dior himself, she came to work in gloves and hats and did not remove them in the office. As a contemporary remarked, she was known and respected as highly in the grand salons of Paris as in Mayfair. On paper, she might not have seemed the ideal appointment for such a crucial role requiring forward thinking and awareness of future movements in fashion, let alone the appropriate education for them. But, more so than Darwin, perhaps, Garland seemed to realise and understand the growing evidence that the young were very different from the establishment, even if they had originated there. What Darwin understood was that, in those fluid times when rigid class barriers were breaking down, an upper-class grandee

Suit by Sybil Daniels
Modelled in Kensington Gore
1950s

might not necessarily be the worst person to bond with the new young, many of whom were first-generation educated.

And he was right. Madge Garland was a pragmatist and she understood her role perfectly well. As she wrote in her message in the 1974 silver programme, 'In those post-war days of great austerity, the prime requirement of industry was to export, and one of the functions of the Schools of Applied Art in the college was to train designers for those industries which competed in that field. Robin noted that the large and growing dress trade was not catered for, and decided to remedy this omission.'

But there were serious difficulties to face. As Garland pointed out, there were no sources from which teachers 'well acquainted with the changing techniques and shifting values of the fashion race could be drawn. Furthermore, there was the inescapable fact that the fashion industry not only lacked interest in, but was opposed to, the idea of training designers for their trade in an art college.' The solution decided upon by Darwin and Garland was to overcome the prejudice by involving members of the fashion industry in the teaching process. It worked brilliantly. The Fashion School opened in 1948 in the 'near-derelict' house at 20 Ennismore Gardens. Apart from Madge Garland, there were ten students and two members of staff.

Janey Ironside became assistant to Professor Garland after a nerve-wracking interview of which she writes in her auto-biography: 'Madge, sitting at her desk, immaculate in a tight bodiced, full-skirted cotton dress from Horrockses – the most successful and prestigious firm making mass-produced dresses at that time – wearing a large straw hat, dark glasses, and short white gloves, terrified me.'

In 1956, apparently out of the blue, Madge Garland tendered her resignation, which was promptly accepted by Robin Darwin. When Ironside asked him why, he replied sharply, 'We disagreed.' It was the beginning of a running battle that would reappear on a regular basis in the next few years and it reflected the difficulties that a forward, even visionary, thinker like Robin Darwin encountered when the question was raised of accepting fashion as an intellectual discipline worthy of the standing of other schools at the College. Fashion was very much the poor relation for several years – not only excluded from the main premises but, more shock-

David Hockney
Mr and Mrs Clark and Percy
1970–71
Acrylic on canvas

ingly, not entitled to award a degree. But the Garland debacle passed. She left and the Ironside years began.

Whereas Madge Garland's background had been all about the Paris of avenue Montaigne and the quality of *haute couture*, Janey Ironside's Paris was instinctively more the Left Bank of Juliette Greco, Sartre and Simone de Beauvoir. She was a good choice for professor of Fashion because, although she was tough – even fierce – with the students, they loved her because, understanding how the age of fashion awareness was tumbling, she empathised with them and encouraged them to reflect the new attitudes in their work.

But, of course, the students were ahead of her, as students nearly always were in the 1950s and '60s, the golden age when youth became a power in the world. The Swinging Sixties were just around the corner; Carnaby Street and the Kings Road, androgyny, mini skirts and drugs – not to mention the pill – were about to happen. The beginnings of the modern world were forged by a new class of articulate young students, and the Royal College of Art School of Fashion was in the vanguard, well before the rest of the world was aware. It had a unique energy and authority because, as the student numbers grew, so their social demographic

changed with the shifting educational principles that enabled the sons and daughters of the working classes to enjoy, for the first time ever, tertiary education, no matter how poor their family backgrounds. The talents that swept through the Fashion School on a wave of energy largely consisted of working-class boys and middle-class girls. The energy, confidence and originality that the mixture introduced to the student body was immense.

And it was fully embraced by Ironside. She was a natural leader and a catalyst for creative boldness. So many of the RCA alumni with whom I have talked have total recall, not only of her dress (normally black and white and with a broad black patent-leather belt) and make-up, lit up by a scarlet gash of lipstick, but also of her precise and pointed way of talking and, above all, her ability to create an atmosphere in her tutorials which, nerve-wracking as tutorials always seem to have been, was honest and invigorating. Several former students pointed out (using terms like scary and terrifying) that the tutorial, no matter how much it exposed raw nerves, was the absolute ground base of the flow of top jobs that were to come to so many of them once they were released into the international fashion world and were able to bring their teaching and natural genius together.

And, if we turn again to the silver programme and pick just a few names among the products of the School of Fashion since it began in 1947, we can see why. The quality is staggeringly high. Household names such as Zandra Rhodes, Ossie Clark, Peter Shepherd, Bernard Nevill, David Bond, David Sassoon, James Wedge, Sally Tuffin, Victor Herbert, Sheilagh Brown, Bill Gibb and too many more to list have played major roles, not only in British fashion but also on the international scene. And it has continued up to the present, with alumni of the stature of Christopher Bailey, Neil Barrett, Philip Treacy, Julien Macdonald, Alice Temperley, Erdem Moralioglu and Holly Fulton.

But before the comparative calm of more recent years there were still battles to come. A huge one was fought, and lost, by Ironside, with the result that she decided to leave the RCA. In 1967 it was determined that the Royal College had reached a point of excellence where it should be granted university status, able to bestow its own degrees. At the same time, despite the great success of Ironside as professor of Fashion,

there were persistent rumours that the Fashion School was to be subsumed into the Textiles School. That did not actually happen, but instead there was a bigger blow. With the granting of university status and the right to award degrees came the news that all schools would be able to award the degree MA (RCA) except the Fashion School, which could only continue awarding the diploma Des RCA.

Ironside felt that she had no choice but to resign and, in her own words, received a swift handwritten reply from the rector accepting her resignation from the end of the academic year. It is easy to imagine her surprise and disappointment. As one of her colleagues has subsequently said, 'She and Robin had a very close relationship.' There was a great deal of controversy and much was made of all three decisions in the press, but Ironside went; then, a mere six months later, degree status was also awarded to the Fashion School. As one person on the staff of the College at the time told me, 'It was the nearest that Darwin could ever get, even in retrospect, to an apology for so mishandling the situation. He was jealous of Janey, of course!'

Janey Ironside had been Madge Garland's assistant and so it seems appropriate that her assistant, Joanne Brogden, should take over from her in turn. In 1968 Brogden became head of department, from which role she was promoted to professor of Fashion in 1971, the year when Darwin was succeeded by Lord Esher as rector of the College. The Brogden years, which continued until 1989, were ones of expansion and consolidation during which, with the appointment of Jocelyn Stevens as the College rector in 1984, she also had her battles to fight. Not surprisingly, perhaps. Stevens arrived garlanded with stories of his buccaneering days in publishing, including graphic 'reports' of his penchant for throwing typewriters out of the window at moments of emotional 'stress'. Certainly, he was not an easy rector for the School of Fashion. As a student from the time told me, 'Not all rectors took any great interest in fashion – and he was one who didn't.'

But Stevens did like to meddle and Brogden's life was far from easy. As the same student says, 'Jocelyn, despite all his brilliance, sent a gentlemanly institution into a complete political flurry.' He certainly seems to have enjoyed fermenting a degree of intrigue in the Fashion School. Brogden was

Antony Price
1960s

A Student at the School of Fashion
Royal College of Art
1949

Burberry Prorsum
Autumn/Winter 2012
Womenswear Show Finale

Trine Hav Christensen
Rebecca Thomson
Alex Mullins
Show Fashion 2012

the first professor of Fashion to see the huge opportunity for graduates to get very well-paid and influential positions in Europe and America. She saw her role very clearly: to produce young professionals who were ready to go out into the fashion world at all levels. As she says, 'From Germany to France and Italy, they were in great demand. Famous labels like Missoni and MaxMara talent-scouted them even in some cases before the graduate show. They respected young talent and flocked to employ our people at important levels because they knew how accomplished they were. They treated them very well and paid them well, too. That was my dream: to allow them to develop and then to let them fly.'

The Fashion School seems to have been a hotbed of political petty intrigue and it is perhaps not coincidental that Garland, Ironside and Brogden all resigned their posts. Internal ousting for preferment came to a head.

In 1975, Alan Couldridge and his wife, Valerie, were asked by Joanne Brogden to teach in the Fashion School. Both were students at the Royal College from 1960 to 1963 and married while still studying. They went on to the sort of professional life many tyros in the fashion world begin with, spending half of their time as designers and the rest as teachers. Valerie worked at Wallis and Alan at Liberty designing millinery

while lecturing at Harrow School of Art. Valerie taught in the School for ten years but Alan remained for the next 25 years, including five as head of the School of Fashion, at the invitation of Jocelyn Stevens. As the School was not well equipped, with several studios unfit for use, Couldridge suggested that a Project Office should be set up to create teams of students, lecturers and technicians to work on industrial projects to raise the School profile and to bring in money, which was used to re-equip the studies and computerise the department. It was a very successful policy. Accumulated funds were used to send students to the European trade shows in Frankfurt, Paris and Milan. The Fashion Department became wealthy, but then Stevens decided that all the funds had to become part of RCA general funds and closed the departmental bank account.

Further economies were demanded and to achieve them the Fashion and Textile Departments were joined together with a new professor, John Miles. It was a time of internecine strife which had such a debilitating effect on both Schools that students and staff became totally demoralised. The opinion of those who lived through it is that the rector backed the wrong man and the College was weakened by the inevitable departure of Couldridge. But a breeze of sea change was

blowing, bringing to the Royal College of Art a new rector, Christopher Frayling, and a new head of the School of Fashion. The stables were cleaned out, ready for a buoyant new approach.

When Christopher Frayling was given the job of rector of the Royal College in 1996, it soon became clear that he would become very pro-fashion as he realised its increasing importance to the College. After the many bitter fights and disappointments of the past, most of which were honourable and for principles, the new professor, Wendy Dagworthy, seemed 'a simply inspired choice'. She took up her post in 1998 as head of Fashion and Textiles and is now dean of the School of Material. She had been a very successful designer with her own business and label and had worked at Central Saint Martins as fashion course director, so she brought to her new role not only practical experience in the modern fashion world but also a vast range of international experience in judging competitions, assessing courses and setting up awards and projects. She could be said, without denigrating the skills and abilities of her predecessors in the role, to be the first professor of Fashion at the RCA to have a totally rounded and balanced international knowledge of the field. So it is not surprising that she recalls that, when she took up her new role, 'things seemed a little muddled'.

Dagworthy is an inveterate pragmatist so, although leaving Saint Martins was a very hard decision, she took the job at the RCA because the students were all postgraduates – as the entire course is – and the numbers were so much smaller. 'I love the passion they all bring to their work, whether they are destined to have their own label or go into the industry. All courses need that sort of balance. I also love that everything we do is on a one-to-one basis. I was also tired of theatricals. I felt it was time for fashion to have some reality.'

Dagworthy did not change any of the courses but has certainly worked hard to change attitudes within the College and considers that it is very important to have a proper number of research students, In all, the Fashion School has around 45 students a year for the two-year course, and they come from many lands. Dagworthy is proud of the increasing importance of the menswear course, led by Ike Rust, and is pleased that the students are more conformist and less rebellious than in the past.

Professor Wendy Dagworthy OBE
Dean of School of Material

So, this is the Royal College of Art Fashion School. A late starter compared with most of the other schools, it has benefited from a wide and even eccentric group of talents and strong personalities from its inception. At the beginning, professors, lecturers and students had to fight to overcome a wall of prejudice that was political as well as social. They had to suffer snubs and ill-informed meddling. They fought to stop their discipline from being seen as trivial. In much of this, the changes in society that always seem to have been first signalled by fashion students have helped, of course, but there is no doubt that, from the grandeur of the early days to the informed professionalism of today, the Royal College of Art's School of Fashion has been moulded and developed by extraordinary characters, hard-working and principled on both the teacher and pupil level, today as much as in the past.

Acknowledgements

I would like to thank all the staff, past and present, students and alumni, who shared their reminiscences of the College so candidly.

The Useful Art of Graphic Design
Rick Poynor

THE RCA FOUNDED THE
SCHOOL OF GRAPHIC DESIGN
IN 1948 AS PART OF A DRIVE
TO BRING ABOUT GREATER
PROFESSIONALISM

Graphics RCA Exhibition
Raymond Hawkey, *4-3-2-1* for the
Daily Express, 1961
David English, *A Prize of Arms*, 1961
RCA Galleries
April–May 1963

he RCA founded the School of Graphic Design in 1948 as part of a drive to bring about greater professionalism. It is sometimes said that Richard Guyatt, the new professor of Graphic Design recruited by principal Robin Darwin, coined the term 'graphic design'. This is not the case – the American designer W A Dwiggins had used the description as early as 1922 – but it was certainly a novel usage in Britain. Guyatt later admitted to reservations about the choice of term, recalling that 'Publicity Design' had been the school's intended name until an article in *The Times* lamented its vulgarity. 'With a certain sense of relief, but not much conviction, the name "Graphic Design" was chosen,' Guyatt wrote. 'No one was quite sure what it meant, but it had a purposeful ring, avoided the associations connected with the words "Commercial Art" and promised a wider scope in training than that allowed by the use of the limiting word "Publicity".'[1]

In its challenge to find a suitable name, the School internalised from the start an uncertainty of definition and a structural tension that runs through the entire practice of graphic design. The term has always been blurred at its many edges, if not unstable. Even in 1963, Guyatt could suggest that the boundaries of graphic design were 'vague, shifting and far-flung'.[2] It is not one activity or a single form of communication but many, and for practitioners situated on the inside, this comparatively young profession always seems to be in the process of becoming a new kind of practice that the accepted name cannot adequately account for. An acknowledgement of this underlying condition can be seen in the College's periodic rethinks and departmental name changes for the subject: Graphic Design became Communication Design, then Graphic Design again, then Graphic Art and Design, Graphic Design again, Graphic Design and Art Direction, and then Communication Art & Design. Most recently, under the direction of Professor Neville Brody, the course has been renamed Visual Communication – a term in use in education and elsewhere, as an alternative to graphic design, since the 1960s.

Over the years, in its various incarnations, graphic design has been taught within the school alongside illustration, printmaking, photography, television and film design,

moving image and sound. The degree of interaction between departments may have fluctuated, but students have always been free to combine different forms of practice, or to move sideways and realign themselves.

A critical question for graphic design, also present from the School's inception, is how it stands in relation to fine art. In his inaugural address, 'Head, Heart and Hand', Guyatt, who as a commercial artist had designed posters for Shell, reflects on the relationship between the fine arts and the applied arts. Acknowledging the functional aspect of design, he argues that the emotional force for creative work comes not from its function but from a search for perfection of form; the designer's language 'is one of proportion, of shape, of pattern, and of line'.[3] He goes on to suggest that designers and commercial artists have assumed a place that once belonged to fine artists. Guyatt saw the 'useless' arts as a vital source of invigoration for the 'useful' arts of design. For John Piper, reviewing the School's Printmaking Department, it was equally essential that the tidy professionalism of career-conscious designers be 'counteracted by meeting the little tensions, revolts and unexplained awkwardnesses and refusals to fit, of art.'[4] This alone, he insisted, would expand the designer's range. Those who, in recent years, have questioned the proximity of art and design thinking and practice within the School, as though it were a comparatively late development, appear to miss the fact that their cohabitation was encouraged and nurtured from the start.

Geoffrey Ireland
Ark 1
1950
Magazine cover

In the early years of the School, Guyatt and his colleagues looked back to what they saw as a golden age of graphic art before the Second World War. In art and design, they valued Englishness, tradition and the gentlemanly visual manners of illustrator–designers such as Eric Ravilious and Edward Bawden, who had both studied at the College; Bawden taught decorative design in Guyatt's School. John Lewis, recruited as a tutor by Guyatt in 1951, described the College as 'like joining a club where one knew most of the members'.[5] 'I have a lingering image of Edward Ardizzone, on the staff of the Illustration Department, breaking off every

Anthony Bisley
Edge of the City
1958
RCA Film Society Poster

Stephen Abis
*British Paintings from the Paris
Biennale*
1963
Exhibition poster

Gordon Moore
Fighter Plane
1957
Poster for *Ark* 19

so often while giving a talk, and taking a pinch of snuff from his silver snuff box,' recalls Alan Bartram, a design student at the college from 1955.[6] In 1954, Lewis and John Brinkley, also a tutor, published *Graphic Design*, a guide for students, with an introduction by Guyatt. The book makes dismissive passing mention of the Bauhaus ('"Fitness for purpose" does not make an object beautiful.'[7]) and nods at a few European examples, but the authors prefer to concentrate on the work of figures such as Eric Gill, Reynolds Stone, Paul Nash, Ravilious and Bawden – 'uncontaminated with the coarser aspects of the advertising, publishing and printing trades'.[8] There was little sign in this account of the great impact that Modernism had already made in Europe and America. Other teachers in the School at that time included John Nash, Abram Games, F H K Henrion, Berthold Wolpe and Ruari McLean, with whom Guyatt went on a research trip to Switzerland to look at Swiss posters – to 'see how it was done' – and visit leading art schools.[9] Reading accounts of those years conveys a strong sense of a group of well-meaning educational amateurs making it up as they went along.

The early development of graphic design in the School can best be gauged now from issues of *Ark*, the College journal, first published in October 1950.[10] *Ark* was regarded, like the College's Lion and Unicorn Press, as a vital source of design and publishing experience for students, particularly for designers given the opportunity to act as advertising manager or art editor; the students also designed the magazine's advertising. Until issue 17 *Ark* maintained a sedately bookish two-column grid, though there were signs by issue 13 (Spring 1955), with a pared-down sans serif cover by Alan Fletcher and an article about recent developments in typography by Herbert Spencer (later professor of Graphic Arts in the School), that some of the students were pushing impatiently towards a more Modernist treatment of page design. Fletcher had earlier studied at the Central School of Art, where Spencer and Anthony Froshaug pioneered the teaching of Modernist typography in Britain, as did Edward Wright who taught at the RCA in the mid-1950s; Froshaug joined the school as first-year tutor in 1961.[11] In issue 20 (Autumn 1957), edited by Roger Coleman, Alan Bartram and David Collins applied a consistent, austerely Modernist page grid influenced by Dutch, Swiss and Italian graphic design.[12]

Where the older generation of teachers had resisted new-fangled photography, the medium now began to challenge the dominance of illustration. The RCA annual report for 1957, notes 'an increasing interest in the various uses of photography which is noticeable throughout the College today'.[13] In *Ark* 23, an article titled 'Designers Vision' runs interspliced extracts from three 1958 ARCA Diploma theses as a sign of the way some graphic designers were addressing the problems of their profession. Anthony Bisley's 'The Impatient Image' is an unpunctuated, experimental rush of impressions: 'a new range of experience hidden vast more than factual information enriching our vision inside outside past the world of sense experiences a new strange world technical development too fast beyond our grasp atoms mesons protons cosmic rays supersonic waves.'[14] Bisley's RCA Film Society poster for *Edge of the City* is an explosion of light trails a world away from nostalgic engravings of countryside scenes. Guyatt was impressed enough to show the poster and cite Bisley's thesis reflections on photography in a paper published in *Motif* about contemporary art students. For the serious student, Guyatt writes, the techniques of mass communication, printing and photography, the preoccupation with movement and space on a molecular or a cosmic scale, 'open up new worlds and seem to point in a new direction'.[15]

These were productive and exciting years in the life of the School, as the post-war generation asserted a new sensibility whether the staff fully grasped it or not. Commenting wryly on *Ark*'s success in the 1959 RCA annual report, Darwin notes that 'these exercises in fractured wording and the cult of the incomprehensible are as much a part of contemporary design as are action painting or "beatnik" literature... the more generally unintelligible *Ark* becomes both in matter and presentation, the better it sells'.[16] By the early 1960s, the School's graduates included David Gentleman, Dennis Bailey, Raymond Hawkey, Len Deighton, Alan Fletcher (who then won a scholarship to Yale for a year), Romek Marber, John Sewell and Ridley Scott. In 1959, the RCA's graphic achievements were celebrated internationally in an extensively illustrated, 18-page article in *Graphis*, where Guyatt reiterates that the College's aim is 'to train and produce graphic designers who are not only competent professionals, but also artists'.[17] The culmination of

this period came in the *Graphics RCA* exhibition of 1963, presenting 15 years' work by the School of Graphic Design, covering graphics, printmaking, the Lion and Unicorn Press, *Ark*, the new television and film design course, advertising and the professional work of graduates.

In the early 1960s, RCA graphics had moved into a new phase. The Modernism and intellectualism of the late 1950s had given way to a new commercial Pop attitude shared with the RCA painting students. Brian Haynes, art editor of *Ark* 32 (Summer 1962), one of the magazine's Pop issues, recalls how the designers pooled images with the painters along the corridor. The vigour and brashness of American graphic design was a big influence and the aim was to have fun and 'to get a new style which was still easy then because there was so much material still to process'.[18] In retrospect, the graphic invention, control and vitality in these issues of *Ark*, and in posters produced by the designers for the Film Society and other College events, is impressive, though Reyner Banham, for one, in a review of 'Graphics RCA' in *New Statesman*, poured scorn on what he saw as a superficial obsession with style. 'Since the graphics boys had control of *Ark* and most other public manifestations of the College... they have contrived to give the impression that the RCA is madly with-it, never misses a trick and is preoccupied with fashion.'[19]

In the School's middle years, it is harder to identify a clear strand of development, though *Ark* would never regain its earlier heights of graphic leadership. Its lessons had been absorbed, and designers such as Hawkey and Baynes were now working for the press. British graphic design, once a new idea that had to be argued for, was becoming organised and professionalised, and this was reflected in the School, where a new cadre of experienced tutors arrived from the mid-1960s: Jock Kinneir and Margaret Calvert, designers of Britain's road signs; American designer Bob Gill, founder with Alan Fletcher of Fletcher/Forbes/Gill; Douglas Coyne; Nicholas Jenkins; and another American, Lou Klein.[20] In 1970, a second issue of *Graphis* devoted to the RCA, once again introduced by Guyatt, shows the ascendance in these years of slickly produced 'idea' graphics: sharp, clear typographic detailing with strong photographic or illustrative images.[21] If there was less experimentation now, less to

surprise, challenge or disconcert the viewer, there was also a new analytical seriousness – in answer to critics demanding greater rigour – in the setting up of a Readability of Print Research Unit under senior research fellow Herbert Spencer, whose first published report appeared in 1968.[22] In 1978, Spencer replaced Guyatt as the School's professor, a post he held until his early retirement in 1985.

That year saw a notable change of direction, after the sobriety of Spencer, with the appointment of the Dutch graphic designer Gert Dumbar, a graduate of the College, as visiting professor (assisted by Liz McQuiston as head of department). Dumbar revelled in his reputation for anarchic, expressive and subjective graphic design, even as he worked for big clients. 'The department is in a trough – it's like a motor that is out of tune,' he told an interviewer. 'The system there is very authoritarian, and I want to change it to run in an organic way.'[23] Dumbar's stay was all too brief – he was replaced by Derek Birdsall, who also left after a short time – but it helped to energise a rebirth in RCA graphics that continued to the end of the 1980s and beyond. Students from these years, such as Phil Baines, Andrew Altmann, David Ellis, Howard Greenhalgh, Sean Perkins, Morag Myerscough, Angus Hyland, Paul Neale, Nigel Robinson, Andy Stevens, Jonathan Barnbrook, Peter Miles, Damon Murray and Stephen Sorrell, became key figures in British graphic design in the 1990s and 2000s.[24] The influence on emerging designers of Altmann, Ellis and Greenhalgh, who formed their own company, Why Not Associates, immediately upon graduating in 1987, cannot be overstated. 'We certainly didn't want to work for anybody else,' said Ellis, 'and I couldn't think of any London studio that would let us do the kind of work we wanted.'[25] Such presumption had few precedents: the approved path was to freelance to gain experience, or to take a job, probably as a junior designer, at an established design company. Graphic Thought Facility (Neale, Robinson and Stevens) and Fuel (Miles, Murray and Sorrell) soon followed Why Not's example. In a design boom, in the abundant pages of an avid design press, these bold start-ups were quick to gain publicity.[26] Today, it is routine, even expected, for RCA Visual Communication students to set up studios and businesses together straight after graduating.

These designers had come of age in a decade when British and international graphic design, under the influence of Postmodernism, had become much more stylistically self-conscious and self-assertively experimental, in defiance of many of the tenets of client service and problem-solving that previous generations of graphic designers held dear.[27] The music scene and the style press had given immediate, non-RCA predecessors such as Peter Saville and Neville Brody a platform for work as personally motivated as it was fashionable. The new generation of RCA graduates took it for granted that these freedoms could be applied more broadly, beyond the sphere of youth culture, in work for a new breed of design-aware client. This foregrounding of graphic design, to a degree that would once have been unthinkable, can be observed within the College in the key public document of the prospectus, designed for the year 1988/9 by Phil Baines. The typography, scaled from microscopic to huge, floats across the cover and spine, colliding in a series of dynamic layers, while the photographs inside of College life are cropped into audacious, Dumbar-esque, irregular shapes with curved sides and chunks cut out around the edges.

From 1988 to 1994, graphic design was under the leadership of acting course director Margaret Calvert and then Professor Tony Cobb. In 1994, in a significant change of direction, Dan Fern, professor of Illustration, became head of the newly titled School of Communication Design, with responsibility for both illustration and graphic design. Fern, like Guyatt before him, saw the relationship between the fine arts and the applied arts as being key to teaching at the RCA and one of the factors that set it apart from other institutions. He acknowledged that the traditional borders between illustration and graphic design existed and had value, but felt that they should be crossed constantly at the College, as happened in his own practice, despite the risk of confusion that came with convergence.[28] The new technologically driven circumstances of communication design were open, fluid and collaborative; they required flexibility and maturity coupled with a strong individual voice. In a personal notebook from 1997–8, Fern writes: 'As became clear following the critical appraisal process for 1996–7, it has become increasingly artificial to separate out the two disciplines, since the concentration of activity is now in the overlap between them, and since neither term accurately describes

Daniel Eatock
Greeting Card from *Utilitarian
Greeting Cards* Set
1998

Valerio di Lucente, Sarah Gottlieb,
Selina Swayne and George Wu
Arc 11
2008
Magazine cover

Jonathan Barnbrook
*Technology is Nothing More than
a Process, Not an End in Itself*
1990
Machine-generated stone-carving
on slate

this activity.' In 1998, the two courses officially merged to become Communication Art & Design, reflecting 'the multi-disciplinary nature of contemporary communications' and allowing students to determine their own paths.[29]

The effects were perhaps not entirely as intended, owing to the fast-changing conditions, outside the RCA, of both illustration and graphic design. Illustration had been in the doldrums, its thunder stolen in the early to mid-1990s, after the boom years of the 1970s and 1980s, by digital graphic design and typography; Fern described it as looking 'almost folksy'.[30] The course realignment was in part an attempt to address this perception by reframing the practice, but in the late 1990s illustration experienced a wider resurgence as illustrators came to terms with digital image-making. At the same time, some graphic design students grew disenchanted with what they saw as the self-indulgence of contemporary graphic design. They seemed reluctant to engage in anything so obvious or crass and reacted by turning to more art-like forms of practice, as the new course formally licensed them to do.[31] This drew criticism, especially at degree shows, from those in the business expecting to see traditional, industry-serving graphic design coming from the College: 'The key issue that has distracted the course for decades has been "art". Communications graduates have been at pains to present their work within the context of white walled galleries, not grubby old commerce... The "process" has become the king, not the problem to be solved.'[32]

The relationship of 'communication' to 'art' is not, however, intrinsically vexed or distracting and it retains the potential, as the School's leaders always argued, to be one of the course's strengths. Some rebalancing may be necessary, but to swing too far away from art would be to deny the lessons of the department's 60-year history and many of its finest moments. Since the mid-1990s, RCA communication graduates such as Marina Willer, Daniel Eatock, James Goggin, Frith Kerr, Amelia Noble, Sophie Thomas, A2/SW/HK (Scott Williams and Henrik Kubel) and A Practice for Everyday Life (Kirsty Carter and Emma Thomas) have continued to make significant contributions to the diverse field of graphic design, often, though not invariably, by setting up as independent designers. The new Visual Communication course is once again in transition and so is the discipline it both mirrors and aspires to lead. The continuing imperative to redefine the course's relationship to graphic design stems from the mutability of a practice faced with the evolving demands of society and commerce. Whatever direction this takes, there will be a permanent need for questioning and committed visual communication.

TE·CH·NO·LO·G·Y

IS NOTHING MORE

NOTHING MORE

X TXXHAN

NOT PROCESS

AN END IN ITSELF

Martin Carty
Chemicals
1995
Poster project based on *Shampoo
Planet* by Douglas Coupland

Ursula Dahmen and Tatiana
Karapanagioti
*Dancing in the Dark: Dance,
Performance and the Body in Film
and Video*
1997
Poster for film and lecture series

[1] Guyatt, R. (1963) 'Graphic Design at the Royal College of Art', in: *Graphics RCA: Fifteen Years' Work of the School of Graphic Design, Royal College of Art*, London: Lion and Unicorn Press, 21–2

[2] Ibid., 22

[3] Guyatt, R. (1977) 'Head, Heart and Hand', reprinted in: *Two Lectures*, RCA Papers 2, see also Guyatt, R. (1974), 'Graphic Musings', in: *The Royal College of Art 1974–75*, a promotional booklet about the College, 36–7

[4] Piper, J. (1963) 'Print Making', in: *Graphics RCA*, 33

[5] Lewis, J. (1994) *Such Things Happen: The Life of a Typographer*, Stowmarket: Unicorn Press, 148

[6] Bartram, A. (2009) *British Graphic Design: The Formative Years*, London: self-published booklet in an edition of 20, 7

[7] Lewis, J. and Brinkley, J. (1954) *Graphic Design with Special Reference to Lettering, Typography and Illustration*, London: Routledge & Kegan Paul, 88

[8] Lewis, J (1994) op. cit., 155

[9] McLean, R. (2000) *True to Type: A Typographical Autobiography*, London: Werner Shaw, 58

[10] For the history of *Ark* and its impact on British culture, see Alex Seago (1995) *Burning the Box of Beautiful Things: The Development of a Postmodern Sensibility*, Oxford: Oxford University Press

[11] See Kinross, R. (ed.) (2000) *Anthony Froshaug: Typography and Texts*, London: Hyphen Press

[12] Bartram, A., op. cit., 9. Bartram rejects Alex Seago's suggestion in *Burning the Box of Beautiful Things* that *Ark* 20 owes anything to Edward Wright's influence: 'We did not see him until after it was published.'

[13] Darwin, R., *Royal College of Art Annual Report 1957*, 13

[14] Chapman, G., Bisley, A. J. and Broadhead, D. (1958) 'Designers Vision', *Ark* 23, Autumn, 33

[15] Guyatt, R. (1958) 'Art & Indolence: A Guide to the Art Student of Today', *Motif* 1, November, 58 (paper presented to the Double Crown Club in April 1958)

[16] Darwin, R., *Royal College of Art Annual Report 1959*, 47

[17] Guyatt, R. (1959) 'Royal College of Art', *Graphis*, 84, July/August, 290

[18] Quoted in: Seago, A., op. cit., 196

[19] Banham, R. (1995) 'Department of Visual Uproar', *New Statesman*, 3 May 1963, 687, quoted in: Seago, op. cit., 205. On RCA posters of the period, see Alex Seago, 'RCA Posters 1948/1965', a folding poster essay accompanying an exhibition of the posters at the College, 1–8 May 1992

[20] On the growth of British graphic design, see Poynor, R. (2004) 'Spirit of Independence', in: Poynor (ed.) *Communicate: Independent British Graphic Design since the Sixties*, London: Laurence King Publishing, 12–47

[21] Guyatt, R. (1970) 'Royal College of Art', *Graphis* 146, 488–542. See also *Queen*, 21 June 1967, special issue about the Royal College of Art edited by Richard Guyatt and designed by graphic design students and staff.

[22] Spencer, H. (1968) *The Visible World*, London: RSA. For an untitled discussion about graphic design between Bob Gill and Spencer, see *Ark* 42, 1968, 3–8

[23] Quoted in Coad, E. D. (1985) 'Dumbar Girds up for the Royal Summons', *Design and Art Direction* 42, 11 October, 30

[24] See Why Not Associates (1997) *Why Not?*, London: Booth-Clibborn Editions; Barnbrook, J. (2007) *Barnbrook Bible: The Graphic Design of Jonathan Barnbrook*, London: Booth-Clibborn Editions; Ryan, Z. (2008) *Graphic Thought Facility*, A+D Series, Chicago: Art Institute of Chicago

[25] Quoted in: R. Poynor (1998) 'Type as Entertainment: Why Not Associates', in: *Design Without Boundaries: Visual Communication in Transition*, London: Booth-Clibborn Editions, 129

[26] See, for instance, *Direction*, March 1990, featuring Why Not Associates as a five-page cover story: Tim Kirby, 'Fun Boy 3', 26–30

[27] See Poynor, R. (2003) *No More Rules: Graphic Design and Postmodernism*, London: Laurence King Publishing; Adamson, G. and Pavitt, J. (2011) *Postmodernism: Style and Subversion, 1970–1990*, London: V&A Publishing

[28] Poynor, R. (1996) 'Dan Fern', *Eye* 22, Autumn, 10–15

[29] *Royal College of Art Annual Review 1998/9*, 11

[30] 'Dan Fern', *Eye* 22, 1996, 13

[31] For an RCA-educated designer in the vanguard of this tendency, see Daniel Eatock (2008) *Imprint*, New York: Princeton Architectural Press

[32] Johnson, M. (2007) 'Decision Time', 7 March, archived at: www.johnsonbanks.co.uk/thoughtfortheweek/index.php?thoughtid=548. Johnson was on the RCA's revalidation committee for the course name change to Communication Art & Design. See also Michael Johnson (2001) 'RCA Show', *Design Week*, 28 June, 18–19

Design for Public Spaces and Design for Social Value

Paul Thompson

IN HOUSING, TRANSPORT, HEALTHCARE, AND MOST RECENTLY, CULTURAL EVENTS SUCH AS THE LONDON 2012 OLYMPICS, ARTISTS AND DESIGNERS FROM THE RCA HAVE PLAYED A POWERFUL ROLE IN SHAPING BRITAIN'S URBAN AND SOCIAL INFRASTRUCTURE

Underground Roundel from
Westminster Station (signwritten
onto painted plaster)
Designed by Edward Johnston
c. 1930

n housing, transport, healthcare, and most recently, cultural events such as the London 2012 Olympics, artists and designers from the RCA have played a powerful role in shaping Britain's urban and social infrastructure. This essay examines three episodes when significant design commissions within the public arena were undertaken with RCA involvement: firstly, by students and staff in the years preceding the Second World War; secondly, by staff working as independent designers on post-war, public-sector commissions concurrent with their teaching roles at the RCA; and finally, during the late twentieth century, by faculty and research associates working on major RCA research projects in the area of 'socially responsible design'. With each new century, the role of the designer becomes increasingly professionalised, and in each example outlined below, the social value of design has becomes more pronounced. Not surprisingly, the College itself has felt a certain sense of public duty, given the fact that it was established as the world's first, publicly funded art school.

In the nineteenth century, students from the Government School of Design were called upon to contribute to major State ceremonies (the Duke of Wellington's funeral carriage in 1852), or to decorate a significant new public building (the exterior frieze of the Albert Hall in 1873). A sense of duty to serve the public realm can be discerned in Henry Cole's evangelising crusade of the mid-nineteenth century. His ambition to elevate public standards of design was articulated not solely in terms of mercantile advantage, but also in relation to moral and social improvement. Under Cole's leadership of the Department of Art & Science, Richard Redgrave, painter and headmaster of the Central Training School of Art (later the RCA), worked with his students to design Britain's first 'pillar' post-box in 1857. With an improved design in 1859, the pillar box became the national standard in the UK. But with this commission, student input was essentially performed under the tutelage of the professor, with no creative input into the brief, merely its execution. Indeed, the students' role in this project was most probably confined to its construction.[1] This is likely to have been the case, too, with the degree of responsibility exercised by Sir Edward Poynter's female students when assisting their tutor with the decorative designs for the tiles used in the new Refreshment Room of the South Kensington Museum in 1870. These were prestig-

ious commissions in prominent public spaces, but ones that did little to posit the social ramifications or value of design.

During the early twentieth century the public service that was to benefit most from a radical and comprehensive programme of design management was the Underground Electric Railways Company of London, then a private company. Frank Pick, who assumed the role of publicity manager at the Underground in 1908, was a pioneer of corporate design management, commissioning Modernist artists, architects and designers to create a coherent and consistent visual language and identity across architecture, advertising, signage and the interior carriages of trains. One of Pick's most important and enduring commissions was given to the RCA's tutor of Calligraphy, Edward Johnston, who was charged with creating a new typeface and identity for the Underground in 1913. (Johnston served on the RCA staff from 1902 to 1939.) Frank Pick's brief was clear: he wanted a typeface to possess 'the bold simplicity of the authentic lettering of the finest periods', and yet belong 'unmistakably to the twentieth century'.[2] The result, Johnston's sans-serif typeface Johnston Sans (1916), is a masterpiece of functionality and elegance.

Johnston was joined at the Underground by a number of RCA colleagues, including Edward Bawden (alumnus 1925), who designed several posters for the Underground during his student years. Henry Moore (alumnus 1923) was offered his first-ever public commission while working as a Sculpture tutor at the RCA: the offer to create one of the four, exterior stone reliefs, *West Wind* (1928–9) for the headquarters of London Underground at No. 55 Broadway, St James's. Despite the significant contribution made by RCA staff and alumni to the Underground during these decades, it would not be accurate to suggest that British design managers or patrons of public art were 'beating a door' to the Royal College. Nor would it be correct to say that the RCA under its principal, Spencer, was particularly anxious to win such commissions for its staff or students in the manner in which Robin Darwin, a later rector, would be so keen to do. As Fiona MacCarthy's essay in this volume reveals, the College during this period lacked stature in the art world; it was probably more a question of coincidence that such public commissions were offered to talented individuals who happened to be

teaching at the RCA at that time, rather than any conscious decision by the patron to enlist the services of the College.

In 1945 the Labour Party swept into government and rapidly embarked upon its manifesto commitment to create a National Health Service, a National Insurance scheme, nationalised coal, rail and steel industries, a nationalised Bank of England and an ambitious expansion of schools, roads, hospitals and social housing. Such reconstruction plans necessarily demanded the skills of town planners, architects and designers. Unlike the pre-war projects referred to above, these ambitious projects were now to be met from the public purse, and the designers of the Welfare State were called upon to play an increasingly active role as social engineers in these public-sector commissions.

The most visible public event during the post-war period was the Festival of Britain of 1951. Designed to commemorate the centenary of the 1851 Great Exhibition, the Festival of Britain was to be a 'tonic for the nation' and included an exhibition in London on a modest brownfield site near Waterloo. This was chosen by Misha Black of the commercial design practice Design Research Unit (DRU), not solely for reasons of expediency, but also for its long-term potential to foster urban regeneration.[3] A tour of the Festival of Britain was a triumph of 'RCA-ness': with the logotype designed by Graphic

Design tutor Abram Games (RCA faculty 1946–53); a mural designed by Edward Bawden; and the Lion and Unicorn Pavilion, designed by the newly appointed head of Jewellery and Metalwork, Robert Goodden and head of Graphic Design, Professor Richard Guyatt. Hugh Casson was director of Architecture for the South Bank site and was appointed professor of Interior Design at the RCA in that same year. Even the official Festival guidebook was written by the RCA's head of General Studies, Basil Taylor. RCA Principal Robin Darwin served on the board of the Council of Industrial Design during the planning of the Festival and actively promoted the role of the College in such national ventures and partnerships throughout his long tenure at the College. He fully understood that the calls made by the RCA upon the public purse necessitated, in turn, a highly visible public role for the College.

In 1959 Darwin appointed Misha Black to lead the new School of Industrial Design (Engineering) at the RCA. Black was a talented, successful designer who was to become an extraordinary pedagogue in the field of industrial design. For him, commercial and aesthetic considerations had to be underpinned by humanism and social value.[4] He was to play a profound role in defining the design profession and the designer's responsibility to society:

The basic contention of the School [of Industrial Design (Engineering)] is that the contribution of the industrial designer to society is his creative capacity, social consciousness, and human understanding, but that these virtues require a technological vehicle for their expression... Industrial design is a useful art, and its success or failure can only be judged in relation to its effectiveness as a social catalyst.[5]

During his tenure as professor at the RCA, Black remained a partner at DRU, working on major public-sector projects concerned with rail, postal, and civic infrastructure. From 1956 to 1962, together with engineers from British Railways and fellow designer J Beresford Evans, he embarked on a concerted programme designing the bodywork of diesel and electric locomotives at British Railways. With Hugh Casson, he created an exterior, self-service system for the Post Office.[6] He worked on urban rehabilitation schemes for the Civic Trust in Norwich and Burslem city centres; served as architect and industrial designer to the Hong Kong Rapid Transit Railway; and in 1964 was appointed design consultant to the London Transport Executive, overseeing all the design aspects of the new Victoria Line, the first line added to the Underground rail network in 60 years. Black was also to play a highly visible role above ground, in the streets of Westminster, where he was commissioned to design a new system of street signage in 1967. Some 30 years later, in 1996, these street signs would be guiding London cabbies and their passengers in the new TX1 Metropolitan taxi, designed by the RCA's head of Vehicle Design, Professor Dale Harrow, in collaboration with visiting professor Kenneth Grange and Pentagram. The taxi marked a breakthrough in terms of inclusive design, conceived specifically with the needs of wheelchair users in mind.

In his appointment of Bruce Archer to the RCA in 1962, Misha Black set the stage for what was to be the most enduring public-sector design project in the College's then 126-year history. The Industrial Design (Engineering) Research Unit began life as part of Black's School; its first research brief was 'Studies in the Function and Design of Non-Surgical Hospital Equipment', funded by the Nuffield Foundation in 1962. Unfortunately, the research was not well received by its funders, but its early work on patient care and ward

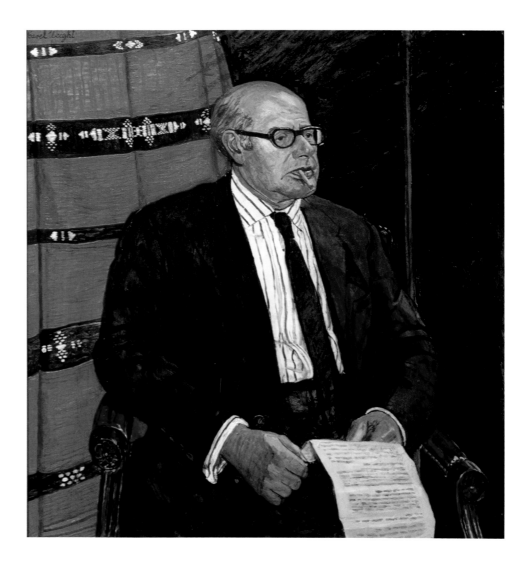

Carel Weight
Portrait of Misha Black
1975
Oil on canvas

efficiency foreshadow research themes that have become areas of expertise within the RCA's Helen Hamlyn Centre for Design, in particular, research into 'Designing Out Medical Error' (DOME) (2009–11) and 'Design for Patient Safety' (2003 onwards). The Industrial Design (Engineering) Research Unit is the clear progenitor of the RCA's research interest in socially responsible design.

In 1963, Archer and his research team received funding from the King Edward's Hospital Fund (now known as the King's Fund) to develop a set of standards for the manufacture of NHS hospital beds and address the problem of dispensing drugs on the ward via the design of a trolley. The King's Fund's desire to address the design of hospital beds coincided with

the publication of a particularly damning Parliamentary Public Accounts Committee report to the Ministry of Health on hospitals' purchasing policy and the lack of any agreed design standards for hospital beds, which were then produced by numerous manufacturers and purchased by hospitals in an utterly uncoordinated manner, without central procurement. As Archer observed, the Public Accounts Committee identified no fewer than 300 designs for hospital beds.[7]

The final, successful prototype was designed by RCA research fellow Kenneth Agnew and was presented at the College within as realistic a ward setting as possible, with curtaining and bedcovers designed by final-year Textile student Rosalie Bullock; a combined table/locker unit designed by Timothy Coward and George Lynn (IDE); and the lighting, communications and services unit designed by student Anthony Smallhorn (IDE). Even an ashtray and non-spill flower vase were designed by glassmaker Mary Stevens.[8] Much to Archer's relief, the findings of his Unit's design and the outcomes of the ward trials were accepted by the Working Party 'practically as written', and the bed entered production and became standard issue among NHS hospitals over the next 50 years.[9]

A review of RCA Annual Reports reveals the most vocal exponent of socially responsible design to be Lord Esher, rector 1971–8, who came to the RCA from the RIBA. Having worked as consultant architect and planner on Hatfield New Town, Esher was liberal, progressive and very conscious of the need for design to improve lives. As he was to state in his first year as rector:

> Our purpose is to stretch the limits of the visual imagination for the betterment of human life, and particularly of under-privileged human lives. Our goal must be to be the European centre of excellence in this field.[10]

Most accounts of Esher's tenure focus more on the political backdrop of his day; but aside from those immediate preoccupations, a clear, underlying moral dimension to the role of design surfaces in Esher's statements. In a Report to Court in 1975, he identified a fissure within the design profession, which is as evident today as it was then:

> Revolted by the luxuries advertised in the Sunday colour supplements, designers have split in two direc-

> tions. Some have sent up the Design Council, thumbed their noses at the antiseptic Scandinavian interior, disguised a book as a ham sandwich, or a teapot as a cushion or a camel. Others, the more socialised, have immersed themselves in work for the third world, or the handicapped child, or the hospital service.[11]

In a similar vein, Frank Height, the new professor of Industrial Design (Engineering), perceived his discipline to be 'a conditioning and reformist element in society, as well as a practical one'.[12] Designers had social responsibilities and obligations; they were to assume the mantle of change agent and place more significance on social value than aesthetics or commercial return, according to the temper of the mid-1970s RCA.

In 1976, the landmark symposium 'Design for Need: the Social Contribution of Design' was staged at the RCA. Guest speakers at the conference included Victor Papanek, the *éminence grise* of sustainable design and author of *Design for the Real World: Human Ecology and Social Change* (1971).

Kenneth Agnew
King Edward's Hospital Fund Bed
1965

At the conference, its organisers Professor Christopher Cornford, head of the new Department of General Studies, and Professor Height both advocated for a design concerned with social value, ecological awareness, and a set of aspirations that rose above the mindless consumption of economic growth cycles: a firm rejection of 'the design, styling, or promotion of products that are a superfluous pampering of the already over-provided'.[13] Such statements convey an anti-consumption message far removed from the exhortations of a Henry Cole or indeed, many of the Government reports that had, on occasion, chided the RCA for its apparent inability to engage with British industry. Archer's Department of Design Research was disbanded in 1984, but not before it had prepared the ground for the 'DesignAge' programme of 1991.

Helen Hamlyn (alumna 1955, née Jones) had been head of design at Cresta Silks; but it was her interest in design as an agent for social change, rather than fashion, that led her back to her alma mater. In particular, it was the concept of 'design for our future selves' – designing with an increasingly ageing demographic in mind – that fired her.

Together with rector Jocelyn Stevens, Helen Hamlyn established the DesignAge programme at the RCA with its first director, Roger Coleman. Coleman's view on the social value of design is eloquently expressed in a research paper of 1993:

> *Design is potentially more effective than legislation in bringing about social change, in particular because it is uniquely capable of interpreting and humanising the discoveries of science and technology and the end user. Scientists and technologists may develop new systems for guiding vehicles on the road, say, but it is the designer who will deliver that technology as part of a range of new products and in ways that fit the product to the user, both physically, psychologically and practically.*[14]

In 1993 DesignAge hosted an important symposium at the RCA, in which the design of vehicles, retail environments, fashion and textiles, products, services, ergonomics, marketing, advertising and education were all analysed within the context of an ageing population, giving rise to the concept of 'inclusive design' – a design approach that met the needs of older consumers (in terms of ease of use), but which simultaneously felt every bit as good to use for those consumers

not yet in need of reading glasses.[15] Coleman first used the term 'inclusive design' at a conference on ergonomics in Canada in 1994.

Under the executive leadership of Roger Coleman and Jeremy Myerson, DesignAge expanded into the Helen Hamlyn Centre in 1999 with Helen Hamlyn's support and the guiding influence of the rector, Professor Sir Christopher Frayling, who made the Centre's work pivotal to his design mission for the RCA. It is now a world-leader in socially responsible design, moving beyond the bailiwick of 'design for our future selves' into such specialised fields as the design of medical equipment, in partnership with surgeons from Imperial College, or the creation of healthier office environments.

In 2009, the Centre presented the findings of an Engineering & Physical Sciences Research Council (EPSRC)-funded research study – 'Smartpods' – on the provision of emergency healthcare in the community; the following year it advanced further into this field of emergency healthcare provision, working in partnership with Imperial College Healthcare NHS Trust and the eminent surgeon and former health minister, Professor Lord Ara Darzi of Imperial College, the University of the West of England, and the RCA's Vehicle Design programme. Research was exclusively focused on redesigning the interior of the London emergency ambulance.

The solutions to the traditional problems of ambulance design were radical: the patient's trolley bed was positioned centrally within the ambulance, to allow paramedics full access to the patient from all angles; carefully designed and colour-coded medical supply dispensers were fitted, thus obviating the time-consuming practice of paramedics searching, often in vain, for medical supplies in half empty or randomly replenished storage receptacles; and an interactive computer screen, positioned over the patient, allowed two-way flow of medical data between paramedic and hospital staff. The project concluded in 2011 and won prestigious design awards in both Europe and the United States for its radical, systemic analysis of the problem and its forward-looking design response.

In 2011, the Centre structured its activities around three principal research labs: 'Age and Ability', led by Rama Gheerawo; 'Health and Patient Safety', led by Ed Matthews; and 'Work and City', led by Jeremy Myerson, who holds the Helen

124

Redesigning the Ambulance:
Improving Mobile Emergency
Healthcare
Project Designs
2011
Helen Hamlyn Centre for Design

Hamlyn Chair of Design, an endowed post with the remit to advance research and practice in socially responsible design. The Age and Ability research lab has ventured beyond the field of physical ability into the domain of cognitive ability, designing environments for people with autism. Textile designer Katie Gaudion (alumna 2009) and design engineer Andrew Brand (alumnus 2009) joined the Centre as research associates to work on a project with the Kingwood Trust, a major provider of supported care for adults with autism. Through Katie's work on sensory stimulation via textiles, texture and surface, and Andrew's industrial design approach, the researchers published a series of recommendations and propositions in 2012 for interior layouts, furnishing and tactile surfaces within the homes of adults with autism who express extreme sensory preferences.

As part of the Designing Out Medical Error (DOME) research, a three-year programme in partnership with Imperial College funded by the EPSRC, the Helen Hamlyn Centre for Design created a fully commercial product, the CareCentre, manufactured and distributed by NHS supplier Bristol Maid. This new type of furniture unit was designed to sit at the foot of every hospital bed and support staff in infection control and other clinical processes. According to Professor Myerson, it is a direct descendent of the King's Fund hospital bed of 1965.

Finally, with the transition of SustainRCA in 2011 from a volunteer base to a centrally funded centre with its own academic adviser and an ambition to offer a programme of research fellowships working on environmental and ecological themes, the RCA has – albeit tardily – entered the area of sustainable design and design for the developing world. As rector in 2012, my ambition is to see SustainRCA supervising its own PhD candidates and pursuing a robust programme of faculty research over coming years.

What is significant to note over the course of the past 175 years is how the role of the designer has been transformed and professionalised, and how design within the public space has moved from an essentially secondary or subordinate role of embellishment, into a primary conduit for delivering social value. Today, RCA designers are active participants in the broad arena of service provision, delivering social and economic value through their design decisions. The RCA's current pedagogical approach is characterised by a criti-

Katie Gaudion and Andrew Brand
Sensory Preferences: Housing Design
for Adults with Autism
2011
Helen Hamlyn Centre for Design

cal response to the brief: across all of the MA programmes within the School of Design, students are free to interrogate and – at times – to rewrite the brief, encouraged to question the premise and to consider systemic cause or long-term social need. As Professor Myerson states:

> Designers today are reconfiguring their relationship with the world around them. They're no longer content to just to be the servants of industry, working for business; they see themselves more as social agents of change working with individuals and communities to design for real needs. Empathy, observation and engagement with people very early in the creative process – the type of work done by social scientists in previous generations – are now part of the designer's mentality.[16]

David Constantine and Simon Gue
(Alumni 1990, and co-founders of
third-sector company Motivation,
providing wheelchairs to the
developing world)
Motivation Wheelchair
1991

[1] Frayling, C. (1987) *The Royal College of Art, One Hundred and Fifty Years of Art & Design*, London: Barrie & Jenkins, 46–7

[2] Barman, C. (1979) *The Man Who Built London Transport: A Biography of Frank Pick,* London: David & Charles, 43

[3] Cotton, M. (2010) *Design Research Unit 1942–1972*, London: Koenig Books, 35

[4] See Black's essay 'Fitness for What Purpose?', in: Avril Blake (ed.) (1993) *The Black Papers on Design*, Oxford: Pergamom Press, for a sense of Black's holistic approach to design, balancing functional, commercial, aesthetic and social needs

[5] Blake, A. (ed.) (1993) *The Black Papers on Design*, Oxford: Pergamom Press

[6] For a photograph of this exterior, see University of Brighton archives

[7] *SIA Journal*, 152/153, Oct/Nov 1965, 3

[8] Ibid., 6

[9] Ibid., 7

[10] Mid-term Conference, Wednesday 10 November 1971, RCA archive

[11] Royal College of Art: Rector's Report to Court, 8 December 1975

[12] Bicknell, J. and McQuiston, L. (eds.) (nd) 'Foreword', *Design for Need: the Social Contribution of Design*, anthology of papers presented to the symposium, April 1976, Oxford: Pergamom Press

[13] Cornford, C. (nd) 'Introduction', in: Bicknell, J. and McQuiston, L., op. cit., 7

[14] Coleman, R. (1994) RCA Research Papers 'Design Research for our Future Selves'. vol. 1, no. 2

[15] Ibid., 3

[16] Email communication between the author and Jeremy Myerson, 2 July 2012

Input/Output:
Design Research and Systems Thinking
Jane Pavitt

Previous Page
Top: Ceramics Photolithography
Ceramics Department
c. 1962
Bottom: School of Industrial Design
(Engineering)
1964

Industrial Design (Engineering)
Department
c. 1962

FOR BETTER OR FOR WORSE, IN ITS 175 YEARS THE RCA HAS ACTED AS A TEMPERATURE GAUGE FOR THE STATE OF INDUSTRIAL DESIGN IN BRITAIN

or better or for worse, in its 175 years the RCA has acted as a temperature gauge for the state of industrial design in Britain. At times the target of criticism for its failure to keep step with the demands of industry or the needs of government, the College also had a somewhat uneasy relationship with the community of designers who were attempting a forge a new kind of professional discipline in the mid-twentieth century. In the decades after the Second World War, industrial design as a practice changed considerably, not only to keep pace with economic, social and technological conditions but also because it grew in intellectual terms. During the 1960s, design began to be theorised at an academic level, in ways akin to science, and acquired a more critical voice, a shift that had an increasing impact on RCA design culture in the 1970s. This essay examines the work of L Bruce Archer, whose work contributed significantly to this new ethos for design. Archer's career at the College (1961–87) both spanned and shaped the period in which industrial design shifted from a nascent discipline struggling with its own professional status, to one that embraced a host of specialist sub-disciplines, each with its own scholarly and research agenda.

First, a proviso: a hagiographical account of Archer's career would be entirely at odds with the tenor of his thinking.[1] Archer was a 'systems man' – dedicated to the idea that design was a culture of specialisms, and that the process of design was one of team-work, bringing interdisciplinary expertise to design 'problems', systematising knowledge in a scientific way. In the history of his long career, there are few if any products that are authored solely by him (except in textual form). Archer was no *auteur*, and for this reason his thinking is fascinating when set against histories of design that tend towards the cult of personality.

Design Education in Crisis?

When the RCA resumed its Kensington operations after the hiatus of the Second World War, the conditions for growth were not auspicious. Ramshackle buildings, an ageing staff and a curriculum still steeped in the Arts and Crafts philosophies of the 1920s; the College had neither the time nor inclination to respond fully to the rising wave of criticism from the design professions that had begun in the 1930s. The appointment of Robin Darwin as principal in 1948 was to change this: within 20 years, the College was an accredited university, housed in a new building, with a raft of new and highly specialised programmes, and a burgeoning research culture in a field that had previously been dismissed as merely a 'trade' (industrial design). This changed landscape was not only a matter of shifting institutional priorities – rather, it reflected the advances made in terms of design's professionalisation and theorisation in those years.

The image problem faced by industrial design after the war was central to Darwin's root-and-branch reorganisation of the College. Design was to be given equal status to the fine arts and crafts, and design disciplines were to be upgraded to reflect current industrial concerns. New professors were encouraged to maintain their own commercial practice (a College principle that continues to this day). The new College was organised into ten schools (rather than the previous four). New courses in Industrial Design, Furniture, Fashion and Graphic Design were instituted. Criticism of the RCA's teaching methods and its lack of connection to industry had been vocal in the 1930s – evident in the findings of the 1936 Hambledon Report[2] – which had singled out the College's lack of relevance to the growth of industrial design in Britain. Furthermore, the view from the profession in the 1930s, that designers occupied a lower social position than 'appropriate', was still widely felt:

> The designer is a journeyman in industry and is treated as such. He is paid far less than a skilled machinist. He is too often not looked upon as belonging to the same social class as his employer.[3]

Darwin's appointed professors were representative of a new and confident profession – no longer 'journeymen' but social equals in the clubs and institutes of London, demonstrating not only skill and expertise, but also artistic sensibility and business acumen, all combined with an easy social manner (befitting the club-like atmosphere of the new Senior Common Room at the RCA). Social status, a long-held

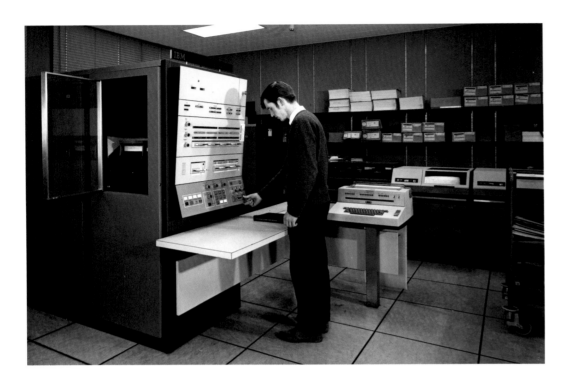

Howard Metcalfe and Edward
Chamberlain (IDE students)
Mode 44 computer (IBM schools
computer)
c. 1963

industry. He brought the kinds of projects to the College that he dealt with in his professional career: collaboration with London Transport, for example, and a host of other major British corporations, in the fields of transport design, service, infrastructure and engineering, as well as product design.

But the College's former reputation – as a school in the Arts and Crafts tradition (and a training ground for those who would go on to teach rather than practise) was hard to shake off, even though many changes were afoot under Black's leadership. In 1964, design critic Reyner Banham took the RCA (and design education in general) to task for its lingering conservatism:

> You can see here, both in the anti-styling snobbery and in the persistence of this craft-based tradition, the continuance of the Lethaby sentimentality about training apprenticeships for guilds. And this is of course basic to both of the top art schools in London because they were... formed under Lethaby's direct guidance. This idea of the honest craftsman hitting things and scraping things for seven years, or whatever it is, to become a fully qualified member of the guild, survives into the Bauhaus, and from the concept of the Gessellen brief which becomes the diploma in design. This concept is almost world wide, and it's only a very bold school which has yet had the guts to break out of that tradition...[5]

anxiety on the part of the profession, was key to this change of attitude. As Darwin put it:

> You won't get good design from the sort of person who is content to occupy a small back room: a man who won't mix because his interests are too narrow to allow him to, a man who is prepared and, by the same token, only desires to eat, as it were, in the servants' hall.[4]

Although this new RCA generation assumed prominent positions in the public realm in the 1950s (as Paul Thompson has shown in his essay), critics now took the College to task for failing to provide design with the intellectual and experimental basis which was starting to be evident in other colleges. Misha Black's appointment as professor of Industrial Design in 1959 completed Darwin's first phase of College reorganisation in terms of design, but the RCA still did not yet represent a specific design philosophy. If it stood for anything, it stood for Darwin's desire to recoup the position of the College from its 'grey paint' and civil service attitudes and propel it into a position of commercial relevance. Black, as co-founder of one of Britain's first multi-disciplinary design consultancies (the Design Research Unit, established in 1942) helped turn the College towards a more professional engagement with

A 'bold' school, in Banham's view, was the Hochschule für Gestaltung (HfG) in Ulm, West Germany, which he had visited some years previously. The Ulm school was at that point the intellectual and philosophical centre for design thinking in Europe. Founded in 1953 as a revival of pre-war Bauhaus pedagogy, the HfG played a vital role in the establishment of a progressive, Modernist design culture in West Germany, under the leadership of its first director, Max Bill. Bill's philosophy of functionalist design (known as 'good form') had shaped the school's reputation for cool and spare product design and typography. The school had gone through a wave of crisis in the period 1956 to 1958, resulting in Bill's departure and his replacement by the Argentinian painter and theorist Tomas Maldonado, whose early role at the school had helped it to develop a strong programme of identity design. Maldonado had become increasingly

frustrated with the narrow and formal constraints of Bill's mission. In his view, design as a discipline should emerge from its stylistic preoccupations to participate in a culture of specialisms – engaging with industrial R&D, consumer behaviour research, management and communications theory. Rather than simply produce products that serviced a prosperous consumer economy (as West Germany was rapidly becoming) designers needed to engage critically and systematically with economic and cultural operations, and develop a research process that would scientifically analyse the factors informing design 'problems'.

The allure of Ulm was strongly felt in London: Banham's Independent Group colleague, Richard Hamilton, reported on his own visit there for *Design*,[6] and incorporated the technical products of Braun (a close affiliate of Ulm) into his paintings. Ulm's interdisciplinary interests in new technologies, systems theory, cybernetics, semiotics and psychology appealed to an Independent Group sensibility, like a 'breath of painfully fresh air', as Banham put it later.[7] The appeal of this 'scientific' approach to the arts may seem hard to grasp. But this set of methods; which had emerged from operational research during the Second World War, ranging from ergonomics to cybernetics, management theory to behaviourism; captured a spirit of cross-fertilisation in the arts, design and science that seemed entirely new. As art historian David Mellor has observed: 'the wired, electronic outlines of a cybernetic society became apparent to the visual imagination – an immediate future... drastically modernized by the effects of computer science.'[8]

Design Methods

So where was the British equivalent of the HfG? The London arts scene was alive to the possibilities of this techno-Utopian vision, and enthusiastically embraced it in the interests of all things 'Pop'. The Institute for Contemporary Arts was the nodal point for such discussions in the 1950s, through the extensive networks of the Independent Group. The RCA's *Ark* journal was also a conduit for debate, particularly as editors such as Roger Coleman and later Ken Baynes straddled the worlds of art and design with equal enthusi-

asm. The Central School, the Slade and Ealing College of Art were early adopters of systems thinking in art and design, becoming the educational testing grounds for such theories (Ealing and the Slade became the first fine art programmes in the UK to embrace computing and cybernetics in the development of 'systems art' in the 1960s). The interdisciplinary work of artists, designers, scientists, engineers and programmers was given public space in the seminal exhibition *Cybernetic Serendipity* at the ICA in 1968, an event which led directly to the founding of the Computer Arts Society, who held their inaugural conference, succinctly titled 'Event One', at the RCA the following year. This brief summary suggests that a rich, parallel history of systems thinking in the arts could be traced alongside that of industrial design – only space precludes me from doing so here.[9]

Designers responded to this current of thinking in different ways. A new generation of designer–theorists took operational research as the basis for design methodology, which came to dominate industrial design education through the 1960s and '70s. Chief amongst these were J Christopher Jones, whose writings on design methods were the first to appear in *Ark*,[10] and who pioneered design methods at Manchester College of Science and Technology; and Archer, whose arrival at the RCA in 1961 signalled a turn in industrial design thinking that was to shape decisively its philosophical direction.

Design Methods, as it became known, was essentially a call for a systematic approach to designing. Using organisational methods drawn from science, technology and communications theory, Design Methods argued that, through processes of analysis and evaluation, design could be undertaken in a 'scientific' way. Once the design 'problem' had been identified, data and information could be gathered systematically, subjected to analysis, then synthesised into a solution. Although drawing its language and assumptions from science, Design Methods awarded logic and creativity equal status in the design process, just so long as creative thinking could be subjected to the same methods of capture and analysis as other informing factors. The aspiration to employ computational methods was a vital part of this, although the actual use of computers within design practice was only just developing.[11] The impact of computing was at an analogous rather than a practical level in the early 1960s. In the words

133

of J Christopher Jones, even the designer could be thought of as a cybernetic mechanism:

> The picture of the rational, or systematic designer is very much that of a human computer, a person who operates only on the information that is fed to him, and who follows through a planned sequence of analytical, synthetic and evaluative steps and cycles until he recognizes the best of all possible solutions.[12]

Archer had begun to develop similar theories while working as a design consultant in the early 1950s. After serving with the Scots Guard during the war, he had entered industry as an engineering draughtsman (combining an early scientific interest with artistic aptitude). Like many ex-servicemen, he began higher study through evening classes, eventually qualifying as a mechanical engineer in 1950. He set up his consultancy soon after (the unsnappily titled Scientists' and Technologists' Engineering Partnership), and began to teach design at the Central School. While at Central he came into contact with the Independent Group, and through these connections was introduced to Maldonado (by Richard Hamilton). Maldonado had expressed admiration for Archer's writings in design and invited him to come to Ulm as a guest professor, which he did in 1960.[13]

At Ulm, Archer encountered active debate about the systematisation of design, as well as matters of psychology, linguistics and political theory. He later described it as the opportunity to 're-educate myself completely', especially on the mathematical, operational research and social sciences side.[14] He made long-standing friendships with students and tutors alike. The product designer and theorist Klaus Krippendorf has recalled his own time as a student in Ulm:

> Who was the most influential product design teacher for me? It was Bruce Archer, who joined the HfG faculty in 1960, right after I had completed my coursework. He actually did give lectures; brought a design method to the department, was intensely involved with his students and open to explore alternative approaches [...] From him I learnt that users of products were not the only ones that designers had to consider. There always are bystanders with opinions and influence, he insisted. Archer was not a

sociologist, but with this addition, he had recognized the social role of products.[15]

Student projects supervised by Archer at the HfG often appeared as case-studies in his later writings: a wristwatch by Reinhard Butter, for example, and the 'radio pill' by Norbert Linke (a diagnostic medical transmitting device, which the patient swallowed, in order to measure stomach acid levels) were described in his articles for *Design* magazine in the 1960s.[16]

In 1961, as his tenure at Ulm finished, Archer returned to London, and was invited by Misha Black to head up a new research initiative in the RCA's School of Industrial Design. This first project, however, was not without setbacks. Funded by the Nuffield Foundation, the King Edward's Hospital Fund and the Department for Health, it was to investigate the design of non-surgical equipment. The project allowed Archer to develop a practical model for his design methods approach: involving consultation with medical specialists, designers and engineers, combined with an exhaustive process of data gathering, feedback, prototyping and testing. The process-based results of his investigation did not find favour with at least one of its sponsors (the Nuffield Foundation withdrew its funding). Archer and his new associates, including the designer Kenneth Agnew, and Reinhard Butter (who had come with him from Ulm), scrabbled for grants and contracts in order to pursue their research. This led to the successful NHS-

Kenneth Agnew
Redesign of Ward Equipment Trolley (Part of the 'Studies in the Function and Design of Non-surgical Hospital Equipment' Project), supervised by Bruce Archer
RCA and Nuffield Foundation
1962

Reinhard Butter
Wristwatch (Student Project for Product Design Department), supervised by Bruce Archer
Hochschule für Gestaltung
Ulm, Germany
1961

funded King Edward's Hospital Fund bed project, and an RCA research collaboration with the health service and its related industries was born which continues to this day.

Despite the early uncertainties of his employment at the College, Archer continued to build the profile of Design Methods within the design profession and the wider field. In September 1962, he helped to organise the first conference on the subject at Imperial College, an event initiated by J Christopher Jones. The fact that the conference was subtitled 'On Systematic and Intuitive Methods in Engineering, Industrial Design, Architecture and Communications' but bore the overall title 'Design Methods' indicates the organisers' ambition to give design methodology equal status alongside its more established fellow disciplines. As well as Archer and Jones, the conference included Peter Slann from Imperial College (a future RCA research fellow); Christopher Alexander (who brought his architectural perspective to the proceedings, in the form of a novel presentation on the systems analysis of an Indian village); Gordon Pask, the renowned cybernetician whose work was a seminal influence on systems thinking; and the RCA's Roger Coleman, who took part in a conversation with painter Howard Hodgkin.

Archer also continued to write for *Design*, contributing an influential series of articles entitled 'Systematic Methods for Designers' in 1963–4. The articles set out the principles of Design Methods, providing a model of basic design procedure (from brief to solution, via various stages of data collection, analysis, synthesis, development and communication). In diagrammatic form, he proposed a methodology for the analysis of the interaction between user, task, tool, and environment. The articles provoked an 'unprecedented demand' and were published as a bound reprint by the Council for Industrial Design in 1965.[17] The earnest and dry tone of the articles seems a far cry from the enthusiastic and permissive engagement with systems theory by artists and critics in the 1950s, despite their common root. Their publication ensured a methodology for design, which was now firmly positioned at the heart of design research at the College.

By 1964, (as the RCA geared up for its expected university status) the so-called 'Hospital Equipment Group' led by Archer was given a more solid footing within the College, and renamed the Industrial Design (Engineering) Research Unit.

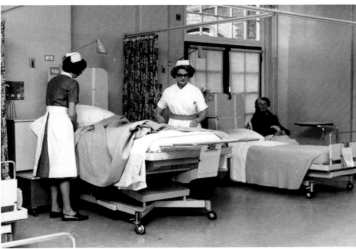

Kenneth Agnew
King Edward's Hospital Fund Bed
1965

Bruce Archer
Man/Tool/Work/Environment
Diagram
Systematic Methods for Designers
1963–4

Later, the name changed again to the Department of Design Research (DDR), with a more autonomous status within the College to conduct teaching and research. For the next ten years, Archer ran the department as a gradual expansion of the principles of Design Methods, using systematic research as the basis for a host of projects, which tackled health and social issues, including medical care and rehabilitation, disability, health and safety matters, and design for education. The DDR also drew in technological and materials research, making wider contacts with other departments in fields such as textiles, furniture design and engineering. New research clusters were founded: most notable were the Experimental Cartography Unit, headed by David Bickmore, which developed computational methods for mapping; the Readability of Print Research Unit, led by Herbert Spencer (later professor of Graphic Arts) and the Design Education Unit, led by Ken Baynes.

Archer gradually diminished his own external commercial work as a designer in order to run the department, but also because his personal convictions had convinced him that design in the service of a consumer society was far less laudable than a systematic approach to design directed at social needs. His fascination lay with the process of design, rather than its products. In 1974, he felt compelled to make a personal statement to the College, concerning the development of his department. The previous year, Archer had argued that 'the state of the art of designing in 1973 is in a state of crisis… the first is a crisis of competence and the second is a crisis of conscience'.[18] His more personal statement the following year was made in response to Lord Esher's (rector from 1971) plans for another College restructure:

Ideologically speaking, I take what is (I fear) a characteristically middle-aged, middle-class intellectual's position, although I believe I have held it since I was a young, working class, shop steward. The elements of this position are represented in some respects by the radical wing of the Liberal Party and in other respects by the social democrat division of the Labour Party. Very broadly, this means that I am against the consumer society, for worker-participation, against dictatorship (of all shades), for Europe, and so on and so on. These attitudes are far from irrelevant to the

conduct of the department. There are some sorts of client I would never work for, and some kinds of design I would refuse to deliver.[19]

His words lack the eloquence if not the passion of other anti-consumerist statements by designers, but they carry something of the same spirit, say, of graphic designer Ken Garland's *First Things First* manifesto of 1964. ('We hope that our society will tire of gimmick merchants, status salesmen and hidden persuaders, and that the prior call on our skills will be for worthwhile services.')

By the early 1970s, Design Methods had taken a more critical turn, towards immersion in methodology and research, and away from direct engagement with commercial concerns, preferring projects where social need was the major priority. The rector, Lionel Esher, commented that RCA designers demonstrated 'a sense of futility in making minor design improvements... when the world is running out of raw materials, a sense of guilt in helping vast international corporations to promote, write off and replace luxury goods when half the world population doesn't have enough to eat.'[20] The question of 'design for need' was avidly received in this recessionary and critical period, as evidenced by Frank Height's valedictory address when he became professor of the Industrial Design School in 1975 (quoted by Fiona MacCarthy earlier in this book). But many felt that systems thinking did not provide the answers to these questions.

Archer's operational and systems research basis for design (with its roots in Cold War technological thinking) was increasingly out of step with the tenor of grass-roots design thinking, and with the volatile state of College politics in the Esher years.[21] The heady and rather Utopian atmosphere of systems thinking in the 1960s (with its sometimes less than scientific adoption of scientific language) had been left behind. Nevertheless, Archer's adherence to Design Methods caused him to apply it to a general review of College policies. Directed by Esher to conduct a review of College governance (which Archer privately coded project N155), he logged every opinion about the RCA's pressing problems on detailed record cards. For example, one handwritten log recorded a conversation with Misha Black, in which Black predicted 'gross economic collapse about which nothing can be planned or more probably controlled, inflation making

things more difficult...' The conversation concluded that nevertheless, Black 'does not anticipate any change in RCA policies until the Rector retires in 1978'.[22] Archer's method, like Black's prediction, could not adequately deal with the sense of urgency and impatience that infected the College.

Despite this, by the mid 1970s, Archer had effectively established a research culture for design in the RCA where none had existed, but it continued its work in a way that was somewhat detached from the buzz of studio debate. In the art and design studios, the idea of systems thinking was increasingly anachronistic. Even the appointment of a new rector in 1981 – Lionel March, a systems man himself – could not supplant the messy vitality and rough-and-tumble nature of College debate with March's own vision of an orderly and scientific research institute.[23] March departed, defeated, after only two years. After a brief interregnum, the arrival of Jocelyn Stevens as rector set the College on a path to ride the wave of 1980s Thatcherite entrepreneurialism. Stevens' sudden and ruthless restructure swept away the Department of Design Research, and Archer's role as its head. It was not only students who had become impatient with the ponderous approach of Design Methods.[24] Archer himself expressed some regret: 'I can see I wasted an awful lot of time in trying to bend the methods of operational research and management techniques to design processes.'[25]

Design Methods represents a remarkable arc of development in terms of the impact it had upon design thinking education. As a spent force by the 1980s, it was consigned to the archives of design history: not that Archer would have disapproved, as he had been an early advocate of 'systematising' the writing of design history, even before such a discipline existed. It is tempting to speculate here on the legacy of his position. Although the singularity of his approach is at odds with the expanded field of design today, there is continuation in terms of design research directed at social need – evident in the operations of the Helen Hamlyn Centre for Design. The lasting engagement with science and technology research is a fundamental part of the School of Design, in its partnership with Imperial College. A new form of creative and far more critical 'systems thinking' is also evident in the Design Interactions programme, headed by Professor Anthony Dunne, where the holistic engagement with the conditions for

design continues to be practised in unorthodox and inter-disciplinary ways. Designers training in an interdisciplinary environment might well articulate their research in terms of a critical act, text, event or system, which has as much (or more) cultural validity as a well-made product. To place this emphasis on the importance of critical enquiry, on process as much as end-product, is, to borrow a phrase of Archer's, a very 'designerly way of thinking' about the world.[26]

Acknowledgements

I would like to express my thanks to Helen Kearney and Neil Parkinson for their assistance in researching this essay.

Ceramics Photolithography
Ceramics Department
c. 1962

1 Archer provided a useful summary of over 100 research assistants, fellows and tutors who worked with him in the DDR and its forerunners. See 'BA Valedictory', L. Bruce Archer Archive RCA/LBA/2007, 1.1.1.A

2 The Report of the Committee of Advanced Art Education in London, London Board of Education (1936) London: HMSO

3 Rooke, N. (1931) RSA Journal, 17 January, quoted in: Penny Sparke (1983) Consultant Design: The History and Practice of the Designer in Industry, London: Pembridge History of Design Series, 52

4 Darwin, R. (1987) quoted in: Christopher Frayling, The Royal College of Art: One Hundred and Fifty Years of Art and Design, London: Barrie & Jenkins, 131

5 Banham, R. (1964) Ark 36, quoted in: Baynes, K., 'Baleful or Beneficent?', Design (A Special Issue on the Royal College of Art), December, 192

6 Hamilton, R. (1959) 'Ulm', Design, 126, June, 53–7

7 Quoted in: Ilpo Koskinen (ed.) (2011) Design Research Through Practice: From the Lab, Field, and Showroom, Burlington, MA: Morgan Kaufman, 32

8 Mellor, D (1993) The Sixties Art Scene in London, London: Phaidon, 107

9 For a detailed account of these relationships, see Alex Seago (1995) Burning the Box of Beautiful Things: The Development of a Postmodern Sensibility, Oxford: Oxford University Press

10 Ark 19, Royal College of Art, 1957

11 The Department of Design Research used computers for research from its early years, but its access to equipment was limited, and it relied on its partnership with Imperial College for the latest technology. In a technical note of 1974, Archer listed the DDR as possessing 'graphics and teletype terminals allowing connection to outside computers in the education and research community' and 'an old GEC905 computer with an interactive graphics display… on its last legs and we have great difficulty in keeping it going'. L. Bruce Archer Archive RCA/LBA/2007, 1.1.1.C: N155: 8-year plan for future of DDR (1974)

12 Jones, J. C. (1970) Design Methods, London: John Wiley & Sons, 50

13 Maldonado wrote to Design magazine in April 1958: 'In my opinion it is necessary to free design criticism from the numerous misconceptions of art criticism terminology and to turn design criticism into a new scientific design analysis. I appreciate especially in the magazine the contributions of Bruce Archer and Christopher Jones.' Quoted in: Jean McIntyre, 'The Department of Design Research at the RCA: It's origins and legacy 1956–1988, unpublished MA dissertation, V&A/RCA History of Design, 15

14 Archer, L. B. (1974) The Design of a Departmental Development Strategy: Working Paper. A Personal Statement, L. Bruce Archer Archive RCA/LBA/2007, 1.1.1.C: N155: 8-year plan for future of DDR

15 Krippendorff, K. (2008) 'Designing In Ulm and Off Ulm', Departmental Papers, Annenberg School for Communication, University of Pennsylvania, 62

16 Butter's wristwatch featured in Design, 176 (1963), 53–7; and Linke's radio pill in Design, 185 (1964), 62–3

17 See Design, 204, December 1965

18 Archer, L. B. (1974) Design Awareness and Planned Creativity in Industry, The Design Centre London/Information Canada Ottawa, 15

19 Archer, L. B. (1974) Personal Statement, 1974, L. Bruce Archer Archive RCA/LBA/2007, 1.1.1.C: N155: 8-year plan for future of DDR, np

20 Quoted in Frayling, C., op. cit., 178

21 Christopher Frayling has reported anecdotally that rumour and suspicion surrounded the projects of the Industrial Design School and the DDR, including the unfounded suggestion that the Experimental Cartography Unit, with its peculiar Cold War nomenclature, was working for the CIA. Frayling, C., op. cit., 186

22 Index card recording a conversation between Bruce Archer and Professor Misha Black, dated 18 July 1974, from L. Bruce Archer Archive RCA/LBA/2007, 1.1.1.C: N155: 8-year plan for future of DDR, 1974

23 See March, L. (1981) 'Systematic Research into Possibilities: The text of Dr Lionel March's inaugural lecture as rector of the Royal College of Art given on 25 November 1981.' BC–1, RCA Archive

24 For accounts of student response, see Jean McIntyre (1996) 'The Department of Design Research at the Royal College of Art: Its Origins and Legacy 1959–1988', in: Christopher Frayling and Claire Catterall (eds) Design of the Times: One Hundred Years of the Royal College of Art, Richard Dennis Publications/RCA, 61

25 Archer, L. B. (1979) 'Whatever Became of Design Methodology?', Design Studies (1), 17–18, reprinted in: Nigel Cross (ed.) (1984), Developments in Design Methodology, London: John Wiley & Sons, 347

26 Ibid., 348

Where is the Testing Ground?[1]

Andrew Wilson

THE RCA'S STRENGTH OVER 175 YEARS – AND ESPECIALLY IN TERMS OF THE PRESSURES OF A MORE CONTEMPORARY CONTEXT – IS TO HOLD FAST TO A SHARED SET OF PRINCIPLES THAT REVOLVE AROUND 'THE CREATIVE AND INDIVIDUAL ACT OF MAKING ART: EXPRESSION THROUGH VISUAL THOUGHT'

John Stezaker
Mask IV
2005
Collage

Hannah Starkey
Untitled, October 1998
1998
Framed C-type print

Previous Page:
Show RCA 2012
Dyson Building
Royal College of Art

aking art is about testing the boundaries between things, an activity that is often defined by the edges between practice and discourse at the margins. It is thus difficult to brand and even harder to market. The Royal College of Art – a postgraduate institution – exists for its students to test what art might be now and where they might want to take it. No preconceptions, no rigid identity or conformity, no programme. The most important spaces in the College are the studios where individual students think, make and talk about their work, both with other students and tutors. Boundaries exist between different departments described by medium (Painting, Photography, Printmaking and Sculpture), but within each department a student may choose to pursue a practice in any medium so that a Painting student may be making film and a Printmaking student might be making a performance. As John Slyce – a longstanding visiting tutor in the Painting department – has observed, 'The barriers that keep disciplines and departments separated from each other can at least be made permeable if not entirely broken down... I have always considered it a particular strength in the approach of the School of Fine Art at the Royal College that not only are the barriers that interrupt coherence across departments, media, and practices scrutinised and challenged, but so too is the barrier no less artificial that separates the institution and thereby the students from the world "outside".'[2]

In the 1990s this world 'outside' was undergoing quite substantial change, with contemporary art becoming a more or less permanent fixture of the journalist's repertoire. Part of this repertoire was the creation of the young British artist, the 'yBa'. But where did the idea of the yBa – well described by Michael Bracewell as 'a complex and generational grouping of artists, who happened to comprise, as a phenomenon, a good story'[3] – originate? Journalism requires that these kinds of myths of origin should exist alongside an attendant narrative and easily recognisable identity – a designer or a publicist might call it branding. The standard account of British art of the 1990s locates its mythic origin at the *Freeze* exhibition organised by Damien Hirst at an empty London Port Authority building at Surrey Docks in London's Docklands in the summer of 1988. This exhibition

of Hirst's fellow students from Goldsmiths quickly became the doorway through which contemporary art in Britain could be identified, addressed and written about. BritArt became the flipside of BritPop and the additional branding of Cool Britannia by the mid 1990s underscored a sociability and a shimmer of celebrity and notoriety that progressed inexorably along a path from Goldsmiths to Groucho's via warehouse shows, Charles Saatchi and Jay Jopling. The words used by the critics and journalists reflected a concatenation of contradictory adjectives: youthful, edgy, brash, punkish, pop, conceptual, polished, sensational, contemplative, visceral, transgressive, defined. This was art that was about big themes and experiences culled from daily existence such as life, death, sex and belief, all packaged with professional, if DIY, sheen. 'Damien Hirst' or the phrase 'Goldsmiths student' both became metonyms for contemporary art through the 1990s in a surprisingly durable fashion, despite this being little more than a crude simplification.

Journalists seemed to forget about students from the other colleges, both in London and also around Britain. The year 1995 saw the first institutional assessments for yBa: the *Brilliant!* exhibition at the Walker Art Gallery in Minneapolis and *General Release*, organised by the British Council as part of that year's Venice Biennale. Both revealed – as did the celebratory apotheosis of Charles Saatchi's relationship to yBa two years later, the Royal Academy *Sensation* exhibition – that although the situation was altogether more complex, a sea change in art and its place in British society had taken place, even though this change was hard to define except in the glibbest of ways. Of the 12 artists in *General Release*, three were graduates of the RCA – Jake and Dinos Chapman (Sculpture and Painting respectively, graduated 1990); Elizabeth Wright (Sculpture, graduated 1990) and Cerith Wyn Evans (Film and Video, graduated 1984). This mix was repeated in *Brilliant!* and *Sensation*.[4] Goldsmiths was not the only college in London, and if the initial attention on artists from that college had been on graduates from the BA, this also ignored the distinction between those artists that had done BA courses and those that had gone on to do postgraduate study – the position of students from the RCA as a wholly postgraduate institution was singular in this respect. From this perspective it is instructive to think that if a typical BA student exists in a project-based environment, the RCA

143

MA student is largely self-generated in their approach. David Rayson, a painting student between 1995 and 1997, typifies this shift from BA to MA at the RCA as one where the student comes to work in a 'much more individualistic and self-reflective realm. Contemporary visual culture and debate enabled the students to develop strategies of how they could discuss and critique their studio practices, but impulse and creative mischievousness were actively supported along with the strategic and more distilled ways of working.'[5]

In trying to understand the particularity of being a graduate of the RCA since the 1990s – in Painting, Photography, Printmaking or Sculpture – the best place to start is at the degree show, in the studio, Plato's cave perhaps, where semblance and reality, matter, form and evanescence can be tested and stretched. In this respect, Gavin Turk's *Cave* 1991 is both another creation myth for a moment in history but also a fairly useful prism through which can be observed the forces and principles that shaped and continue to shape the RCA. For his degree show Turk cleaned and emptied out one of the nineteenth-century wood-panelled sculpture studios. This was just prior to a departmental move away from the sprawl between studios and Nissan huts in South Kensington to studios in a converted factory across the river in Battersea. Turk painted his studio white, emphasising purity as much as a quality of emptiness. High up on one wall was placed an English Heritage blue plaque that stated that 'Gavin Turk Sculptor worked here 1989–1991'. Despite his use of the phrase 'worked here' on the face of this plaque that formed part of Turk's degree show installation, the RCA's Academic Board for Concessions and Discipline along with its Final Examination Board decided that Turk had 'displayed insufficient work of the standard required for Final Examination'[6] and so, following re-examination, refused to award him an MA certificate – pretty much the first time in its then 150-year history that this had happened (it had almost happened to David Hockney, but instead he got the Gold Medal).

The studio space served as a vitrine for the plaque, providing a context not dissimilar to Yves Klein's emptied and cleaned out room for Iris Clert's gallery in Paris in 1958, *The Specialisation of sensibility from the state of prime matter to the state of stabilized pictorial sensibility – The Void*. At his re-examination Turk played on such references; using a slide projector he discussed his own work in the context of slides showing Jannis Kounellis's *Untitled* 1969 (his installation of horses in an underground garage in Rome), Jeff Koons' self promotional advertisements for his 1988 *Banality* exhibition and English Heritage plaques to commemorate John Ruskin and William Morris, among other works. He explained at the time that he felt this was necessary 'to illustrate the

lineage and context within which the work was operating. As far as I was concerned, the board was unable to see the piece because they desire to see a readily consumable traditional Sculpture. It seemed to me that an interest in contemporary debate was absent or even irrelevant.'[7] What *Cave* articulates is a struggle between making and theory as much as it was also a collision between tradition and those contemporary shifts that derail orthodoxy – it is perhaps an illustrative coincidence that Jocelyn Stevens shortly after resigned as rector of the RCA to head up English Heritage. Such stark shifts are an inevitable part of the evolution and change within art, and a recognition of the important part played by art colleges in fostering such a questioning of the status quo. Turk in this respect was in many ways fighting a battle against the structure of the Sculpture Department, but in ways that were similar perhaps to the contrast at Saint Martin's School of Art in the mid-1960s when the conditions of sculpture were tested by artists such as Barry Flanagan, Richard Long, Hamish Fulton and John Hilliard, in ways very different from the metal sculpture of Anthony Caro or the Pop-inflected use of colour and materials by the New Generation sculptors such as Philip King or Michael Bolus. What the circumstances around *Cave* amply illustrate is this inevitable conflict between radicality and orthodoxy that is played out in the landscape of the art college studio. In the 2012 exhibition *The Perfect Place to Grow: 175 Years of the Royal College of Art, Cave*, in the guise of *Cave (Relic)* (1991–3) will once again be shown in the College building – a vitrine taking the place of the studio.

Writing retrospectively, Martin Maloney asserted that Goldsmiths in the late 1980s and early '90s was 'the hotbed of change. Its non-hierarchical teaching programme... stressed the democracy of material and meaning. The school asked students to make art that had something to say, to make it in a new way, and to engage with the contemporary world.'[8] Maloney further observed that the characteristic achievement of recent British art had been 'its radicality of content, not radicality of form'. In one respect Turk's *Cave* highlights the different emphasis given to critical and theoretical purchase at the RCA, where artistic practice continued to be defined through medium-specificity. This tension between medium-specificity and the breaking down of difference, as much as between theorised or untheorised practice, goes some way towards defining the principles underlying the identities of the Fine Art departments at the RCA. Difference is both celebrated and challenged in much the same ways that dialogue exists between making and thinking. This can be recognised in Paul Huxley's view that Painting students should 'work in the knowledge that the authority of painting's

tradition is not automatic. Each painting must begin as if it might not be a painting: it must be questioned, it might be proved.'[9] Theorisation may be specific to certain departments (Photography or Curating Contemporary Art[10], say), or it might be fed through the views of individual tutors, such as John Stezaker's role in Humanities in the 1990s or the ways in which Matthew Higgs similarly provided a bridge between the Painting and Curating courses, bringing a wide range of artists, critics and curators into the College. Either way a range of often conflicting positions (difference again) allows students to test their own work and thinking. The seminars in Photography, for instance – ranging from art theory and history to philosophy, cultural studies, psychoanalysis, history and literature – were 'not designed to be academically pure or coherent but thought provoking'.[11]

At about the same time as Turk's final show, the Printmaking Department emerged from the Beaux-Arts inspired teaching of Alistair Grant to a more critically grounded examination of

printmaking under Tim Mara's direction, which has continued and diversified under the leadership of Chris Orr and more recently Jo Stockham. And yet, for students like Adam Dant – one of the first intake to be interviewed by Grant and yet enter Mara's department, a group of students identified as 'Alastair Grant's last practical joke'[12] – the course offered a place where the traditions and technical requirements of the workshop rubbed shoulders with a new attention to criticality that might not be defined wholly by aesthetics. This is clear in the mix of tutors and visiting tutors who came to the course such as Helen Chadwick, Terry Frost, Nigel Rolfe or Kate Whiteford – and that has continued. Dant and his creation of Donald Parsnips reflect the course of such a shift, between outmoded representational codes – the woodcut as much as the pamphleteering of the Ranters or the achievement of seventeenth-century satire – and a sophisticated engagement with the immediacy of the street and an attention to the everyday. In this sense printmaking continues to carry

Gavin Turk
Cave
1991
Installation

overtones of the worlds of design and illustration ('communication'), as much as it does an embrace of aesthetics and theory in equal measure.

Such a shift can also be recognised in the RCA's Photography Department over the last 20 years. The department had originally been set up and run in the School of Communication, but in 1992 was reconstituted and sited as a department within Fine Art. Many of the imperatives that had originally driven the department in terms of the role of photography as a commercially defined medium continued under John Hedgecoe, but had decisively changed by the time of the appointment of Olivier Richon as head of the department in 1997. Through the first half of the 1990s, with no particular language or approach dominating the department, it meant that students had to think about their decisions and actively engage with other departments, self-organising lectures and crits. Additionally in this early period the presence of John Stezaker in Humanities offered a range of critical language to the students that might otherwise be lacking (a key position that he held in respect of all the other Fine Art departments). If, under Richon, the focus of the Photography Department has been to dissolve the division between theory and practice, this has been achieved by a close attention to the creative and critical aspects of the practice. One of Richon's first changes was to introduce theory seminars that ranged between philosophy, psychoanalysis, aesthetics and semiotics in such a way as to provide 'a critical framework dedicated to photography as a distinct form of representation with its histories and practices (as distinct from the all-in-one ideology of a Fine Art course which, like at Goldsmiths, often occludes the specificity and history of the discourse of photography).'[13]

So, if Turk's *Cave* provides a way of introducing the idea that the conditions and determinants of what art – and more specifically, sculpture – might be are put under question, another aspect worth extracting from the example of *Cave* is the traditional importance of the studio and an emphasis on studio practice at the RCA. This is perhaps well exemplified by Tracey Emin's phrase 'The Perfect Place to Grow' – words that shone like a beacon at The Tracey Emin Museum in Waterloo between 1995 and 1998 and were appliquéd on her first quilt *Hotel International* 1993 and later became the title given to an installation of 2001. Emin has explained how Alan Miller, Painting tutor through the 1990s, 'was a true ally. He showed me how to be a painter',[14] and yet that from the initial high of being offered a place, it was in certain respects downhill all the way, it being a tough switch in culture from her Printmaking BA at Maidstone College of Art to be given a place in the Painting Department at the RCA. Her unhap-

piness at the RCA was also caused by her inability to make a good painting (halfway through her time at the RCA she destroyed many of her paintings with a sledgehammer in the College courtyard). However, with Miller's help Emin learnt 'a lot technically about painting and I definitely learnt what kind of artist I never wanted to be. Looking back, it was the right place for me.'[15] Through the 1990s, for Emin the best studio was a stage or a communal place – the bar or café – as well as solitary place of creation, and her Museum – like The Shop with Sarah Lucas a year or two earlier – generously embodied the best of this duality.

Although the Painting Department was at this time run in a fairly loose way, like the other departments it operated according to an idea of medium-specificity. Similarly for Richon it remains important not to lose sight of the specificity of the photographic medium, however much this might be coloured by his identification of photography's hybridity, as 'a medium with no fixed identity. This disregard for a fixed essence is photography's strength: no aesthetic purity but a multiplicity of rhetorical forms.'[16] This protection of medium-specificity, identified as a particular strength by Matthew Higgs who was a tutor in the Painting Department in the 1990s alongside Peter Doig,[17] might in one respect emphasise the lack of crossover or interchange between departments unless initiated by the student; a film for instance if made by a Painting student would be understood to engage with the language of painting.

Medium-specificity within the Painting Department has produced over more than 20 years a rich environment in which different approaches could be investigated – and is an environment which therefore allows for the expression of content (over a pursuit of form, of one approach to painting) to be the motor driving the different students along. This reflects also one role of the MA, to allow students to unpack, readdress and put back together their work – as critic Sacha Craddock observed: 'any MA of any worth will expect a real turn around for the new student, a breaking of recently formed habits.'[18] This process is not necessarily harder when there are no barriers between different media – the approach however is very different. Similarly, Higgs – writing in the catalogue for the 1997 interim Painting show – pointed out that the show was a declaration of 'difference... No "School" will emerge. 20 artists elected – and were subsequently selected – to study at the same place at the same time. No other connection exists. No national tendencies. No shared positions. No social agenda. No common ideology.'[19]

In Painting the RCA's approach to medium-specificity has encouraged different kinds of language and approaches to

Spartacus Chetwynd
Xerox Mask, Cruikshank
2004
Paper, glue and tape

Jake Chapman
Insectocutor
1992

Chris Ofili
Now's the Time
1993
Acrylic, oil and elephant dung on canvas

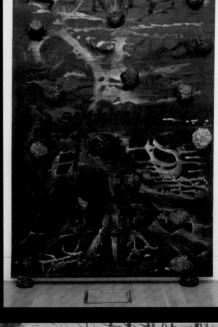

David Rayson
Weeping Willow
2008
Archival ink on paper

Anthea Hamilton
Untitled
2004
Oil on linen

George Shaw
Scenes from the Passion: Four Paths
1998
Enamel on board

Peter Kennard
A Poster of *Broken Missile* Taped
to the Fence of Greenham Common
by a Protester
1982
Photograph

painting to flourish over the last 20 or so years. Artists as different as Dexter Dalwood, Andrew Grassie, Phillip Allen, Chris Ofili, Neal Tait, Dan Coombs, Chantal Joffe, Tim Stoner, Martin Westwood, Paul Housley, Clunie Reid, Dawn Mellor, Nigel Cooke, Kaye Donachie, Peter Lewis, David Rayson, Hurvin Anderson, Gillian Carnegie, George Shaw, Stuart Cumberland, Jasper Joffe, Ian Kiaer, Marta Marcé, Claire Pestaille, Markus Vater, Anna Sofia Bjerger, Gordon Cheung, Sara MacKillop, Sigrid Holmwood, Will Daniels, Jamie Shovlin, Varda Caivano, Spartacus Chetwynd, Thomas Hylander, Daniel Sinsel, Sam Windett, Nicholas Byrne, Anthea Hamilton, Helene Appel or Laura Oldfield Ford have all come out of that one single department over the last 20 years. For some artists, their work has remained consistent with their final show, for others their work has made dramatic shifts; for some, painting is about the application of paint to a surface that has edges, to others, their attention and practice has moved into sculpture or installation, photography, film or performance. Similar lists could equally be made of students from other departments. Their range puts the lie to a single branding for art of the last 20 years – whether yBa or post-yBa – but it also underlines the view that the college studio is 'the testing ground where the making of modern painting takes place… the laboratory for its new alchemy… A place of privacy to bring into being something whose reason for being they themselves may doubt… Privacy and space in which to invent and build… Channels of interaction to test their ideas and share their ambitions.'[20]

However, recently there has been a concerted effort to draw the Fine Art departments together physically on a shared campus in Battersea designed by Haworth Tompkins. This built on Christopher Frayling's long-held vision for future College development once the Sculpture studios had taken over a converted factory in 1991 – the building having reopened in 2009 following refurbishment by Wright & Wright. In 2010, the Painting Department moved into the Sackler Building that had been designed by Haworth Tompkins and paid for not only by an award from the Sackler Foundation but also, pointedly, by the sale in 2008 for £8.1m of Francis Bacon's painting *Study from the Human Body, Man Turning on the Light*, 1962, which he had originally given to the College in lieu of studio rent in 1969. Significantly, this is the first time in the College's history that it has had a

dedicated studio building for painting – David Rayson, once a student and now professor of Painting memorably described the old studios as 'stacked on top of each other like shelves.'[21] Once the Sackler Building had been completed, construction work started on the Dyson Building and this year, two years later, the Printmaking and Photography programmes moved in. Alongside studio space for the two departments, the building also houses a gallery space and a 230-seat lecture theatre, as well as a group of 40 incubator units so that recent design graduates can start to test their designs in the marketplace, giving them access to dedicated studio and workshop space, and to a range of shared facilities within the College. Looking forward, the Battersea campus will also include a building to house the two applied arts programmes of Ceramics & Glass and Goldsmithing, Silversmithing, Metalwork & Jewellery.

The creation of this Battersea campus, however, does not signal that the barriers will be down and the differences between the different media and practices will be lessened. In a text written by the four Fine Art heads of department in 2009, the year before the opening of the Painting Department's building, it was asserted that 'The departments of the Fine Art School have strongly resisted merging in any way, however economically expedient that might seem. We have noted in other institutions, when Fine Art departments merge, particular facilities are soon lost and it is unlikely that these will ever be regained. It is so much easier to pull something down than try to rebuild it. The move will achieve proximity, not unification.'[22] Ultimately, the equation between difference of practice and medium-specificity is determined by that other equation forged between the student and the studio – the studio being the microcosm and heart of the College. This commitment has been emphasised by a number of recent appointments, notably Alex de Rijke as dean of Architecture, and in 2011 Naren Barfield as pro-rector (academic) – the first practising artist to be appointed to the role in the College's history. The RCA's strength over 175 years – and especially in terms of the pressures of a more contemporary context – is to hold fast to a shared set of principles that revolve around 'the creative and individual act of making art: expression through visual thought.'[23] It is apt, therefore, that the recently appointed dean of Fine Art, Ute Meta Bauer, who is art school trained and has 'always

Dexter Dalwood
Untitled
1989
Oil on canvas

Tom Hunter
Woman Reading a Possession Order
(from *Persons Unknown* series)
1997
Cibachrome print

believed in creating my own structures and contexts rather than waiting for things to happen'[24] – is joining the RCA at a time in which the negotiation between an individual pursuit of a practice defined by media or department will become ever more urgent. Between 1999 and 2002, Bauer was a co-curator of *Documenta 11*, part of the team headed by Okwui Enwezor (and alongside RCA Professor Mark Nash among others). From 2005 to 2009, Bauer was director of MIT's Visual Arts Program and for the last two years has served as head of its new programme in Art, Culture and Technology. Bauer's interest has consistently been directed at cross-disciplinary practice and research, and the ACT programme at MIT with its emphasis on activity at the intersection of art, culture, science and technology typifies her approach that may carry through at the RCA. Her view is that 'expanding the notion of what contemporary art might be, while questioning the role of art in changing societies has to be part of the critical debate. One should bear in mind, for instance, how video and performance art has been invented by painters and sculptors. Today the RCA is running from two campus sites, with all the Fine Art programmes located at Battersea. Nevertheless, we strongly encourage our students to look beyond their comfort zone and experiment across programmes. Today practitioners in the arts pursue research and investigate the very field they are working in.'[25] As is to be expected, new skills and areas of intervention are being developed all the time at the RCA, but what is perhaps unusual is the retention of all the old skills, techniques and ways of working – it being for Bauer not a question of 'either/or; it encompasses all of that'.[26] It is a view that significantly serves to re-emphasise the RCA's commitment to what happens in the studio, between studios and between disciplines, as much as fundamentally between exploring, making and thinking.

Acknowledgements

I would like to thank all the students and members of staff, past and present who have helped me in the course of writing this text, in particular, Phillip Allen, Stuart Comer, Dexter Dalwood, Adam Dant, Teresa Gleadowe, Margerita Gluzberg, Matthew Higgs, Peter Kennard, Tania Kovats, Melanie Manchot, Neil Parkinson, David Rayson, Clunie Reid, Octavia Reeve, Olivier Richon, Jo Stockham, Milly Thompson, Paul Thompson, Clarrie Wallis and Richard Wentworth.

[1] Huxley, P. (1993) 'Foreword', *RCA Painting School Degree Show 1993 supplement*, exhibition catalogue, Royal College of Art, 4

[2] Slyce, J. (2004) 'A School is a Factory', *Fine Art RCA 2004*, exhibition catalogue, Royal College of Art, 7

[3] Bracewell, M. (2002) *The Nineties, When Surface Was Depth*, Flamingo, 13

[4] The 21 artists included in *Brilliant!* numbered among them Jake and Dinos Chapman, Tracey Emin and Chris Ofili, who had graduated from the RCA, while the 42 artists in *Sensation* included Jake and Dinos Chapman, Tracey Emin, Alex Hartley, Chris Ofili, Hadrian Pigott, Gavin Turk and Cerith Wyn Evans as graduates of the RCA.

[5] Email communication between the author and David Rayson, 2 July 2012

[6] Quoted in: 'Gavin Turk and the Royal College Degree Show', *Frieze* no.1, September–October 1991, 12

[7] Ibid.

[8] Maloney, M. (1997) 'Everyone a Winner! Selected British Art From The Saatchi Collection 1987–1991', *Sensation, young British artists from the Saatchi Collection*, exhibition catalogue, Royal Academy of Arts, 26

[9] Huxley, P., op. cit.

[10] The Curating Contemporary Art course was set up at the RCA in 1992 by Teresa Gleadowe. Initially co-funded by the RCA and the Arts Council of Great Britain, philosophy and theory were initially provided by Jon Bird's Visual Culture MA course at Middlesex University, which all the students followed. (Middlesex was paid a fee by the RCA out of the Arts Council's annual grant; the involvement with Middlesex being a condition of Arts Council funding for the course.) In addition to the course at Middlesex, Bird provided a weekly seminar at the RCA. In 1999 the collaboration with Middlesex ended when Dominic Willsdon was appointed to provide the theory component to the course, until his departure in 2005 when Jonathan Rée took over this role.

[11] *Photography Department Student Handbook 2000/01*, Royal College of Art, 2000, 11

[12] Email communication between the author and Adam Dant, 3 July 2012

[13] Email communication between the author and Olivier Richon, 15 July 2012

[14] Emin, T. (2009) 'Alan Miller was a true ally. He showed me how to be a painter', *The Independent*, 22 January (http://www.independent.co.uk/opinion/columnists/tracey-emin/tracey-emin-alan-miller-was-a-true-ally-he-showed-me-how-to-be-a-painter-1488542.html, accessed 8 July 2012)

[15] Emin, T. (2006) untitled text in: *Generation, The Summer Show*, Royal College of Art, 17

[16] 'Photography', *Show RCA*, exhibition catalogue, Royal College of Art, 2008, 47

[17] Email communication between the author and Matthew Higgs, 3 July 2012

[18] Craddock, S. (2005) 'The Hum of the Heater...', *RCA Show 2005*, exhibition catalogue, Royal College of Art, 38

[19] Higgs, M. (1997) 'Some thoughts on the occasion of an interim exhibition', *Swell, painting*, exhibition catalogue, Royal College of Art, np

[20] Huxley, P., op. cit.

[21] Cited in: Edwin Heathcote (2009) 'RCA's Sackler Building, Battersea by Haworth Tompkins', *The Architects' Journal*, 26 November (http://www.architectsjournal.co.uk/buildings/rcas-sackler-building-battersea-by-haworth-tompkins/5211341.article accessed 8 July 2012)

[22] Rayson, D., Richon, O., Stockham, J. and Williams, G. (2009) 'School of Fine Art', *Show RCA 2009*, exhibition catalogue, Royal College of Art, 12

[23] Ibid.

[24] Ute Meta Bauer interview by Carson Chan, *Kaleidoscope* (http://kaleidoscope-press.com/issue-contents/ute-meta-bauer-interview-by-carson-chan/, accessed 20 July 2012)

[25] Email communication between the author and Ute Meta Bauer, 4 September 2012

[26] Ibid.

The Power of 'Besottedness': Art School and the Future
Sarah Teasley

Shing Tat Chung
'The Superstitious Fund' Project
2012
Installation

Jasleen Kaur
Lord Robert Napier
2011
Photograph

Previous Page
Top: Markus Kayser
Solar Sinter
2011
Mixed media
Bottom: Tobias Revell
*88.7: Stories from the First
Transnational Traders*
2012
Mixed media

ENOUGH OF THE PAST – WHERE ARE WE GOING?

The Power of 'Besottedness':
Art School and the Future
Sarah Teasley

James Wignall
Fallen Icon
2010
Architectural drawing

Markus Kayser
Solar Sinter
2011
Mixed media

The RCA's 175th anniversary reminds us that 'art schools'– shorthand for the different forms that higher education in art and design has taken over the past two centuries – have been with us for a while. We know from the other essays in this volume – and likely from personal experience – that the form, content and social value ascribed to 'art school' can vary drastically from period to period, and place to place. In its lifespan alone, the RCA has taught everything from textile design to holography, and from illustration to architecture. Once, it asked students to spend their days drawing from plaster models; now, inspiration and idea development may derive from anything and anyone, from global finance and older residents of Kensington and Chelsea to climate science, bioethics and Britain's postcolonial history. Many graduates pursue careers as artists, designers, architects, curators and critics, but others take less conventional routes, advising government, science and NGOs, launching start-ups and achieving pop music stardom. Tutors, too, are expanding definitions of art and design's contribution to the world through critical research practices that change the way we see the world, as well as determining how it looks.

While art schools' questions, methods and orientation in the world may have broadened since 1837, some things are constant. Looking globally, these include continued questions about art schools' ideal relationship to industry and national prosperity, and conflicting concerns – often held at the same time – that art school is either too luxuriously removed from the grind of ordinary life and work, or too orientated towards industry for the creative anarchy necessary for art to flourish. We are still not entirely comfortable with art schools' position in higher education, and we would be much happier if we could establish some kind of incontrovertible and universal way to evaluate art and design 'outputs' in a rubric comparable to those of humanities, social and natural sciences. Are art schools for professional training or for liberal arts-style intellectual development? Should they point students towards engaging with pressing social and economic issues, or provide them with a space away from life's pressures to dream, imagine and explore? Is design education really the same as art education? Should we teach skills or conceptual development? And who should fund higher education, generally? Such questions seem entirely contemporary, but as

the essays in this book demonstrate, often vividly, they have shaped higher education in art and design since its inception. This should not surprise us: it's the rare creation that doesn't bear the stamp of its place and time, be that cultural, social, political or economic – what generations of art school students know as 'context'.

Rather than looking into the past to understand how art schools' context has shaped its development, this essay will peer forwards, in an attempt to see how our context may change, and how art school might adapt to it. Hopefully, little of what follows will surprise; the argument, in fact, is that experience has already allowed us to know what we do and how we do it best, and that much of adapting to the future may rest on recognising these traits and abilities.

Many of the historical changes that will affect art schools in future are clear; what is less obvious is how we will respond to them, or the form they will take. Technological change is a good example. We can predict some of the impact that digitisation will have on art and design education: the shrinking cost of technologies such as additive manufacturing will broaden students' options for how to make things, offering a range of choices including hand tools, traditional workshop machinery and the old–new technology of CNC milling, as well as 3D printers and whatever comes next. (Nanoscale biological fabrication? The cost of gene sequencing and other scientific technologies is coming down, too.) As it becomes easier to make through software, we will need to understand not only how to use the interface but what is happening underneath the hood, before what sociologists call 'the black box effect' takes hold. We might learn something from the digitisation of graphics, printing and cinema in the 1980s and '90s, and we should stress the importance of learning code. Unlike classical engineering education, in which students fabricated their own tools to familiarise themselves with machines, art and design students may not programme their own software, but they should learn how their new tools behave.

But digitisation will also bring effects that we cannot predict in nature or magnitude, as students who are digitally literate in ways we cannot yet know – a generation exposed to iPads, online environments and smartphones from infancy – enrol in art school. Daniel Charny, curator and director of From

Now On and former senior tutor in Design Products, argues that their technological familiarity will be unrecognisable to those of us who grew up in a more analogue world, and that we will need to explain to them just how important physical objects were to us.[1] We cannot foresee the nature and extent to which students' relationships with screens, script and things will change, but we can prepare ourselves by engaging with emerging technologies – by getting our hands dirty in a new way. We can recalibrate our media literacy to respond to this increasingly dense field of information by developing critical tools for assessing new technologies and information's validity and applications, and continue to help students become critical but not cynical. We must also recognise the relevance and import of the knowledge we have gained through our own continuing experiences with existing and old–new technologies, and think analogously through it.

The impact of continued globalisation too is inevitable if unpredictable – and already well visible in the final paragraphs of Fiona MacCarthy's essay in this volume. We tend to see globalisation in art and design higher education as driven by a set of contemporary conditions and concerns including art schools' international reputations, foreign corporations' and governments' willingness to fund overseas study for exceptional young talent and the invidious pressure to patch holes in income left by dwindling state support through high foreign student fees. But movement in transnational networks is hardly a novel condition. Artists from the Americas and Asia studied in the painting ateliers of nineteenth-century Paris, and artists, designers and architects from Korea, Taiwan and China travelled to Japan in the early twentieth century to study there. More recently, a generation of creative minds now shaping art and design education in the UK gained experience working in Japan in the late 1980s and early '90s. Art schools can learn from these experiences as we chart our globalisation strategies. Looking ahead, our playing field will change as the new art and design universities springing up in China mature, providing competition as well as opportunities for staff and student exchange – and hopefully, some provocative challenges to our accepted ideas about how and why we teach. We might also expect numbers of African students and collaborative projects with African schools to rise, again cross-fertilising school cultures and

enriching student experience. Programmes such as Global Innovation Design, a new collaborative Master's programme in development between the RCA and institutions in London, Tokyo and New York, will enable students to experience the logic of global practice while still in school, and offer a satisfyingly unanswerable challenge: what happens when an art school's 'local community' is literally transnational?[2]

Globalisation also means changing communities within the UK (and many other countries), adding new art and design traditions to the mix as well as other cultural attitudes towards art and design education. As with new technologies, we will be best served by welcoming plurality, but there is a challenge here, too: how might we enable students from under-represented groups in art and design to choose art school as a next step? Inspire, a joint initiative of the RCA with Arts Council England to increase the numbers of black and minority ethnic curators, is one example of how this might be done, but such initiatives require a commitment to long-term and external funding, and raise complex questions about integration versus special-track education. Internal globalisation affects content as well. Without reinventing the 'culture wars' of 1980s to '90s North America, we need a better understanding of 'the ordinary' – and to recognise that 'the ordinary' can take multiple forms at one time and place, without threatening existing traditions. One way in which this happens already, in an almost organic form: RCA tutors often say that our students learn the most in the first term, when they are confronted with the attitudes, values and abilities of peers from six continents at the same time as they are dropped into London's particular culture.

How will the pull of global networks mesh with expectations for art and design schools to participate in their local communities and contribute to local and national economic wellbeing? In Britain, given the still-important role of state funding in supporting art and design education at all levels, this is a crucial question. So is the tension between governments' desire to restrict immigration, concerns about equipping young Britons with skills for meaningful work and the important role played by young, creative and skilled migrants – including many RCA graduates – in generating new industries and arts cultures (as well as revenue) in their adopted home. And how will the pull of the global interact with the

decades-old trends in education towards standardisation and compliance culture? National quality assurance guidelines lead, at best, to accountability, high standards and greater opportunity for student satisfaction, at worst to homogenisation, low morale and an inability to take risks. A careful balance is required, so that we do not damage art schools' growth and international reputation by accident, and lose the ability to meet students' expectations for art school as a place of experimentation, particularly in Britain.

For simple reasons of supply, art and design education at all levels – like all areas of creative practice and inquiry, including the sciences – is unlikely to enjoy ample state support again for a while. Here, British art schools can look to other nations where semi-privatisation occurred one or two decades earlier to see what we might do, and what may happen to us. If we are creative and fortunate, we cultivate partnerships with other levels of government or new funding streams such as corporate patronage and alumni support, as do many American universities. A less sanguine scenario might see us competing for limited and dwindling state funding – a scenario in which it's all too easy to imagine either a mass sink towards mediocrity or a 'survival of the fittest' pruning of institutions, in which provincial art schools and programmes that serve first-time university-goers may suffer most – and talented students will be discouraged from pursuing a postgraduate arts education due to the phenomenal cost. Here, the importance of maintaining British art schools' strong reputations becomes even more clear: we cannot see how we will be funded, but we must continue to stress quality as well as value for money.[3] We need to continue publicising what we do and to continually experiment with the best language for doing so, both to attract new students and to remind government and society why our continued existence – and support for art and design generally – is important. To some extent, this may even be welcome: it's helpful to be asked why we do what we do for our own sakes, as well as important for accountability. But we also need to tell our interlocutors when the questions they're asking aren't the right ones, or are limited, rather than acquiescing to a system that our experience tells us is inaccurate or flawed. As Helen Kearney, 2012 RCA research student, points out:

The current argument that 'design is equivalent to a STEM [science, technology, engineering and mathematics] subject' as a way of validating its continued funding and public support is dangerous. There's a danger in campaigning too much. We have rigour and standards but we're creative. That's what makes us interesting. We're at the edges. Taking the concept and pushing it further and further, in all sorts of directions, is what art can do.[4]

Questions around sustainability will not disappear, either. Art schools' campaigns to focus students' attention on the environmental, social and economic sustainability of projects combined with students' own awareness – now fostered since primary school, in many cases – are already effecting behavioural change, to the extent that some students argue sustainability should no longer be an assessment criteria: they'll consider it regardless, as a matter of course. Currently, students' enthusiasm for sustainable practice cannot always be mirrored in industry, where concrete considerations like existing production lines, unverifiable supply chains and low margins, as well as old attitudes, continue to impede sustainable business practices. The latter will be less of an issue in 20 years, when today's students are decision-makers. But social and economic concerns will not disappear, and environmental pressures only increase as oil reserves are exhausted, global warming intensifies and the toll of decades of enthusiastic industrial production on people, cities and countryside in industrialising nations becomes apparent. Art schools need to continue emphasising sustainability now, both as a form of competitive research into good practice and so that we are able to best meet these challenges in future.

This is particularly true in fine art disciplines, where relative distance from industry – manufacturing as well as advertising – has allowed sustainability to take a back seat to other considerations, most obviously the art market's ravenous appetite. There is a wicked illogic here, however, as the impact of market demand on students' approaches to their practice raises concerns about the sustainability of the system itself. Ute Meta Bauer, dean of Fine Art, has commented: 'Before the incursion of the market, art schools could still more easily be testing grounds for experimentation and innovation, including failure. But are they still places where you can discuss the meaning of artistic production within the larger field of culture, or, perhaps more precisely, debate what *is* culture today in such a globally expanded field of experience and how art schools have adapted to this fact?'[5] Today, design students too find their work commodified as 'the latest thing' hours after first presentation, thanks to design blogs and Twitter feeds. While useful in raising public awareness of strong work and the potential public contributions of critical design (also in attracting support for its young practitioners, one hopes), the immediate mediatisation of graduates' work evokes somewhat unnerving parallels with past bubble economies in tulips and flats. Art schools need to continue to assert the importance of rigorous, sustained peer and tutor critique within the institution for students' self-awareness of the work, and to strengthen support structures for 'life after art school' such as FuelRCA.

It is safe to say that these trends – digitisation, globalisation, standardisation, pressure to contribute to the national economy, declining state support, environmental and professional sustainability issues – will continue for the foreseeable future. As outlined above, some of our responses are clear, but the future itself – how people will react to these trends more broadly, and what other contingencies may arise – isn't actually that foreseeable. What art schools can do, though, is to remind ourselves of our best qualities, strengths and character – not what we are, necessarily, but what we can be – so that we might put these elements of 'best practice' towards future challenges as they arise. The rest of this essay, then, outlines a set of characteristics that art schools can have.

At its best, art school is an assemblage of laboratories, experimental spaces in which tutors and technicians model professional practice and students gain skills, self-awareness and confidence *as everyone does their work*. Labs are where artists and designers (and scientists) propose, hypothesise, create, test, examine, interrogate, reformulate, fail and succeed, in a never-ending process that's often as frustrating as it is joyous, yet compels beyond reason. Participants at all levels are expected to identify techniques appropriate to their projects, to engage in the conversation and critique and to challenge and develop their practice through it. Professor Anthony Dunne of Design Interactions argues, 'In an ideal world, at MA level there shouldn't really be disciplines but

studios with different agendas and ideologies exploring different roles and possibilities for art and design in society. Each should be a sort of atelier where students and staff work together – experimenting, reflecting, learning, disseminating.'[6] Ideally, we talk across disciplines: challenging each others' assumptions and ways of working, so that we emerge with a stronger sense of why we work as we do, while also drawing new ideas and methods from the photographers, fashion designers or historians down the hall. This may happen *within* programmes – Innovation Design Engineering at the RCA and the MA in Transdisciplinary Design at Parsons the New School for Design are two examples of programmes where designers, artists, engineers and the odd economist work collaboratively on briefs that intentionally need multiple skills and perspectives. But it blossoms most compellingly, perhaps, when encouraged but also left up to chance, for example by providing communal (and therefore irrational and inefficient, but that's partly the point) spaces for improvisation and unexpected encounters. Professor Jo Stockham of Printmaking sketches an intoxicating image of what this might be:

> *Here's to sociability and play as work, craft and meaning bought into relationship... My art school ideal would have a garden at its centre (or on its roof!) and a shared canteen where people are learning to cook. Cloisters with seating alcoves where people could walk and talk even in the rain, at least one large simple empty space with clear walls which opened on to the garden where people could stage events, have parties, invite in dancers, show films, host workshops and encourage improvisation.*[7]

While easier to implement at postgraduate level than at undergraduate, the laboratory system requires a certain autonomy granted to its researchers, and autonomy requires trust, confidence and self-criticality. Such a culture understands that failure is important, and granting some autonomy to students is partly about allowing them to fail.[8] It runs on the assumption of good faith: that in an art school, tutors and students alike are there because they can't bear to be anywhere else, and consequently bring their best to endeavours. Here we might look back to former RCA rector Robin Darwin, who said:

Jane Bowler
Blue Raincoat
2010
Recycled plastic

Screenshot of *Unmaking Things:
A Design History Studio* Website

We are fortunate here as compared with universities to which some students may go for expedient reasons; for the awards that is to say which are offered, rather than for interest in the subjects studied. Students come to us because they are truly besotted in their work and for the most part ask only for the freedom and protection necessary to its pursuit. They are, I believe, essentially concerned with ideals beyond themselves and thus, without knowing it, serve the traditions of Learning that have been hallowed for all time. It strikes me sometimes as faintly comical, though I am intensely proud of the fact, that in these material days, we here should be privileged to help in keeping this ancient fire aflame.[9]

Darwin's characterisation of art school students as both besotted and oddly selfless, concerned with things beyond and outside themselves, is almost maddeningly accurate; indeed, his only slip was in not including tutors, too, in his formulation. Noam Toran, senior tutor in Design Interactions, describes the best project briefs as those that challenge the tutor as well as the students, for which there's no obvious answer, and the question and challenges are open-ended and likely unsolvable.[10] The questions can be self-reflexive: how might we improve our practice? What else is out there – in other disciplines, as well as our own – that we might use to do so? How can we set the bar higher for our discipline, too? Asking such questions individually in the communal setting allows tutors to learn from students, too. Reflecting on their experience running a student-led space, Department 21, in the RCA's 2009/10 academic year, Brave New Alps (RCA graduates Fabio Franz and Bianca Elzenbaumer) commented, 'We had the feeling that those tutors who came along had a sense of being peers of the students, simply trying to walk a line of creative practice that also students were exploring. It felt like walking a piece of the way together, having interesting discussions and learning from each other.'[11]

Art schools can be connected, even embedded in their communities and in industry, allowing tutors and students to ask 'real-life' questions, experience 'real-life' work and potentially realise the solutions. (Some questioning is provoked rather than requested: we might look back to Womanhouse, the house-sized installation created by the Feminist Art Program begun at California Institute of the Arts in Los Angeles in the early 1970s to tackle gender issues in the art and local community, as a powerful example here.) Students also gain professional networks, technical, critical thinking, communication and planning skills and the confidence to engage industry and peers. They are places where emerging practitioners can fit themselves into genealogies of practice, write themselves into the larger narrative of their profession. But the relationship can be more complex. Rector Paul Thompson argues, 'Is our role to produce students who are industry-ready, or to produce thinkers and game changers? The latter... Our role is to be imaginative, to ask 'what if?' – to be provocateurs, and give inspiration.'[12] Sam Livingstone, senior tutor in Vehicle Design, feels similarly:

We're not in the business of training students for industry, but in preparing them to create the future. The question for us is 'how to make sure that the future isn't the past in exaggerated form', i.e. we don't just want to transmit how we've done things to the next generation, and to have them plug into the existing mould. We want to enable them to make their own structures and practices. We're not a finishing school for car designers. We want to support people who might lead and go beyond where we are now. We're not trying to usurp the mould, the existing idiom, [rather] we're simply not considering it. Art school can encourage students to go further, so that when they leave, they're not slotting into what exists already, but actively shaping its next steps.[13]

Providing students with skills for research and critical analysis and a strong sense of intellectual rigour is part of this, as is enabling speculation. The art school's role as an experimental space outside of industry can allow for following an idea to its conclusions, no matter how extreme, impractical or defiant of natural law, social convention or accepted knowledge they may be. As 2012 History of Design graduate Marilyn Zapf suggests, 'Projects may not be ethical, but perhaps that's not a problem. Following ideas to completion, then addressing the problem is a way that art schools can work.'[14] Vehicle designers, for example, can pursue the idea of designing mobility rather than designing cars, and graphic designers the possibilities of designing democratic practice.

Installation View of *Impact!*
Exhibition
with Zoe Papadopoulou's *Nuclear
Dialogues* in the Foreground

Here, art schools share their critical power with the humanities and their rigour with both arts and sciences, but adding a visual, tactile and aural language that communicates differently, sometimes more immediately.[15]

According to Gareth Williams, senior tutor in Design Products, it is the combination of freedom and constraint that gives art schools their power.

> There is always a tension between colleges being places for entirely free and autonomous exploration and expression of creative ideas, and places where students can interact with the 'real world'… from which they can learn. This interaction can sometimes seem intrusive but needs to be present to best prepare students for the future. Art and design universities should be places which celebrate and cherish individualism and autonomy, where people can ask the 'what if?' questions and be taken seriously, but where they can meet contrary and sometimes contradictory points of view and evidence too.[16]

One possible – and again useful – constraint is the gamut of expectations for what art school students will contribute to society: from individualistic self-expression that provokes

reflection in others to projects that directly aim to benefit others. For students, this means the expectation that they will, as Williams phrases it, 'employ their skills as transformative agents in social contexts. We… want to make designers who can think imaginatively and coherently about a range of social, economic and technological challenges.'[17] Tutors and students both can channel art schools' particular combination of creativity, criticality and embrace of the unexpected towards public issues at local and national levels. Art school as experimental lab space fulfils a second social role, too, generating potentially useful ideas for society at large but also functioning as a kind of beacon of uncontrollable creativity, blinking out into the world to unsettle, comfort and excite. This is as true for often unsung local art schools as it is for massively mediatised metropolitan schools like the RCA, Central Saint Martins and Goldsmiths and the *zeitgeist*- and imagination-capturing schools of past eras; we might include 'support local art schools' in the 'to-do' list above, too.[18]

These are only some of the things that art schools can do; the list continues far longer than these pages allow, as do examples of good practice. But volume and familiarity are the point: art schools possess many of these attributes as a matter of course. At its best, the RCA certainly does. It is exhilarating, exhausting in the intensity of its stimulus, heady, nourishing, challenging, confounding, confidence-inspiring, joyous and energising. It makes us want to contribute – to the school, to our colleagues and students, to our communities – because we receive so much from our time and effort in it. The 'art school of the future' isn't just about defining what we should be and do, but also about recognising and acknowledging what we already are and do, and finding strategies for ensuring that these qualities persist and deepen, in the near and further future. We don't speak much of 'besottedness' these days, but perhaps we should.

'Exploring the Gap between Promise and Performance in Technical Drawings' Workshop Department 21's Outdoor Platform during *Show RCA 2011*

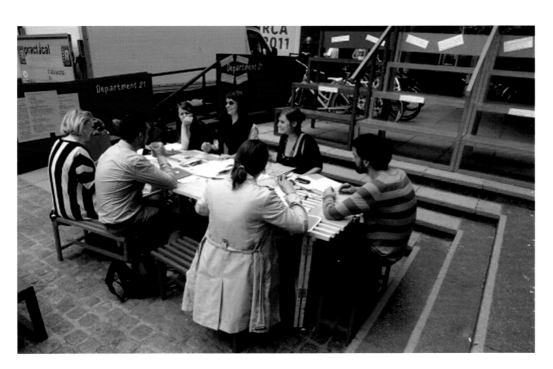

1 Charny, D. (2012) comments made as part of 'Design and… Education', Victoria and Albert Museum, 17 July

2 On the transnational state of design education, see Traganou, J. (2011) 'From Nation-bound Histories to Global Narratives of Architecture', in: Glenn Adamson, Giorgio Riello and Sarah Teasley (eds) *Global Design History*, London: Routledge, 166–73; and Jilly Traganou and Miodrag Mitrasinovic (eds) (2009) *Travel Space Architecture*, London: Ashgate

3 The concept of 'quality for money' in higher education is inspired by Michael Wood (2011) 'Must we pay for Sanskrit?', *The London Review of Books*, 15 December, 10

4 Interview with Helen Kearney, 28 June 2012

5 Bauer, Ute Meta (2009) 'Under Pressure', in: Steven Henry Madoff (ed.) *Art School (Propositions for the 21st Century)*, Cambridge MA/London: MIT Press, 219–30

6 Anthony Dunne, email correspondence received 17 July 2012

7 Jo Stockham, email correspondence received 23 July 2012

8 The RCA's Learning and Teaching Strategy, 2011–15, states: 'We expect [students] to take risks. The freedom to make mistakes is an important part of the learning process.'

9 Darwin, R. (1968) Royal College of Art Inaugural Meeting of the Court, 7 February

10 Interview with Noam Toran, 16 July 2012

11 Brave New Alps (Fabio Franz and Bianca Elzenbaumer), email correspondence received 18 July 2012. See also the Robbins Report (1963): 'It is the essence of higher education that it introduces students to a world of intellectual responsibility and intellectual discovery in which they are to play their part… The element of partnership between teacher and taught in a common pursuit of knowledge and understanding, present to some extent in all education, should become the dominant element as the pupil matures and as the intellectual level of work done rises… (*The Robbins Report: Higher Education*, report of the Committee appointed by the prime minister under the chairmanship of Lord Robbins Cmnd. 2154, London: HMSO, 181)

12 Interview with Paul Thompson, 14 June 2012

13 Interview with Sam Livingstone, 6 July 2012

14 Interview with Marilyn Zapf, 28 June 2012

15 For one argument in support for the arts and humanities more generally as vehicles for open-ended thought, and for the social import of such research, see Thomas, K. (2011) 'Universities under attack', *The London Review of Books*, 15 December, 9–10. See also Terry Eagleton (2010) 'The death of universities', *The Guardian*, 17 December

16 Gareth Williams, email correspondence received 19 July 2012. See also Ken Lum's comment, 'Students need to challenge dominant ideologies by coming into dialogue with them. This is one of art school's primary roles. But such a role can be achieved only if the instructor's knowledge about the art world is convincing to students. This is one of the reasons that I think it's important to teach, even if I continue to have doubts about the art world at large. What students need to be taught is that art is about making everything in the world relevant.' (Ken Lum, 'Dear Steven', in: S. H. Madoff (ed.) op. cit., 329–39)

17 Gareth Williams, ibid.

18 For more on this argument, see J. Beck and M. Cornford (2012) 'The Art School in Ruins', *Journal of Visual Culture* 11:1, 58–83

THE ROYAL COLLEGE OF ART AND ITS CONTEXT
Nancy Casserley

Queen Victoria crowned

1837

1838 William Dyce replaced Papworth as superintendent of the School and professor

1837 Royal College of Art founded as Government School of Design, based at Somerset House and under authority of Board of Trade; John Buonarotti Papworth appointed part-time principal, with staff of two drawing instructors, one modelling instructor and a librarian

William Dyce

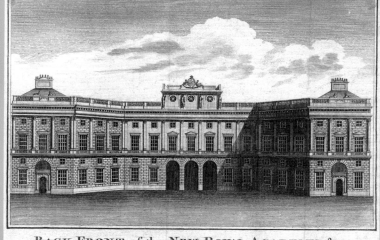

Somerset House

1839 Daguerrotype process of photography introduced

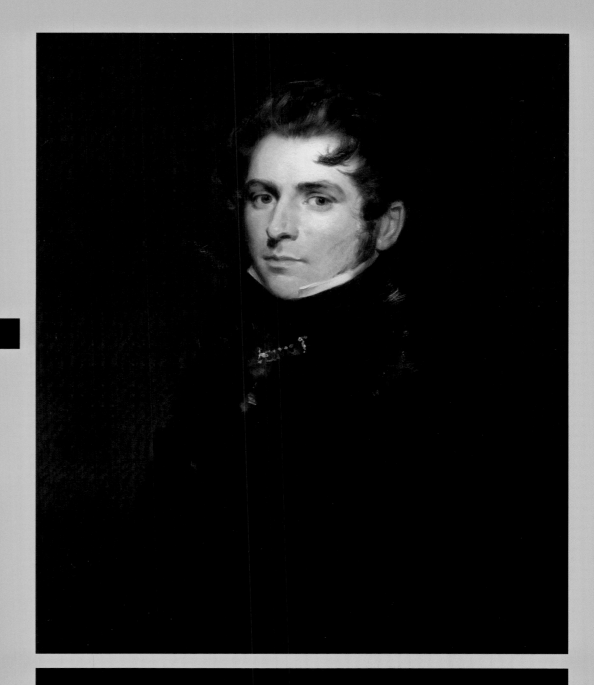

Sir John Watson Gordon
Charles Heath Wilson
c. 1808–64
Oil on canvas

1841 Female School of Design founded at Somerset House; regional Schools of Design established; teacher training classes began at School

1843 Duties of superintendent divided, with Dyce as inspector of provincial Schools and Charles Heath Wilson as director and headmaster of School

1845 Students revolted against Wilson's leadership; Glasgow Government School of Design founded

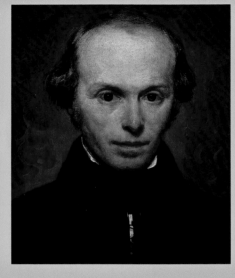

Richard Redgrave
Self-portrait
Oil on canvas

1846 Richard Redgrave joined School of Design; staff also revolted against Wilson's leadership

Richard Redgrave (centre) with Students at the South Kensington Museum

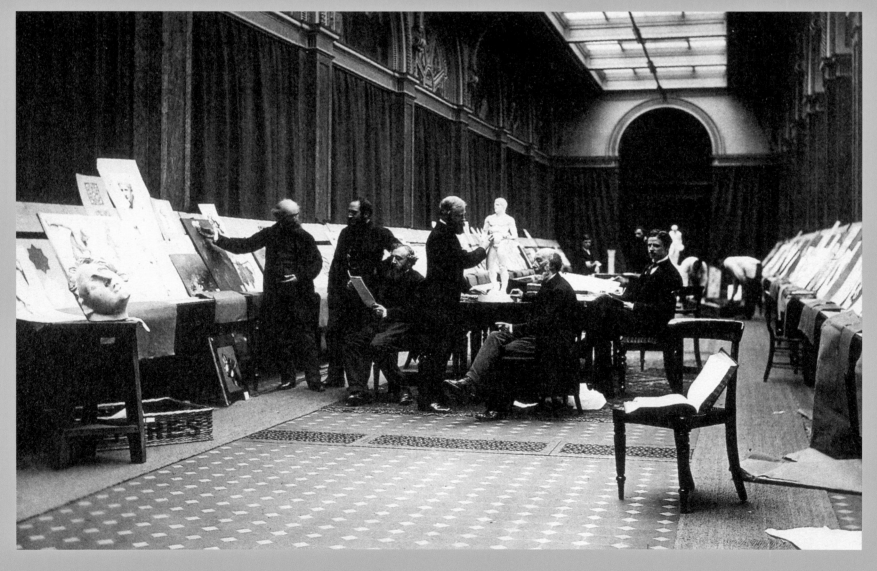

1847 Christopher Dresser
became pupil, aged 15

1848

1848 Karl Marx and Friedrich
Engels published *The
Communist Manifesto*;
Pre-Raphaelite Brotherhood
founded by William Holman
Hunt, John Everett Millais and
Dante Gabriel Rossetti

1848 Government School of Design
reorganised under three masters,
including Redgrave

Joseph Edgar Boehm
Sir Henry Cole KCB (1808–82)
1875
Terracotta

1851 Items from the Great Exhibition selected by Cole and Redgrave to add to School's teaching collection; Female School moved to 37 Gower Street

1849 *Journal of Design and Manufactures* published, with Henry Cole and Richard Redgrave as co-editors; Select Committee of 1849 considered future constitution and management of both teaching and design branches of School of Design

Gottfried Semper
Cabinet on Stand
1855
Ebony, silver-gilt and porcelain

WELLINGTON'S FUNERAL CAR.

1851

1851 Publication by John Ruskin of first volume of *The Stones of Venice*; Great Exhibition held in Crystal Palace in Hyde Park

1852 Government Schools of Design reorganised under new Department of Practical Art, with Henry Cole as general superintendent assisted by Redgrave as superintendent of Art and headmaster of renamed Central Training School of Art

Central Training School and Museum of Manufactures, featuring 'Chamber of Horrors' of items based on 'false principles', moved to Marlborough House; Metropolitan School of Ornamental Art, primarily teaching school, remained at Somerset House with Richard Burchett as headmaster; Redgrave created 22-part National Course of Art Instruction for use at all schools under aegis of Department of Practical Art; Gottfried Semper began teaching at Central Training School; Central Training School undertook as its first major public commission – the Duke of Wellington's funeral carriage, designed by Semper, constructed by male students and decorated with panels embroidered by female students

171

1853 Museum of Manufactures renamed Museum of Ornamental Art; Department of Practical Art renamed Department of Science and Art; Metropolitan School of Ornamental Art moved to Marlborough House, reorganised as Normal Training School

Plate from *Grammar of Ornament* by Owen Jones

1854 St Martin's School of Art founded in London

1856 Publication of *The Grammar of Ornament* by Owen Jones

1857

1857

1857 Schools moved to temporary site in South Kensington, frequently referred to from this point as 'the South Kensington Schools'; Department of Science and Art moved from authority of Board of Trade to Privy Council on Education

Richard Redgrave with RCA Students
Queen Victoria London Ornate (Science and Art) Pillar Box No. 126
1857–9
Cast iron with enamel compass on the lid and aperture in roof

The Loan Collection at the South Kensington Museum

THE LOAN COLLECTION OF WORKS OF ART AT SOUTH KENSINGTON MUSEUM.—SEE NEXT PAGE.

1857 Queen Victoria and Prince Albert opened South Kensington Museum

1859 Publication of *On the Origin of Species* by Charles Darwin; Thonet introduced Chair No. 14

Helen Allingham
The South Border at Munstead Wood
Designed by Gertrude Jekyll
c. 1900
Watercolour

Sir Edwin Landseer Lutyens
Sketch of Gertrude Jekyll in the Garden Court of Munstead Wood, Godalming
1896
Drawing

1861 Gertrude Jekyll became pupil, aged 18

1861

1861 William Morris et al set up Morris, Marshall, Faulkner & Co to create and sell medieval-inspired, handcrafted items for the home; death of Prince Albert

Luke Fildes
Design for Playing Cards
1863
Watercolour, bodycolour and gold paint on paper

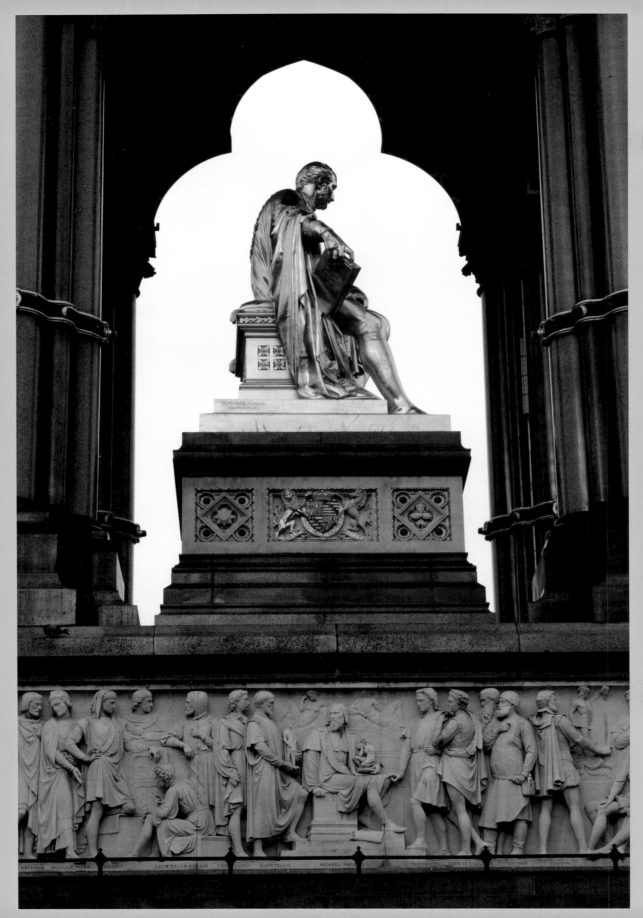

1863 Department of Science and Art introduced National Scholarships for advanced students, with Luke Fildes as first National Scholar

1863 Manet's *Le déjeuner sur l'herbe* exhibited at *Salon des Refusés* in Paris

National Art Training
School Interior

1866 Elizabeth Thompson,
later Lady Butler, began
studying at School

1864 Schools renamed National
Art Training School, moved
to purpose-built buildings in
South Kensington

1865 Kate Greenaway became
a pupil of School, aged 19

1867 Japanese woodblock prints exhibited
at *Exposition universelle* in Paris

Exposition universelle, Paris

Lady Elizabeth Butler
Scotland For Ever!
1881
Oil on canvas

Frieze
Royal Albert Hall, London

Plate from *Principles of Decorative Design* by Christopher Dresser
1873

DECORATIVE DESIGN.
Illustrating Cornice, Ceiling & Wall Colouring.

F. Waller, Lith 18. Hatton Garden.

1873 Henry Cole retired; students from School decorated South Kensington Museum and created frieze on Royal Albert Hall

1873 Publication of *The Principles of Decorative Design* by Christopher Dresser; The *Illustrated London News* began publishing photographs following the invention of the halftone process

1873

Edward John Poynter
October (original cartoon for one of the tile panels in the Refreshment Room of the V&A)
1870
Pencil and watercolour

1874 First Impressionist exhibition held in Paris

1875 Thomas Edison invented incandescent light bulb

Christopher Dresser
Minton Footbath
1874

1875 John Burchett succeeded Richard Burchett as headmaster of School; Edward Poynter became principal of the School and director of Art; Alphonse Legros hired to teach etching in move away from industrial design and towards fine art training

1876

1876 Alexander Graham Bell's telephone and Thomas Edison's telegraph demonstrated at *Philadelphia Centennial Exposition*

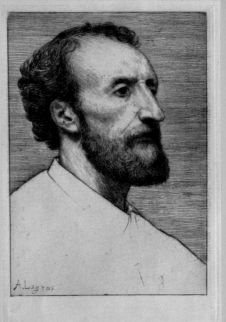

Alphonse Legros
Portrait of Dalou
c. 1863
Black ink on paper (etching)

A Postcard of the Waterman Building,
Rhode Island School of Design

1877 Jules Dalou hired to teach modelling at School

Under the Window by Kate
Greenaway
1878

1877 Rhode Island School of
Design founded in USA

1878 *Exposition universelle* held
in Paris, Eadweard Muybridge
made photographic study of
horse in motion

1880 Edward Lantéri succeeded Dalou as modelling instructor

Christopher Dresser
Semi-spherical Kettle
c. 1880
Electroplated silver

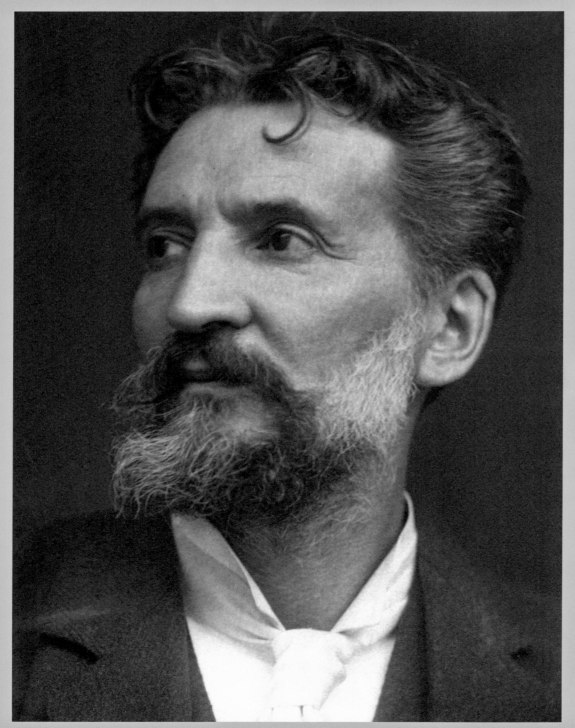

1881 Poynter succeeded by John Sparkes as part-time principal and by Thomas Armstrong as director of Art

George Charles Beresford
Edward (Edouard) Lantéri
1902
Vintage print

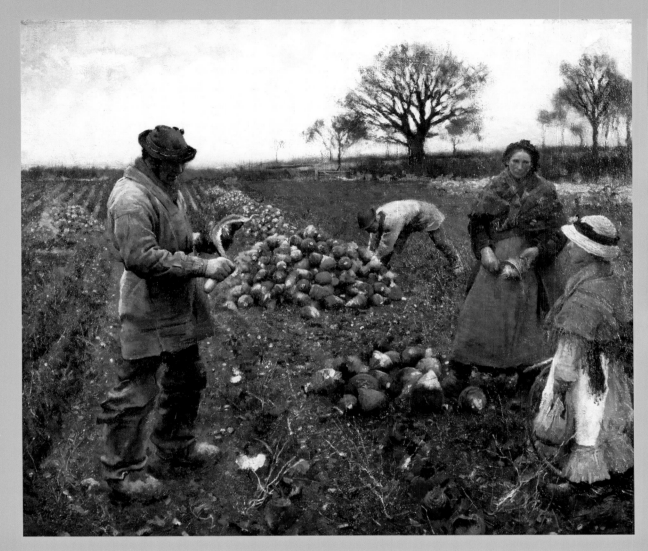

Sir George Clausen
Winter Work
1883–4
Oil on canvas

Sir Edwin Landseer Lutyens
Town Hall
1886
Drawing

1885 Edwin Lutyens became pupil at School, aged 16

1884 Report of Royal Commission on Technical Instruction found insufficient attention paid at School to original purpose of improving industry through design

1885 New English Art Club founded as alternative to Royal Academy; George Eastman invented roll film

Illustration from L'Ornement
Polychrome by Auguste Racinet
1885–7

1885

C R Ashbee
Bowl and Knife
c. 1901

1888 Founding
of the Guild of
Handicraft by
C R Ashbee

1888 Committee report found declining attendance at School due to poor teaching, poor accommodation and increasing competition from private teaching studios with less rigid curricula; staff structure reorganised as result of report with fixed salaries paid to instructors

1889 Eiffel Tower built for *Exposition universelle* in Paris

1893 *World's Columbian Exposition* held in Chicago; Victor Horta designed Tassel House in Brussels

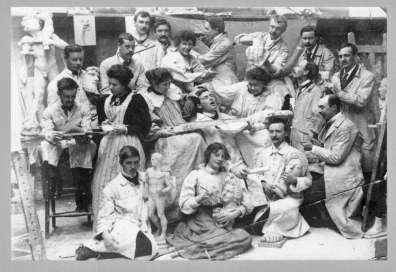

End of Term Frolic
c. 1894

1894 Secretary of Department of Science and Art formulated plan for School involving longer teaching hours; Sparkes became full-time principal

1895 School visitors developed plan to improve School, including practice teaching for trainee art teachers and provision of loom, kiln and forge for students of design and 'art workmen'

1895 Guglielmo Marconi developed radio telegraph communication technique; H G Wells published *The Time Machine*

Morris & Company Announcement

ORRIS AND COMPANY caution their friends against being misled by firms trading under the name of William Morris. The designs by the late William Morris, author of "The Earthly Paradise," and such of those by Sir Edward Burne-Jones as were expressly designed for them for stained glass & tapestry, can only be reproduced by Morris & Company, 449, Oxford Street, W., and Merton Abbey, Surrey.

1896 William Morris died

1896 National Art Training School given permission by Queen Victoria to be renamed Royal College of Art; Central School of Arts & Crafts established in London

National Art Training School Interior

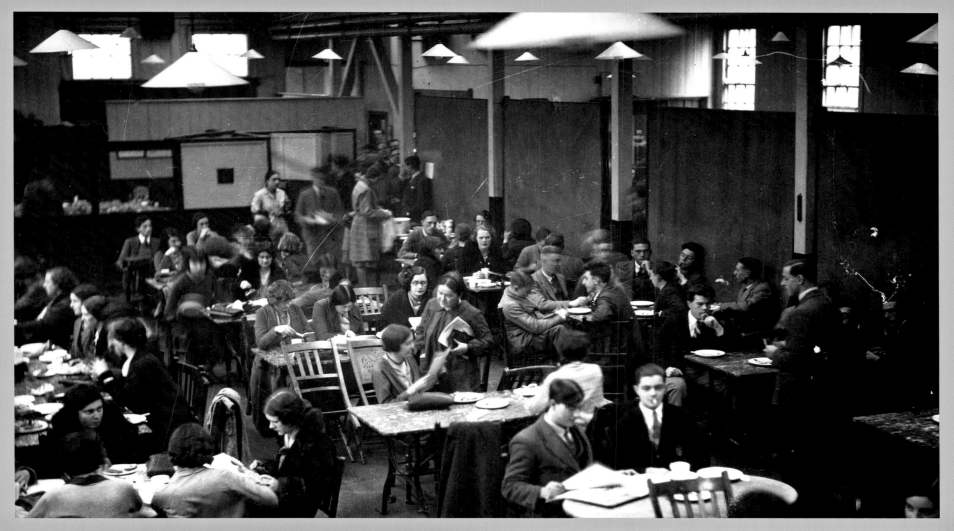

Queen's Gate Common Room
Early twentieth century

1897 Vienna Secession founded
by Klimt, Hoffmann, Olbrich
and others; National Gallery of
British Art (later Tate Gallery)
founded

1897 School changed name to
Royal School of Art, with ability
to grant diplomas

1897

Queen Victoria celebrated
Diamond Jubilee

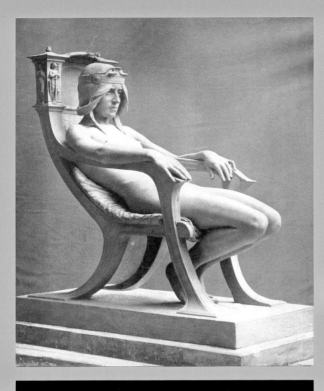

Albert Toft
The Spirit of Contemplation
1899–1900
Bronze

1899 Crane resigned as principal, succeeded by Augustus Spencer with title headmaster; responsibility for College moved from Department of Science and Art to Board of Education

1898 Walter Crane succeeded Sparkes as principal; Crane reduced emphasis on teacher training, attempted to broaden range of studies towards design and handicraft

Unsuccessful attempt made to provide more space for College by using tower and third floor of Aston Webb addition to South Kensington Museum for College library, classrooms and staff accommodation

Aston Webb Addition to South
Kensington Museum

1899 Name of South Kensington Museum
changed to Victoria and Albert Museum

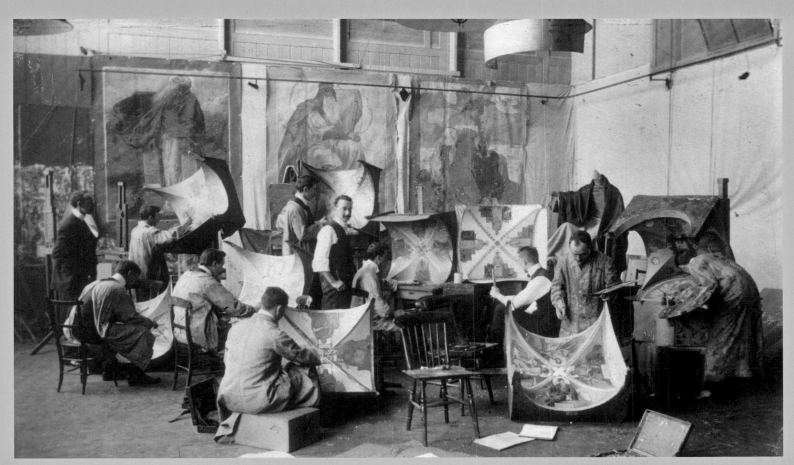

Men's Class in the Mural Room
Early 1900s

Paris Métro Station Entrance,
designed by Hector Guimard

Board of Education appointed Council for Advice on Art to advise on College curriculum and general direction of College; Council stated that purpose of College was training of art teachers of both sexes, designers and 'art workers'; sole female teacher retired and matron charged with discipline of female students

1900 Hector Guimard designed wrought-iron Paris Métro entrances in the Art Nouveau style; Fortuny showed Delphos gown; Eastman Kodak Company introduced Brownie camera

1900

1901

1901 Following Council recommendation, College reorganised into four Schools (Architecture under Beresford Pite, Design under W R Lethaby, Mural and Decorative Painting under Gerald Moira, and Sculpture and Modelling under Lantéri), which remained basic structure until 1948

Lethaby brought with him instructors in stained glass, embroidery, tapestry weaving, wood-carving, gesso, silverwork, jewellery, writing and illumination; introduction of one-off lectures by practitioners such as W A S Benson and Halsey Ricardo; Edward Johnston became part-time instructor in lettering

Death of Queen Victoria

Edward Johnston
Illuminated Script
1927
Ink on vellum

1902 Spencer's title of headmaster changed back to principal; space issues at College addressed with temporary wooden and tin huts located between Exhibition Road and Queen's Gate to accommodate students of sculpture and modelling, stained glass, pottery and metalwork

1903 College relinquished authority over regional colleges to local authorities

1904 Sylvia Pankhurst became student at College as National Scholar

1903 Orville and Wilbur Wright carried out first powered flight; Josef Hoffman founded Wiener Werkstätte

1904 Charles Rennie Mackintosh designed Willow Tea Rooms in Glasgow

1905 French Impressionist exhibition organised by Durand-Rouel at Grafton Galleries in London; Matisse, Derain and others referred to as 'les fauves' at Salon d'Automne in Paris; Die Brücke group formed in Dresden

Men's Life Modelling Class
c. 1905

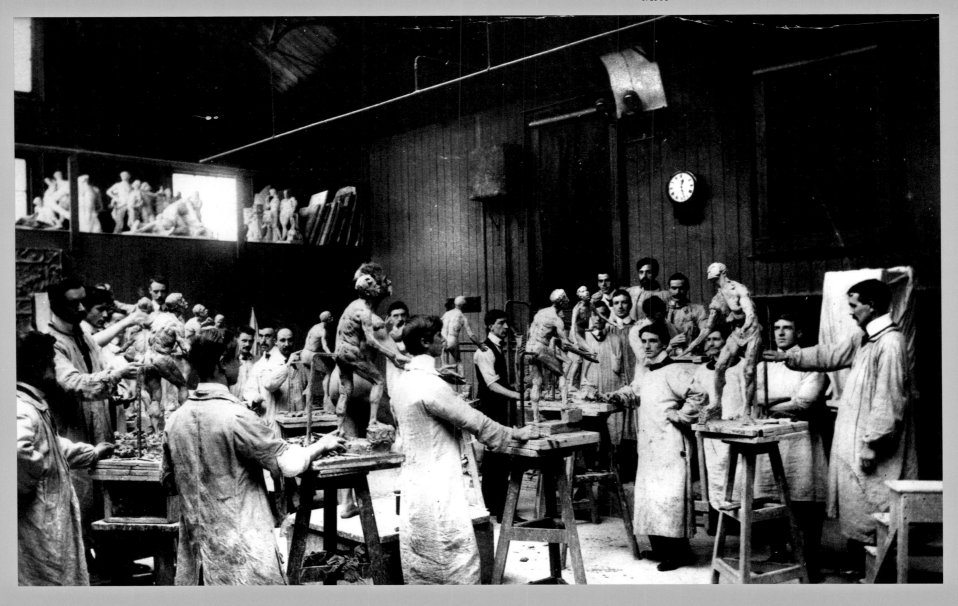

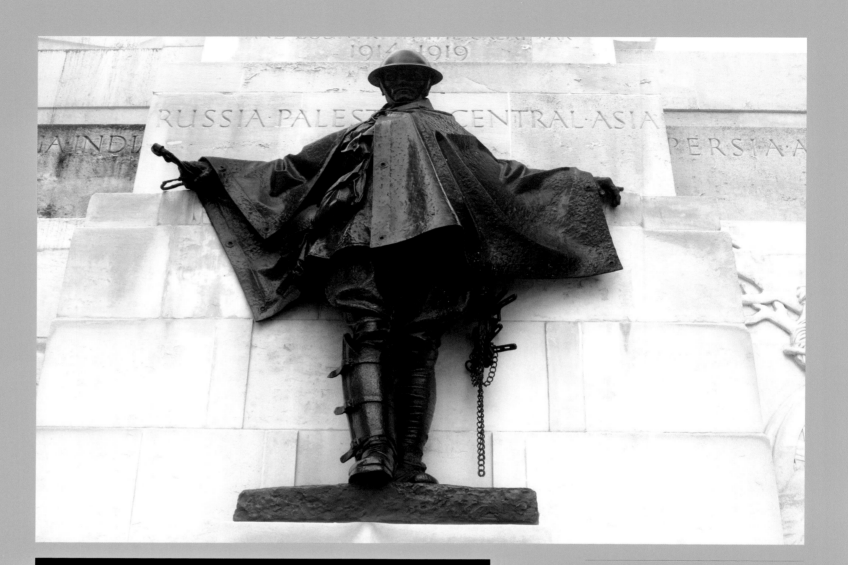

Royal Artillery Memorial
Designed by Charles Sargeant
Jagger and Lionel Pearson
Unveiled in 1925
Hyde Park Corner, London

1907 Council of Advice for Art
disbanded, replaced by four visitors
to oversee College affairs; Charles
Sargeant Jagger became student

1907 Picasso painted *Les
Demoiselles d'Avignon*; Leo
Henry Baekeland invented
Bakelite; Deutsche Werkbund
founded by Hermann Muthesius
and others

1908 Publication of *Ornament
is Crime* by Adolf Loos; Ford
introduced Model T car; Frank
Pick, as marketing officer for
Underground Electric Railways
Company of London, began
development of corporate
identity and visual style of
London Underground

1907

1909 Departmental Committee of Board of Education formed to consider purpose and methods of College following criticism of both

Sylvia Pankhurst
In a Leicestershire Boot Factory
1907
Watercolour

1909 Louis Blériot flew across English Channel ; Filippo Tommaso Marinetti published *Futurist Manifesto*; Frank Lloyd Wright completed Unity Temple in Oak Park, Illinois, which was first structure built solely of reinforced concrete

1910 Roger Fry showed Manet,
Cézanne, Gauguin, Van
Gogh and Matisse at Grafton
Galleries; Peter Behrens
completed AEG Turbine Factory
outside of Berlin; Dupont began
producing vinyl-coated fabric

1911

1911 Departmental Committee report commissioned by
Board of Education noted that provincial art schools should
train teachers for their own localities and train designers for
local manufacturing industries, while RCA should focus on
research and higher specialisation in art and craft; report
recommended increase in workshop element of design
courses at College, stricter entrance exams, reduction of
emphasis on training teachers, and provision of additional
space for College

Underground Roundel from
Westminster Station
(signwritten onto painted plaster)
Designed by Edward Johnston
c. 1930

1911 Camden Town Group
founded by Walter Sickert and
others; Der Blaue Reiter group
formed in Berlin

Walter Sickert
*Conversation/Study for l'Attain de
Camden Town*
1908–9
Charcoal, white chalk and ink

1910 Completion of buildings for
Victoria and Albert Museum;
College administration separated
from Museum

1911 Josef Hoffman
completed Palais
Stoclet in Brussels;
exhibition of
Gauguin and
Cézanne paintings
held at Stafford
Gallery, London

Palais Stoclet, Brussels
1911

1912 Edwin Lutyens began design and construction of New Delhi

1913 Omega Workshops founded by Roger Fry; *Armory Show* of modern art held in New York; London Group formed; Cass Gilbert's Woolworth Building completed in New York; Wyndham Lewis formed Vorticists and its literary magazine, *Blast*

1914 Antonio Sant'Elia designed the Città Nuova

1913 Auguste Rodin visited the RCA; £65,000 allocated to College under Public Buildings Bill for building on site opposite Victoria and Albert Museum; Beresford Pite plans for new building approved by Board of Education

1914

1914 Plans for new College building put on hold

World War I began

Illustration from *Nouvelles Fantaisies Décoratives* by Henri Gillet
1914

1915 Design and Industries Association founded to promote British industrial design

1916 First Dada manifesto presented in Zurich; Coco-Cola introduced curvaceous Coca-Cola bottle; Edward Johnston created Johnston Sans typeface for London Underground; Lloyd George became prime minister

1917 Foundation of de Stijl group; Marcel Duchamp's *Fountain* rejected by the Society of Independent Artists exhibition in New York; abdication of Tsar Nicholas II of Russia

Paul Nash
Sunset over the Malverns
1944
Watercolour on paper

1917 Paul Nash recruited as war artist and sent to Western Front

1918 Gerrit Tomas Rietveld designed Red and Blue chair

World War I ended

Francis Derwent Wood
The Boy David at the Machine Gun Corps Memorial
1925
Hyde Park Corner, London

1918 Francis Derwent Wood succeeded Lantéri as professor of Sculpture

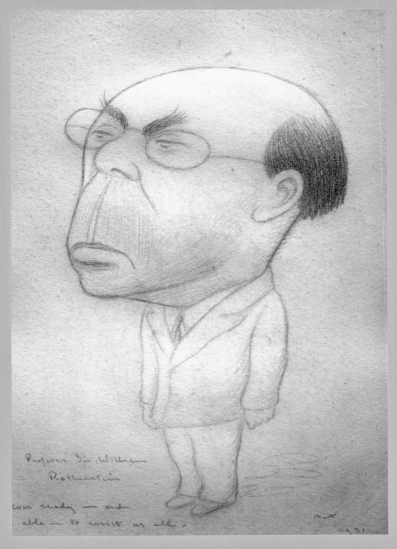

Max Beerbohm
Professor Sir William Rothenstein
1931
Pencil

1920

1920 William Rothenstein succeeded Spencer as principal of RCA, initially on part-time basis, shifting emphasis from teacher training to employment of practising artists and designers; Engraving Department, including new courses in wood-engraving and lithography, elevated to fifth School of College

1919 Bauhaus founded by Walter Gropius in Weimar

1920 Design and Industries Association organised *Household Things* exhibition at Whitechapel Art Gallery, London

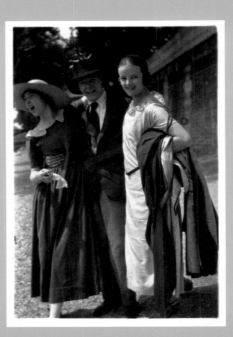

Barbara Hepworth in Paris with Henry Moore (centre) and Edna Ginesi (left)
1920

1921 Alessi and Braun founded as manufacturers of housewares; Erich Mendelsohn completed Einstein Tower

Henry Moore
Head of the Virgin
1922–3
Marble

1921 Henry Moore and Barbara Hepworth enrol as students at RCA

Edward Bawden
Our Family (Frog)
Linocut

1922 Rothenstein became professor of Painting in addition to role as principal

Short refresher courses introduced at College for industrial designers; Paul Nash began teaching in the Design School; Enid Marx, Edward Bawden, Eric Ravilious and Douglas Percy Bliss began studies at College

1922 James Joyce published *Ulysses*; British Broadcasting Corporation founded; Madeleine Vionnet introduced bias cut in fashion design; King Tutankhamun's tomb discovered in Egypt; Union of Soviet Socialist Republics founded

1923 Publication of *Vers une architecture* by Le Corbusier

1923 Edward Burra became student in Painting School

Edward Burra
Hop Pickers Who've Lost Their Mothers
1924
Watercolour and pencil

1924 *British Empire* Exhibition opened at Wembley with stadium designed by RCA alumnus Maxwell Ayrton; André Breton published *Surrealist Manifesto*

1925 Marcel Breuer designed Wassily Chair; first Surrealist exhibition at Galerie Pierre in Paris; *International Exposition of Decorative Arts* in Paris featured Art Deco pieces; Bauhaus moved from Weimar to Dessau

Ceri Richards
Couple Dancing
c. 1953
Lithograph

1925 William Staite Murray became instructor of Ceramics; student magazine *Gallimaufry* illustrated by Ravilious, Bawden and Bliss; Enid Marx graduated from College

1924 Henry Moore became part-time instructor in Sculpture School

Reco Capey became chief instructor in Design School; Ceri Richards began studies at College; Robert Anning Bell succeeded by E W Tristram as professor of Design; Beresford Pite succeeded by J Hubert Worthington as professor of Architecture

Edward Bawden
Lion and Unicorn Crest
c. 1958
Linocut mounted on board

1924

John Piper
Abstract Composition
1960
Watercolour and collage

John Piper
Garn Fawr, Pembrokeshire
1970
Gouache on paper

1926 John Piper became
student at College

1926 General strike in UK called
by Trades Union Congress;
Heinz Schulz-Neudamm
designed poster for Fritz Lang's
film *Metropolis*; Chanel showed
little black dress

1927 Warner Brothers released
first sound film, *The Jazz Singer*

1928 Gio Ponti founded Domus
in Milan to promote modern
interior design; UK voting
franchise granted to all women
over the age of 21

Barnett Freedman
Sicilian Bagpipe Player
1929
Pen ink and wash

Eric Ravilious
Edward Bawden Working in His Studio
1930
Tempera on board

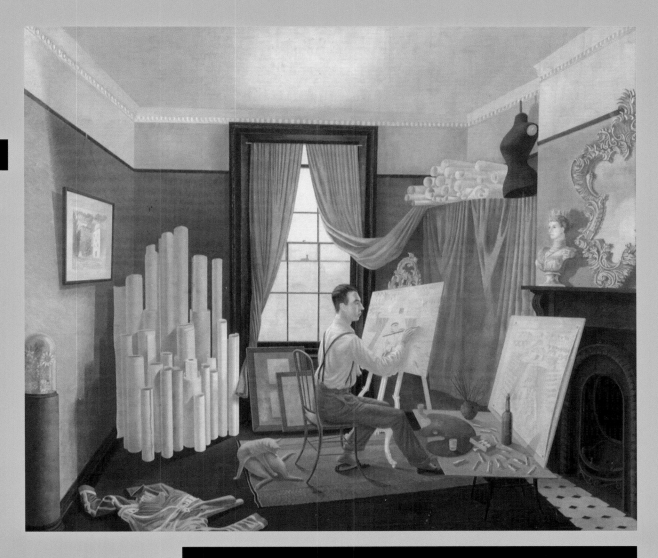

1929 Allan Gwynne-Jones appointed professor of Painting

1929 Mies van der Rohe designed German Pavilion and Barcelona chair for Barcelona Universal World Exposition; Museum of Modern Art opened in New York; Le Corbusier completed Villa Savoye; stock markets crashed around the world

1930 Rothenstein resumed post of professor of Painting; Ravilious began teaching at College

1930 Morley College murals by Bawden, Mahoney and Ravilious opened by Stanley Baldwin; Society for Industrial Artists and Designers founded; Moholy-Nagy completed *Lichtrequisit*, kinetic light sculpture; Alvar Aalto designed organically shaped glass vase for Littala; Chrysler Building built in New York

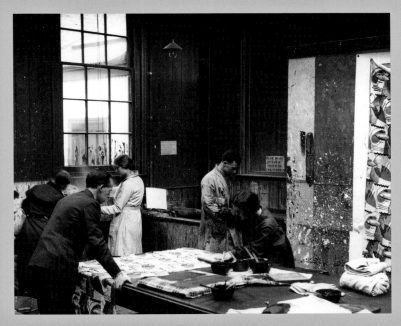

Reco Capey in the Textile Studio
c. 1930

1931 Gorell Committee appointed by Board of Trade to consider state of art education in Britain; Empire State Building completed in New York; El Lissitzky, Alexander Rodchenko and others began publishing *USSR in Construction*; Dupont began production of artificial rubber

1931 Henry Moore resigned from teaching position at College; Ruskin Spear began studies at College

1932 Publication of *Brave New World* by Aldous Huxley

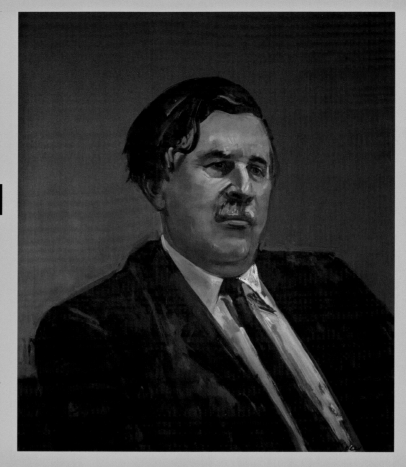

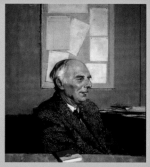

Ruskin Spear
Portrait of Rodney Burn
1962
Oil on canvas

Ruskin Spear
Portrait of David Pye
1974
Oil on board

Left: Ruskin Spear
Portrait of John Moon
OBE
Oil on board

Astrid Sampe
Soft Sand
1956
Cotton and print media

1933 Gilbert Spencer appointed professor of Painting

1933 Design and Industries Association began publication of journal *Design for Today*; Council for Art and Industry founded with funding from Board of Trade; establishment of Connell, Ward and Lucas architecture practice, which would design early Modernist houses such as Concrete House in Bristol (1935) and 66 Frognal in Hampstead, London (1938); Bauhaus forcibly closed; Nazi Party took control of German cabinet

1932 Astrid Sampe graduated from College

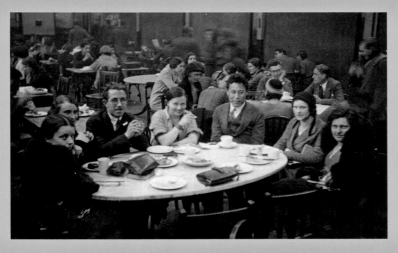

RCA Common Room
Early 1930s

1934 Gorell Report criticised lack of cooperation between industry and art schools; publication of *Art and Industry* by Herbert Read

1935 *British Art in Industry* exhibition held at Royal Academy; Frank Lloyd Wright's Fallingwater completed; first Penguin book published; Works Progress Administration created by US government

Misha Black
All for the West End
1936
Poster

1934 John Nash began to teach in the Design School

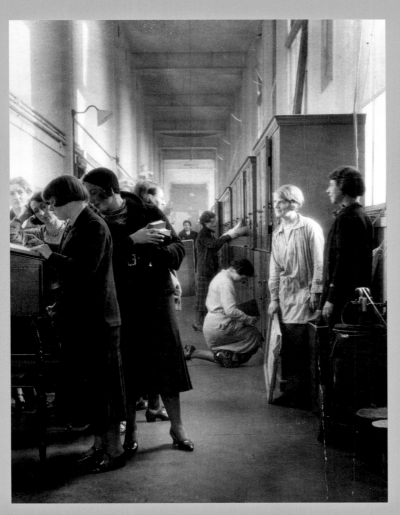

1935

Students Signing Book of Attendance
Painting School
c. 1932

Sample of *Shield* Moquette
Designed by Enid Marx
c. 1935

1935 Walter Gropius considered but passed over for major role at College

P H Jowett succeeded Rothenstein as principal of College; Board of Education set up Hambleden Committee to consider how to address findings of Gorell Report on art education; Hambleden Committee considered but ultimately rejected incorporation of College into University of London

John Minton
Portrait Sketch
Oil on canvas

1937 Board of Trade established National Register for Industrial Artists; Council for Art and Industry published *Design and the Designer in Industry* and *The Working Class Home*; Gropius emigrated to USA and began teaching at Harvard Graduate School of Design; Mies van der Rohe became head of Architecture Department at Armour (later Illinois) Institute of Technology in Chicago, designed masterplan for campus as well as individual buildings; Moholy-Nagy founded New Bauhaus design school in Chicago, which became Institute of Design at Illinois Institute of Technology

1938 Reco Capey held new post of industrial liaison officer at College for one year until post abolished

1938 Picasso's *Guernica* exhibited in London; Volkswagen started production of Volkswagen Type 1, designed by Ferdinand Porsche and known as the Volkswagen Beetle; Owens-Illinois and Corning Glass obtained patent for fibreglass in US

1936 Abdication of Edward VIII, accession of George VI

1936 Hambleden Report recommended abandonment of teacher training programme at College, introduction of improved and expanded teaching of industrial design, addition of courses in weaving, furniture design, commercial art and dress design, installation of new Board of Governors to ensure that reforms carried out, and necessity of finding new site for College; John Minton began studies at College

1939

1939 War Artists Advisory
Committee established

Outbreak of World War II

1939 Robin Day graduated from College

Lucienne Day
Three Daughters of Mexico
1955
Silk mosaic textile

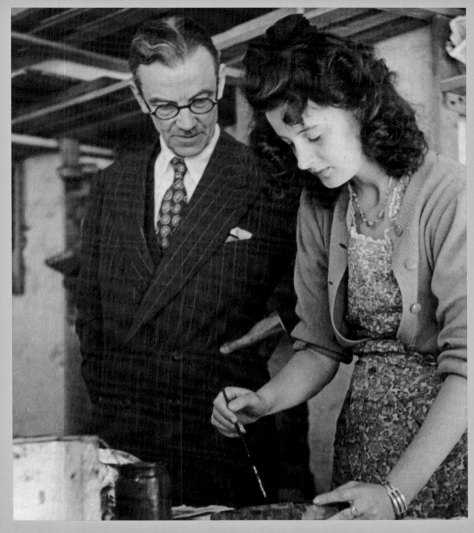

Percy Jowett Watches a Student
Painting at a Studio in Ambleside,
Lake Windermere, Cumbria

1940 College remained closed after summer holiday, relocated to two hotels in Ambleside, Cumbria, in December; Lucienne Day graduated from College

1940 Publication of A *Potter's Book* by Bernard Leach; Charles Eames and Eero Saarinen won awards at MoMA's *Organic Design* exhibition; Winston Churchill became prime minister

1941 Commercial television
broadcasts began in US

1942 Utility clothing introduced
in UK

1943 Jackson Pollock held first
one-man show in New York

John Tunnard
Installation
1942

1943 Weir Committee on
industrial design, appointed
by Department of Overseas
Trade, recommended that
College be renamed 'Royal
College of Art and Design'
and be reorganised to allow
greater specialisation in all
branches of industrial design,
but name change not adopted

1944 Exhibition Road premises
of College struck by flying
bomb, Queen's Gate huts
turned into builders' sheds

1944

1944 Education Act revised examinations system for art and design training, introduced National Diploma in Design; Council of Industrial Design founded in UK; Arts Council of Great Britain founded

1945 Francis Bacon exhibited at Lefevre Gallery; George Orwell published *Animal Farm*; Second World War ended with Potsdam declaration; British Labour Party won landslide victory in general election; Attlee began service as first Labour prime minister

1946 *Britain Can Make It* exhibition at Victoria and Albert Museum; Knoll Associates in the US began to manufacture furniture by Mies van der Rohe, Le Corbusier, Breuer, Saarinen and Bertoia; Charles and Ray Eames created Side Chair; Vespa motor scooter designed by Corradino D'Ascanio for Piaggio; Sony Corporation founded in Tokyo

1945 College returned from Ambleside to South Kensington

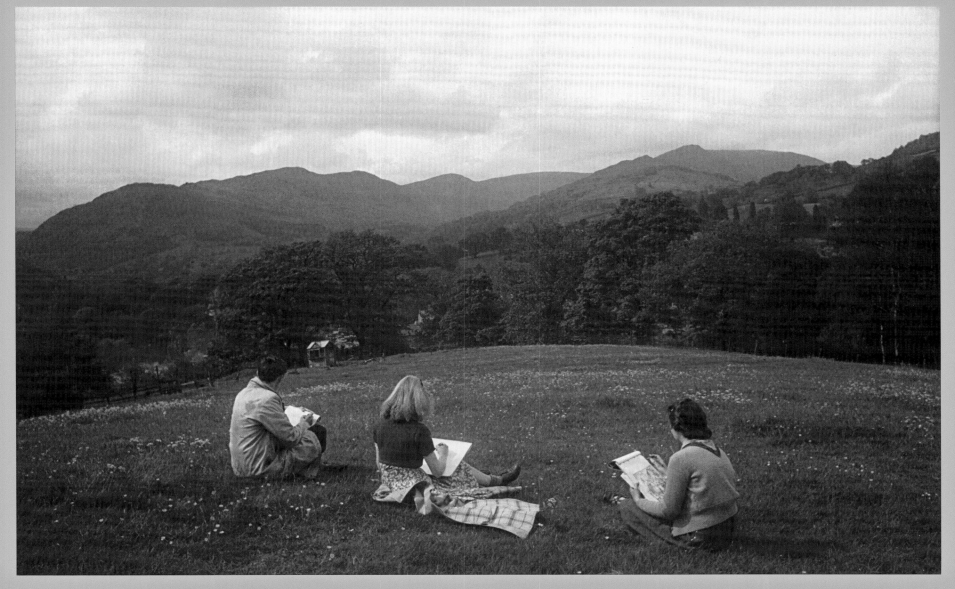

Three Art Students Painting and Drawing in the Countryside Around Ambleside, Lake Windermere, Cumbria

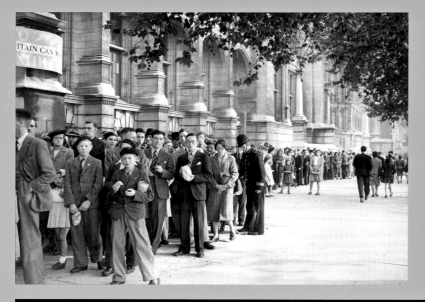

Queue for *Britain Can Make It*
Exhibition at the Victoria and
Albert Museum
28 September 1946

1947 Development of first point-contact
transistor at Bell Labs, USA, leading to
miniaturisation in the field of electronics;
Henri Cartier-Bresson, Robert Capa and
others founded Magnum Photos; Christian
Dior launched the New Look; Richard
Neutra designed Desert House

1948 South Africa adopted
apartheid policy; state of Israel
proclaimed; Siegfried Giedion
published *Mechanization Takes
Command*; Polaroid introduced
first instant camera, Model 95

1947

1946 Basil Ward appointed professor of
Architecture at College; Robin Darwin,
as training officer at Council of Industrial
Design, wrote Report on the Training of
the Industrial Designer, urging greater
specialisation at College and provision
of buildings and equipment to do so

Robin Darwin
Coastal Landscape
n.d.
Watercolour

Robin Darwin
Landscape with Cows in Kent
n.d.
Watercolour on paper

1948 Robin Darwin succeeded P H Jowett as principal of College

Four main Schools (Design, Drawing and Painting, Engraving and Sculpture) reorganised into ten schools and supplemented with new courses including Graphic Design, Engineering and Furniture Design, and Fashion Design, the latter under leadership of Madge Garland; four Boards of Faculties appointed, composed of representatives from Schools with overlapping interests; plan put in place for different diplomas to be awarded based on whether study completed in fine arts (Associateship of the Royal College of Art) or in industrial design (Designer of the Royal College of Art); Department of Theatre Design introduced for only one year; Rodrigo Moynihan appointed as professor of Painting, Richard Guyatt as professor of Design, Robert Baker as professor of Ceramics, Robert Goodden as professor of Silversmithing, Richard Russell as professor of Light Engineering and Furniture, Frank Dobson as professor of Sculpture, Robert Austin as professor of Engraving; National Health Service founded

1949 Minister of Education established College as educational charitable foundation, designated a National College and administered by governing council rather than by Ministry of Education

Leases acquired on Cromwell Road for College space, resulting in College division between five sites on Cromwell Road, Ennismore Gardens, Queen's Gate and Exhibition Road; Department of Typography started within School of Graphic Design

Len Deighton
Ark 10
1954
Magazine cover

1951 First colour televisions sold in US; Marimekko founded in Finland; Winston Churchill became prime minister for the second time

David Mellor
English Cutlery
1990s

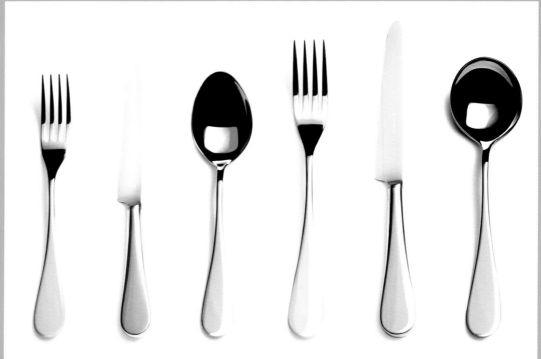

1950 First issue of student journal *Ark* published; opening of first Senior Common Room at College as meeting place for faculty and display area for student work; Francis Bacon artist-in-residence at College; College Council decided to appoint fellows in addition to granting Honorary Diplomas

1951 College incorporated as company limited by guarantee; creation of Department of Interior Design headed by Hugh Casson; 26 staff members and 24 students contributed to Festival of Britain, including the architecture and interior design of Lion and Unicorn Pavilion and Festival emblem

1952 Arne Jacobsen designed Ant chair; Tetrapak began production in Sweden

1952 School of Architecture closed; nave windows of new Coventry Cathedral designed by Lawrence Lee, head of Stained Glass Department, and recent College graduates Geoffrey Clarke and Keith New; Richard Russell designed oak stacking chairs for Cathedral

1953 Chevrolet introduced Corvette

Plate from *Captain Cook's Florilegium*
Lion and Unicorn Press
1973

1954 Buckminster Fuller took out US patent on geodesic dome; polypropylene invented by Guilio Natta

1954 Department of Engineering Design established at College; David Mellor graduated from College

1953 Lion and Unicorn Press started under guidance of Professor Richard Guyatt of School of Graphic Design

Establishment of central College library; Department of Interior Design became School; Calligraphy course discontinued; street decorations and damask used to decorate Westminster Abbey for the Coronation of Elizabeth II commissioned from College; Ulm School of Design founded in Ulm, Germany

1955 HRH The Duke of Edinburgh named fellow of College; Frank Auerbach, Bridget Riley and Robert Welch graduated from College; School of Engraving incorporated into the School of Graphic Design

1955 Citroen launched DS, designed by Flaminio Bertoni; Robert Rauschenberg showed *Bed*, an early Combine work, at Charles Egan Gallery in New York; Sony introduced TR-55 transistor radio

1956 Short photography courses introduced at RCA for students specialising in other disciplines; Janey Ironside replaced Madge Garland as head of School of Fashion; Peter Blake graduated from College; Alan Fletcher graduated from College

1956 *This is Tomorrow* exhibition at Whitechapel Art Gallery in London; Soviet troops suppressed uprising in Hungary; Eero Saarinen's TWA Terminal for JFK Airport completed

Peter Blake
Children Reading Comics
1956
Oil on board

1957 Treaty of Rome established European Economic Union; Roland Barthes published *Mythologies*; Jock Kinneir and Margaret Calvert began redesign of UK motorway signage system, later extended to UK road network

1957

1957 Carel Weight succeeded Rodrigo Moynihan as professor of Painting; Terence Conran joined staff of School of Interior Design

1958 Department of General Studies introduced to teach history, philosophy and academic theory of art and design, included as compulsory part of diploma courses; staff and students contributed to Great Britain pavilion at Brussels World's Fair

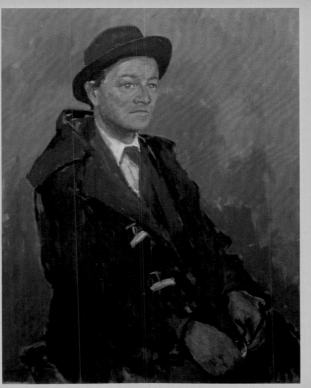

1958 National Advisory Council for Art Education established, with Sir William Coldstream as chairman, to consider general system of art examinations and course structures in England with possibility of greater freedom for individual art colleges; Jasper Johns held first one-man show in New York

1959 Xerox introduced first photocopy machine, Xerox 914; Reyner Banham published *Theory and Design in the First Machine Age*; first section of M1 motorway opened

Robin Darwin
Portrait of Hugh Casson
1957
Oil on canvas

Robert Welch
Three-branch Stainless Steel Candle Holder
1956–7

1959 David Queensberry succeeded R W Baker as professor of School of Ceramics; Department of Engineering Design became School of Industrial Design (Engineering) under Professor Misha Black; sections of interior of *SS Oriana* designed by College staff and students; Lucy Rie began as occasional visiting lecturer in Ceramics at College

1961 Berlin Wall erected; Mary Quant showed first miniskirts; Peter Cook and others founded Archigram

1961 Precursor of Department of Design Research set up by Professor Misha Black within School of Industrial Design to undertake sponsored academic research programmes and to carry out design projects under contract to industry, commerce and government departments; Ridley Scott graduated from College in Graphic Design

David Hockney
Bertha Alias Bernie
1962
Oil on canvas

Darwin Building under Construction, 1961

1962 Andy Warhol exhibited his *Campbell's Soup Can* paintings at Stable Gallery in New York; Robin Day designed M5 stacking polypropylene chair for Hille

1962 College's administrative department and all departments of Industrial Design moved to new Darwin Building on Kensington Gore, designed by H T Cadbury-Brown in association with Hugh Casson and Professor R Y Goodden; David Hockney graduated from College; introduction of Department of Film and Television

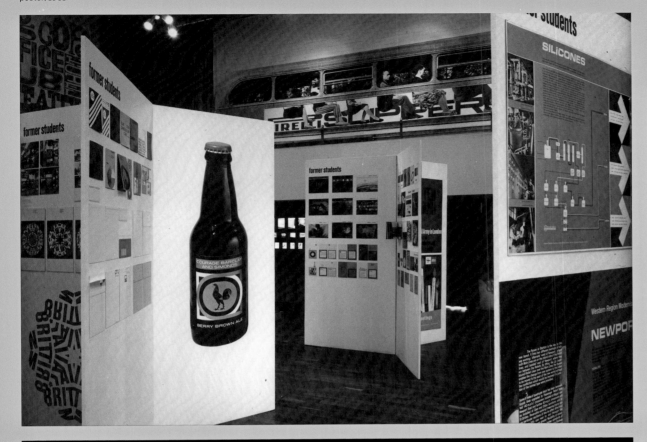

1964 Rolling Stones released
first album in UK; Terence
Conran opened Habitat in
London; Courrèges, Chanel
and Yves Saint Laurent showed
trouser suits; Harold Wilson
became prime minister

Zandra Rhodes
Top Brass (produced as a furnishing
fabric for Heal's)
1964
Eight-colour print on cotton sateen

1963 Major exhibition *Graphics RCA*, to celebrate
achievements in College graphic design from
1948 to 1963; government acceptance of Robbins
Report conclusions regarding higher education in
UK resulted in expansion of university system and
widened access to universities

1963 US President John F
Kennedy assassinated; Beatles
released first album in UK

1963

1964 College library and
common room block
finished in Darwin
Building; Zandra Rhodes
graduated from College

1966 Readability of Print Research Unit established by senior research fellow Herbert Spencer within the School of Graphic Design; Hans Coper became tutor in Ceramics & Glass Department at College

Royal College of Art Royal Charter

1967 College granted Royal Charter, making it independent institution of university status with power to grant degrees; HRH The Duke of Edinburgh appointed College visitor; Robin Darwin named first rector; Experimental Cartography Unit established at College with funds from Natural Environment Research Council, to work on map-making with computers

1967 Emil Ruder published *Typography*; Guy Debord published *The Society of the Spectacle*

1968 Publication by Stuart Brand of the first issue of *The Whole Earth Catalog*, Menlo Park, California; student uprisings began in Paris and spread throughout much of world

1968

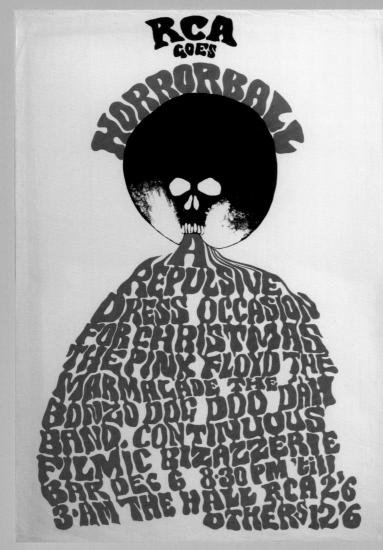

Eduardo Paolozzi
Large Bronze Head
1994
Bronze

1969 Introduction of Vehicle Design course

1969 Apollo 11 landed on moon; Ettore Sottsass designed Valentine typewriter for Olivetti; The Gap founded in California

Alistair Grant
Untitled
Lithograph with coloured chalk

1970 Alistair Grant named head of Department of Printmaking

1970 Derek Walker named chief architect and planner for new town of Milton Keynes; Issey Miyake launched Miyake Design Studio in Tokyo

1968 Marianne Straub became tutor in Textiles Department at College; Eduardo Paolozzi began 21-year association with College as staff and visiting staff

1971 microprocessor developed by Intel; Victor Papanek published *Design for the Real World*

1973 Department of Design Research sponsored by Department of Education and Science to carry out a major research project on design in general education

1971 Lord Esher succeeded Robin Darwin as rector; James Dyson graduated from College; Joanne Brogden named professor of Fashion

1972 Industrial Design Unit became independent Department of Design Research under Professor Bruce Archer; Peter de Francia became professor of Painting

1972 *Italy: the New Domestic Landscape* exhibition held at MoMA; Robert Venturi, Denise Scott-Brown and Steven Izenour published *Learning from Las Vegas*; John Berger published *Ways of Seeing* to accompany BBC television series; UNESCO adopted the World Heritage Convention; Alan Fletcher, Theo Crosby, Colin Forbes and others founded Pentagram

1973 OPEC oil crisis; opening of IKEA's first store outside of Scandinavia

1974 Knitwear became separate area of concentration in School of Fashion; School of Graphic Design divided into departments of Communications, Printmaking and Illustration; Experimental Cartography Unit became part of the Natural Environments Research Council

1974 Harold Wilson became prime minister for the second time

1975 School of Graphic Design renamed School of Graphic Arts, including departments of Graphic Design, Printmaking and Illustration

First PhD applicants admitted to College; Sir Hugh Casson retired as professor of Environmental Design, succeeded by Frank Height; Sir Misha Black resigned as professor of Industrial Design, succeeded by John Miller

1975 War in Vietnam ended; Rei Kawakubo showed first Comme des Garçons collection in Tokyo

1975

Bill Gibb
Waterfall Dress
1973

1976 Department of Graphic Information introduced within School of Graphic Arts; Department of Environmental Media became independent department; establishment of first chair of Design Management

1977 Establishment of Department of Design Management

Design Education Unit set up to pursue the theory and practice of art and design education, offering Master's degree in Design Education Studies; Department of Environmental Media became separate entity no longer linked with School of Sculpture; Robert Heritage succeeded by Frank Huille as head of School of Furniture; month-long student occupation of College administrative offices to protest increase in fees

1976 Bic introduced disposable lighter

1977 Opening of Pompidou Centre, designed by Renzo Piano and Richard Rogers; Charles Jencks published *The Language of Postmodern Architecture*; George Lucas directed *Star Wars*

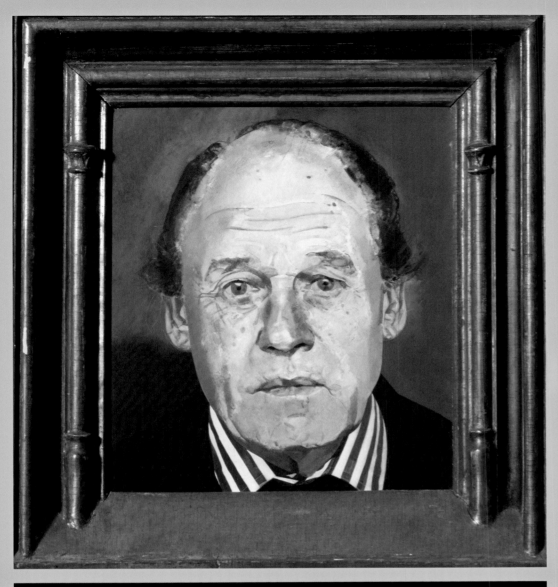

Peter Blake
Portrait of Richard Guyatt
1981
Mixed media on board

1979 School of Graphic Arts reorganised into three departments: Graphic Design (including general graphics and graphic information), Illustration and Printmaking; June Degree Show had its first audio-visual presentation

1978 Lord Esher succeeded as rector by Professor Richard Guyatt; Herbert Spencer appointed as professor of Graphic Arts; Readability of Print Research Unit renamed Graphic Information Research Unit; Quentin Blake became head of Department of Illustration; student magazine *Ark* ceased publication

1979 Sony introduced Walkman; IBM manufactured first laser printer; first commercial automated cellular telephone network launched in Japan; Margaret Thatcher became prime minister; Ridley Scott directed *Alien*

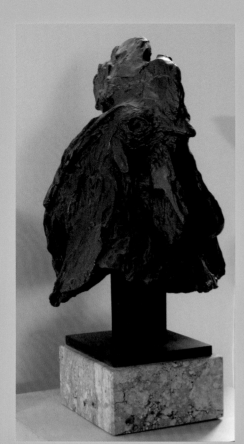

Bernard Meadows
Head of Cock
c. 1950
Bronze

Professor Richard Guyatt succeeded by Dr Lionel March as rector

Based on recommendations of report commissioned by Council of College, schools and departments of College reorganised into five chaired faculties: Faculty of Applied arts (Ceramics and Glass, Fashion Design, Silversmithing and Jewellery, Textile Design); Faculty of Painting, Sculpture and Environmental Media; Faculty of Theoretical Studies (Cultural History, Design Education and Design Research); Faculty of Three-dimensional Design (Environmental Design, Furniture Design, Industrial Design (including joint course with Imperial College and Brunel College) and Management Studies); Faculty of Visual Communication (Film and Television, Graphic Arts (Graphic Design, Illustration, Printmaking), Photography); hologram facility introduced in Photography Department; introduction of Animation Department within Film and Television Department

1982

1980 Dr Christopher Frayling became head of Department of General Studies; Department of General Studies restructured and renamed Department of Cultural History; introduction within School of Industrial Design of Industrial Design Engineering, a joint two-year course with Imperial College, and Polymer Engineering and Design, a three-year joint course with Brunel University; Professor Phillip King succeeded Professor Bernard Meadows as head of School of Sculpture

1980 Muji no-brand household and consumer goods company established in Japan

1981 Ettore Sottsass, Andrea Branzi and others found Memphis design group; MTV began broadcasting; Azzedine Alaia showed stretch jersey minidresses

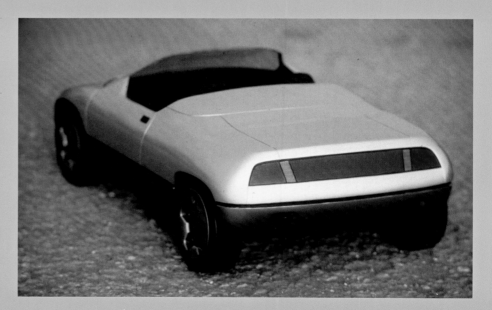

Roland Heiler
Porsche Small Sports Car/Model
1982

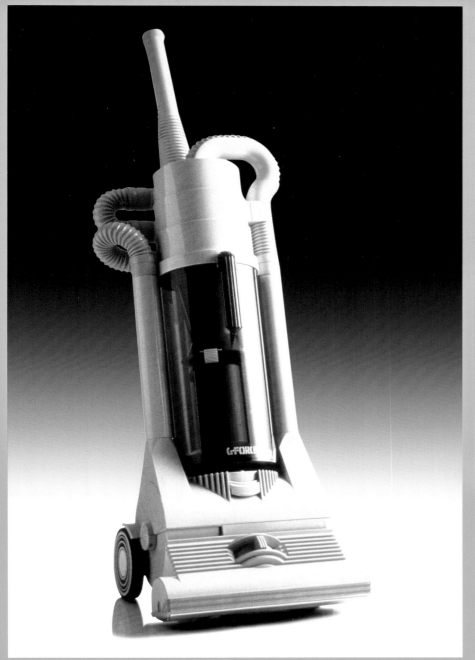

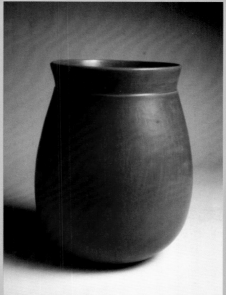

1982 Ridley Scott released
Blade Runner; Michael Graves
completed Portland Building,
USA

1983 James Dyson introduced
vacuum cleaner with Dual
Cyclone technology

Magdalene Odundo
Earthenware Burnished Pot
1982

James Dyson
G-Force
1983

1983 Faculty of Painting, Sculpture and Environmental Media renamed Faculty of Fine Arts

School of Sculpture included new focus on landscape sculpture; Design Management discontinued as separate department; fashion collection marketed at Marks & Spencer under RCA label

1982 Introduction of joint course with the V&A called Design and Decorative Art: History and Technique; following government funding cutbacks, establishment of Bursary Fund for students, RCA Trust for College fundraising, RCA Society as alumni association, and RCA Enterprises to manage commercial activities within the College; based on Archer Report, change in internal College governance structures, including appointment of a dean; joint research programme introduced between College and Cranfield Institute of Technology

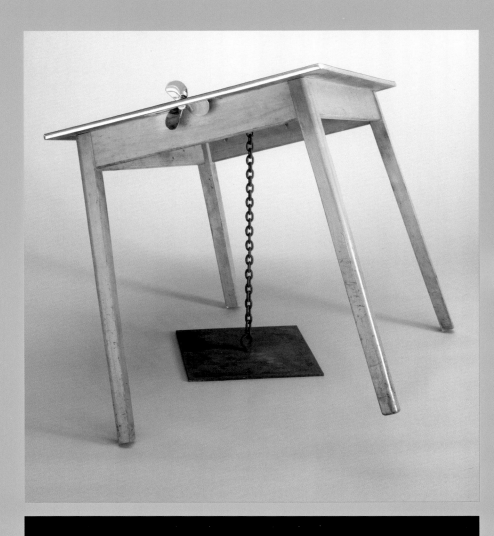

Richard Wentworth
Shower
1984
Wood, plastic laminative,
iron and brass

1984 Apple introduced
the Macintosh computer;
completion of AT&T Building,
New York, designed by
Philip Johnson; Turner Prize
established

1985 Major College restructuring as result of funding issues: reduction in number of College faculties from five to three (Faculty of Communication, Faculty of Design, Faculty of Fine Art)

College divided into 19 departments (no schools), including the new or reorganised departments of Animation and Audio Visual Arts, Film, Architecture and Design Studies, and Transport Design; Management Studies included as element of every course; television training programme abolished; director of Research appointed to implement research within each department; two-year courses now standard throughout College; new staff structure implemented which removed right of tenure and cut costs; course validation board introduced to ensure high quality of work of every course; introduction of degree in holography; Professor Bruce Archer appointed College's director of Research; Professor Herbert Spencer retired and Gert Dumbar appointed visiting professor of newly renamed Department of Graphic Art and Design; Professor Derek Walker became head of Architecture Department; Robert Heritage resigned as visiting professor in Department of Furniture Design; conversion of 41–43 Jay Mews for use of Cultural History Department; *Printmakers at the Royal College of Art* exhibition at Barbican Centre, curated by Alistair Grant

1984 Jocelyn Stevens succeeded Dr Lionel March as rector

Significant cuts to Government financial support of College raised possibility of College closure due to lack of funding; School of Silversmithing and Jewellery renamed School of Metalwork & Jewellery; Visual Islamic Arts Studio established by School of Painting; tapestry course moved from Textile Department to Painting; Printmaking became independent department and moved from Faculty of Visual Communication to Faculty of Fine Arts; students in School of Environmental Design with Part 1 RIBA allowed to graduate with both MA and second stage of professional qualification; School of Industrial Design installed first computer centre in UK focusing on using computers as tools for industrial design; simple computing equipment installed in Department of Graphic Design; Photography Department acquired 'computer-steered' laser

1985 Michael Graves designed
tea kettle for Alessi

Dan Fern
Shell Book of the Year: Rhonda Valley
Pit-head Village
(RCA Graduation Work)
1969

1987

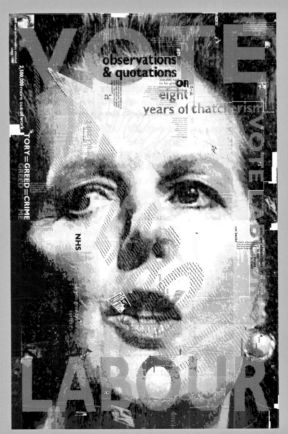

1987 Convocation moved from Gulbenkian Hall to Albert Hall due to numbers

Professor Joanne Brogden succeeded as head of Fashion Design by Alan Couldridge; major departmental exhibitions held to celebrate College's 150th anniversary

1986 Opening of Henry Moore Gallery in expanded Darwin Building

Departments of Design Research, Design Education and Environmental Media closed; Paul Huxley succeeded Peter de Francia as professor of Painting; Dan Fern succeeded Quentin Blake as head of Department of Illustration; closing of College student hostels and appointment of first student housing and welfare officer; summer courses offered at College jointly with UCLA; appointment of first head of Computing along with development of College-wide strategy regarding inclusion of information technology in all departments; introduction of opportunity for first-year students to study a second language at Imperial College; Fashion Department moved to Darwin Building from Cromwell Road site

1986 Disaster at Chernobyl nuclear power plant in Ukraine; Richard Rogers' Lloyds of London building completed

David Ellis
Vote Labour
1987
Poster

1988 Neville Brody given retrospective exhibition at V&A and published *The Graphic Language of Neville Brody*; *Freeze* exhibition organised by Damien Hirst and others in London Docklands; Tony Cragg won Turner Prize

1988 Reorganisation and re-equipment of Industrial Design and Transport Departments; College installed personal computer system using Apple Macs; first inclusion of report by Students' Union in College Annual Report; Ceramics & Glass studios and workshops reorganised onto one floor of Darwin Building; Department of Textiles rearranged and housed entirely on one floor of Darwin Building; Departments of Printmaking and Illustration moved to Darwin Building; Painting alone remained in studios on Exhibition Road; major exhibition *Breakthrough* celebrated 25 years of illustration at College

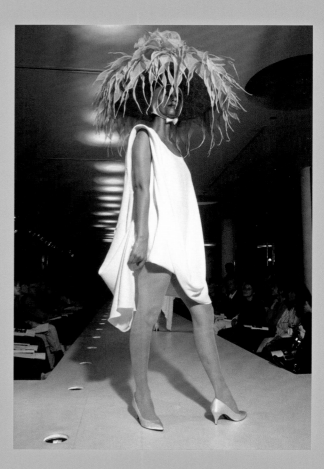

Philip Treacy
RCA Graduation Work, Fashion
Womenswear (Millinery)
1990

1989 Ron Arad designed the Little Heavy Chair; Design Museum in London and Vitra Design Museum in Weil Am Rein, Germany opened; Berlin Wall fell

Breakthrough Exhibition Celebrated 25 Years of Illustration at the RCA

1989 Tracey Emin graduated from College

Library began conversion from in-house system of classification to Dewey Decimal System; change from departmental system in College to four faculties (Design for Communication, Design for Manufacture, Fine Art and the Humanities) offering 38 courses, with goal of increasing interdisciplinary activity and facilitating introduction of new courses; Gulbenkian Galleries reopened after reconstruction with *Alistair Grant and Friends* exhibition; Christopher Miles succeeded Richard Ross as professor of Film; Sir Eduardo Paolozzi retired but continued at College as visiting artist; departments of Textiles and Fashion combined; separate Interior Design course introduced; Humanities Faculty introduced three-year course in Conservation offered jointly with the V&A and Imperial College; John Thackara succeeded Professor Bruce Archer as director of Research; photocopier introduced in Library; Convocation gowns with rabbit fur replaced by those with 'fun fur'; Post-experience Programme of short-term study introduced for mid-career students; College opened seven of ten planned computer clusters

1990 Jake and Dinos Chapman graduated from College

Proposed fee differential for different courses withdrawn in face of widespread student objection; record number of 647 MA students registered, along with 22 PhD students and ten students on Post-experience Programmes; new courses introduced in Fashion Menswear, Embroidery, and Technical and Scientific Illustration; Computer Related Design course introduced under Professor Gillian Crampton Smith; two College buildings in Kensington sold and plan introduced to move Sculpture to Battersea; Tim Mara succeeded Alistair Grant as professor of Printmaking; online catalogue system introduced in Library; reintroduction of television-related courses in Faculty of Design for Communication

Jake Chapman
RCA Graduation Work
1990
Sculpture

1991 School of Sculpture moved to renovated factory building on Howie Street in Battersea; School of Painting moved to new Stevens Building in Jay Mews; Rowney Drawing Studio opened for use of all students; Gavin Turk completed his two years of MA study, showing *Cave* at degree show

1991 Dissolution of Soviet Union; beginning of first Gulf War; World Wide Web launched as publicly available service on Internet

Dinos Chapman
But... and... so... therefore... why not...
1990
Oil on canvas

Chris Ofili
Bass Line
1993
Oil on canvas

1992 Anthony Jones succeeded Jocelyn Stevens as rector

HRH The Duke of Edinburgh officially opened Stevens Building, marking 25th anniversary of granting of Royal Charter; new humanities course introduced in Visual Arts Administration, offered jointly with the Arts Council of Great Britain, Tate Gallery and University of Middlesex; Higher Education Funding Council created to disburse government funding to colleges and universities; holography course eliminated but equipment and short courses available to students across College; introduction of new research degree, Master of Philosophy, emphasising increasing importance of research to the College; David Sherlock joined College as first director of Development; creation of Multimedia Studio, including digital sound studio; Helen Hamlyn Foundation and Safeway Ltd sponsored three-year multi-disciplinary DesignAge project to study implications of ageing population for design practice

1992 Nokia introduced first of 2100 series mobile phones; David Carson became art director for *Ray Gun*

1993 Droog Design showed at Milan Furniture Fair

1993 College Plan proposed by Anthony Jones reorganised College into eight schools combining clusters of related courses, with 'academic manager' as head of each school, appointed on two-year rotating basis; streamlined governance structure introduced along with emphasis on more part-time tutors and visiting lecturers; emphasis placed on need for College re-orientation towards research; additional MA structure introduced to allow part-time study; approval by College Senate of College's first Environment Policy; Professor John Hedgecoe retired; Chris Ofili graduated from College

1994 Opening of Thames Water tower in Shepherd's Bush, designed by RCA graduates as result of RCA competition; first 'RCA Secret' sale of anonymous postcard-size works of art by current and former students and staff; Professor Joan Ashworth named head of Animation Department at College; Professor Dan Fern appointed head of the School of Communication Design at College

1994 opening of Channel Tunnel connecting England and France; Sony introduced Playstation

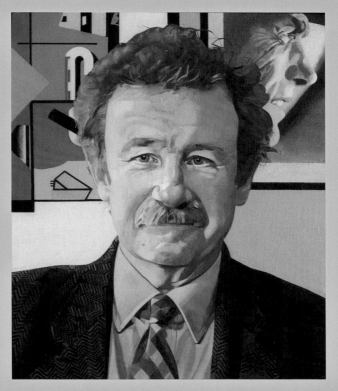

Peter Blake
Portrait of Professor Sir Christopher Frayling
2009
Oil on canvas

1996 Professor Christopher Frayling named rector to succeed Anthony Jones

Two significant exhibitions held at College to mark centenary as Royal College of Art; Foundry in Sculpture School installed ceramic shell facility; opening of redesigned and enlarged Library; Ceramics & Glass course accepted first PhD students; Jonathan Ive joined Apple to lead industrial design team

1995 Internet and email access made available at a number of key points in College; Professor David Carter resigned as head of School of Design for Industry

1995 Ban Shigeru developed paper log houses as shelters for earthquake victims in Japan; Starbucks opened first stores outside of US

1997 Frank Gehry's Bilbao Guggenheim Museum opened; Toyota marketed Prius hybrid car; *Sensation* exhibition held at Royal Academy; Tony Blair became prime minister

Ron Arad
Rover Chair
1981
Mixed media

1998 Paul Huxley retired as professor of Painting

Wendy Dagworthy joined College as professor of Fashion, Chris Orr joined as professor of Print-making, Graham Crowley joined as professor of Painting; Professor Martin Smith became head of Ceramics & Glass; RCA restructured as six schools: Applied Art, Architecture and Design, Communications, Fashion & Textiles, Fine Art and Humanities, offering total of 21 courses; Graphic Design and Illustration combined as new Communication Art & Design course; Vehicle Design tutor Dale Harrow and design team designed TX1 London taxi; visiting tutor Chris Ofili won Turner Prize

Helen Hamlyn with Christopher Frayling (right) and Chris Smith (left, Secretary of State for Culture, Media and Sport) at the Launch of the Helen Hamlyn Research Centre January 1999

1997 RCAfé opened, designed by three second-year Furniture students; first College website created

Ron Arad succeeded Floris van den Broecke as professor of Furniture; Michael Langford and John Miles retired; new RCA logo launched, emphasising postgraduate nature of College; first College-wide energy efficiency competition held; Higher Education Funding Council for England granted special funding status to College for foreseeable future; Film and Television School closed; Professor Olivier Richon named head of Photography

1999 Sony introduced the Aibo dog robot; Daniel Libeskind's Jewish Museum opened in Berlin; Tracey Emin nominated for Turner Prize

228

2000

2000 Architects
Herzog & de Meuron
converted former
Bankside Power
Station to house
Tate Modern

2000 Eight of ten shortlisted jewellers for Jerwood Prize for Applied Art were RCA graduates, including the winner

Computer Related Design Department and partner institutions received £1 million award for EQUATOR project; Professor Nigel Coates of the School of Architecture & Design designed Body Zone for Millennium Dome; College received the Queen's Anniversary Prize for Higher and Further Education for the RCA/V&A Conservation course; Clare Johnston joined College as professor of Textiles; Professor Dale Harrow became head of Vehicle Design

2001 Al Qaeda terrorists attacked World Trade Center, New York

1999 Helen Hamlyn Research Centre opened, focusing on practical research into design and its social implications; six-part BBC documentary 'Royal College of Art' explored life at the RCA; new curriculum introduced for Vehicle Design

Jonathan Barnbrook
Heathen by David Bowie
2002

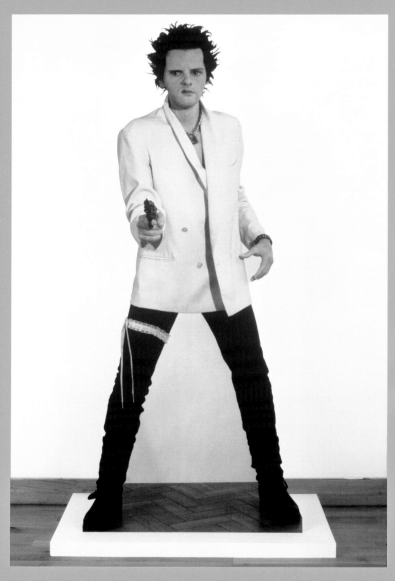

Gavin Turk
Pop Up
2000
Photograph on aluminium

2001 College received major award to establish Arts and Humanities Research Board Centre for the Study of the Domestic Interior, led by Dr Jeremy Aynsley, History of Design course director

Graphic Design and Illustration courses within School of Communications renamed the Communication Art & Design Department; College scored 5 out of 5 in the national Research Assessment Exercise for art and design; research activity at College consolidated in new Research Office; Visual Arts Administration course in School of Humanities changed name to Curating Contemporary Art; 2001 Animation graduate Suzie Templeton won BAFTA for Best Short Animation; Benedict Carpenter, PhD student in Sculpture Department, won first Jerwood Sculpture Prize; Vehicle Design Department had first PhD student; Critical & Historical Studies Department created in School of Humanities with Joe Kerr as head of department

2003 Jake and Dinos Chapman nominated for Turner Prize

2004 Online social networking service Facebook launched

2002 RCA received grant from London Development Agency to establish advanced rapid-prototyping facility

Johannes Paul, Simon Nicholls,
James Tuthill and William Windham
(Omlet)
Eglu
2003
Chicken coop

2003 Lord Snowdon succeeded as provost by Sir Terence Conran; School of Fashion & Textiles carried out industry-generated projects including footwear project by Manolo Blahnik

Printmaking Department continued publishing programme with new works by Cornelia Parker, Professor Ron Arad and others; Eglu, portable chicken-coop designed by Industrial Design Engineering graduates Omlet; Printmaking Department introduced part-time MA over three years

2004 InnovationRCA created to provide focus for College's relationships with industry; Jay Osgerby and Edward Barber won Jerwood Applied Arts Prize for table design

2003

2005 Critical & Historical Studies
admitted own research students;
new timetable and course structure
introduced to reflect increased
importance of dissertation for
MA students

Joint innovation fund set up with Imperial College; introduction of FuelRCA professional practice programme; InnovationRCA launches magazine, *Innovate*; tutors from Ceramics & Glass Department facilitated new ceramic art fair, Ceramic Art London, held in the RCA galleries; 2003 graduate Erdem Moralioglu won Fashion Fringe prize; Professor Anthony Dunne joined College as head of Design Interactions Department; *Communicate: Independent British Graphic Design since the Sixties* exhibition at Barbican Art Gallery included work by many graduates of College

Dunne & Raby
Electro-Draught Excluder Portrait
Placebo Project
2001

2006 Professor David Rayson became head of
Painting; Professor Mark Nash joined College
to become head of Curating Contemporary Art;
Professor Hans Stofer joined College to become
head of Goldsmithing, Silversmithing, Metalwork &
Jewellery; Alan Fletcher subject of retrospective at
Design Museum

Edward Barber & Jay Osgerby
De La Warr Pavilion Chair
2005
Die cast aluminium frame, pressed
aluminium seat and back, bent steel
tube legs

Hans Stofer
Pin-cushion
2006
Stainless steel pins, porcelain,
rubber, silicon

Neal Tait
Country Booby
2008
Acrylic and tempera on linen

2007 Design London launched to create 'innovation triangle' between design (RCA), engineering and technology (Imperial College Faculty of Engineering) and business (Tanaka Business School at Imperial College); Jonathan Barnbrook (MA Graphic Design, 1990) subject of retrospective at Design Museum; Apple introduced iPhone

2008 Completion of Wright & Wright's refurbishment of Sculpture Building in Battersea; plans unveiled to increase College's physical space by 50 per cent through complete development of Battersea campus by 2014

James Dyson Foundation donated £5 million towards expansion; ReachOutRCA designed education programme for Frieze Art Fair; Professor Jo Stockham became head of Printmaking Department at College; *Design and the Elastic Mind* exhibition at MoMA, New York, featured Anthony Dunne, Fiona Raby and other Design Interactions alumni; V&A exhibition *Cold War Modern: Design 1945–70* curated by Jane Pavitt and David Crowley

2007

2009

Dr Paul Thompson named rector

Professors Tord Boontje and Richard Wentworth joined College as heads of Design Products and Sculpture, respectively; Professor Miles Pennington became head of Innovation Design Engineering; Professors Ron Arad, Tom Barker, Sandra Kemp, Glynn Williams and William Lindsay left College; Haworth Tompkins' Sackler Building in Battersea completed, Painting Department moved in; Ceramics & Glass Department engaged in project collaborations with Sir John Soane's Museum and Freud Museum, London; discontinuation of RCA/V&A Conservation course; Moving Image Studio opened on Battersea campus; SustainRCA, the RCA's forum for work, issues and debates relating to area of sustainability, launched

Ian Kiaer
Offset/Black Tulip (Yellow)
2009
Oil paint on canvas, yellow foam,
Perspex plinth, mauve pearlescent
cotton and plastic packing cushion

College embarked on strategic plan to introduce additional Master's programmes and to grow in size from 1,100 to 1,500 students by 2015

Construction began on Dyson Building in Battersea, new home from 2012 for Photography and Printmaking; Sackler Building received RIBA Award; Design Products exhibited *HotelRCA* alongside International Furniture Fair in Milan; Critical Writing in Art & Design Department introduced in School of Humanities; *RCA Secret* raised £100,000 for RCA Fine Art Student Fund; Professor Dan Fern retired as head of Communication Art & Design; Professor Neville Brody joined College as head of Visual Communication; Jane Pavitt joined College as head of History of Design; Thomas Heatherwick (MA Industrial Design, 1994) designed British pavilion at *Shanghai Expo*; RCA Corporate Partners introduced to facilitate student bespoke projects for industry; AlumniRCA Scholarship Fund launched; Apple launched iPad tablet

Dyson Building, Battersea Campus

235

Pratap Bose
Tata Motors Pixel Concept Car
2011
Carbon fibre, leather, aluminium,
composites and Perspex

Konstantin Grcic
Medici Chair
2012

2011 New academic structure introduced with six schools, led by deans, and 21 programmes rather than departments

Schools of Applied Art and Fashion & Textiles combined into new School of Material with Professor Wendy Dagworthy as dean; Architecture became separate School; Sir James Dyson succeeded Sir Terence Conran as provost; Professor Alan Cummings retired; Nigel Coates succeeded as head of Architecture by Professor Alex de Rijke as dean of Architecture; Professor David Crowley became head of Critical Writing in Art & Design programme; College joined Universities of Lancaster and Newcastle in research consortium to boost creative economy; Sir Po-Shing and Lady Woo made major gift towards applied arts building to open on Battersea campus in 2015; Helen Hamlyn Research Centre renamed Helen Hamlyn Centre for Design; Helen Hamlyn Centre for Design and Vehicle Design programme partnered London NHS and others to redesign the emergency ambulance

2012 College alumni including Zara Gorman, Trine Hav Christensen, Tom Crisp, Thomas Heatherwick, Edward Barber and Jay Osgerby, Tracey Emin, Anthea Hamilton, Chris Ofili and Bridget Riley designed key elements of 2012 Olympic Games

Former Professor of GSM&J David Watkins designed medals for London Olympics; Ab Rogers joined College as head of Interior Design programme; Charles Walker joined College as head of Architecture programme; Jane Alexander and Professor Naren Barfield appointed pro-rectors, with Jane Alexander representing the most senior female appointment in College history; College attained first 50 per cent gender balance at dean level; RCA stages major exhibition celebrating its 175th anniversary, opened by HRH The Duke of Edinburgh

2012

INTERVIEW
Sir James Dyson

DRAWING IS STILL THE BEST WAY TO COMMUNICATE IDEAS QUICKLY – THAT'S WHY ALL THE ENGINEERS HERE CARRY A SKETCHBOOK

Drawing for Dyson Air Multiplier™ Fan
2011

James Dyson with *G-Force*
1983

"While at Gresham's school in Norfolk, I had considered becoming either a doctor or an artist, although my handlebar-moustached careers adviser suggested I become an estate agent. Following the careers officer's 'advice', I did go off to speak with an estate agent and even applied to be a doctor. I went for an interview at St Mary and St George's hospitals. For some bizarre reason they offered me a place. But it didn't take long for the medic at St George's to recommend art. I knew he was right. And so I chose Byam Shaw in London, because under the principal Maurice de Sausmarez it had an excellent reputation.

I did one year at Byam Shaw with Bridget Riley teaching us. We were taught very well how to draw – it's the foundation of everything. What was missing, though, was that I had yet to discover there were other things you could do besides paint and draw. Maurice recommended I apply to the Royal College of Art.

Drawing is still the best way to communicate ideas quickly – that's why all the engineers here carry a sketchbook. CAD is great for detailed intricacies of design but it all starts with a sketch – a Rotring propelling pencil, 0.9mm with 2B.

At the time the College was exclusively a graduate school. But, as luck would have it, it was experimenting by letting ne'er-do-wells in the back door. Well, they accepted three students [including me] without degrees. They were running an experimental scheme by which you could get in straight from school, or having just done a Foundation course. This was during the era of Hugh and Margaret Casson, and among the staff were John Miller, Margaret Dent and the renowned structural engineer, Tony Hunt.

The College had grouped us with the Interior Design and Industrial Design people, forming a kind of three-department class. I started with Furniture, but it wasn't until I stumbled

James Dyson with Jeremy Fry
Building a Pedalo from a
Scrap Bike
Provence
1968

James Dyson
Ballbarrow
1974

across Hugh Casson's lectures that I orchestrated a move to Interior Design. At least, it was called Interior Design but it could not have been further away from pillows and plush curtains. While Furniture was about crafting beautiful things, Interiors felt like the nitty-gritty of design. Furniture in those days was all secret lapped dovetails – it never really grabbed me. Hugh had a profound effect on me, though. He taught passionately, and watching him sketch on a blackboard was mesmerising. He had me hooked. Sadly, I never took any of the courses offered by Misha Black in Industrial Design Engineering. Misha was a design heavyweight and I should have taken notice.

I was in the same year as the sculptor Richard Wentworth, who started off at the College studying Design before switching to Fine Art. It was fluid in those days and mattered not a jot that you flitted between fields: painting to furniture to interiors to engineering. We were encouraged to explore filmmaking, sculpture and industrial design. I eventually settled on engineering, and Richard on sculpture. When I started at the RCA, I didn't have a clue what engineering was about. I chanced upon it but saw the beauty in mechanics – I was hooked. Of course, I had some catching up to do: maths is indispensible to understanding structural concepts.

During the 1960s and '70s at the College, non-conformity was positively celebrated and young people were creating their own culture. We were enjoying life to the full – there were even a few protest marches. I traded in wine to make ends meet, supplying staff and the Junior Common Room. I wasn't hedonistic or renegade, but I did have quite long hair, wore the odd flowery shirt and had bell-bottoms made in Kensington Market. I honestly just became absorbed in my London studies, although it hardly felt like studying. It was an adventure. My peers were, and still are, some of the most exciting artists and designers around. David Hockney was already fetching high prices at [John] Kasmin's gallery, and I remember Ossie Clark graduating with flashing light bulbs down the front of a dress. And the late Anton Furst was also a fan of Buckminster Fuller.

Tony Hunt had a profound influence on me. I'd never met anyone like him. He was as passionate about the aesthetics of a structure as he was about workings. He also introduced me to the geodesic world of Buckminster Fuller. Buckminster Fuller could envisage ideas that were beyond conventional lines of thought. Wrong thinking. He inspired me to go on and design large-span structures, well, a geodesic theatre in London for Joan Littlewood. I'd met Joan at a Bohemian hangout in Clerkenwell. I overheard her saying that she wanted to build a new theatre at Stratford East. Under the influence of Buckminster Fuller and space-frame structures, I designed an aluminium mushroom-shaped lattice, though unfortunately, we didn't have enough funding to build it.

Somehow I've managed to approach most of my ventures in an unconventional way – the wrong way can sometimes turn out to be the right way. Even at the RCA I went off cue. I was studying Interior Design but built a high speed, flat-hulled fibreglass landing craft as my final year project. Jeremy Fry, founder of Rotork and my industry mentor, tapped into my desire for making things. Off the cuff he had mentioned he wanted to make a boat. Jeremy had already been working on it, but he wanted me to finalise it. I would get away from the RCA as often as possible to test prototypes. Hugh Casson was never anything less than encouraging and let me get on with it. He awarded me a 2:1, despite not having actually designed an interior.

Dyson Airblade™ Hand Dryer
2010

Dyson Air Multiplier™ Fans
2011

Dyson DC35 Multi Floor with Root
Cyclone™ Technology
2012

When you look at the projects coming out of the Innovation
Design Engineering course over the timeframe of, say, 2010
to 2012, and compare the students and their work to that of
the late 1960s, I suppose the biggest difference is a greater
commercial focus now. It is an exciting and challenging time
to be a design engineer. Technology is progressing faster.
New materials are emerging. And people are becoming
harder to please. To compete globally, British designers are
needed more than ever."

Sir James Dyson

INTERVIEW
Margaret Calvert

Margaret Calvert
RCALENDAR Rubber Stamp
1984

MY LONG ASSOCIATION WITH THE ROYAL COLLEGE OF ART CAN BE TRACED BACK TO MY TIME AS A STUDENT, STUDYING ILLUSTRATION AND PRINTMAKING AT CHELSEA SCHOOL OF ART, IN THE LATE 1950S

Margaret Calvert
Woman at Work
2008
Painting based on the 'Man at Work'
road sign

"My long association with the Royal College of Art can be traced back to my time as a student, studying illustration and printmaking at Chelsea School of Art, in the late 1950s. Brian Robb, then head of Illustration (also at the Royal College, a few years later) invited Jock Kinneir to come in, as a visiting tutor, to give illustration students an insight into what graphic design was all about – still to be established as a course in its own right. I was completing the four-year National Diploma in Design course – no degree status then.

Jock had just left Design Research Unit, Britain's most prestigious design consultancy in the 1950s and '60s, headed by Misha Black and Milner Grey, to start his own practice (in three small rooms above a garage in Old Barrack Yard, a mews just off the Hyde Park end of Knightsbridge). He wanted a design assistant, so he invited me – initially to work on the design of signs for the then new Gatwick airport. Asked what my job would entail, his comment was: 'Well it's design – nothing like what you have been doing here.' The decision to choose graphic design as a career had been made for me. I dismissed any thoughts of going on to the Royal College of Art to study illustration. I knew by then that I wanted to be a designer. This was 1957. I had just turned 21.

My initial introduction to teaching came at the request of Misha Black, the professor of the RCA's Industrial Design Department. This was in 1966, the year Kinneir Calvert and Associates was established. David Tuhill, a former RCA graduate, joined us in 1972 to form Kinneir Calvert Tuhill. We were then quite a large company taking on commissions in Europe and further afield (the company folded in 1979). Misha thought it would be a good idea if the Industrial Design students were given an introduction to typography, as so many design products had ill-conceived and badly applied instructions. Jock suggested that I take on the job.

We had only recently completed designing Britain's radical new road signing system, starting with the motorways, and ending with a complementary system for the entire network, including pictograms.

My time with the product designers was soon to end, however, after setting a typography project for the illustrators – an incredibly talented second year that included Linda Kitson and Dan Fern. Eventually, I joined the Graphic Design Department on a one-day-a-week contract, at the request of Professor Dick Guyatt.

Gert Dumbar was appointed visiting professor of Graphic Design in 1985, as a result of the course being restructured from three to two years. He invited me to take on the role of acting head of department, but for one term only – until Liz McQuiston was free to take up the full-time appointment. As my role was a temporary one, I knew it wouldn't interfere with my personal work too much. I was working independently by then, designing extra weights of Calvert for the Monotype Corporation.

Then, in 1987 Derek Birdsall replaced Gert Dumbar – Gert was finding it difficult to commute from his studio in The Hague. To my surprise, Derek offered me the post of head of Graphic Design. I was reluctant to accept it at first, knowing

Margaret Calvert and Jock Kinneir
School Children Crossing
Early 1960s

Jock Kinneir and Margaret Calvert
UK Road Sign Maquette
Early 1960s
Gouache

that a full-time post would leave me little time for my own work. I thought it would be a challenge working with Derek, who was so very different from Gert. But it wasn't long, however, before Derek left at short notice over a difference of opinion with the rector, Jocelyn Stevens, regarding the content of the new course document.

It is to their immense credit that so many students, over such a short period, made names for themselves after graduating. Most notably, although there are many more: David Ellis and Andy Altmann from Why Not; Phil Baines, professor of Typography at Central Saint Martin's; Jonathan Barnbrook; Paul Neale and Andy Stevens of Graphic Thought Facility and Angus Hyland, Pentagram partner – soon to be followed by Marina Willer, also a Pentagram partner; Frith Kerr and Amelia Noble.

When I accepted the new title of acting course director, in 1989, the letterpress department, thought to be an outmoded form of print production, was under threat of closure. We felt it well worth fighting for, as a creative force, under the guidance of the remarkable Alan Kitching. Eventually, it was offered as a College-wide course to all students interested in the tactile qualities of letterpress printing. (There were fewer students then, with a comfortable staff–student ratio).

We were fortunate in that we had our own funds to set up a small computer unit, supervised by Richard Doust, senior tutor and expert in digital technology. This was invaluable in the production of the last-ever degree show catalogue, designed and produced by first-year Graphic Design students, while at the same time having to contend with the noise and dust from the new Stevens Building, which was in the process of being erected just outside my office.

Great as the staff were, I felt the need to inject some new blood into the team, who were nearer in age and interests to the students. Nick Wurr of the Partners, and Moira Bogue of *I-D* magazine were the perfect complement. It was interesting, however, to see which tutors were most effective, regardless of age or interests.

The rector, Jocelyn Stevens, was on the whole very supportive of Graphics, having come from a publishing background – although he could be a bit fierce at times. He was particularly supportive of the group of first-year students designing the degree show catalogue, as he attached great importance to its value as a promotional tool for the College. The first one, awarded a D&AD Silver Award, was considered to be the 'best thing in the Show', according to the illustrator and engraver, Andrew Davidson, who graduated in the early 1980s.

Margaret Calvert
*Jesmond Platform Sign
in Calvert Typeface*
Tyne and Wear Metro
1981

Margaret Calvert and Neville Brody
Calvert Brody Typeface
2012
Developed by Henrik Kubel

Students, already well informed regarding who was who in graphic design, were encouraged to eschew fashionable trends and find their own voices, seeking inspiration elsewhere. They were aware that, as graphic designers, they could be working with a diverse range of clients, often in collaboration with not only illustrators but also designers from a broad range of disciplines. Designers such as Peter Saville and Neville Brody were, however, much admired for their radical approach.

I still keep in touch with both staff and students – sometimes offering advice over a cup of coffee, or collaborating on joint projects, such as designing a digital version of Transport, with (former RCA student) Henrik Kubel for Gov.uk, the Government's official website."

Margaret Calvert

ABCDEFGHIJKLM
NOPQRSTUVWXYZ
abcdefghijklm
nopqrstuvwxyz
0112234556789
[{(&)}]

INTERVIEW
Sir Ridley Scott

I HAD REALISED I WOULD NEVER MAKE A PAINTER – THERE WERE ARGUMENTS ABOUT WHETHER OR NOT MY PAINTINGS WERE PAINTINGS OR ILLUSTRATIONS

"I applied to the Royal College of Art after my first degree at West Hartlepool College of Art – the RCA was top of the list as the most acclaimed art college at that time. I had realised I would never make a painter – there were arguments about whether or not my paintings were paintings or illustrations.

The RCA had a particularly strong Graphic Design Department, which would give me a more specific creative target and a broader canvas. I was thrilled to be accepted, starting autumn 1958 and finishing in 1961. 'Television and film design' and photography were just beginning to happen, and America was becoming a big influence.

I was struck by the level of professionalism and the highly competitive nature of Graphic Design at the RCA. All students were of a very high standard. Putting us all together was the beginning of my being aware of the competitive nature of my chosen profession. I realised from very early on that I would have to fight hard and do very well if I was going to make it. One was pretty well left to it.

The mood of the College at the time was rebellious and politicised, [as well as] studious and introverted. It could be very competitive, with not much being given away and everything kept close to your chest. You observed all the time, watched what everyone else did and tried to do better and be the most original.

During the Richard Guyatt era of Graphic Design, it wasn't easy for a student to work with type and photomontage. Nothing was easy. Nothing worth achieving ever is. It was really all part of the design curriculum. This was the school of everything. You just had to be pushy. And go for it. That's what all students must understand from day one.

The European school of typography and graphics failed to take root in the RCA in the 1950s, I think, because the College was still steeped in fine art – painting, engraving, sculpture. And it was only really aware of integrating the industrial side of the arts. It was isolated for so long from European and American visual language.

A lot of the staff had been war artists, so for Bob Gill to come in with button-down shirts, black suits and talking in a slick Madison Avenue way was incredibly attractive. US advertising was way out, and I realised very early the need to learn fast and absorb all that I could and then make my own decisions. I had strong views even then and could sort the wheat from the chaff, and that's still important today in everything I do.

We always looked at all the graphic journals of the period. The influence of Madison Avenue, which was very much part of the American 'dream' and 'way', was very attractive to us all. Eventually, I got a travelling scholarship, so after leaving the RCA I went to the States. Getting in [to the RCA] was one of my defining moments, but it was gaining first class honours at Convocation and receiving a travelling scholarship to the US that set me on the path for later life.

I remember one of our tasks was about the Festival of Britain, and another was to think of a scheme for IBM. By the second year, I was spending time in the Photography Department whenever I could. It was difficult to get into – you had to spend time chatting people up so they would allow you in the darkroom. I bought a camera and was out every weekend on a photographic vigil.

From an early age, though, it was film that attracted me. All my free time in Stockton-on-Tees was spent at the local cinemas, watching everything and learning. You never stop learning. Even now. You can learn from so-called 'bad' films and television, and there is usually something that you react to, which makes you ponder and try to find your own way. Subsequently, of course, Hollywood became the 'face' and the 'mind'.

Stills from Ridley Scott's *Boy
on a Bicycle*
1965

Still from Ridley Scott's *Alien*
1979

I barely had the opportunity to work with film while at the RCA – there was no film department as such. There was only one Bolex wind-up clockwork camera, an instruction book and a light meter inside a steel cabinet. George Haslam, head of Television and Film Design at the RCA, and a talented television designer under Tim O'Brien at Teddington Studios, was our tutor, adviser and supporter, though he provided no real film-dissecting or analysis at all. That wasn't his forte.

He would give us scripts to flick through, and we would come back with a set design and models. By then, I was already into the Television Department – a one-year course. I presented my script for a short film *Boy on a Bicycle* to George, who allowed me to borrow the Bolex for a month to shoot the film in North Hartlepool. I was given £65 to finance the film and processing. I am grateful to George for that. It was a big budget.

In the late 1950s, films of different genres, language, locales and those with a certain grittiness had particular impact on me. I should name *Saturday Night and Sunday Morning*, *The Seven Samurai*, *Citizen Kane* and *The Third Man*. Kurosawa and Welles were masters, to appreciate with their vastly differing styles.

There aren't very many visual metaphors or devices I employ cinematically that I can trace back to my student days. You try not to repeat yourself. Or I try not to. Perhaps curiosity and determination are the key factors I needed then, and need now, on every film I develop and make.

At the RCA, I was more focused on my own hyper-desire to become a good filmmaker; then a better one; then a very good filmmaker and then go even higher. The process never stops. Of course, I had some acquaintance with David Hockney, who was obviously an artist of supreme inventive-ness even then – someone to watch. He was always going to make his mark. I wish I had bought some of his paintings at each stage of his development. He also never stops wanting

Ridley Scott Directing *Gladiator*
2000

to learn. Otherwise, I seemed to take off in my own direction. I knew where I wanted to end up.

I think young artists today are probably helped by the expanding awareness of fine art over the past 30 years or so. There are more buyers and more galleries. But, it's still very tough and always will be. All you can do is keep doing it, having the passion and following your own criticism. You must never stop trying to improve."

Ridley Scott

INTERVIEW
Christopher Bailey

Previous Page:
Christopher Bailey
Burberry Chief Creative Officer
2008

Christopher Bailey
Graduation Show
1994

Christopher Bailey
Graduation Show
1994

I NEVER REALLY KNEW ABOUT THE WORLD OF FASHION, IT WAS NOT EVEN ON MY RADAR WHEN I WAS YOUNGER. I KNEW ABOUT DESIGN, THOUGH. I KNEW ABOUT ART, AND I LOVED FABRICS – I LOVED EXPRESSING THINGS THROUGH CRAFT

I grew up in Yorkshire, in the English countryside, which is beautiful but definitely not a fashion capital. I never really knew about the world of fashion, it was not even on my radar when I was younger. I knew about design, though. I knew about art, and I loved fabrics – I loved expressing things through craft. My love for architecture came from my father, who is a carpenter. I loved watching him make things, and I loved construction, which I guess translates into clothes. My art teacher suggested that I send my work to art schools, and that was the start of my journey into fashion and ultimately, design.

The University of Westminster was my first taste of the fashion industry and helped me put into perspective the realities and excitement of our dynamic industry. When I started at the RCA, I was impatient and hungry to practise, and I still remember the excitement and this great energy I felt when entering the building. From the very beginning, the RCA taught me the importance of opinion, and throughout my studies there, I learnt the means to express it in a three-dimensional way.

I was incredibly fortunate to be awarded a scholarship to the RCA by the family of the late Bill Gibb and I can say, without question, I would not be where I am today had it not been for that support – thanks not only to the financial assistance which it gave me, but also to the mentoring and guidance that is so crucial at a stage of your life where every decision makes a huge impact on your future.

Burberry Prorsum Autumn/Winter
2011, Womenswear Collection Finale

It was during my time at the RCA that I learned the importance of expressing yourself, and having a confidence and belief in your vision. It was an incredible feeling when Donna [Karan] asked me to join her in New York after graduating [in 1994]. That moment changed my life and set me on the path that has led me to where I am today. I was just completely seduced by this incredible woman, who had a way of approaching design that just blew me away. It was an unbelievable experience to work with her; she taught me how to use my eyes. The clearest message that Donna taught me was to do what you do with passion or to forget it, and I always thought that was a pretty good way to approach everything in life.

For me, design and innovation have always gone hand-in-hand – be it during my studies at the RCA or at Burberry. It's very important to embrace new technologies and innovation, but never lose sight of what your brand is truly about. Burberry, for example, is now as much a media-content company as it is a design company, because it's all part of the overall experience. There seems to be an assumption that technology and innovation are somehow competing with reality, whereas for us, the two complement each other, allowing us to really heighten the physical experience of seeing the collections, colours, fabrics and also of hearing the music and all the drama and emotion that you feel when all those elements come together in that moment.

I think British talent is exceptionally strong now, with so many young British designers having success here and abroad – partly due to the amazing colleges and array of courses – but also to talent scholarships for up-and-coming designers creating more and more opportunities. It's even more important in this economic climate that we keep supporting these colleges and emerging talent. I think scholarships are key to this. With the RCA scholarship, for example, we hope to support students who may otherwise not have been able to complete a specialist design course, and to give them the freedom to not just study but to dream during their time at the Royal College of Art.

Burberry Regent Street Flagship Store, London

I think being able to express your own point of view is as important in the world of work as is it when you are a student – you always have to stay true to your own point of view. The RCA has always supported individuality and creativity, and it was the RCA that gave me the tools and the platform to leap into the design world. The support, mentoring and guidance I received during my studies, gave me the belief and self-confidence to explore the many wonderful opportunities that I've had.

We had many tutors, some of whom are still involved with the RCA. They all influenced us in many different ways, including the technicians – some giving more practical guidance and helping us to learn the craft of our work. Others there helped us to open our minds and to look at the world in a different way.

The culture of the College was an open environment, where the main event was to push yourself and to seek your own path. It was a very clever structured/unstructured approach to learning, experimenting and discovering. Though the pressures were significant, it was a very free and exciting time and place, and even then you had a sense of being somewhere special with clever and interesting minds.

The diversity of design at the RCA was what made it so special to me – it felt like a labyrinth of excitement through every door and around each corner. It helped you to put your own work into context and to explore the bigger picture and how design impacts everything we do every day. It was for me very personally fulfilling to be among a group of people who were inspiring and open to collaborating and letting you in.

My peers go across all the different sectors of design, from industrial design, graphics, photography, architecture, textiles – you name it. Some of them are very familiar names and others have quietly changed the world and how we live in it through the influence of design. All of us certainly have a much broader, more open mind, thanks to the filter that the RCA gave us to look at the world of which we are a part."

Christopher Bailey

British Craftsmanship at the Heart of the Burberry Trench Coat

INTERVIEW
David Hockney

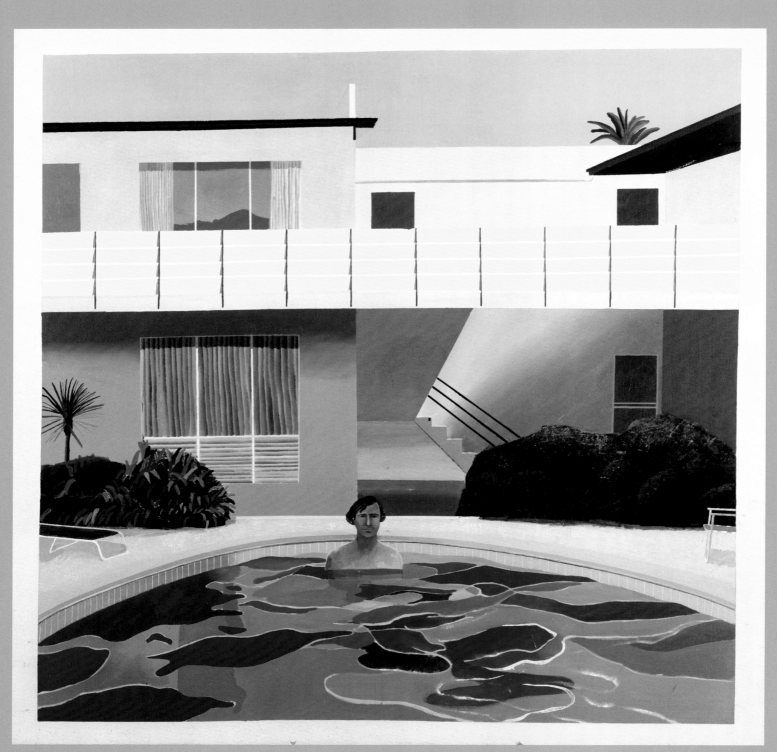

Previous Page:
David Hockney at the RCA with
Critical & Historical Studies Students
January 2012

David Hockney
Portrait of Nick Wilder
1966
Acrylic on canvas

THE ROYAL COLLEGE OF ART HAS CHANGED A LOT FROM WHAT IT USED TO BE IN MY TIME

David Hockney and Derek Boshier
in the Painting School
1961

"

'The Royal College of Art has changed a lot from what it used to be in my time. I used to be in a building on Exhibition Road, and on Cromwell Road. When they put the windows in, they didn't put them in the right place – they put them in the east, which of course, doesn't work because you get the sun in the morning. If you put windows in the west, you get the sun in the evening. But if you put windows in the north, you get light consistently throughout the day. I was glad to hear that when they built the new building they'd put the windows in the right place.

I was a student at Bradford Art School from the age of 16 to 20 and was taught by people from the Royal College of Art – Frank Lisle and Derek Stafford. Back then you did your GCE (General Certificate of Education) at 16, but I wasn't going to be put off art school. I'd actually applied to The Slade, as well as the RCA, and got into both, but I chose the RCA because there were people there that I knew.

When I left school, however, I had to do two years of National Service. Others, like Norman Stevens, went straight to the RCA, but I was scrubbing hospital floors. So when I was 22 and arrived at the College in October 1959, I was very eager to get back to some proper work.

I had only visited London three or four times before that – I was very provincial, and the College was so lively. I'd left home, was living in a room in Earl's Court and had about £100 a term to live on. You could do exactly what you wanted. You could even smoke. I remember having to sandpaper off the nicotine stains on my fingers before going to visit the registrar to borrow some money. They couldn't be seen to be lending to fellows that smoked.

When I arrived at the College, I didn't quite know what to do. There was compulsory drawing for a term, which was fine with me – I liked drawing. But then around the second

David Hockney
Detail from *I'm in the Mood for Love*
1961
Oil on canvas

I would stay in the school until about ten at night, whereas most students stopped about three and went home. I'd always go to the cinema and then come back to work when everyone else had left. On the way, I'd always have a look in Carel Weight's office – I was a bit cheeky in picking up envelopes or letters and reading them. I got the name 'Our Man in the Staff Room' from that Carol Reed film (and Graham Greene novel) *Our Man in Havana*. I was a confident, cheeky sort of lad but the staff always liked me. I didn't see them as antagonistic – in the end, they just ran a very lively school.

What happened in those days was that students who had left the College two or three years before would often come back and hang around. Peter Blake had left four or five years before me, but he would come back. I also got to know Ridley Scott. Although he was a Graphics student, he used to wander round the Painting studios when there was no one else around. We kept bumping into each other in Hollywood years later.

There were quite a few peers from that time I maintained friendships with: Allen Jones, Patrick Caulfield – but by the mid-1960s, I was spending a lot of time in California and ended up living here. It's much sunnier and more temperate than New York. At the time it was sexy, I thought. And what I didn't realise was that, being claustrophobic, I welcomed the horizontal lines of LA rather than the vertical lines of New York.

I made my first trip to New York in 1961. It was clear that, somehow, something had shifted from Paris to New York. I would have been of the generation to see that. Francis Bacon – now he's a generation older – for him, Paris would have been the centre. By the centre, I mean of activity. Paris had been that in the 1930s and '40s, with artists like Matisse, but in the '60s – in my period – it shifted.

The first Abstract Expressionism started in the mid-1950s. I hitchhiked down to London to see Jackson Pollock at the Whitechapel in 1956. It was a period of transformation. I was still interested in French artists like Dubuffet and Yves Klein and more interested in depiction – depicting what the world looks like. I hadn't really been that interested in Pop Art as such. But there's nothing like looking back at a period and seeing it much clearer later.

term, they made drawing not compulsory and introduced General Studies, which were lectures on nuclear physics or something like that. It was said at the time that people were leaving art school and not being properly educated, I think that's what started it. But for me, things like drawing, painting and learning other skills were the real serious activity.

To get myself going again – I didn't really know what I should have been doing as I hadn't been at art school for two years – I drew what was hanging up: a skeleton. I did a kind of academic drawing that took me two or three weeks.

In those years, the College was a marvellous place, with very lively, lively students. Most of us were living on scholarships. They (the tutors – Carel Weight, Ruskin Spear, Ceri Richards, Roger de Grey, Colin Hayes and Sandra Blow) left you alone, though at the end of the first year, they told us we were the worst year they'd ever had.

Most of us had had very traditional teaching methods up until that point, and when we got to the RCA we wanted to do more physical things and abstraction, which was getting big, coming from America. I think they were slightly at a loss as to how to deal with that.

Melvin Bragg did some programmes recently about class and culture. I told him that he'd missed something big: Bohemia. In 1961, homosexuality was illegal, but I never gave it a thought. The first straightforward gay men I met were at the College – Quentin Blake and Adrian Bird.

The Bohemian world was different. There weren't people telling you off because you weren't prim and proper or respectable. You were a free spirit and did what you wanted to do. Bohemia was classless. It's kind of lost now. These days, even the gays, they want to get married. I'm glad that I've lived when I have. It was freer. I even remember airports when there was no security. Socially, it's more boring today.

I never needed to do teaching – I realised that I could manage without and could spend my days doing what I wanted to do, but maybe I lost contact with the younger generation and the chance to influence. What if I could teach now? It's an interesting time. There are so many things to question. I'm moving away from single viewpoints and linear perspectives. One thing we did recently was around the show at the Royal Academy. We let a TV crew go in but went back in April to shoot it ourselves with just three cameras and a tiny team – me as cameraman. We got far, far more depictions of the interior and close-ups. Why doesn't the BBC use its cameras in such ways? The problems with depiction should be stated. Old media is fading. You can see it in that the old media is talking about the new media. I follow it all very carefully."

David Hockney

David Hockney
Merced River, Yosemite Valley
September 1982
Photographic collage

David Hockney
Untitled, 26 February 2010, No. 2
iPhone drawing

David Hockney in his Bridlington
Studio
February 2009

INTERVIEW
Tracey Emin

Tracey Emin

PAINTING AT THE RCA AT THAT TIME WAS REALLY CONSERVATIVE. IT WAS THE HEIGHT OF THATCHERISM. JOCELYN STEVENS WAS DIRECTOR AND IF YOU DID PAINTING YOU HAD TO JUST PAINT ON CANVAS

Previous Page:
Tracey Emin
*Outside Myself
(Monument Valley)*
1994
C-type print

I did a BTech fashion course at Medway College, but I dropped out after a year and a half because I was rubbish at it. Billy Childish was the person who encouraged me to paint and make art. We both saw life experiences as good subjects. I really liked Egon Schiele because I have always been a massive fan of David Bowie. David Bowie was influenced by Schiele, with his album cover for *Heroes*. But Billy really encouraged me to paint and make art.

After Medway, I went to Sir John Cass and did printmaking. My fine art degree was at Maidstone College. I took a year out before going to the Royal College of Art to do Painting. I chose to go to the RCA because I wanted to learn to oil paint. Ken Kiff was a tutor there, and I liked his work.

The interview to get into the College (with Adrian Berg, Alan Miller and Professor Paul Huxley) was a jovial experience. Looking back now, I think the students were chosen like a football team, in that we all had something to bring to the course, and I was coming from a completely different place. The majority of people who go to the Royal College of Art are pure A level students, who come from middle-class back-

Tracey Emin
Sleeping With You
2005
Reclaimed painted timber and warm
white neon

Tracey Emin
Pelvis High
2007
Acrylic, oil pastel on canvas

Interview
Tracey Emin

Tracey Emin
Love is What You Want
2011
Neon (coral pink heart, blue text)

grounds and are born with a sense of security. Not all but some. I was chosen because I had really good sketchbooks. One of the criteria was to submit four, and I submitted seven. My paintings were appalling because I used screen ink but that's why I was given a place because I needed to learn how to paint.

Painting at the RCA at that time was really conservative. It was the height of Thatcherism. Jocelyn Stevens was director and if you did painting you had to just paint on canvas. You couldn't do anything else. And I think if I hadn't learnt to use oil paint and make stretchers, I would have been asked to leave the course. The art history course could have been different, much more sophisticated. I was very surprised after Maidstone – I had very high expectations. I remember being very shocked that a lot of the students didn't write their own theses – they just copied others.

I worked alongside studying to support myself through the programme, working for a home catering firm cutting up vegetables and washing up. I worked at Gaz's Rockin Blues in Soho as a cloakroom attendant and scrimped around doing various part-time jobs to make money. In my second year, I worked six days a week at the College until ten at night, then it was seven days a week during the spring and summer terms.

I was lucky enough to receive the hardship fund that was specially set up for students who came from very impoverished backgrounds or had some calamity in their lives. At the end of the first year I was delighted to receive the travel scholarship, which was quite a lot of money at the time, except there was one snag: I could have the scholarship as long as I didn't travel. I had to come into the College every day and under the supervision of Peter Allen, the school technician, and my Painting tutor, Alan Miller, I had to learn how to stretch and prime canvases, and oil paint. During that summer, I was allowed to have as much canvas or as much paint from any series that I wanted. Looking back on it, it

was one of the best things that ever happened to me. Turkey could wait.

Alan was a long-term influence on my work in that the practical help he gave and advice has helped me to this day. He taught me how to prime and stretch canvas properly, how to apply oil paint and what you could mix with it. He gave me this tuition during the summer during my first and second year. I remember the time he saw my first oil painting and he jumped up and down and said, 'You've done it, you've done it.'

When I was in my second year at the RCA in 1989, I heard something was happening at Goldsmiths. A group of boys in my year were always going on about 'Goldsmiths this' and 'Goldsmith that' but it meant nothing to me as I was looking forward to going back to Turkey to do watercolours of fishing boats and donkeys.

There were lots of things that made me unhappy at the RCA. I always referred to it as 'debutantes' day out'. It was incredibly

Tracey Emin
Beautiful Reflection
2011
Embroidered calico

Tracey Emin in her Studio at the Royal
College of Art
1987

posh, and I felt at the time like a misfit and found it hard to make friends, unlike Maidstone, which had just been really fantastic. But I really enjoyed my secondary courses: Esoteric Mysticism and Sacred Geometry.

I only had a handful of friends at the RCA, and I still care about those people now. My closest friends were Susan the secretary, and Rachel who worked in the shop. And the person I'm still most in touch with is David Dawson, who I shared a studio with for a year, who is a very good painter and photographer.

Smashing up my paintings in the College courtyard came out of frustration with myself. My only regret was never having it on film. I used a sledgehammer and my paintings were on wood. I went ballistic slashing the sledgehammer around and no one could get near me. And it was simply because I had nowhere to put my paintings so they had to go. That was a mark of my own failure. I later destroyed all of the paintings I made at the RCA by throwing them into a skip. It wasn't because I didn't care about them. It was because I cared about them too much.

In 1996, I did a three-and-a-half-week project called *Exorcism of the Last Painting I Ever Made*. The impetus came though the fact that oil painting made me feel guilty and I had to get over it. It was wrapped up with my abortion and my feelings of failure.

One of my deepest regrets is swapping the painting that was meant to go into the RCA collection. The one that is in it now, *Friendship*, wasn't the painting that was chosen by the selection committee group. They chose a painting of my grandmother. One evening Stan the caretaker was on his break and I took the keys from his office. I went to the store and I swapped the paintings over. The painting was six foot by six foot – the same size as the one I put back in so that no one would notice. I scrawled a note on the back of the painting to the effect 'I am not ready to give you my grandmother'

and an apology. It is with the deepest regret that I ever swapped those paintings over, and there's definitely a lesson to be learnt. It was years before anyone noticed, but for me it was too late.

The Perfect Place to Grow, featured in the *175 Years of the Royal College of Art* exhibition, is about nurturing and love. My dad one day decided he was going to make me a table. He made two of the worst trestles ever known to mankind. He was never much of a carpenter, but he was a fantastic gardener. We should be encouraged to do what we are naturally good at, not what we are not good at. But, still, some of the results can be interesting. Maybe perfection isn't everything.

I have been painting seriously for 11 years now. Sometimes it takes me seven years to do a painting, sometimes it takes me one day, sometimes half an hour. I love painting but I'm still really afraid of it. Always have been, probably always will be."

Tracey Emin

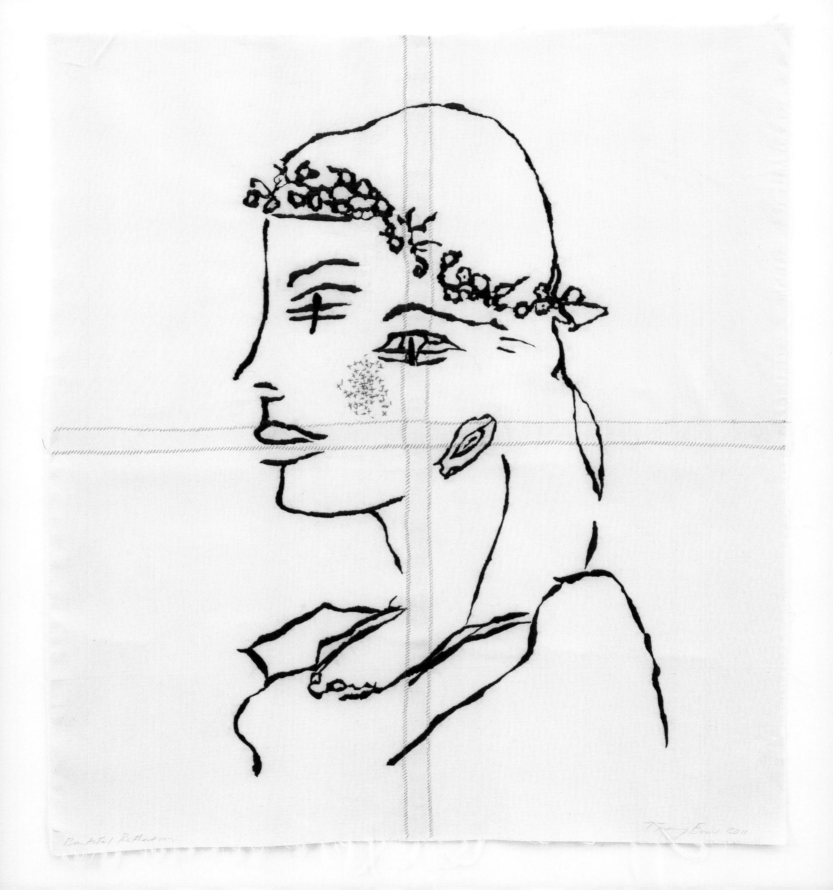

Beautiful Reflection

COPYRIGHT AND PHOTOGRAPHY CREDITS

287

174 Bottom: © Victoria and Albert Museum, London

176 Top: Royal College of Art archive

Bottom left: © Leeds Museums and Galleries (City Art Gallery)/
The Bridgeman Art Library

Bottom right: © Interfoto/Atelier S/Mary Evans Picture Library

177 Right: Cassell, Petter & Galpin, Colour Reference Library, Royal College
of Art archive

178 Left: © Victoria and Albert Museum, London

Right: Courtesy the Michael and Mariko Whiteway collection

179 Left: Courtesy Rhode Island School of Design archives

Right: Royal College of Art collection

Bottom: © George Routledge & Sons, 1878, courtesy the Michael and
Mariko Whiteway collection

180 Left: © National Portrait Gallery, London

Right: Courtesy the John Cox collection

181 Left: © Tate, London 2012

Right: Courtesy RIBA Library Drawings & Archives Collections

Bottom: Firmin-Didot, Colour Reference Library, Royal College of Art
archive

182 © Interfoto Agentur/Mary Evans Picture Library

183 Left: Royal College of Art archive

Right: Royal College of Art archive

184 Top: © Mary Evans Picture Library

Bottom: Royal College of Art archive

185 Royal College of Art archive

186 Left: © Laing Art Gallery, Newcastle

Right: © Mary Evans Picture Library

187 Top: Royal College of Art archive

Bottom: © Epic/Tallandier/Mary Evans Picture Library

188 Royal College of Art collection

189 Royal College of Art archive

191 © Estate of Sylvia Pankhurst, courtesy the Pankhurst family

192 Top: His Majesty's Stationery Office

Left: © TfL from the London Transport Museum collection

Right: Royal College of Art collection, © Estate of Walter R Sickert,
all rights reserved, DACS 2012

Bottom: © Imagno / Mary Evans Picture Library

193 Top: Courtesy RIBA Library Drawings & Archives Collections

194 Top left: Massin, Colour Reference Library, Royal College of Art archive

Bottom left: Royal College of Art collection, © Tate, London 2012

195 Left: Royal College of Art collection

Right: Courtesy Bowness, Hepworth estate

196 Top left: The Henry Moore Foundation archive, reproduced by permission
of The Henry Moore Foundation

Bottom left: Royal College of Art collection, © the estate of Edward Bawden

Right: Photograph courtesy The Ingram Collection at The Lightbox,
© estate of the artist, c/o Lefevre Fine Art, London

197 Left: Royal College of Art collection

Right: Royal College of Art collection, © the estate of Edward Bawden

198 Top left: Royal College of Art collection

Top right: Royal College of Art collection

Bottom: Royal College of Art collection

199 Left: Royal College of Art archive

Right: Royal College of Art collection, © estate of Eric Ravilious, all rights
reserved, DACS 2012

200 Left: Royal College of Art collection, the estate of Ruskin Spear/
Bridgeman Art Library

Top right: Royal College of Art collection, the estate of Ruskin Spear/
Bridgeman Art Library

Middle right: Royal College of Art collection, the estate of Ruskin Spear/
Bridgeman Art Library

Bottom left: © Estate of the artist, photograph by Joe Mackay

201 Top left: Elizabeth Clements papers, Royal College of Art Special
Collections, photographer unknown

Bottom left: Royal College of Art archive

Top right: © TfL from the London Transport Museum collection

Bottom right: © TfL from the London Transport Museum collection

202 Royal College of Art collection

203 Left: Royal College of Art collection, by kind permission of The Robin and
Lucienne Day Foundation

Right: 3 July 1943, photograph by Kurt Hutton/Picture Post/Hulton
Archive/Getty Images, © 2007 Getty Images

204 Courtesy The Ingram Collection at The Lightbox

205 3 July 1943, photograph by Kurt Hutton/Picture Post/Hulton Archive/
Getty Images

206 Left: Photograph by Planet News Archive/SSPL/Getty Images

Right: Royal College of Art collection, © estate of the artist 2010

207 Royal College of Art collection, © estate of the artist 2010

208 Left: Royal College of Art Special Collections

Right: © David Mellor Design

209 Royal College of Art Special Collections, Lion and Unicorn Press

210 Royal College of Art collection

211 Left: © Geffrye Museum, London

Right: Royal College of Art collection, © estate of the artist 2010

212 Left: Royal College of Art archive

RCA STAFF AND STUDENT DATES

Abis, Stephen	Student 1961–4	Boshier, Derek	Student 1959–61
Adjaye, David	Student 1991–3, staff 1998–2001	Boty, Pauline	Student 1959–62
Agnew, Kenneth	Student 1959–61, staff 1961–78	Bowler, Jane	Student 2008–10
Alexander, Jane	Staff 2011 to present	Bowling, Frank	Student 1959–62
Allingham, Helen	Student 1866–7	Brand, Andrew	Student 2007–9
Altmann, Andrew	Student 1985–7	Bratby, John	Student 1951–4, staff 1957–8
Arad, Ron	Professor 1997–2009	Brewster, Simone	Student 2005–7
Archer, L Bruce	Staff 1961–88	Britton, Alison	Student 1970–73, staff 1984 to present
Ardizzone, Edward	Staff 1953–61	Brogden, Joanne	Student 1950–53, staff 1957–71, professor 1971–89
Armstead, Henry Hugh	Student early 1840s	Brody, Neville	Professor 2010 to present, dean 2011 to present
Ashworth, Joan	Staff 1994–8, professor 1998 to present	Brown, Barbara	Student 1953–6, staff 1968–90
Auerbach, Frank	Student 1952–5	Buhler, Robert	Student 1936, staff 1948–75
Austin, Robert	Student 1919–22, professor 1947–55	Burra, Edward	Student 1923–4
Aylieff, Liz	Student 1993–6	Burchett, Richard	Principal 1851–75
Aynsley, Jeremy	Staff 1996–2002, professor 2002 to present	Burn, Rodney	Staff 1929–31, 1946–65
Ayrton, Maxwell	Student 1897–9	Butler, Elizabeth (Lady)	Student 1865–6
Bacon, Francis	Artist in residence 1950–51	Cadwallader, Gareth	Student 2008–10
Baier, Fred	Student 1972–5	Cain, Lily	Student 2010–12
Bailey, Christopher	Student 1992–4	Caivano, Varda	Student 2002–4
Bailey, Dennis	Student 1950–53	Calvert, Margaret	Staff 1966–81
Baines, Phil	Student 1985–7	Capey, Reco	Student 1919–22, staff 1925–53
Baker, Robert W	Professor 1948–59	Carnegie, Gillian	Student 1996–8
Barber, Edward	Student 1992–4	Carty, Martin	Student 1993–5
Barfield, Naren	Professor 2011 to present	Casey, William Linnaeus	Student c. 1857–8
Barnbrook, Jonathan	Student 1988–90	Casson, Hugh	Professor 1951–75
Barton, Glenys	Student 1968–71	Casson, Margaret	Staff 1951–74
Bawden, Edward	Student 1922–6, staff 1930–40, 1948–53	Caulfield, Patrick	Student 1960–63
Baynes, Ken	Student 1957–60	Chadwick, Helen	Staff 1994–6
Bellany, John	Student 1965–8, staff 1969–73	Chapman, Dinos	Students 1988–90
Berg, Adrian	Student 1958–61, staff 1987–9	Chapman, Jake	Students 1988–90
Binyon, Helen	Student 1922–6	Chetwynd, Spartacus	Student 2002–4
Bisley, Anthony	Student 1955–9	Christensen, Trine Hav	Student 2010–12
Black, Misha	Professor 1959–75	Clark, Ossie	Student 1962–5
Blake, Peter	Student 1953–6, staff 1964–76	Clarke, Geoffrey	Student 1948–52
Blake, Quentin	Staff 1965–87	Clausen, George	Student 1868–73
Blamey, David	Student 1977–80, staff 1989 to present	Coates, Nigel	Professor 1995–2011
Bliss, Douglas Percy	Student 1922–5	Cocksedge, Paul	Student 2000–02
Blow, Sandra	Staff 1960–75	Coe, Susan	Student 1971–4
Bogue, Moira	Student 1982–4	Cole, Henry	General superintendent of department of practical art and successors, 1852–73
Boontje, Tord	Student 1992–4, professor 2009 to present		
Bose, Pratap	Student 2001–3	Coleman, Roger	Student 1953–6

Constantine, David	Student 1988–90	Fletcher, Alan	Student 1953–6
Coper, Hans	Staff 1966–75	Frayling, Christopher	Staff 1979–99, rector and vice-provost 1996–2009
Couldridge, Alan	Student 1960–63, staff 1972–92	Freedman, Barnett	Student 1922–5, staff 1928–40
Couldridge, Valerie	Student 1960–63, staff 1974–83	French, Hilary	Staff 1998 to present
Cragg, Tony	Student 1973–7	Fulton, Holly	Student 2005–7
Crane, Walter	Principal 1898–9	Games, Abram	Visiting staff 1946–8, staff 1948–53
Crosby, Theo	Professor 1990–93	Garland, Ken	Visiting staff 1977–87
Crowley, David	Staff 1999–2010, professor 2010 to present	Garland, Madge	Staff 1948–56
Crowley, Graham	Student 1972–5, professor 1998–2006	Gaudion, Katie	Student 2008–10
Dagworthy, Wendy	Professor 1998 to present, dean 2011 to present	Gentleman, David	Student 1950–53
Dalou, Aimé-Jules	Staff 1877–80	Gibb, Bill	Student 1966–7
Dalwood, Dexter	Student 1988–90	Gibson, Leslie	Student 1930–33
Dant, Adam	Student 1990–92	Goodden, Robert	Professor 1948–74
Darwin, Robin	Principal 1948–67, rector 1967–71	Gorman, Zara	Student 2008–10
Day, Lucienne	Student 1937–40	Grant, Alistair	Student 1947–51, staff 1955–86, professor 1986–90
Day, Robin	Student 1935–9	Grcic, Konstantin	Student 1988–1990
de Cordova, Denise	Staff 2012 to present	Greaves, Derek	Student 1948–52
de Francia, Peter	Professor 1972–86	Greenaway, Kate	Student 1865–9
de Rijke, Alex	Student 1984–6, staff 1995–6, professor and dean 2011 to present	Groobey, Kate	Student 2008–10
Deacon, Richard	Student 1974–7	Gue, Simon	Student 1988–90
Deighton, Len	Student 1952–5	Guyatt, Richard	Professor 1948–78, rector 1978–81
Derwent Wood, Francis	Student 1889–90, professor 1918–24	Hamilton, Anthea	Student 2002–4
Dillon, Charles	Student 1966–71	Hamilton, David	Staff 1974–84, professor 1984–2000
Dillon, Jane (nee Young)	Student 1965–8, staff 1986–7, 1994–2005	Hamlyn, Helen (nee Jones)	Student 1952–5
Dobson, Frank	Professor 1946–53	Hall, Ashley	Staff 2009 to present
Dresser, Christopher	Student 1847–52, staff 1852–68	Harbutt, William	Student early 1870s
Dumbar, Gert	Student 1963–6, visiting staff, staff 1985–7	Harcourt, Geoffrey	Student 1957–60
Dunne, Anthony	Student 1986–8, professor 2005 to present	Harrow, Dale	Staff 1989–2006, professor 2006 to present
Dury, Ian	Student 1963–6	Hawkey, Raymond	Student 1950–53
Dyce, William	Superintendent and professor, 1838–43	Heatherwick, Thomas	Student 1992–4
Dyson, James	Student 1966–71	Hedgecoe, John	Staff 1966–75, professor 1975–94
Ellis, David	Student 1985–7	Height, Frank	Student 1949–52, staff 1959–74, professor 1975–86
Emberton, Joseph	Student 1911–4	Hepworth, Barbara	Student 1921–4
Emin, Tracey	Student 1987–9	Heritage, Robert	Student 1948–51, staff 1972–4, professor 1974–7
Epstein, Jacob	Artist in residence 1950–51	Herman, R W	Student 1840
Farthing, Stephen	Student 1973–6, staff 1978–85	Hockney, David	Student 1959–62
Fedden, Mary	Staff 1958–64	Hunt, Martin	Student 1963–6, staff 1968–86
Fern, Dan	Student 1967–70, staff 1974–86, professor 1986–2010	Hunter, Tom	Student 1995–7
Field Reid, Amos	Student 2010–12	Huxley, Paul	Staff 1976–86, professor 1986–98
Fildes, Luke	Student 1863–5	Hyland, Angus	Student 1986–8

Ironside, Janey	Staff 1949–51, professor 1956–68	Minton, John	Student 1936–8, staff 1948–57
Jagger, Charles Sargeant	Student 1907–11	Moody, Francis Wollaston	Staff 1875–1881
Jekyll, Gertrude	Student 1861–2	Moore, Henry	Student 1921–4, staff 1924–31
Joffe, Chantal	Student 1992–4	Moralioglu, Erdem	Student 2001–3
Johnston, Clare	Professor 2000 to present	Morgan, Huw	Student 1994–6
Johnston, Edward	Staff 1901–39	Morrison, Jasper	Student 1982–5
Jones, Allen	Student 1959–60	Moynihan, Rodrigo	Professor 1948–57
Jones, Owen	Student c. 1852	Mukii, N'gendo	Student 2010–12
Jowett, Percy	Student 1905–7, principal 1935–48	Mullins, Alex	Student 2010–12
Kapadia, Asif	Student 1995–7	Murray, William Staite	Staff 1925, chief instructor 1926–39
Kaur, Jasleen	Student 2008–10	Myerscough, Morag	Student 1986–8
Kayser, Marcus	Student 2009–11	Myerson, Jeremy	Staff 1989–2002, professor 2002 to present
Kennard, Peter	Student 1977–80, staff 1994 to present	Nash, John	Staff 1934–40, 1948–58
Kerr, Joe	Staff 2001 to present	Nash, Mark	Professor 2006 to present
Khan, Idris	Student 2002–4	Nash, Paul	Staff 1924–5, 1938–9
Kitaj, R B	Student 1959–61	Neale, Paul	Student 1988–90
Kitching, Alan	Staff 1988–2006	Nelson, David	Student 1973–6
Klimowski, Andrzej	Staff 1989–2003, professor 2004 to present	Nevill, Bernard	Student 1953–5, professor 1984–8
Kossoff, Leon	Student 1953–6	Noack, Ruth	Staff 2012 to present
Kubel, Henrik	Student 1998–2000, staff 2009 to present	Osgerby, Jay	Student 1992–4
Lamb, Alexander	Student 2010–12	Ofili, Chris	Student 1991–3
Lantéri, Edward	Staff 1874–80, professor 1880–1917	Orr, Chris	Student 1964–7, staff 1974–98, professor 1998–2008
Lee, Lawrence	Student 1944–8, staff 1948–68	Pankhurst, Sylvia	Student 1904–6
Legros, Alphonse	Staff 1875–1881	Paolozzi, Eduardo	Staff and visiting staff 1968–89
Leon, Nick	Staff 2007 to present	Parry, Eric	Student 1976–8
Lenthall, Ron	Staff 1956–82	Pasche, John	Student 1967–70
Lethaby, William	Professor 1901–18	Pavitt, Jane	Staff 2010–11, dean 2011 to present, professor 2012 to present
Levien, Robin	Student 1973–6	Pennington, Miles	Staff 2007–9, professor 2009 to present
Lutyens, Sir Edwin	Student 1885–7	Piper, John	Student 1928–9
Macdonald, Julien	Student 1994–6	Poynter, Edward John	Staff 1875–81
Mach, David	Student 1979–82	Price, Antony	Student 1965–8
Martin, Mary	Student 1929–32	Priestman, Paul	Student 1983–5, staff 1987–91
Mara, Tim	Student 1973–6, professor 1990–97	Pye, David	Staff 1948–63, professor 1964–74
March, Lionel	Rector and vice-provost 1981–6	Quay, Brothers	Students 1969–72
Marx, Enid	Student 1922–5	Queensberry, David	Professor 1959–83
McMorris, Ekua	Student 2007–9	Raby, Fiona	Student 1986–8, staff 2005 to present
Meadows, Bernard	Professor 1960–80	Ravilious, Eric	Student 1922–5, staff 1930–38
Mehta, Deshna	Student 2010–12	Rayson, David	Student 1995–7, staff 2001–6, professor 2006 to present
Mellor, David	Student 1950–54		
Meta Bauer, Ute	Professor and dean, 2012 to present		

Redgrave, Richard	Staff 1846–52, positions including headmaster and superintendent of art 1853–75
Reid, Clunie	Student 1993–5
Restieaux, Mary	Student 1972–4
Revell, Tobias	Student 2010–12
Rhodes, Zandra	Student 1961–4
Richon, Olivier	Staff 1997–2006, professor 2006 to present
Riley, Bridget	Student 1952–5
Rogers, Ab	Staff 2012 to present
Rosoman, Leonard	Staff 1956–76
Rothenstein, William	Principal 1920–35
Rowe, Michael	Student 1969–72, staff 1984 to present
Russell, Dick (Richard D)	Professor 1948–64
Sampe, Astrid	Student 1931–2
Sandhu, Inderjeet	Student 2011 to present
Scott, Ridley	Student 1958–61
Semper, Gottfried	Staff c. 1852
Shaw, George	Student 1996–8
Shovlin, Jamie	Student 2001–3
Smith, Jack	Student 1950–53
Smith, Martin	Student 1971–3, staff 1989–99, professor 1999 to present
Smith, Richard	Student 1954–7
Spear, Ruskin	Student 1931–5, staff 1948–75
Stannus, Anthony Carey	Student 1863
Stevens, Alfred	Staff 1845–7
Stevens, Andy	Student 1988–90
Stevens, Jocelyn	Rector and vice-provost 1984–92
Stezaker, John	Staff 1991–2006
Stockham, Jo	Staff 1997–2007, professor 2008 to present
Stofer, Hans	Professor 2006 to present
Straub, Marianne	Staff 1968–74
Temperley, Alice	Student 1997–9
Templeton, Suzie	Student 1999–2001
Thompson, Paul	Rector and vice-provost 2009 to present
Tilson, Joe	Student 1952–5
Timney, Sue	Student 1977–9
Townsend, Henry James	Staff c. 1845–47
Treacy, Philip	Student 1988–90
Triggs, Teal	Professor 2012 to present
Tunnard, John	Student 1919–23

Turk, Gavin	Student 1989–91
Walker, Derek	Professor 1985–90
Ward, Basil	Professor 1946–1956
Watkins, David	Professor 1984–2008
Weight, Carel	Staff 1947–57, professor 1957–72
Weil, Daniel	Student 1978–81, professor 1991–4
Welch, Robert	Student 1952–5
Wentworth, Richard	Student 1966–70, professor 2009 to present
Walker, Charles	Staff 2012 to present
Walker, Kevin	Staff 2012 to present
Wilding, Alison	Student 1970–73
Willis, Jeff	Staff 2002 to present
Wiltshire, Hermione	Staff 2011 to present

INDEX